CREATIVE DRAWING

SECOND EDITION

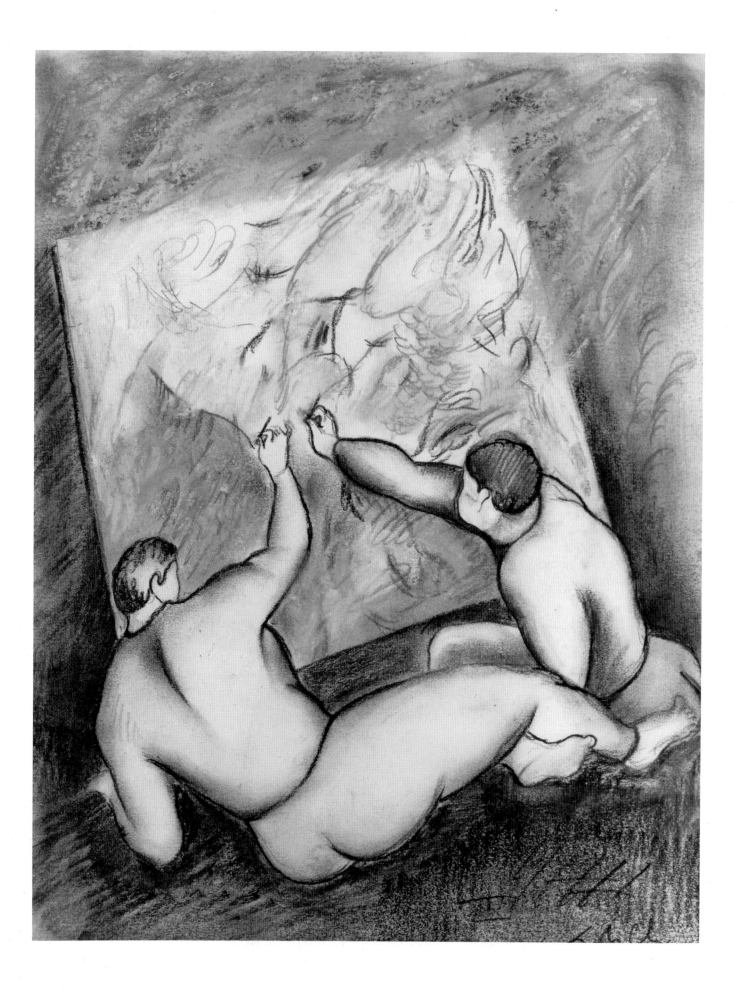

CREATIVE DRAWING

SECOND EDITION

HOWARD J. SMAGULA

Laurence King Publishing

LAURENCE KING

Published in 2002 by Laurence King Publishing Ltd
71 Great Russell Street
London WC1B 3BP
Tel: + 44 20 7430 8850
Fax: + 44 20 7430 8880
email: enquiries@laurenceking.co.uk
www.laurenceking.co.uk

ISBN 1-85669-310-4

Editor: Richard Mason
Picture Researcher: Julia Ruxton
Designer: R & M Foenander
Cover Designer: Price Watkins Design
Typeset by Fakenham Photosetting, Fakenham, Norfolk
Printed in China

Front cover: Ron Batchelor, *Untitled*, c. 1990. Courtesy the
artist/Richard Stockton College.

Back cover: Edgar Degas, *Dancer Adjusting Slipper*, n.d. Pencil and
charcoal. The Metropolitan Museum of Art. Bequest of Mrs. H. O.
Havemeyer, 1929. (29.100.941)

Frontispiece: Sandro Chia, *Evening of Collaboration*, 1981. Crayon
and pastel, 16 × 12 in (40.5 × 30.4 cm). Courtesy Anthony D'Offay
Gallery, London.

PICTURE CREDITS

CONTENTS

PROJECT LIST

PREFACE

The premise of this book is that with proper guidance and self-motivation anyone can learn to draw. Drawing is a visual language with its own vocabulary and internal logic. *Creative Drawing* seeks to dispel the myth that people need to be born with talent to achieve credible results. It introduces students to the traditions, theoretical concepts, and technical skills that form the basis for solid achievement. Most importantly, the text emphasizes the creative potential of each student. Everyone has a unique world view that can be enhanced through the art of drawing.

Part I, "The World of Drawing," introduces readers to many creative aspects of contemporary drawing, and provides insights into the history of this venerable discipline. Since non-Western drawings have been influencing the practice of drawing for at least 150 years, this section has been expanded in the second edition. Part I also includes more architectural renderings and illustrations used in magazines and newspapers. Since many of today's students will enter the graphic design and illustration fields, this will serve the interests of a broad constituency.

Part II, "The Elements of Drawing," introduces students to basic graphic techniques and visual elements. It assumes no prior knowledge of drawing and begins "hands-on" instruction with a detailed exposition of drawing materials and how they influence the drawing process. These materials are deceptively simple and must therefore be used efficiently: To achieve credible results, one must do a lot with a little. This requires a thorough understanding of the interaction between tool and paper. Chapter 3 covers gesture and continuous line-drawing techniques. Students are introduced to construction methods and shown how to analyze, plan, and build their drawings. Chapters 4, 5, and 6 cover the important roles played by *line*, *value*, and *texture*, and feature many practical projects. Chapter 7, "Composition and Space," helps students integrate these elements into unified compositions, while Chapter 8 introduces perspective. Both these chapters have been expanded and include more examples.

Part III, "Creative Expressions," directs students toward more personally expressive drawings. Chapter 9, "Creativity and Visual Thinking," has been substantially revised to offer more challenging drawing assignments. Chapters 10, 11, and 12 focus on creative ways in which students can make use of the concepts and techniques already covered. Chapter 10, "Exploring Color," includes new examples of artists working in many color media, and invites students to experiment with both dry and wet media. Chapter 11 examines the ways in which artists have interpreted still lifes, figure drawings, portraits, and landscapes. This chapter has been enlarged to offer more figure illustrations and advice about how to draw the human figure.

Chapter 12, "Image and Idea," profiles a larger group of contemporary artists who have developed unique themes and drawing styles. Using these individuals as conceptual "models," students are made aware of how artists develop personal concepts and sensibilities, and then transform them into coherent bodies of artistic work.

Chapter 13, "Drawing Applications," demonstrates ways in which the drawing process is used or reinvented by professionals today. For example, William Kentridge has redefined film animation. Instead of creating a new graphic image for each film frame, he creates large charcoal drawings and then slightly alters them for each photographed film frame by adding or erasing sections. The resulting short, animated films are haunting and highly evocative because the images have been drawn, redrawn, and partially erased by the invisible hand of the artist.

Chapter 13 also covers drawing in the digital age. The computer is presented as an instrument that can increase the efficiency and vision of the artist. Despite the power of this tool, however, it still needs to be guided by the skills and knowledge of the artist and designer.

New to the second edition are a series of practical Guides about how to handle, store, mat, and frame drawings safely. Since good slides of student drawings may play an important role in landing that first job or getting into graduate school, I have also included a step-by-step guide that shows students how to photograph drawings to achieve professional results.

Creative Drawing takes students on a journey from understanding basic theories of drawing and selecting materials to outcomes of the drawing process: how to frame their best drawings for public or personal display. It is my hope that students, having been given a solid grounding in the art of drawing, will continue to learn, evolve creatively, and extend the body of knowledge and accomplishment upon which this discipline is based.

I am indebted to the feedback of many colleagues who teach and coordinate drawing and foundation programs: L. B. Arnillas, Seton Hill College; David Cook, Sterling College; Kelly Cornell, Lake-Sumter Community College; John Dinsmore, University of Nebraska at Kearney; Alain Gavin, Chicago State University; Kevin Harris, Sinclair Community College; James Knutson, Black Hills State University; Stephen LeWinter, University of Tennessee at Chattanooga; René Marquez, University of Delaware; Deborah Mitchell, South Dakota School of Mines and Technology; Ray Neufeld, Long Island University; Debora Oden-Meza, University of Nebraska; Kathleen Schulz, Raritan Valley Community College; A. J. Smith, University of Arkansas at Little Rock; Ray Statlander, New Jersey City University; Jerry Sumpter, University of Nebraska. I am also indebted to the staff of Laurence King Publishing, namely, editorial director Lee Greenfield, designer Richard Foenander, picture researcher Julia Ruxton, and especially to my editor Richard Mason, whose creative skills and project management were a constant source of inspiration.

Howard Smagula, Montclair, January, 2002

— PART 1 —
THE WORLD OF DRAWING

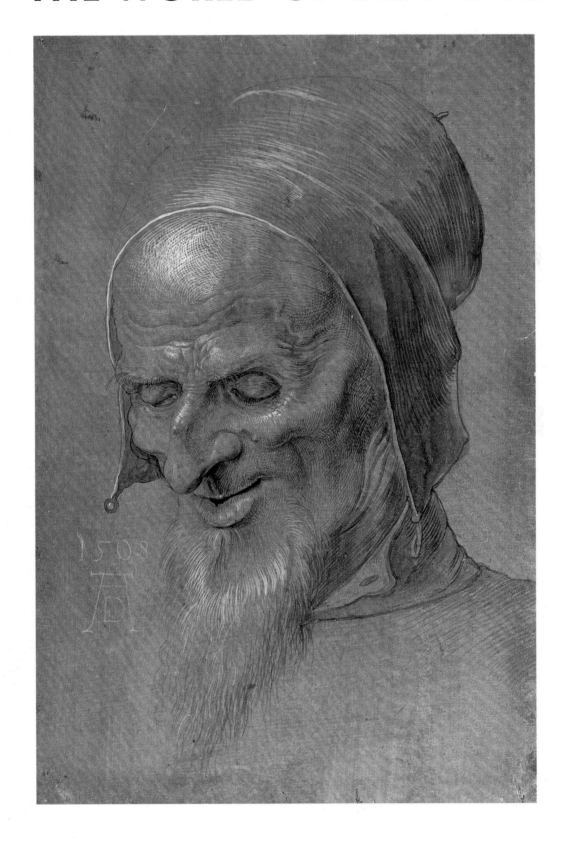

INTRODUCTION
LOOKING AT DRAWINGS

Throughout history few artforms have achieved the universality that drawing has. Every culture, from the most ancient and primitive to the most modern and technologically advanced, has made use of drawing in some form or another. Drawing, or the making of meaningful marks, is a universal pursuit of the human spirit and thus in a variety of forms transcends geographic borders, continents, and cultures to become the closest thing we have to a universal language.

Much of the power and expressiveness of this visual medium stems from a marvelous paradox that surrounds it. Drawing is at once a remarkably simple and spontaneous process, yet one which produces results that are visually rich and deeply involving. Compared with painting, sculpture, and other costly and time-consuming media, drawing is a relatively straightforward and immediate process. Most drawings are made by organizing a series of lines or marks (usually dark) on a sheet of paper or other suitable flat surface. Simple enough. Yet one of the most compelling aspects of this simple process is the extraordinary range of visual effects, images, spatial concepts, and feelings that can be expressed through this medium.

The primary reason drawing can communicate such an array of information and sensibilities is because it functions as a basic language, a *visual* language that predates the written word. Drawing has always played a vital role in the achievements of humankind, serving as an important means of visual notation and expression. Learning and practicing this artform will heighten your perceptions and enable you to discover important aspects about yourself and the world around you.

By the time most people reach adulthood they have seen a remarkable number of drawings. This artform is included with increasing regularity in many museum and gallery exhibits. And magazines and newspapers are full of drawings calling our attention to a feature article or editorial opinion.

To help you become a skilled maker of drawings you need to learn how to 'read' drawings from the special perspectives of art professionals. How are the lines and spaces organized? What materials and drawing techniques are used? What visual effects or concepts are communicated? Knowledge gained from this kind of active viewing can be applied to your own efforts and hasten your progress as a student of drawing.

DRAWING TODAY

The range of images, feelings, and concepts that can be expressed through the drawing medium is virtually limitless. Every artist uses the materials and methods of drawing in unique and personally expressive ways – this is part of its fascination. The drawings featured in this section will give you some idea of what this medium can express and how the organization and look of a drawing responds to individual concerns and contemporary concepts.

(overleaf) Albrecht Dürer, *Head of an Apostle*. Brush and India ink and white body color on green, 12½ × 8⅓ in (31.7 × 21.2 cm). Albertina, Vienna.

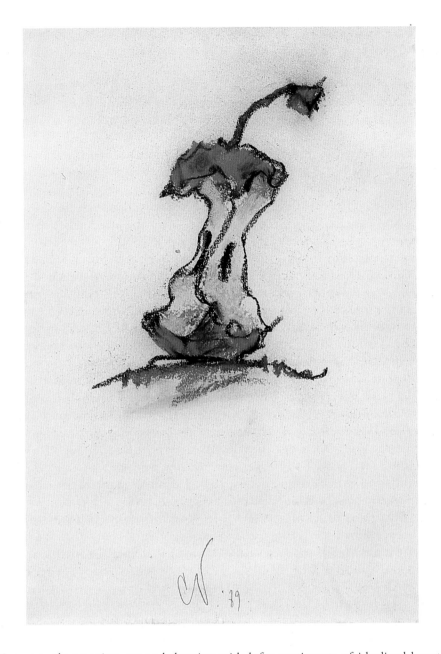

0.1 Claes Oldenburg, *Apple Core*, 1989. Charcoal and pastel, 12⅞ × 9⅛ in (32.7 × 23.2 cm). Private Collection. Reproduced with permission of the artist.

Many people associate art and drawing with lofty sentiments of idealized beauty and 'truth'. Artists today, however, often take delight in challenging or redefining these concepts in terms of modern sensibilities.

The amusing drawing by Claes Oldenburg (b. 1929) of an apple core (Fig. **0.1**) makes us rethink the nature of beauty. This drawing cleverly transforms the way we perceive an object so commonplace that we rarely notice it.

By placing the image slightly above center in this drawing, the artist isolates the apple core and elevates a piece of organic refuse into the realm of the visual arts. Also, by contrasting the vigorous charcoal and pastel lines and marks with the smooth expanse of the creamy white paper that surrounds them, Oldenburg imparts a curious importance and monumentality to this object that belies its humble origins. Spontaneously flowing lines follow the contours of the apple core and define its shape, while tonal variations between the light flesh of the apple and the reddish skin are rendered with a seemingly casual flair. The artist is also calling attention to the means of drawing, the flowing lines, choppy strokes, and smudged color passages that form this arresting image.

Claudio Bravo's drawing *Three Heads* (Fig. **0.2**) makes superb use of classical drawing techniques that are usually associated with European masters of the seventeenth and eighteenth centuries. A Chilean by birth, Bravo lives in Tangier in Morocco, partly drawn by the solitude of this foreign city, but also attracted by its special qualities of light and the unique subject matter of North Africa.

Although his work may look "photo-realistic," Bravo only works directly from the model, whether he is doing a landscape, a still-life, or a portrait series. Such direct observation produces drawings that are detailed and naturalistic, yet far removed from the kind of wall-to-wall realism achieved with a camera. *Three Heads* presents us with a dreamy, romantic vision in which great care is lavished on physical details yet the factual world of mere appearance is successfully transcended. Bravo evokes the mystery and unique presence of these three men and makes us wonder about their lives.

These three portraits form a unified composition, yet Bravo presents them in isolation, each subject seemingly involved in quiet introspection. Technically, Bravo reinforces the concept of isolation by drawing each head with a different combination of colored chalk. The largest and most prominent portrait is created with carefully blended lines of black conté crayon, sanguine (a reddish chalk), and sepia, a dark brown colored chalk. The center portrait is created entirely with black conté crayon and the smallest head is drawn only with sanguine.

Each portrait plays a special role in the drawing's scenario and each contributes to the richness of experience made possible by the artist's vision. In this drawing Bravo carefully describes the features of three men but at the same time manages to evoke feelings about Morocco and its ancient history and traditions. In a sense he is also revealing to us something of his adopted country's soul and being.

Elizabeth Murray (b. 1940) makes drawings that are large, dynamic, and richly embellished with dense textures and complex coloristic tonalities. She has developed a style of pastel drawing characterized by bold, curved shapes which refer, in semi-abstract ways, to everyday objects in the world. *Black Tree* (Fig. **0.3**) was made by overlapping two sheets of paper and creating what is referred to as a shaped format. On this slightly irregular sheet the artist has created a stylized image of a

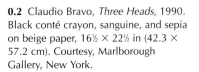

0.2 Claudio Bravo, *Three Heads*, 1990. Black conté crayon, sanguine, and sepia on beige paper, 16½ × 22½ in (42.3 × 57.2 cm). Courtesy, Marlborough Gallery, New York.

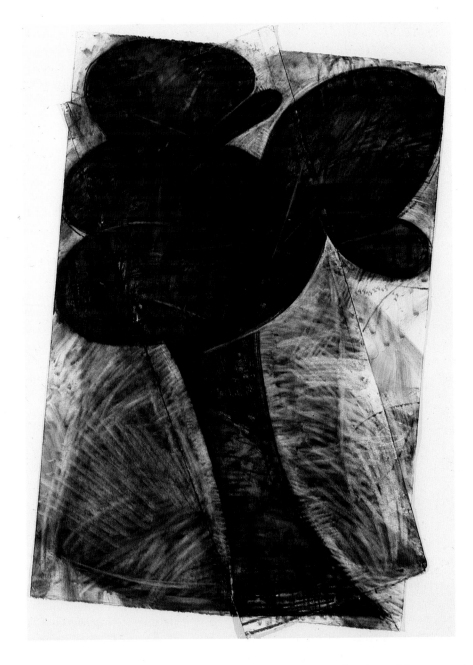

0.3 Elizabeth Murray, *Black Tree*, 1982. Pastel on 2 sheets of paper, 48 × 36 in (121.9 × 91.4 cm). Collection Estée Lauder Cosmetics, Paula Cooper Gallery. Courtesy Pace Wildenstein.

tree. Many of the images in Murray's drawings are marvelously ambiguous and make reference to more than one object or thing. For instance, referring to *Black Tree*, the artist observed that "the trunk could be a neck and the foliage a head with hair or ears."

Murray loves the immediacy and directness of drawing with charcoal and pastel. Often she will blacken the paper and then use her eraser to lift off portions of the pastel until a ghost-like image seems to emerge from the depths of the paper. The vigorous chalk marks, the scrubbed and rescrubbed surfaces, and the overlapping forms found in this drawing allow viewers insights into the artistic process that gave birth to this work of art.

The three drawings we have viewed so far make use of some form of recognizable imagery. By comparison, *Anabasis* (Fig. **0.4**) by Cy Twombly (b. 1929) seems to have no subject matter and to be the result of randomly and naively scrawled lines. But, beyond their outward appearance, his drawings have a subtle and sophisticated sense of order that is meditatively thoughtful and sensuously pleasurable. In this

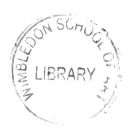

0.4 Cy Twombly, *Anabasis*, 1983. Oil and wax crayon on paper, 39½ × 27½ in (100 × 70 cm). Courtesy, Galerie Karsten Greve, Cologne, Germany.

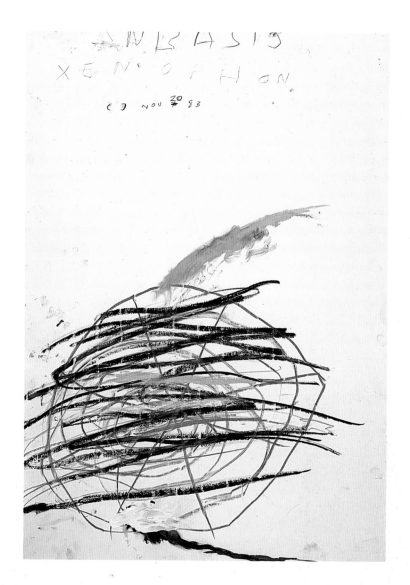

work Twombly participates in a form of expressive, intense engagement with the very process of mark making that is the essence of drawing. In doing so the artist explores various aspects of his conscious and unconscious self. *Anabasis* makes reference to no image other than the image created by the act of drawing. Twombly is not presenting us with a representational image, he is inviting us to participate, through our viewing, in the pleasurable activity of mark making.

Although there is no traditional imagery in Twombly's drawing, this does not mean that there is no content or meaning to the piece. Twombly is a serious student of Classical Greek and Roman literature and quite often themes suggested by his reading find their way into his drawings. The title of this drawing is derived from the Greek word meaning "go up" or "walk;" the term was defined by the Ancient Greek writer Xenophon, whose name is written faintly in the drawing, to mean a bold military advance. Certainly the activity, vigor, and thrust of the massed lines in *Anabasis* suggest action and movement and perhaps allude to the kind of forceful military mission Xenophon described in his writing.

Another concern among contemporary artists is a desire to explore personally meaningful issues and sometimes urgent social concerns. *Whispers from the Walls*, a large-scale installation piece, by Whitfield Lovell (b. 1953), is a multi-media artwork that evokes the life of rural African-Americans living in the South in the 1920s (Fig. **0.5**). To create this environment Lovell constructed an open-ceiling cabin-like struc-

ture measuring 23 by 18 feet out of unpainted, weathered wood. The exterior of this shell is deceptively stark and simple. Inside, however, the "cabin" comes alive with full-size, ghost-like images of men and women who might have lived in such a home. These drawings are made directly on the raw wood with charcoal and are based on photographs Lovell selected from among thousands he found in a Texas archive. The photographs, mostly produced in commercial studios in the South, depict individuals and couples who chose to have their images recorded in a semi-formal way. The drawings seem to emanate from Lovell's chosen material rather than lying on top of the weathered and worn surfaces – they appear to be as much a part of the wood as its grain. This quality is important to Lovell because the catalyst for this installation was his historic awareness of the abrupt and violent removal of an entire community of African-Americans in Denton, Texas at the turn of the nineteenth century. The removal was caused by the foundation of a college for white women teachers near the black settlement, which local officials deemed to be too close to the white facility.

Even though this community of cabins was demolished and carted away as scrap, Lovell's artwork gives voice and vision to this racial injustice. Along with the haunting images buried within the wall, the artist has created a sound environment as well. An audiotape is heard softly in the background with the barely discernible sounds of children laughing and adults engaged in domestic conversation. The

0.5 Whitfield Lovell, *Whispers from the Walls* (detail), 1999. Interior installation view. Courtesy, D.C. Moore Gallery, New York. Photo: Steve Dennie. University of North Texas Press.

installation thus forcefully represents the images and voices of African-Americans who are long gone but not forgotten; triumphantly their whispers from the past drown out the hateful rhetoric that swarmed around their lives and community.

Much of Lovell's work seems to be motivated by themes of loss and the persistence of memory. Although the artist did not live through this time, he was mesmerized by the vivid stories and childhood memories of his grandparents who were originally from the South. *Whispers from the Walls* is a quiet yet powerful reminder that, despite physical forces of change, the human spirit can endure; through the alchemical nature of art, defeat can be transformed into victory.

The above drawings were all done within a fine art or personally expressive context. The drawing process, however, is used by countless graphic designers, illustrators, architects, and product designers as a universal language and is an indispensable means of exploration and visual expression. A colleague of mine is fond of pointing out to his drawing students that virtually everything they see in the room – any room – was drawn before it was built. Drawing can describe how anything, from a 747 jumbo jet to a remodeled kitchen, is constructed.

Drawings do not exist just on museum walls and in the homes of collectors. They enliven and inform the realm of popular culture which seems to be growing exponentially every year. It is now difficult for most people to imagine a world without magazines, newspapers, cable television, and the internet. All these media make use of some form of drawing. Although photographs are an important part of our visual diet, drawing also plays a special role in terms of illustrating magazine articles, advertisements, and newspaper publications.

0.6 David Johnson, *Buddy Red Bow*, 1998. Pen and ink, 7¼ × 8 in (18.4 × 20.3 cm). Courtesy, the artist/Richard Solomon, New York.

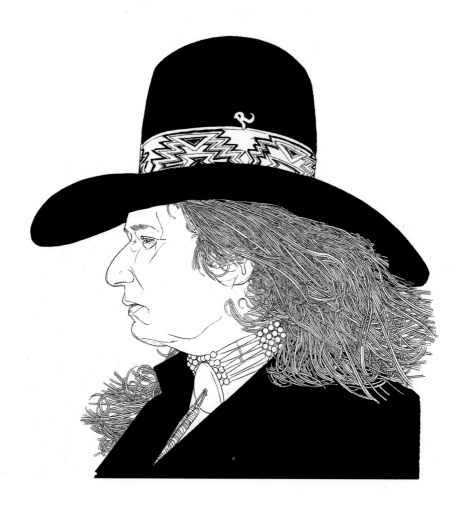

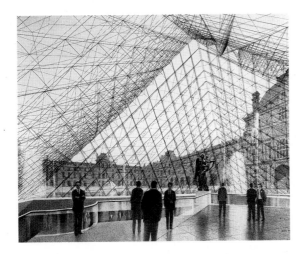

0.7 Pei Cobb Freed & Partners, *Interior View of Addition to the Louvre from the Pyramid Looking into the Court Napoléon*, 1986. Plotter drawing (by Paul Stevenson Oles and Rob Rogers) with felt-tip pen and pencil on paper, 18 × 22 in (45.7 × 55.9 cm). Courtesy, Pei Cobb Freed & Partners.

In a more serious but equally captivating mood, David Johnson's pen and ink portrait of the late Oglala Lakota country singer Buddy Red Bow was published with a music review in *The Wall Street Journal*. This image reveals an introspective and dedicated musician whose clothes and personal artifacts speak volumes about his Native American background and heritage (Fig. **0.6**). Looking at this drawing makes us want to know more about him as a musician and performer.

Many contemporary illustrators achieve visual results equal to those of the traditional fine arts. Illustrations that are drawn to accompany written articles are intended to visually reinforce the thematic content of the text, perhaps even to make the printed page seem less austere and to encourage us to read the article.

The physical world around us would not exist in its present form without the help of drawing. Before any large architectural commission gets to the construction stage hundreds of drawings must be made, from preliminary sketches defining the basic shape of the structure to blueprints specifying minute building details. Because of their need to draw and redraw various elements, architects have been keen proponents of drawing's newest tool – the computer.

Once visual information about a building is programmed into a computer database, architects can redraw the building from a variety of perspectives. This drafting automation saves countless hours of drawing time, particularly when the structure is as complex as the pyramidal glass and steel addition Pei Cobb Freed & Partners created for the Louvre Museum in Paris (Fig. **0.7**).

This image employs both computer-aided and hand-rendered drawing techniques. A mechanized pen, called a plotter, was driven by a computer to create the highly accurate and complex geometric network of lines that represent the framework of this transparent structure. To show how the building might look from the interior and to give it scale, artists hand-drew the figures in the foreground and the exterior buildings using felt-tip pens and pencils.

It is important to remember that no computer system draws on its own. People created the complex software and people must guide its operations every step of the way. The computer-aided drawing process is just another instrument in the toolbox of the contemporary artist. Along with the practical and functional abilities of the drawing discipline, it can also be used to create visionary images of buildings that will never be built. Because drawings can turn what we imagine into something real (at least on paper), our minds are enriched and our sense of wonder is kindled.

Drawing is also one of the most adaptable of visual mediums. Contemporary artists and designers are constantly discovering new roles for drawing to play. They are asking new questions and coming up with new answers. Designers and illustrators working for the Wilsonart International company, a maker of high-pressure

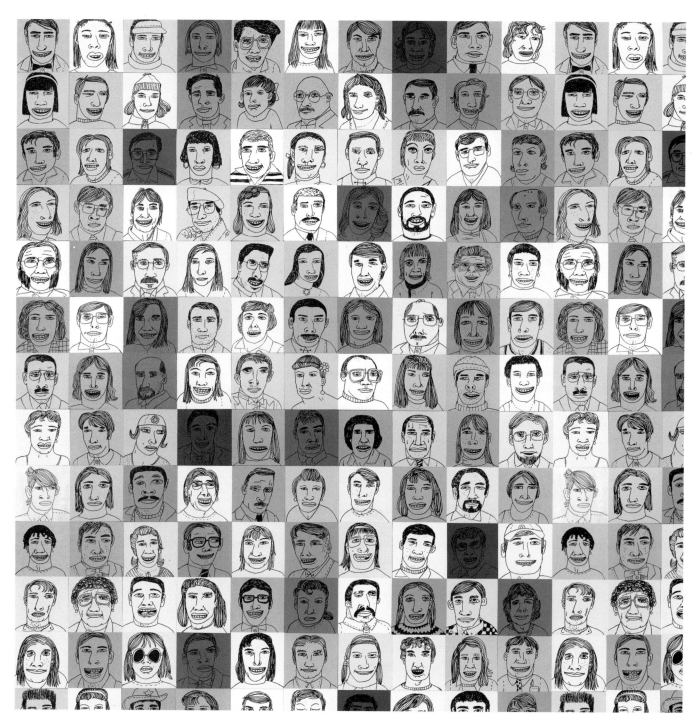

0.8 Mark Todd, *Yearbook*, 1999.
Ballpoint pen on color sample chips,
4 × 4 ft. From Wilsonart International,
Millennium Collection.

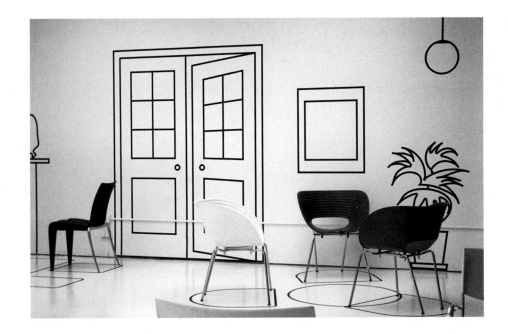

plastic laminates (the kind that might be used on table tops or kitchen counters), used the latest technology to expand on the uses of this conventional material. Digital printing methods gave designers the opportunity to incorporate any design or drawing on the laminated surfaces in quantities as small as a single sheet. With the older manufacturing methods, quantities less than a million square feet were unfeasible. A hundred drawings by schoolchildren were used to create the custom laminate shown in Figure **0.8**. Wilsonart's custom laminate division is equipped with a sophisticated computer lab which can take any design or drawn image and create sheets of durable laminate out of them. Architects can now create customized work surfaces in homes and offices that personally relate to the people who work and live in these spaces.

The medium of drawing is compelling in its directness and simplicity. You pick up a pencil or marker and make some lines and marks. In 1999 the designers Constantin and Lauren Boym, a husband and wife team, were commissioned by the makers of Vitra Chairs to design an exhibit display for the Chicago Merchandise Mart that would showcase their sophisticated line of chairs. During the course of client discussion, the Vitra team kept saying that they wanted to "warm things up." On a whim (not quite understanding what this meant) Constantin said, "Okay, I'll draw a fireplace or a radiator on the wall." Eventually this led to the creation of a large-scale wall drawing (Fig. **0.9**): bold drawings of commonplace fixtures and domestic objects adorn the stark white walls and floor of the display room, working in counterpoint to the elegant lines of the chairs. The Boyms believe that this quality in design is badly needed in order to make everyday experiences and objects relevant to human needs.

As the examples in this brief introduction reveal, there is little that contemporary drawing cannot describe or express. Chapter 1 will enable you to learn about the practice of drawing and offer guidance for your own work in this artform.

1 THE EVOLUTION OF DRAWING

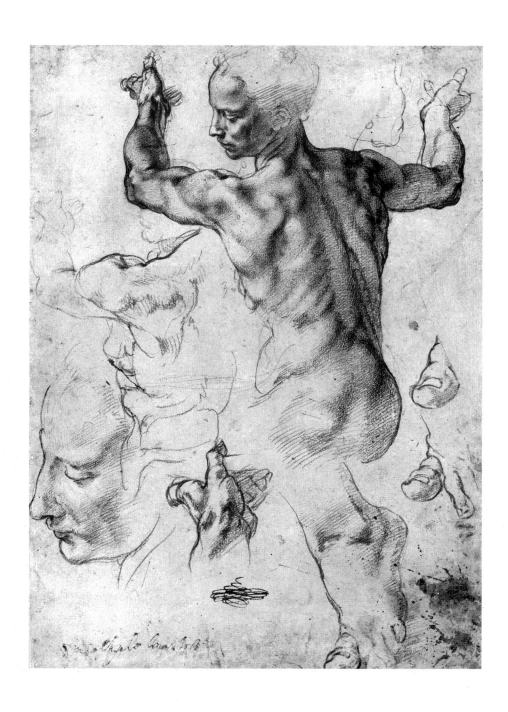

efore we begin to draw we should become familiar with some of the aims and traditions of this popular artform. Different cultures and time periods have approached drawing from a variety of perspectives, but all have used this form of visual expression to communicate significant ideas and record important information.

This chapter will provide you with a better technical understanding of how the elements of drawing have been used to create images and record information. The purpose of this section is not to provide you with a comprehensive historical survey of this artform. Our objective is for you to acquire personal drawing skills that you can use to express your own ideas and communicate your own perceptions. But much practical information and applicable theory can be gleaned from an understanding of this craft's origins and evolution.

THE ORIGINS OF DRAWING

Some of the earliest drawings known to the world, discovered in Lascaux, France as recently as 1940, bear silent testimony to the power of prehistoric visual expression. No doubt earlier examples vanished due to weathering and deterioration of the rock. But, if the caves of Lascaux are any indication, prehistoric forms of visual expression were quite lively and strikingly modern in appearance.

Jean Leymarie, a French scholar specializing in the history of drawing, eloquently describes Lascaux's mesmerizing visual and psychological effects:

This cave imposes its powerful and symbolic hold even before one comes face to face in the semi-darkness with its astounding display of overlapping paintings, engravings and drawings . . . At Lascaux there are human figures, hand-prints, abstract signs, but the main theme is the procession of animals, in a style at once realistic and magical . . . After the rotunda of bulls coupled with horses (Fig. **1.1**),

(opposite) Michelangelo Buonarroti, *Studies for the Libyan Sibyl* (detail), 1511. Red chalk on paper, 11⅜ × 8⅜ in (28.8 × 21.3 cm). The Metropolitan Museum of Art, New York. Bequest of Joseph Pulitzer. 24.197.2 recto.

1.1 Bull and kneeling bovine animal, c.16,000–14,000 BC. Paint on limestone rock, length of bull: 11 ft 6 in (3.5 m). Main Hall, Lascaux, France.

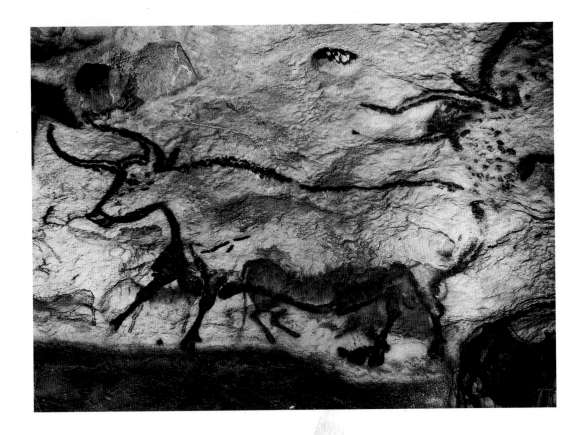

1.2 Frieze of deer heads. Main Hall, Lascaux, France.

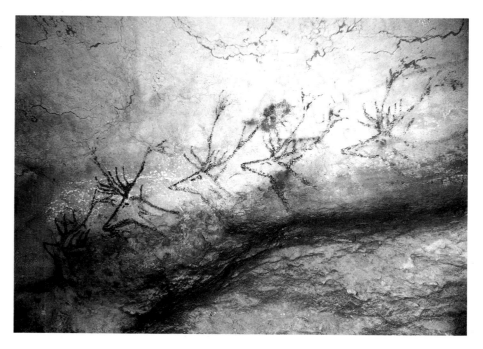

1.3 Jaune Quick-to-See Smith, *Wasatch Winter*, 2001. Lithograph. Courtesy, the artist.

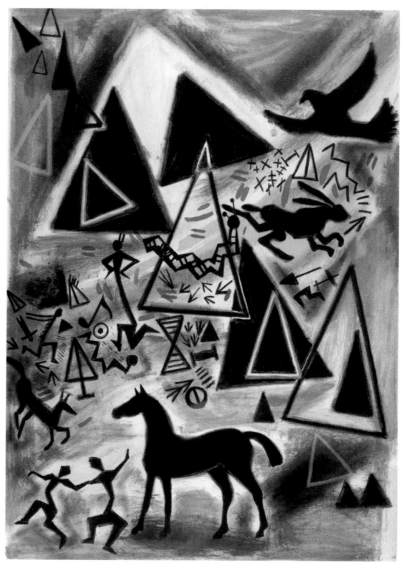

a narrow corridor leads to the main nave. On the right side extends a frieze of deer which seem to glide along the rock-face as if swimming in a moving stream (Fig. **1.2**), the antlers of their upraised heads forming supernatural patterns of lines.

We will probably never fully understand the motivations behind the creation of these remarkable drawings. However, it is safe to assume that they were associated with magical beliefs that connected an animal's visual representation with control over that creature. Although the purpose of these drawings was probably to ensure an adequate food supply, we must also acknowledge their haunting beauty. Whatever spiritual mission these drawings might have had, they also bear witness to another significant aspect of the human psyche, our need for aesthetic expression.

Jaune Quick-to-See Smith (b. 1940) is a Native American artist (Flathead/Shoshone/French Cree) whose work has been inspired by similar ancient images that were carved and painted on the walls of natural rock formation in America. *Wasatch Winter* (Fig. **1.3**) is a lithograph thematically based on the petroglyphs of the West Mesa Escarpment near Albuquerque, New Mexico. Its mysterious, runic marks are combined with the silhouettes of native animals and lively geometric forms. Quick-to-See Smith manages to breathe new life into these thousand-year-old images and evokes a curiously "ancient-modern" quality.

There is no doubt that contemporary artists are interested in rekindling the visual and emotional power associated with humanity's earliest surviving art works.

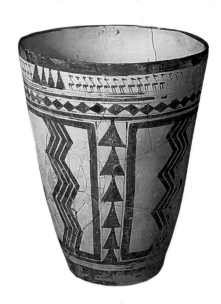

1.4 Painted pottery bowl from Susa, Iran, late 4th millennium BC. Height 8 in (20.5 cm). British Museum, London.

EARLY CIVILIZATIONS

After the prehistoric period the next clear stage of graphic expression occurs with the establishment of agrarian societies around 8,000 BC. Here drawings verge toward geometric, linear compositions that suggest a new order and control (Fig. **1.4**). At this stage of evolution humanity had for the most part abandoned nomadic life in favor of increasingly structured communal societies that lived in villages, tended herds of domesticated animals, and grew crops. The hallucinatory cave visions of a people greatly dependent on chance and fortune have been transformed into care-

1.5 *Last Judgement from Osiris*, from the *Books of the Dead*, found at Theban Necropolis. c. 1,300 BC. Painted papyrus, height 2¾ in (7 cm). British Museum, London.

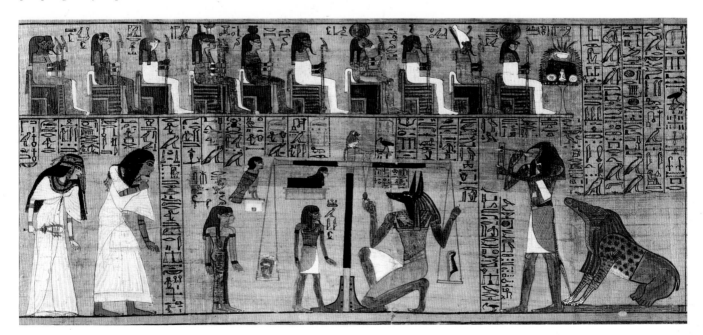

fully organized structures that suggest linear rows of crops and the geometric layout of early settlements and towns.

The art of Ancient Egypt represents, perhaps, the longest unbroken span of stylistic continuity in the history of the world. Many of this early civilization's artistic principles were well formulated by 3,000 BC and remained viable for over three thousand years. Many of the achievements of this civilization profoundly influenced Greek and Roman art and through the influence of these important cultures Egyptian art still affects our world.

Some of the earliest paper drawings in existence can be found in Egyptian manuscripts know as the *Books of the Dead*. These scrolls are made of papyrus, a substance created from the thin-shaved pith of the papyrus plant and glued together to form a continuous sheet. These ancient manuscripts contain a series of carefully orchestrated instructions, prayers, and illustrations for the guidance and protection of the deceased soul in its dangerous journey to the other world. The most dramatic moment in the *Books of the Dead* comes when pilgrims' hearts are weighed against a feather (Fig. **1.5**) to see if they are worthy to enter the Kingdom of the Dead. In this illustration the deceased is represented by the small human-headed hawk above and slightly to the left of the balancing heart. Fortunately for this individual, the heart achieves equilibrium with the feather, otherwise the hapless pilgrim would be thrown to the hyena-like creature waiting at the far right.

All the human figures and mythological creatures in this Egyptian manuscript are drawn in a highly stylized and strictly codified manner. Every subtle position of their hands, faces, and feet is predetermined and executed according to formulas that tended to remain unchanged for centuries. These drawing conventions were so well established they quite literally became a visual language. The flat linear patterning of the large figures in the *Books of the Dead* is echoed by the smaller hieroglyphic characters that comprise their written language. In Ancient Egypt, pictographic symbol and drawn image are fused.

The modern comic strip image illustrated in Figure **1.6** owes much to these early Egyptian drawings. Not only does it pay homage to the staying power of Egyptian art and myth (highly popularized of course) but it also emulates the way the *Books of the Dead* integrate text and image.

1.6 From *Thomas, Argondessi, & DeZuniga*, 'Infinity, Inc.' no. 42, 1987. Courtesy, DC Comics Inc.

THE DRAWN WORD

The development of drawing and written language parallel each other, perhaps more closely than is generally recognized. The shapes of the letters of the words are derived from Middle Eastern pictograms that portrayed people, animals, objects, and ceremonial activities. There is general agreement among scholars that not only our written language (directly modeled on Roman letters) but practically all of the world's writing started with simple, diagrammatic, or diagram-like images. Written language (and the refinement of drawing) began around 3,000 BC when pictograms were combined to express an idea that could not be represented by a single image. For instance, the Sumerians, who lived in what is now Iraq, depicted "wild ox" by combining their signs for "ox" and "mountain" (Fig. **1.7**).

1.8 Egyptian Apis.

1.9 Phoenician Aleph.

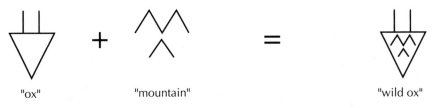

"ox" "mountain" "wild ox"

1.7 Wild ox.

To synchronize with the sounds of spoken language, visual symbols evolved into representations having constant sound values. The evolution from pictographic image to the modern alphabet can be traced in the history of our Roman letter "A."

The Egyptian character for their sacred bull, called "apis," was represented by a visual image of a bull with horns (Fig. **1.8**). Around 1,000 BC the Phoenicians (a sea-faring people who lived in city-states along the Mediterranean coast near present-day Lebanon) greatly advanced the development of writing. They invented a simplified system of visual sound-symbols that was easy to learn, read, and write. Their word for "ox," "aleph," is shown in Figure **1.9**. Out of this Phoenician system the Greeks developed their alphabet of twenty-four characters by changing various unused Phoenician consonant characters into vowel letters such as "alpha." The visual letter for the Greek "alpha" (Fig. **1.10**) evolved from the Phoenician "tilted ox," or "aleph." The Romans further refined the Greek shape into the more elegantly proportioned and symmetrical letter "A" (Fig. **1.11**) which has remained in this form, virtually unchanged to the present day.

1.10 Greek Alpha.

1.11 Roman "A."

THE CLASSICAL WORLD

During the Classical Greek period, between 500 and 300 BC, a dramatic shift in drawing occurs. The formalized, diagrammatic look, stemming from the earliest agrarian drawings, gives way to illusionistic works that feature the human figure in naturalistic settings. Few conventional drawings on paper and paintings survive, but many remarkable drawings are preserved as vase paintings.

The drawing seen in Figure **1.12**, *Lapith and Centaur*, was done on the interior of a shallow drinking cup, called a "kylix," by an anonymous artist known today as the "Foundry Painter." Using freely drawn brush lines this artist suggests a three-dimensional space through the use of overlapping forms. Lavish detail focuses our attention on the warrior's costume and the features of the man and centaur. The art of the Romans further extended the Ancient Greek interest in naturalism and together they established the foundation for European art's obsession with pictorial realism.

1.12 The Foundry Painter, *Lapith and Centaur* (interior of an Attic red-figured kylix), c. 480–470 BC. Staatliche Antikensammlungen, Munich.

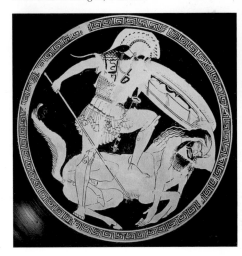

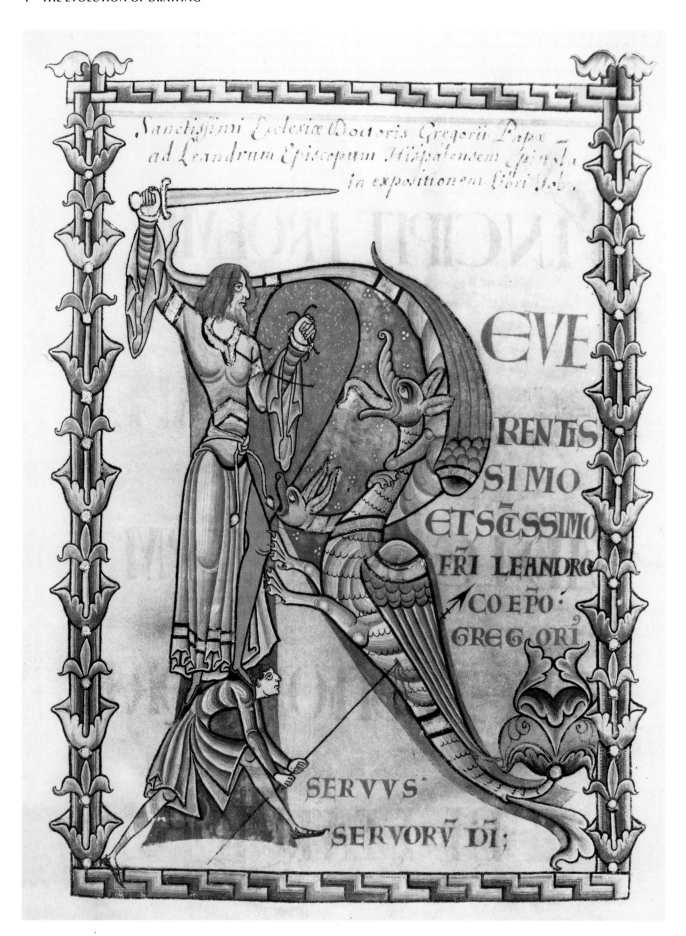

THE MEDIEVAL PERIOD

After the fall of the Roman Empire, about AD 500, the Christian church slowly began to fill the social and governmental void left by the passing of this great empire. Although Roman religious beliefs were abandoned, other aspects of the Classical past were revived. The development of a finely designed alphabet by the Romans had a profound influence on the evolution of drawing in the West. Roman calligraphers (master scribes) used chisel-edged pen points that varied the width of the lines as the letters of the alphabet were drawn. These thick and thin lines swelled and curved according to the angle of the hand to the paper and the shape of the letter. In fact, the elegantly proportioned design of the letters themselves greatly influenced drawn images in Europe for centuries. Medieval illuminated manuscripts (Fig. **1.13**), like their Egyptian counterparts, harmoniously combined verbal and visual information to instruct the faithful. Unlike the art of the Classical world, however, realism was not the goal of the medieval artists, who favored symbolic images representing timeless theological truths.

THE ITALIAN RENAISSANCE

Not until the end of the fourteenth century, most significantly in northern Italy, do we see a sharp transition from stylized manuscript drawings to images drawn from life. This was the beginning of a period known in the West as the "Renaissance." It was at this time that the Italian artist Antonio Pisanello (c. 1395–1455) extended the possibilities of descriptive drawing in remarkable ways. Working in a style that

1.13 (opposite) *Initial R with Saint George and the Dragon*, from the *Moralia in Job*, early 12th century. Illuminated manuscript, 13¾ × 9¼ in (34.9 × 23.5 cm). Bibliothèque Municipale, Dijon.

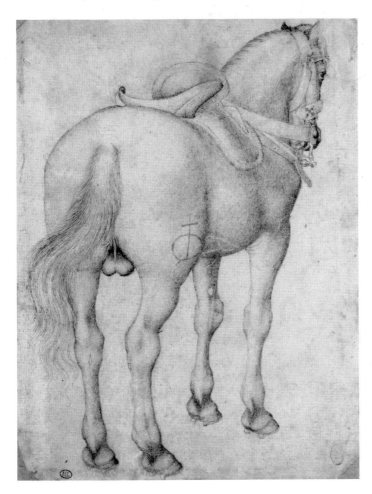

1.14 Antonio Pisanello, *Study of a Horse*, 15th century. Pen and ink on paper, 8⅘ × 6½ in (22.3 × 16.6 cm). Louvre, Paris.

1.15 Paolo Uccello, *Perspective Study of a Chalice*, 1430–40. Pen and ink, 13⅛ × 9½ in (33.9 × 24.1 cm). Uffizi, Florence.

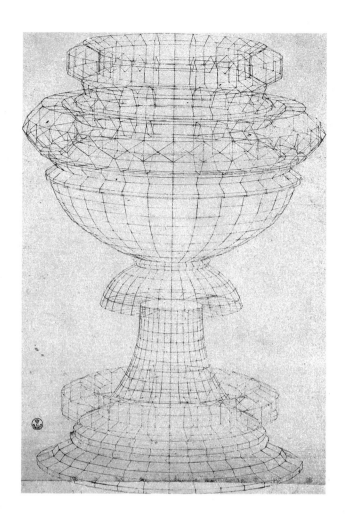

1.16 Leonardo da Vinci, *Plans for a Spinning Wheel*, c. 1490. Biblioteca Ambrosiana, Milan. Courtesy, Archiv für Kunst und Geschichte, Berlin.

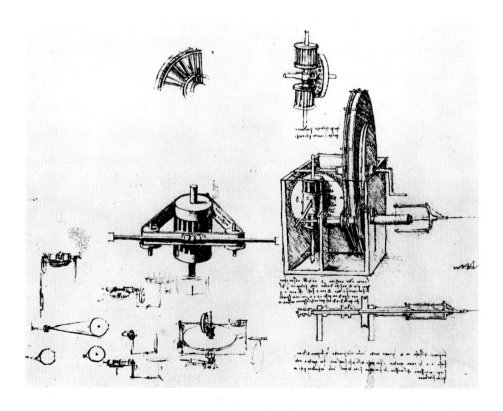

combined some of the features of late medieval art with an emerging concern for naturalism, Pisanello made numerous drawings directly from life. His *Study of a Horse* (Fig. **1.14**) represents the new interest artists found in the world of appearances. Its free-flowing lines, naturalistic recording of light, and its *composition* clearly point the way toward Renaissance concepts of drawing. Unlike the flat, linear styles of illuminated manuscripts, Pisanello's lines respond to the interplay of light as it falls on a horse that stands before him. His strokes are as carefully varied in thickness as the earlier illuminations, but their new mission is the accurate recording of form as revealed by the play of light on a three-dimensional surface. Significantly, the horse is not drawn in diagrammatic profile but appears to exist in three-dimensional space. In drawings of this period illusion takes precedence over symbolic representation.

The Renaissance was a complex period that simultaneously sought to revive the Classical values of Ancient Greece (the term Renaissance means rebirth), to promote a life centered on humanistic learning, and to define the world through the process of scientific analysis. One of the most significant developments of the Renaissance was the refinement of a system of drawing based on optical laws called *perspective*.

Paolo Uccello (1397–1475) was one of the first Renaissance artists to wholeheartedly embrace the study and application of this system. His drawing *Perspective Study of a Chalice* (Fig. **1.15**) is a striking example of how the Renaissance unified scientific analysis and visual expression. Uccello logically broke down the circular form of the chalice into a series of geometric facets and *elliptical* shapes. This three-dimensional form is drawn with such accuracy that any skilled craftsperson might easily fabricate its exact shape in metal. Certainly this visualization of three-dimensional form was of great practical interest to Renaissance artists, who were often goldsmiths and sculptors (see Chapter 8, "Perspective").

By the late Renaissance, drawing, at least in the hands of inspired artists such as Leonardo da Vinci (1452–1519), was a powerful resource that could be directed toward practical concerns. Leonardo's notebook drawing *Plans for a Spinning Wheel* (Fig. **1.16**) describes with great technical accuracy the workings of a highly efficient industrial machine that could be used in the textile industry. Much of the wealth generated during the Italian Renaissance derived from the wool trade, so the development of machines such as this one was of great economic importance.

Although the concept of the drawing as an independent work of art, that is, done for its own aesthetic sake, advanced steadily during the Renaissance, drawing was also destined to play a major role in the realization of large-scale, architecturally related paintings. The red chalk drawings Michelangelo (1475–1564) completed as studies for his frescos in the Sistine Chapel command as much attention today as the murals themselves. *Studies for the Libyan Sibyl* (Fig. **1.17**) reveals Michelangelo's obsession with the visual and psychological power of the human body. Tirelessly, he searched for the right pose and facial expression that would prove most effective for his painted compositions. For artists like Michelangelo, drawing offered a way to efficiently explore compositional effects and refine many details of *gesture* and form.

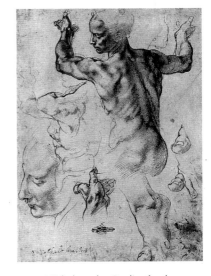

1.17 Michelangelo, *Studies for the Libyan Sibyl*, 1511. Red chalk on paper, 11⅜ × 8⅜ in (28.8 × 21.3 cm). The Metropolitan Museum of Art, New York. Bequest of Joseph Pulitzer. 24.197.2 recto.

THE NORTHERN EUROPEAN RENAISSANCE

Like Italy, northern Europe also enjoyed an economic, political, and artistic resurgence during the fifteenth century. But the work of French, Flemish, and German artists expressed a different set of traditions and sensibilities. The northern Europeans worked on a smaller scale than the Italians and their art was characterized by a high degree of precision and control. Therefore, they preferred pen and *ink* and *silverpoint* to the more spontaneous materials of *charcoal* and chalk.

Silverpoint, the predecessor of today's pencil, is nothing more than a thin wire of silver held in a holder, or stylus. This tool, used extensively during the Middle Ages and the Renaissance, produced a fine light gray line much like that of a modern hard lead pencil. But silverpoint requires a specially prepared paper because the relatively hard metal does not leave a mark on ordinary soft paper surfaces. To make the paper surface more abrasive it was coated with a mixture of finely ground bone dust and glue stiffener. Often a small amount of *pigment* was added to the stiffener to create pale blues, pinks, grays, and earth tones.

Jan van Eyck (fl. 1432–1441), a Flemish artist renowned for his mastery of new effects in oil painting, created this subtly modeled, highly detailed *Portrait of Cardinal Albergati* (Fig. **1.18**) using silverpoint on grayish-white prepared paper. Silverpoint is a demanding, time-consuming process but one which produces luminous tonal areas and meticulous details. Northern Renaissance artists believed that the visible world was but a mirror of God's divine light and truth. Van Eyck's keenly observed and accurately rendered portrait expresses this philosophical attitude with great conviction.

While most of the fifteenth- and sixteenth-century Italian draftsmen were primarily painters, their colleagues in the north, influenced by centuries-old monastic book production traditions, developed a keen interest in the process of making and

1.18 Jan van Eyck, *Portrait of Cardinal Albergati*, 1431. Silverpoint on paper, 8⅜ × 7 in (21.3 × 17.8 cm). Staatliche Kunstsammlung, Dresden.

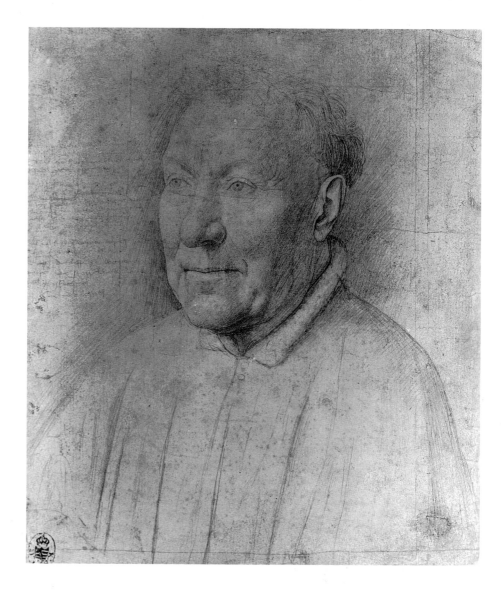

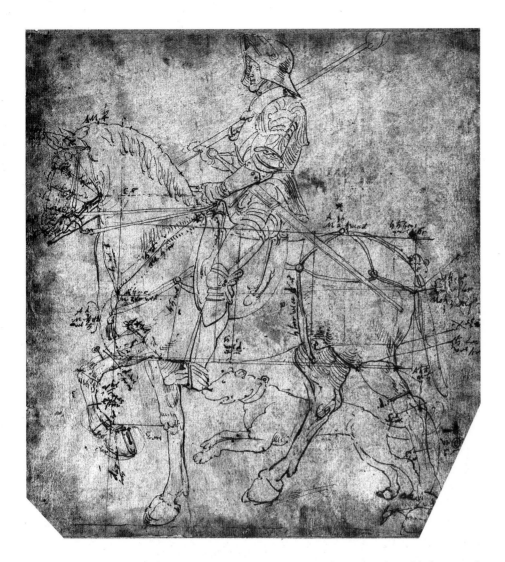

1.19 Albrecht Dürer, *Knight on Horseback*, c. 1513. Pen and brown ink, 9⁷⁄₁₀ × 7³⁄₁₀ in (24.6 × 18.5 cm). Biblioteca Ambrosiana, Milan.

publishing prints. No doubt the financial rewards that came with publishing and selling printed images had much to do with this interest. The process of engraving (and later etching) involves making fine linear grooves on the smooth surface of a metal plate and then filling in these depressions with ink. Pressure from a press transfers the inked lines of the plate onto a piece of dampened paper. Engravings and etchings greatly resemble drawings made with a fine-nibbed pen and ink.

One of the most accomplished northern Renaissance artists was Albrecht Dürer (1471–1528). The preliminary study shown in Figure **1.19** was done in preparation for a copperplate engraving Dürer was working on. In this drawing the artist determines the exact position of the horse and rider with loosely flowing but accurate lines. A brown ink wash darkens the background and dramatically spotlights the mounted horseman. In order to use this drawing of the knight and horse as an exact pattern, Dürer made the ink and wash drawing the same size as the planned print and even blocked it out with a grid to facilitate transfer of the image.

EASTERN VISIONS

By the time of the European Renaissance, Asian cultures of great sophistication and refinement had been firmly established for more than a thousand years. These ancient societies evolved from a different set of religious, philosophical, and aesthetic beliefs from those of Europe, as is reflected in their drawings. For the most

part, Asian draftsmen were uninterested in the static, analytic description of volume and space that has characterized European drawing since the Renaissance. Instead, intuitive, impressionistic effects are highly prized; every brushstroke represents an unreproducible occurrence in life. This artistic sensibility reinforces, for example, the Chinese concept of reality as a continual process of change and infinite variation.

Nature, poetry and lyrical interpretations of the landscape figure greatly in Chinese art. In the first place, writing and the creation of visual art are not separate disciplines as they are in the West. Far Eastern draftsmen, using a special long-haired calligraphic brush, are able to produce an amazing amount of distinctive brush-strokes and marks that are combined in many ways in their drawings. The Chinese written language comprises thousands of unique ideograms (or picture symbols), each of which represents a specific concept or object. In this culture one must learn to draw before one can write.

Cultural traditions within Chinese art place great importance on the philosophical attitude of the artist. Before the drawing takes form, the concept and feelings it expresses must be experienced and felt by the artist. The poems of T'ao Yüan-ming (AD 365–427) express many of the aesthetic concerns and attitudes of Chinese art. His poem "The Song of the Eastern Fence" might be considered a manifesto of sorts for the philosophical and aesthetic ideals for much of Chinese art. Disgruntled with his work as a government official, he retired to the small piece of property that was a perquisite of the position (after only eighty-three days in the job) and devoted his time to writing poetry, drinking wine, and growing chrysanthemums. From his writing we know his patch of land contained three paths, five willows, and a bamboo fence on the eastern side. It was here that he retreated from the world and wrote his widely known poem "The Song of the Eastern Fence:"

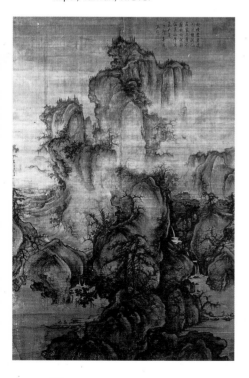

1.20 Kuo Hsi, *Early Spring*, 1072 (Northern Song dynasty). Hanging scroll, ink and slight color on silk, length 60 in (152.4 cm). National Palace Museum, Taipei, Taiwan, R.O.C.

I built my house in the midst of the haunts of men,
But there is no portico here for their carriages,
And if you ask why this is so, I say,
"My heart lives far away, and keeps itself for company,"
Lazily I pick Chrysanthemums by the eastern fence,
In peace I look towards the mountains to the south;
The mountain breeze is delicious in the fading light;
Wandering birds fly out in pairs.
Somewhere there lies a deeper meaning.
I would like to say it, but I have forgotten the word.

The Taoist themes that appear in this poem – contemplation, oneness with nature, renunciation, flight from the striving of the world – also appear in the ink and wash scroll titled *Early Spring* (Fig. **1.20**) by the landscape artist Kuo Hsi (c. 1020–c. 1100). Stylized representations of rocks, trees, water, mountains, and valleys are superimposed into one seamless vision that is at once contemplative and harmonious yet active and lively. The only evidence of human beings is so subtly interwoven into the grand scheme of this idealized world that it is almost invisible: upon close scrutiny a tiny village appears in the far right, midway up the scroll. The scene encapsulates the line of Chinese thought concerned with everything being in its proper place, in a harmonious state of being.

Japanese art shares many of the aesthetic and visual characteristics of Chinese drawings. Until Japan's great Kamukura period (which began in the twelfth century and extended to the early part of the fourteenth century), this country's art was greatly influenced by that of China. During the Edo period (1615–1867), however,

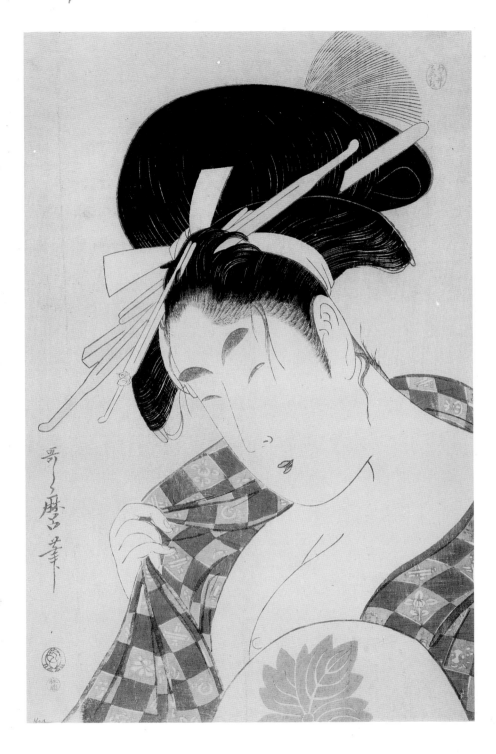

1.21 Kitagawa Utamaro, *An Oiran*, 18th century. 14¹¹⁄₁₆ × 9¾ in (37.3 × 24.8 cm). The Metropolitan Museum of Art, New York. Bequest of Mrs. H.O. Havemeyer. #1663.

Japanese art developed stylistic characteristics that made it quite distinct and original. Kitagawa Utamaro, a well-known Japanese artist of the late 1700s, made this exquisite print of a courtesan for a growing middle class socially displaced by a changing feudal society (Fig. **1.21**). It resonates with worldly, sensual qualities absent from the ethereal landscapes and austere royal portraits of Chinese art.

As Philip Rawson describes in his book *Drawing*, East Indian graphic art is similarly concerned with resonances of feeling found in Chinese art. Within this cultural tradition certain natural forms and movements convey specific metaphors: "the hip

1.22 Anon., *Krishna*, from Jaipur, Rajasthan, India, 18th century. Color on paper, 26¼ × 18⅛ in (66.6 × 46.1 cm). The Metropolitan Museum of Art, New York. Rogers Fund. #18.85.2.

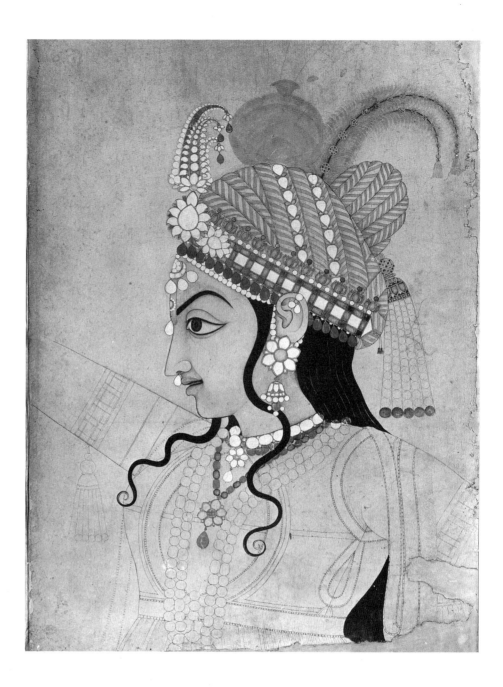

and thigh of a girl move like an elephant's trunk, her fish-shaped eyes glance like silver fish in a dark pool, her draperies flutter between her legs like ripples on a river between its banks."

In India, poetry and the visual arts were not viewed as separate disciplines as they tended to be in the West. Certainly the language cited above indicates the importance of poetic concepts to Indian draftsmen and it is matched by the elegant visual language of their drawings. Figure **1.22** depicts Krishna, one of the most popular deities in Hinduism. Aesthetic symbolism rather than realism is the aim of this drawing. It relies on the use of traditional visual conventions which are repeated in many representations of this powerful god. For instance, the artist is required to draw his brow arched, as if it were a bow ready to release an arrow.

Persian drawings, like those of India, reveal the influences of Chinese art. During the fourteenth century, elegant, carefully controlled Chinese drawings based on

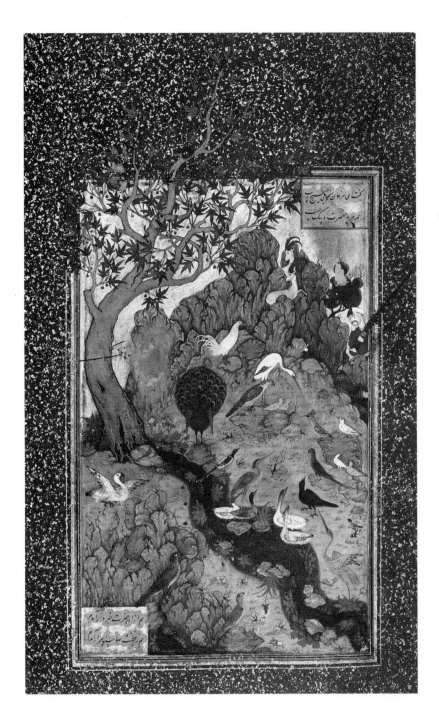

1.23 Habib Allah, *Concourse of the Birds*, from the *Mantiq at-Tayr* (Language of the Birds), c. 1600. Colors, silver, and gold on paper, 10 × 4½ in (25.4 × 11.43 cm). The Metropolitan Museum of Art, New York. Fletcher Fund. #63.210.11 recto.

linear calligraphy made their way to India and Persia (now Iran). The finest examples of graphic art to come out of Persia are known as "Persian miniatures." These small drawings and paintings, many measuring only 6 by 8 inches, depict in exquisite detail court scenes and stories from literature. *Concourse of the Birds* (Fig. **1.23**) was made by Habib Allah (c. 1600), an artist who worked in the city of Isfahan. Set within a deep blue, gold-flecked ground, the framed scene shows a great variety of birds who, according to the story, set out to find their leader – a parable of humankind's search for God. The contrast between the spacious and empty blue and gold background – like the heavens – and the teeming, lush garden of birds is very moving.

AFRICAN ORIGINS

Some scientists believe that the human species – and perhaps the first expressions of art – originated in the vast continent of Africa. Africa is distinguished by its many peoples, countries, and civilizations; one of the most sophisticated and advanced cultures the world has ever seen, the dynastic Egyptian civilization (discussed on pages 23–24) proved to be a significant catalyst in the establishment of European thought. The Ancient Greeks and Romans were in awe of Egyptian art, architecture and technology, and Egyptian ability to organize and marshal vast resources to complete large-scale projects that rival twentieth-century efforts.

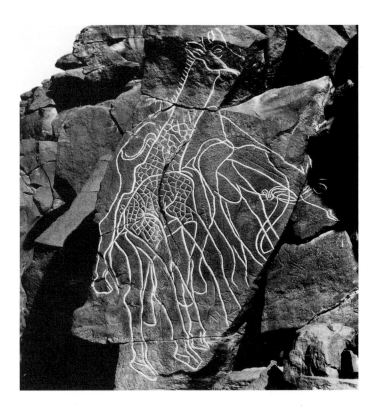

Curiously, the discovery of prehistoric art in Africa predates the more widely known finds in Spain and France. Altamira in Spain was discovered in 1879 and Lascaux in France was brought to light in 1940. In 1721 a Portuguese missionary told the Royal Academy of History in Lisbon of ancient paintings that he had seen in rock shelters in Mozambique, South Africa. Since then, thousands of paintings and rock engravings (about forty thousand in number) have been documented throughout the entire continent of Africa. Drawn on ancient rock surfaces with incised line and paint are mysterious symbols and images of animals and humans that were probably used in rituals designed to ward off evil, enhance fertility, and ensure the survival of the clan.

The elegant images of giraffes and an elephant (shown in Fig. **1.24**) were found engraved on stone at Fezzan, Libya. Scholars believe that these incised figures of animals and human figures were created between the seventh and eighth millennium BC when the region – today a desolate moonscape of stone and sand – was a fertile land of rivers, lakes, and lush vegetation.

At the beginning of the twentieth century, Europe "discovered" the art of this vast continent and it was to have a profound effect on avant-garde art in the West. Like the arts of Asia, much African art is deeply embedded within the religious and philo-

sophical matrix of its various societies. Many of these non-European cultures do not have traditions of making representational drawings on paper. Nevertheless drawings made with a variety of other materials by so-called "tribal" societies play important roles in their day-to-day life. Women of the African Kuba tribe (from Zaire in the south-central portion of the continent) apply linear designs with specific social meanings on long lengths of raffia cloth (Fig. **1.25**). These cloths are wrapped around their waists and worn during important ceremonial dances. Instead of hanging framed images on walls, Kuba women wrap the drawings they create around their bodies, thereby incorporating their artistic expressions more fully into their personal and cultural lives.

THE AMERICAS

By the time the first European explorers arrived in the Western hemisphere, the landmass constituting North and South America – from the Arctic circle to Tierra del Fuego – had been inhabited for millennia by a variety of peoples with ancient histories and rich cultural traditions. Although art played an important role in their lives, they did not separate functional from nonfunctional objects and call the latter "art." Beautiful and meaningful artworks were incorporated into everyday life. Everything had a purpose: some things were overtly utilitarian and others were used in ritual observances and had meaningful symbolic associations.

A rare manuscript that survived the "civilizing" onslaught of the Spanish conquistadors offers us a world view of the indigenous peoples of Mexico (either the Aztec or Mixtec culture) during the early part of the sixteenth century (Fig. **1.26**). At the center of the manuscript is Xiuhtecutli, an ancient fire god. Four sections radiate

1.24 (opposite, right) Giraffes and elephant, Fezzan, Libya, 8,000 BC.(?) Grooves in stone. Courtesy, Frobenius Institute.

1.25 (opposite, left) *Panel from a Woman's Skirt*, Kuba, Zaire. Woven raffia, appliquéd design, 158 × 24 in (401 × 61 cm). Brooklyn Museum of Art. Gift of Mr. and Mrs. Milton F. Rosenthal.

1.26 A view of the world, detail from *Codex Fejervary-Mayer*. Aztec or Mixtec, c. 1400–1521. Paint on animal hide, each page 6⅞ × 6⅞ in (17.5 × 17.5 cm), total length 13 ft 3 in (4.04 m). The National Museums and Galleries on Merseyside, Liverpool, England.

1.27 Dakota Sioux Winter Count, Fort Totten Reservation, North Dakota, 1890–1900. Cotton cloth, ink, pigment, length 40¾ in (103.5 cm), width 35¼ in (89.5 cm). Detroit Institute of Arts, Michigan. Gift of Mr. and Mrs. Richard Pohrt.

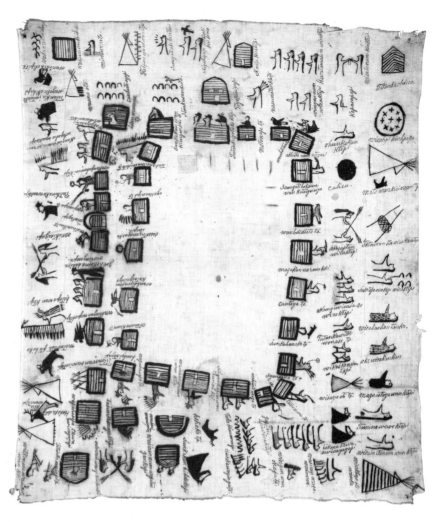

from this important deity, each quadrant associated with a specific god and each including a tree with a bird in its branches. Streams of blood flow to the fire god from various symbolic attributes in the four corners. This drawing – a religious "map" of sorts – is filled with mythic information about what these people believed in and how their spiritual world was constructed.

Pictographic images were also a way of recording tribal history for the American Plains Indians. Known as "Winter Counts," these drawings on buffalo hides (later muslin cloth) functioned as historical records for the community, featuring particular occurrences to represent each year. As the decades passed the Winter Count keeper organized the pictographic images in spirals or in rows, eventually passing the drawings on to future generations of keepers. The Winter Count seen in Figure **1.27** begins at the lower right corner and moves vertically before spiraling to the left; it covers the years 1823 to 1911. The sense of tight-knit community in which Native Americans lived and their closeness to nature is revealed in a stark poetry: the 1833 entry, for example, is referred to in this Winter Count as "the stars fell," a circular pictograph with small crosses for stars representing the famous Leonid meteor showers of November, 1833. Other tribes' Winter Counts call this event "plenty-stars winter" and "storm-of-stars winter." Some Winter Count events were obscure and meaningful only to the people involved; other events were of a more obvious and tragic nature – such as the deadly smallpox epidemics of 1837 and 1838, represented by pictographic bodies with spots drawn on them. Such records rise far above any utilitarian function of documenting history and kindle a sense of cultural continuity and social meaning.

NEW EXPRESSIONS

During the seventeenth century, artists working in the Netherlands developed drawing styles that were less formal and more naturalistic than the German artists who had come before them. One of the greatest graphic artists of this period was Rembrandt van Rijn (1606–69). Compared with Italian art of this period, his style was more subdued and more naturalistic, yet also often dramatic and emotionally expressive.

Christianity was no longer the sole theme of works of art during this century and like other northern artists Rembrandt explored the visual splendors of the landscape and the quiet beauty and pleasures of domestic scenes such as those seen in *A Woman and her Hairdresser* (Fig. **1.28**).

Unlike many of his contemporaries Rembrandt never traveled to Italy to study at first hand the extroverted painting styles of the Italians (particularly that of Caravaggio); but through a friend who had spent considerable time in Rome, Rembrandt was introduced to southern compositional styles. In his mature work Rembrandt manages to brilliantly synthesize the highly controlled, analytic northern

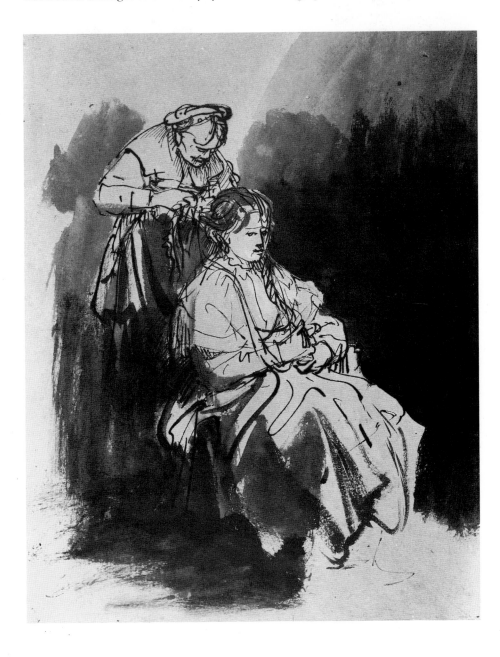

1.28 Rembrandt van Rijn, *A Woman and her Hairdresser*, 1632–4. Pen and bister, with bister and India ink wash, 9⅛ × 7 in (22.3 × 18 cm). Albertina, Vienna.

1.29 Francisco de Goya, *Bobabilicon (Los Proverbios, Nr 4)*, c. 1818. Etching. The Metropolitan Museum of Art, New York. Harris Brisbane Dick Fund. #24.30.5.

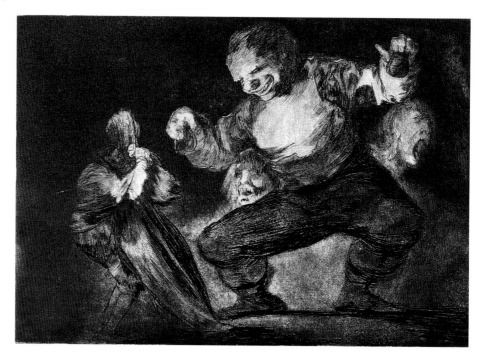

mode with the Italian Baroque style of art, which favored dynamic compositions and strong contrasts of light and dark. Tempered with a psychological restraint rarely found in the work of contemporary southern artists, Rembrandt's drawings and prints impress us today with their intimate celebrations of life's commonplace activities.

What is striking about Rembrandt's *Woman and her Hairdresser* is its spontaneity of construction and its economy of means, two qualities highly prized in modern times. With a few rapidly penned lines, the artist has created a simple visual structure that is reinforced and embellished with the dark, rich tones created by an ink wash. To integrate the elements of line and *tone* in this drawing, passages of brushwork mimic the dynamic, sharp lines of the pen, for example, the brushed lines in the lower portion of the seated woman's skirt. Rembrandt's choice of secular subjects, as well as his spontaneous drawing style, signaled the emergence of works of art that begin to reflect the changing social, political, and economic realities of the seventeenth century.

The French Revolution (1789–99) raised the hopes of many intellectuals that forms of government sensitive to the rights of all people would eventually take the place of despotic monarchies. The Spaniard Francisco de Goya (1746–1828) shared in this dream but lived to see it turn into a nightmare. When Napoleon's armies attacked the Spanish Monarchy, Goya and many of his countrymen hoped the event would lead to a liberal reformation of government. But the atrocities of French troops led to bitter popular resistance and a reign of anarchy. After the defeat of Napoleon, the restored Spanish Monarchy exacted its own bloody reprisals and political repression. In response to these developments Goya's art withdrew into a private world dominated by nightmarish visions and faceless terrors. His print *Bobabilicon* (Fig. **1.29**), from a series called "The Proverbs," illustrates with frightening intensity the spectre of a world gone mad. Executed in a dramatic visual style that emphasized the stark interplay of light and dark (Rembrandt was one of the masters Goya admired most), his drawings foreshadow the important role imaginative expression was to play in drawings of the Modern Era.

THE MODERN ERA

In the mid-nineteenth century leading French artists such as Gustave Courbet (1819–77) and Edouard Manet (1832–83) reacted against the prevailing Romantic emphasis on emotion and fantasy in art and began to forge an aesthetic sensibility based on new attitudes about realism. In the first place they insisted on a return to drawing from direct observation. Secondly, they began to develop new attitudes concerning the reality of the flat surface the painting or drawing was made on. Manet insisted in a coolly analytic way that a painted canvas or drawing is in essence a flat surface covered with pigments or drawn marks. An interesting conflict was at work in the visual arts at this time. While artists were seeking to accurately record visual appearances they were also beginning to recognize the abstract reality of the flat painting or drawing surface.

The *Study for the Portrait of Diego Martelli* (Fig. **1.30**) by Edgar Degas (1834–1917) illustrates these dualistic concerns of mid-century art. Degas's friend Diego Martelli is drawn with great concern for illusionistic representation. Yet certain passages of this chalk drawing call attention to the means of the drawing process. The coarse parallel chalk lines that represent his waistcoat are juxtaposed in

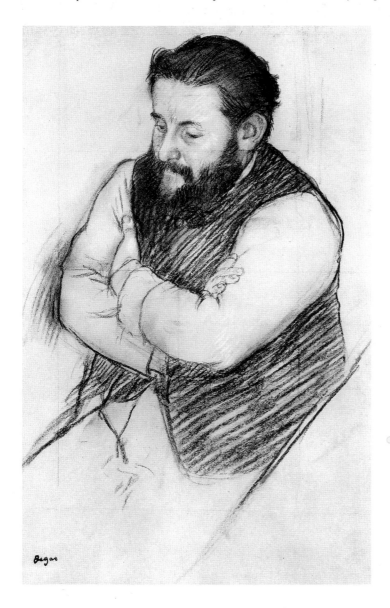

1.30 Edgar Degas, *Study for the Portrait of Diego Martelli*, 1879. Black and white chalk on tan paper, 17⅝ × 11¼ in (45 × 28.6 cm). Fogg Art Museum, Harvard University Art Museums. Bequest of Meta and Paul J. Sachs.

1.31 Georges Seurat, *Woman Embroidering*, 1883. Conté crayon on paper, 12⅘ × 9⅖ in (32.7 × 24 cm). The Metropolitan Museum of Art, New York. Bequest of Joseph Pulitzer. #55.21.1.

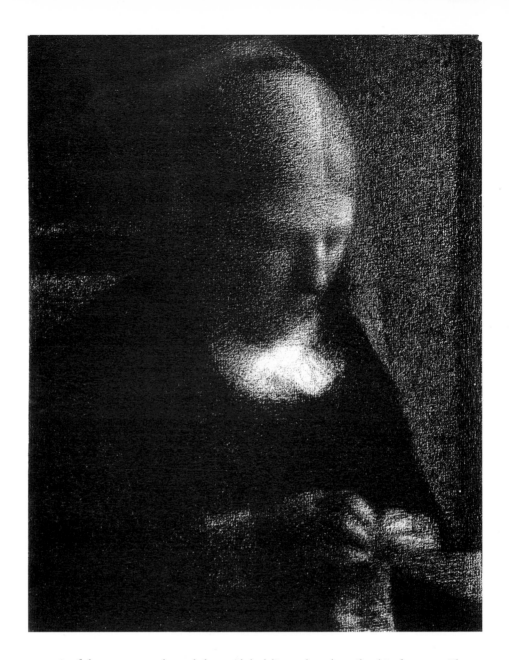

meaningful contrast to the subtly modeled lines that describe his features. These two drawing methods are fused when the flatter rendering of Martelli's upper body joins the dark tone of his beard. The tension between three-dimensional illusion and our awareness of the identity of the chalk lines on a flat surface endows this drawing with a special life and sets the stage for the development of new ideas and attitudes toward drawing.

Toward the end of the nineteenth century a group of highly individual artists, later dubbed Post-Impressionists, emerged to make major contributions to the foundations of modern art. Impressionism was a form of French-dominated realist painting that sought to re-create on canvas the effects of natural light on the landscape. Paul Cézanne (1839–1906), Vincent van Gogh (1853–90), Paul Gauguin (1848–1903), and Georges Seurat (1859–91) were the major Post-Impressionist artists who built upon and extended the ideas of Impressionism.

All these artists used drawing to develop their concepts and extend their visions. But drawings of Seurat's deserve special attention in view of their unique characteristics. Perhaps more than those of the other Post-Impressionists, his drawings establish a new identity and role for drawing, as independent of painting and fully capable of standing on their own as complete works of art.

Seurat's drawings derive much of their energy from some meaningful contradic-

tions that embrace them. Although Seurat tried to make use of the latest scientific developments in perception and color theory, his work appears driven by deep intuitive feelings rather than formal theory. *Woman Embroidering* (Fig. **1.31**), for example, depicts an intimate, personal activity yet, like many of Seurat's mature compositions, it does so through a neutral, almost analytic drawing technique. The expressive possibilities of mark making are suppressed in Seurat's drawings in favor of meticulous tonal control. The key to this drawing technique is Seurat's use of a specially textured drawing paper. By controlling how hard he pressed on the paper with his conté crayon, the artist could vary the tonal variations from dark to light. The harder he pressed the more his conté crayon would fill in the textural "peaks" and "valleys" of the paper's surface. By pressing lightly, he caused only the raised surfaces of the paper to be darkened, leaving the depressions white. Seurat furthered the scientific inquiry of perception begun by the Impressionists but he did so in a highly personal and unique way.

By the first decade of the twentieth century the tendency toward conceptualization and the abstraction of forms that could be seen in the work of the Post-Impressionists was boldly advanced by two artists working in Paris, Georges Braque (1882–1963), a native Frenchman, and Pablo Picasso (1881–1973), a Spaniard by birth.

Both artists were influenced in large part by Cézanne's earlier concern for form and structure in his art. Cézanne felt that Impressionist art lacked the solidity and cohesive visual unity which characterized great art of the past. In *House among Trees* (Fig. **1.32**) Cézanne has reduced the view of a house nestled among trees into an orderly arrangement of lines, shapes, and tones that represent the essence of the scene's visual and spatial components. These visual elements have given up some of their illusionistic tasks and have assumed new conceptual roles in the life of the drawing.

1.32 Paul Cézanne, *House among Trees*, c. 1900. Watercolor and pencil on paper, 11 × 17⅛ in (27.9 × 43.5 cm). The Museum of Modern Art, New York. Collection of Lillie P. Bliss.

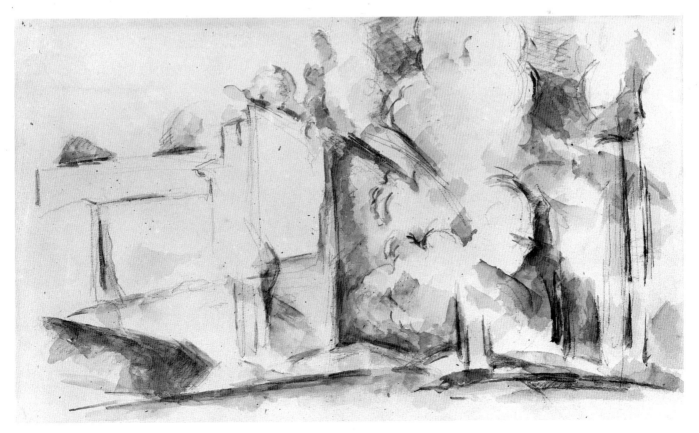

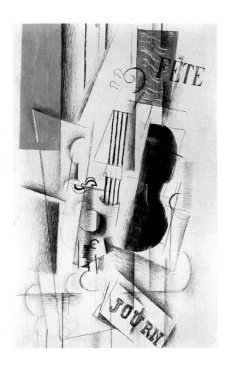

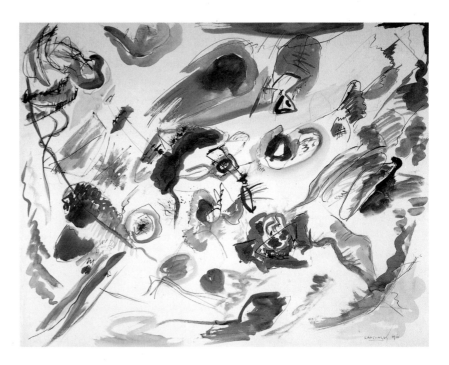

1.33 (left) Georges Braque, *Musical Forms*, 1913. Oil, pencil, and charcoal on paper, 36½ × 23½ in (92.7 × 59.7 cm). Philadelphia Museum of Art. Collection of Louise and Walter Arensberg.

1.34 (right) Wassily Kandinsky, *First Abstract Watercolor*, c. 1910. Crayon, China ink and watercolor on paper, 19¼ × 25 in (48.9 × 63.5 cm). Musée National d'Art Moderne, Centre Georges Pompidou, Paris.

Taking their cues from Cézanne's work, Braque and Picasso developed a style of drawing and painting called Cubism, based on the representation of three-dimensional forms as a complex network of interlocking, flattened planes. One of Braque's Cubist drawings of 1913, *Musical Forms* (Fig. **1.33**), shows a kaleidoscopic array of fragmented images and visual constructs, including bits of lettering. Part of the theory behind Cubism was the realization that modern reality could no longer be represented by a single, fixed point of view. Here Braque disassembles the violin and presents the parts within an organizational structure of flat planes and shallow relief.

The implied structure of time itself is called into question by this Cubist drawing. The image of the violin shows up simultaneously at a variety of junctures rather than in one central location: lines cut across other lines and forms, and shapes overlap as if they were transparent. This Cubist drawing effectively mirrors the newly emerging modern world – complex, interrelational, and conceptually abstract.

Despite the abstract qualities of Baroque's *Musical Forms*, unmistakable references to representational objects are retained. Approximately the same year Braque and Picasso were inventing Cubism, Wassily Kandinsky (1866–1944), a former Russian law professor turned artist, created a completely non-objective watercolor drawing of amorphous shapes and agitated line (Fig. **1.34**). Kandinsky was very interested in music, especially Richard Wagner's music-dramas and Arnold Schoenberg's atonal works, and reasoned that if a musical composition was made up of abstract sounds and rhythms, a visual work of art could equally be made up of non-representational shapes, colors, and lines. *First Abstract Watercolor* comes alive with self-contained harmonies and syncopated rhythms in a visual analogy to music.

CONTEMPORARY DRAWING

In the contemporary art world drawings can no longer be considered a minor form of art. More and more drawings – often referred to as "works on paper" – are shown in galleries and museums as fully independent works of art that in no way take a back seat to paintings or sculpture.

Some of the reasons for drawing's great popularity in the present day have to do

with such inherent characteristics as its economy of means, spontaneity of expression, and the way in which visual structures are so clearly revealed. Drawing also seems to be able to combine and synthesize traditional concerns of art with the need for new forms of expression. The following drawing categories reveal the various functions drawings can perform employing a wide range of visual effects and aesthetic sensibilities.

Visual Description

Despite dramatic changes in the form and function of art in the twentieth century, the traditional role of visual documentation and description is very much alive in contemporary drawing practices.

Dead Mouse in Trap (Fig. **1.35**) by the German painter and graphic artist George Grosz (1893–1959) is both tragic and somewhat comic. The dead mouse seems to stare at us and ask, in a cartoon-world voice, "what happened?" Yet much of the drawing's power lies in the visual accuracy of the scene. Details of the spring-loaded trap, the bait, and the body of the limp, fur-clad mouse combine to reinforce the psychological dimensions of this rendering: although mice are generally regarded as house pests, Grosz makes us feel sorry for this mouse's plight. The delicate and carefully placed pencil lines that trace the contour of the body and the sure handling of light and dark tones create compelling illusions of three-dimensionality.

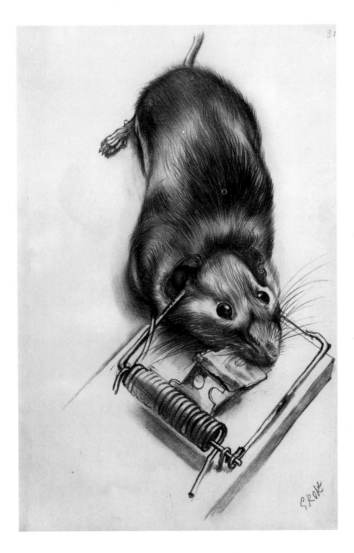

1.35 George Grosz, *Dead Mouse in Trap*, 1950-51. Pencil drawing, 9¼ × 6 in (23.5 × 15.3 cm). Courtesy, Fogg Art Museum, Harvard University. Anonymous gift in gratitude for the friendship and kindness of Dean Wilbur Joseph Bender.

Grosz was certainly in a position to comment on the fragility of life, the random nature of death, and world cruelty. He first achieved fame as a member of a group of German artists who sought to reveal the insanity, violence, and atrocities they experienced during World War I. All of the artists associated with this group had direct military experience which influenced their view of the world and was a catalyst for their art. *Trapped Mouse* is a continuation of Grosz's attempt to "give an absolutely realistic picture of the world."

Imaginative Expression

Drawing also has the unique ability to give visual form to what artists conceive in their minds. Thus the expressive power of drawing is extended beyond the realm of documentation into the fertile world of the artist's imagination.

Most of the drawings that we have reviewed in this chapter make some use of representational imagery. But many contemporary artists firmly believe in the validity of non-representational or abstract forms of art.

Frank Stella (b. 1936) is one of the most articulate and accomplished American practitioners of this type of art. Stella's art seems to represent the view that because of the conceptual nature and complex structure of today's world, abstract art is the most relevant form of visual expression for our era. Certainly his print *Swan Engraving III* (Fig. **1.36**) offers convincing support for this thesis. This work vibrates with an intense visual life and presence that is independent of any imagery other than its self-generated matrix of swirling textures, geometric structures, and energetic lines. There is nothing tentative or timid about this drawing. It is remarkably

1.36 (left) Frank Stella, *Swan Engraving III*, 1982. Etching, 66 × 51½ in (167.6 × 130.8 cm). Printed and published by Tyler Graphics Ltd.

1.37 (right) Queenie Kemarre, *Untitled*, from the *Utopia Suite*, 1900. Woodcut on paper, edn 20, 17¾ × 11¾ in (45 × 30 cm). Courtesy, Utopia Art, Sydney.

self-assured and confident of its identity. Even its enormous size, 5½ feet high, communicates clearly to the viewer the assertiveness of this artwork and its desire to visually dominate the world around it.

One of the most intriguing aspects of contemporary drawing is the relationship that exists between modern visual expressions and the work of non-Western cultures. For example, compare the drawing by Queenie Kemarre, a contemporary aboriginal artist from Australia (Fig. **1.37**) with that by Stella (Fig. **1.36**). Kemarre's untitled drawing makes use of themes, symbols, and forms that have been used for centuries by her ancestors, the native inhabitants of Australia. In the past, these symbols and images served to visually communicate information important for the tribe's survival as well as to provide the cultural cohesion necessary for the group's psychological well-being. Today, these images serve to remind these peoples of their rich cultural heritage. Although aboriginal Australian artists now mostly create their art in new buildings, using contemporary materials and processes, the traditional themes of their ancestors often serve as the catalyst for their own personal expression. Images once made with *ocher* (an earth mineral used in the production of yellow or reddish-brown pigments) applied to bark are now created with ink and paper in modern studios.

Diagrammatic Space

Another role of drawing is to explore theoretical or diagrammatic space. When physicists make drawings of atoms showing a nucleus surrounded by orbiting electrons they are making a diagram of how the workings of an atom might be understood rather than presenting us with a picture of how it looks. Diagrammatic drawings are usually made for the purpose of developing an idea and to give visual form to thought.

Dream/Passage/w1 Room (Fig. **1.38**) by the American Bruce Nauman (b. 1941) presents us with a diagrammatic view of how a specially constructed room might

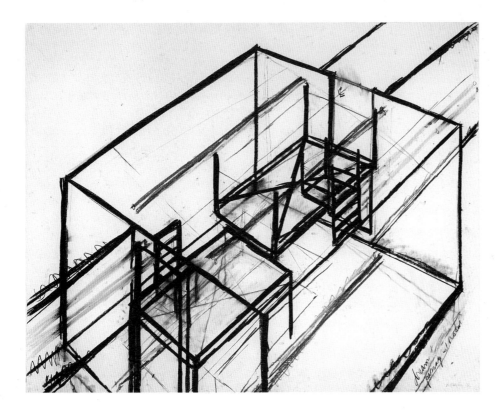

1.38 Bruce Nauman, *Dream/Passage/w1 Room*, 1983. 65 × 80 in (165.6 × 203.2 cm). Berjegeijk, Netherlands, Martin Visser.

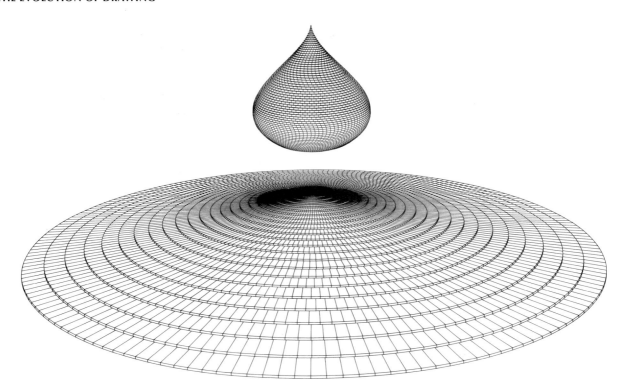

1.39 Agnes Denes, *Teardrop – Monument to Being Earthbound*, 1984. Ink on mylar, 46 × 80 in (116.8 × 203.2 cm). Collection of the artist, New York. The sculpture consists of a circular base and a teardrop-shaped top which levitates above the center of the base afloat on an elastic cushion of magnetic flux. The top is gently and mysteriously moved about by air currents but held in place by superconductive elements. When lit, the teardrop resembles the flame of a candle.

(opposite) Edgar Degas, *Dancer Adjusting Slipper*. Pencil and charcoal on faded pink paper, heightened with white chalk, 13 × 10 in (33.02 × 25.4 cm). Metropolitan Museum of Art, New York. Bequest of Mrs. H.O. Havemeyer, 1929. The H.O. Havemeyer Collection. no. 29.100.941.

function as a site-specific or environmental work of art. Since the 1960s Nauman has been creating conceptually oriented sculpture and architectural structures large enough for a person to enter and move through. This artist's linear drawing provides us with an X-ray view of the proposed room revealing all of its construction details and intricacies. Drawn in perspective from an elevated point of view, it allows us to look downward into the room and imagine ourselves moving through it. Drawing is the most economic and precise way for Nauman to develop his ideas and visually express his thoughts about these large-scale environments.

Agnes Denes is another artist who works in the realm of conceptual drawing space. Her diagrammatic drawings, many of which reveal the invisible structures of scientific concepts, offer visual insights into many areas of inquiry. Although trained as an abstract painter, Denes has spent the last twenty years exploring the aesthetic possibilities of such scientific disciplines as astronomy, crystallography, biology, and genetics.

Denes's fine-line ink drawings on mylar, a special type of sheet plastic, have the look of computer-plotted renderings coupled with the world view of a visionary artist. *Teardrop – Monument to Being Earthbound* (Fig. **1.39**) is, in the words of the artist, "a monument to being earthbound." Free from the constraints of gravity the teardrop shape hovers languidly above the circular grid below and seems to embody humanity's age-old dream of physical freedom from the restraining forces of the earth.

The medium of drawing is capable of expressing a vast range of visual possibilities and personal interests. As developing students we cannot possibly know what we may wish to express with our drawings in the future. Therefore it makes sense to study drawing from a variety of perspectives rather than from one fixed ideological point of view. Learning to interpret and record what we see on a sheet of paper will provide us with a solid foundation for any work we may later wish to do in the visual arts. Now that we have a better understanding of some of the graphic and conceptual means artists employ, we can begin our own hands-on exploration of this exciting medium.

PART II
THE ELEMENTS OF DRAWING

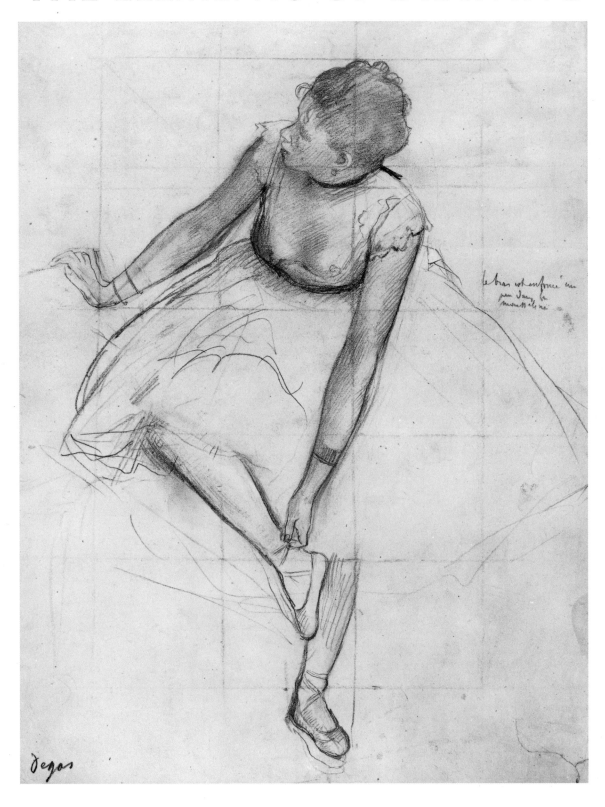

2 Exploring Basic Materials

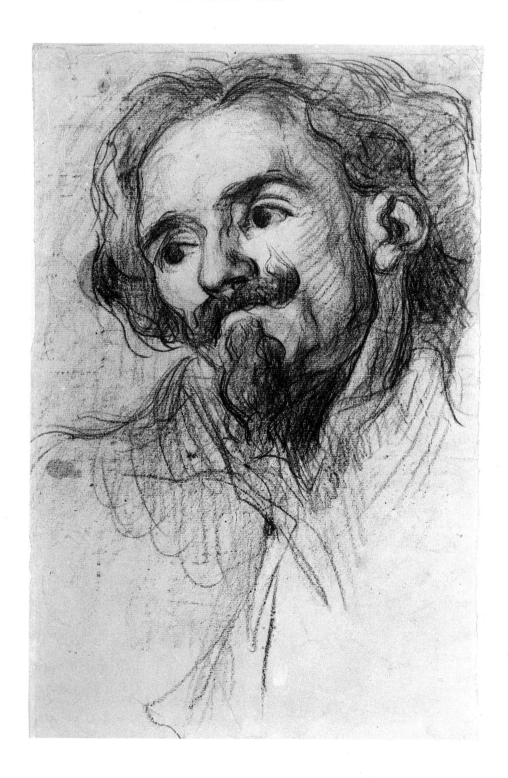

Oone advantage of drawing is the modest amount of equipment and materials needed to pursue this artform. And, while the start-up costs may temporarily put a small dent in your budget, buying such things as a drawing board, paper, and drawing instruments, the on-going expenses are small compared with other visual media such as painting, printmaking, and sculpture. There is an elegant simplicity to drawing that transcends its modest material means – some of the greatest drawings in the world were done with what amounts to a few cents worth of ink and paper. In this artform the artist's thematic concepts and skill in manipulating visual elements such as lines, tonal values, and texture are of primary concern. Learning how various instruments and materials interact and respond to your touch is an important part of the craft of drawing. Once you have gained first-hand experience with basic drawing materials you will have a better understanding of the significant roles they play in the process of drawing.

The materials and equipment required for these initial exercises have purposely been kept simple in order to focus on the visual concepts and drawing skills you will be learning. At the end of this chapter is a concise shopping list of materials and equipment required to get started. By no means is this a comprehensive list of all the materials you might need in the future. This is a basic list of supplies that can be added to as your drawing experience grows. While you are at the art supply store, take the time to browse through the selection of papers and drawing media, making mental notes about those you might like to use in the future.

Drawing Boards

Before you begin to draw you will need a smooth, portable surface to work on. Although you may have access to an adequate table or desk in your classroom or at home, a portable drawing board measuring approximately 20 by 26 inches offers many advantages. Since it is designed to be used as a drawing support, you do not have to worry about scratching it or marring its surface. More importantly, it is easily portable and can be moved when you want a different view of your subject or for working out of doors.

Most art supply stores offer two types of drawing board: those made out of *basswood* and *masonite*. Each has its advantages and disadvantages. The basswood board is made of a smooth-grained, lightweight yet strong wood. In many ways it is an ideal drawing surface since basswood is quite rigid and will hold up well to all kinds of drawing processes. One particularly good feature of this board is that individual sheets of paper can be pinned easily to the surface with thumb tacks or push-pins. It does cost more than masonite, however.

Masonite is a composite material made by bonding wood by-products under pressure. Its extreme hardness prevents paper from being easily pinned to it but this limitation can easily be overcome by using drafting tape (masking tape with a weaker adhesive that is much less likely to tear the paper) or metal spring clips.

Papers

When it comes to the kind of paper best suited to the needs of most drawing students, the choice is simple – *newsprint* or the slightly more expensive *bond paper* pads. Both are convenient to use and available at relatively low cost. Like any performance-based artform, practice is the single most important learning element. You need to be able to draw as uninhibitedly and as frequently as possible without the worry of undue expense. For these reasons 18 by 24 inch newsprint pads are well suited for most student needs.

2.1 (opposite) Paul Cézanne, *Portrait of Achille Emperaire*, c. 1867–70. Charcoal, 19¼ × 12⅛ in (49 × 31 cm). Louvre, Dépt des Arts Graphiques.

Newsprint, however, is relatively fragile, tearing easily and quickly damaged by rough handling or the use of liquid media. Furthermore it physically deteriorates over time. Because of the residual acids left from its manufacture, newsprint becomes brittle and turns yellow with age and exposure to light. Despite these limitations newsprint is still one of the most cost-effective and suitable papers for students to use. Its textured surface responds well to dry media such as charcoal, crayons, and graphite.

The other type of paper most suitable for student work in drawing is called bond. Compared with newsprint, bond paper is usually smoother in texture and whiter in color. "Bond" is a general term used today to indicate paper that is of better quality than newsprint. At one time the term "bond" referred to paper used for important legal and financial documents that were required as permanent records. Before the development of wood pulp as a paper base, cotton fibers were used. Today, because of the expense of this natural material, many bond papers may simply be of a higher quality pulp paper and contain no cotton fiber. Some bond papers, particularly those sold in single sheets, may contain up to 25 percent cotton fiber for superior strength and permanence but most of the bond drawing pads will consist of pulp paper. Professional quality paper will play an important role in your drawing when you have gained some experience and are working on projects that take longer than a few minutes.

Special Papers

As you develop your drawing skills and experiment with different media there will come a time when you will want to try some of the fine 100 percent cotton *rag papers* widely available today. This use of the term "rag" is derived from the fact that, before the development of pulp paper, discarded cotton rags were collected and processed in the manufacture of paper. In the 1800s even daily newspapers were printed on all-cotton paper. Specially made 100 percent cotton-fiber paper is one of the most beautiful and permanent surfaces you can draw upon. Long after today's newspapers, magazines, and even many of our hardcover books have grown yellow and brittle with age, properly stored drawings on rag paper will still retain their flexibility and original color. But longevity is not the only reason for choosing a professional grade cotton paper. For one thing, most fine rag drawing papers are far heavier and sturdier than even the better quality pulp papers. They can stand up to considerable handling, reworking, and erasures without tearing or wearing dangerously thin. Most importantly, these papers will interact with your drawing instruments in significant ways. The sensation of drawing on good quality rag paper is unique and your response to this material may result in more effective drawings.

When you get to the point in your drawing study where you are achieving results that please you, try some of these special papers. Go to a good art supply store and browse through their selection of professional quality paper. Let your personal judgment guide you and select a few sheets with intriguing surfaces and tonalities.

THE DRAWING ASSIGNMENTS

The sequence of projects that follow in this chapter and the next are designed to lead you step by step from simple exercises that explore the nature of drawing materials to more complex assignments that enable you to expressively combine and organize lines, shapes, and tones in a variety of ways. In order to learn the basic skills of drawing you must suppress, for the moment, your desire to make what you think of as "good" drawings. The purpose of these assignments is not necessarily to

produce beautiful drawings but to teach you the conceptual and technical skills you will need to draw effectively. Paradoxically, the more you forget about making successful drawings and concentrate on the objectives of the exercises, the closer you will be to realizing your goal. Sequentially, each exercise enables you to learn some basic principle or skill and gradually forms the foundation upon which all of your drawing abilities are based. Your willingness to thoroughly explore the concepts they express will greatly enhance the effectiveness of these studies.

After you feel you have met the requirements of the project, think up your own creative variations and extend the parameters to suit your expressive interests. Practice is everything. The more you draw, the faster you will progress.

GOOD WORK HABITS

If your instructor assigns a project as homework, find a place away from distracting activity that allows you to work uninterrupted for an hour or two at a stretch. Your drawing classroom or other studio art space might be available during evenings or weekends. If the natural light in this space is lacking, or if you do a lot of work during the evening, invest in a few 100 watt floodlights and aluminum clamp-on reflectors. Any good hardware store will be able to guide you in this purchase. Also, try and make use of a comfortable light-weight chair that can be easily moved when you want to shift drawing positions.

The use of an *easel* is a matter of personal preference. Some people like to work with the drawing flat, others prefer it upright or at a slant on an easel. Also think about where you will store your drawing materials and finished work. Take the time to organize a studio-like space where it is conducive for you to work. Since much depends on concentrated practice, develop consistent work habits. Schedule certain times or days as work periods and stick to this plan.

Before you start on a project read through the entire section and if there are any illustrations offered as examples study them thoroughly. Remember to keep the objectives of the exercise in mind as you execute the drawings. Although the assignment may not always direct you to do several drawings, that is what you probably have to do in order to achieve the objective. Each time you repeat an exercise you reinforce what you have learned and discover something new.

SELF-EVALUATION

No doubt during class meetings with your instructor you will have regularly scheduled group and individual critiques. Critical evaluation is an important aspect of the learning process. Take the time after a drawing session to go over what you have done and develop the habit of evaluating your own drawings in terms of the goals of the assignment. Such self-study analysis will enable you to begin to make an effective critique of your own work and thus optimize the speed at which you learn.

For the time being save all your drawings, even those you are not pleased with. Put them in a folder or red-rope envelope and keep them for future reference. Develop a habit of reviewing your work at least once a week and putting it in a safe place. By the time you are midway through the course your earliest drawings will clearly show you how far your learning has progressed.

DRAWING MEDIA

The materials that produce marks, lines, and tones on the surface or support of the drawing are called "media." Although there are scores of materials that can be used

to draw with, all of them fall into two basic categories: dry, "abrasive" materials such as charcoal, chalk, pencil, and crayons; and "wet" media such as pen and ink, brush and ink, and watercolor. For our instructional purposes we will explore the more commonly used dry media first (pen and ink and brush and ink are discussed in Chapter 10, "Exploring Color"). Charcoal and graphite are more than adequate to begin our practice of the drawing process.

Charcoal and Chalk

In many ways, charcoal is the ideal drawing material for the beginner. It is easy to apply and to erase and it can readily produce a wide range of lines from thin and light to thick and black. Two basic types of charcoal are available in art supply stores: *vine charcoal* and *compressed charcoal*. Vine charcoal is irregularly shaped and thinner than rods of compressed charcoal, a manufactured product made by combining powdered charcoal with a binder under pressure. Vine charcoal is produced by carbonizing dried plant vines in a kiln from which air is excluded. Because of its organic origins and variables in the manufacturing process, different batches of vine charcoal may vary considerably in terms of width and how dark a line they make. Compressed charcoal is more consistent in shape and it comes in a variety of carefully controlled grades from soft to hard. Soft charcoals produce darker, more diffused lines while hard densities create sharper, lighter marks.

Before you begin to draw from a subject – such as a still-life – you need to understand and experience the way basic drawing materials interact and respond to paper. The way you manipulate and control these mark-making instruments will greatly affect your drawings. The first exercises in this chapter are designed to introduce you to mark making and to show you how your control of the lines and tones affects the look of your drawings. This is an important element of drawing. Unlike complex media like painting and sculpture, drawing usually relies on making the most of a few simple materials. Unless you learn to understand, control, and exploit the visual qualities of the basic drawing media your drawings will probably achieve only limited success. Perhaps the most pronounced and consistent flaw in beginners' drawings is the students' failure to exploit the full potential of their drawing instrument and flat, monotonous effects are the result.

The visual impact of a drawing greatly depends upon the relationship between the mark and the surface of the paper. Drawing a single line from edge to edge anywhere on a sheet of paper radically changes the way we perceive the space of the drawing surface. The paper and the drawn mark are greatly dependent on each other for, without the whiteness of the empty paper, the visual effects of the dark lines or marks would be nil.

Drawing is about opposition. The juxtaposition between the flat, open space of the paper and the varying marks and shapes organized on its surface is an essential element of this artform. All drawings, both abstract and representational, are created through the interplay of light and dark areas and of empty and filled spaces.

PROJECT 1

Exploring Charcoals

MATERIALS: 18 by 24 inch newsprint pad, vine charcoal, compressed charcoal.

Charcoal is a soft, pressure-sensitive material capable of producing quite a large variety of tones and marks. The harder you press on this drawing instrument, the darker and thicker the line. Take a stick of vine charcoal and, holding it between your thumb and forefinger near the part that contacts the paper, explore its tonal range by making a series of continuous up and down strokes on the paper from left to right, beginning with very heavy pressure and gradually decreasing it as you cross the page (Fig. **2.2**). The lines on the left should be the darkest and decrease in intensity until you reach the lightest tones possible at the paper's right margin.

Depending on the shape of the vine charcoal's tip, and the angle at which it makes contact with the paper, the width of the line can vary greatly. Experiment freely with different tip shapes and angles on a piece of newsprint to see how thin and thick the charcoal lines can be made. Once you have experimented with line thickness, do a variation of Project 1 and cover the surface of the newsprint with gracefully looping and intersecting lines that change in terms of thickness, darkness, and direction (Fig. **2.3**). If you have varied the size of the loops and how hard you press, you will find that these lines begin to suggest three-dimensional forms in space. Some portions of your drawing will appear to come forward or recede. The combination of shifting line directions and changes of width and tone all contribute to creating spatial illusions on the flat paper surface.

The drawing of *Waterloo Bridge* (Fig. **2.4**) by Camille Pissarro (1830–1903) makes effective use of this versatile material. Notice how the charcoal responds to the varying pressure of the artist's hand. The bridge and boats are rendered in the darkest tones while lighter lines describe buildings in the distance and the water in the foreground. Vine charcoal usually produces marks and lines that are quite dark and moderately soft in tone.

If you use compressed charcoal and newsprint for these exercises, you will notice that they result in a different line quality. Compressed charcoal is generally thicker than vine charcoal so its line is wider. This material comes in a variety of grades from hard to soft. Given equal pressure, the harder the charcoal the lighter the mark. Try several grades of compressed charcoal on scrap paper at your art supply store and buy an assortment to keep on hand.

2.2 (left) Tonal range of charcoal.

2.3 (right) Charcoal exercise.

2.4 Camille Pissarro, *Waterloo Bridge*, c. 1890–91. Charcoal, 5 × 6¼ in (12.7 × 17.1 cm). Ashmolean Museum, Oxford.

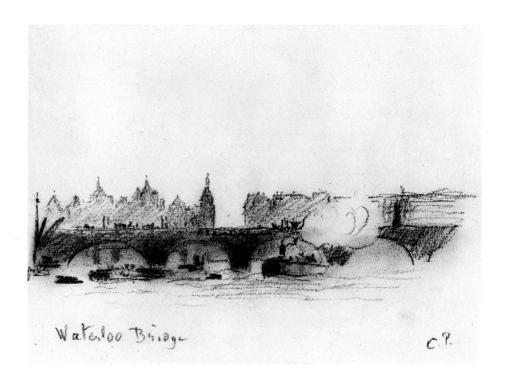

What makes vine charcoal such a useful drawing tool for the beginner, apart from its easily varied line width and tone, is the ease with which it can be erased and corrected. Drawing students have traditionally made use of a soft leather cloth, called a *chamois* (pronounced "shammy"), which can be used to quickly wipe away large sections for redrawing. More precise erasures should be made with a *kneaded eraser*, a soft, pliable eraser that can be kneaded clean when it has picked up a lot of charcoal dust. Both of these erasing methods work quite well with vine charcoal but less efficiently with compressed charcoal because of its density and darkness. Try this out for yourself, making some dark marks on a piece of newsprint with vine and compressed charcoal and erasing them with a chamois and kneaded eraser.

One cautionary note about vine charcoal as a drawing material: the same quality that makes it easily erasable also makes it prone to smudging and smearing. Leave your drawings in their original pad or interleaved between clean sheets of paper.

Another method of preserving charcoal drawings is through the use of spray fixatives. Aerosol cans of *workable fixative* are available at art supply stores and, properly used, help resist the smudging of drawings. However, fixative does not offer total protection and it changes the tonal qualities of the charcoal lines. Carefully follow directions on the can for proper application and, above all, DO NOT breathe the fumes or overspray from these fixatives. The vaporized solvents in such pressurized cans are harmful if you inhale them. Use fixatives only out of doors downwind or in large rooms where you can leave the windows open, quickly spray the drawings, and leave the room. Depending on the ventilation in the room, you can probably safely return in an hour or so. If you can still smell the fumes, it is not safe to be there. In extreme cases of prolonged and heavy exposure, people have become seriously ill from the toxic effects of these substances. Used with restraint and caution, however, they should pose no hazard to your health.

Chalks are closely related to vine and compressed charcoals. These are made by mixing various pigments together with *binders* that allow them to be molded into cylindrical or rectangular shapes. The term *pastel* describes colored chalks made by mixing fine particles of pigment with binders such as gum arabic.

Black chalk is capable of producing some of the darkest tones possible in the dry

media and typically the quality of its mark is sharper and more precisely defined than vine charcoal. *Rocky Landscape* (Fig. **2.5**), by Charles François Daubigny (1817–78), reveals the full tonal range of this material, from the deep velvety blacks of the tree and its shadows to the fine lines which describe the clouds in the distance.

Conté crayon is a popular drawing medium that seems to nicely bridge the gap between brittle, chalky materials such as pastel, and oily or waxy tools such as *lithographic crayons*. While retaining many of the qualities of the chalks, conté crayons, because of the addition of a soapy material to the binder, have a smoother feel to them. Explore the range and textural qualities of chalk and conté crayon and find out how their mark-making ability differs from vine and compressed charcoal.

2.5 Charles François Daubigny, *Rocky Landscape*, c. 1860. Black chalk on brown paper, 17⅞ × 24¼ in (44.9 × 62.9 cm). The Metropolitan Museum of Art, New York. Gift of Mrs. Arthur L. Strasser. #60.64.

Exploring Graphite

Graphite is the dark slippery material found at the core of the familiar "lead" pencil. Like compressed charcoal, this manufactured drawing material comes in a variety of grades. There are over twenty grades of graphite pencils, ranging from the hardest and lightest to the softest and darkest. In the hard category the grades run from 1H, the least hard, to 9H, the hardest and lightest. B grade pencils range in softness from 1B, the least soft, to 8B, the softest and darkest. Three more designated grades lie between these two categories: from the softest to the hardest they are F, HB, and H.

The hardness of graphite is determined by the quantity of binder mixed with the powdered graphite, a natural earth mineral. The more clay in the graphite mixture, the harder the pencil grade.

The best graphite pencils for drawing are found in art supply stores rather than

stationery outlets. Normal writing pencils are often too hard (that is, they produce only relatively light lines) and are limited to narrow graphite widths. Any decent art supply store should be able to supply you with a variety of the graphite drawing instruments mentioned in the shopping list at the end of this chapter. Graphite comes in forms other than pencils such as rectangular blocks and rods. One particularly interesting graphite tool imported by an American distributor from the former Czechoslovakia is simply a solid rod of graphite the diameter of a pencil coated with a thin plastic shell to make handling cleaner. Sharpened to a conical point, this particular tool will produce a wide range of lines and marks.

Graphite is capable of a wide range of visual effects. Its mark-making qualities are beautifully exploited in *Girl Seated on a Sofa* (Fig. **2.6**), an Impressionistic drawing

2.6 Mary Cassatt, *Girl Seated on a Sofa*, c. 1883. Pencil, 8⅔ × 5¾ in (21.9 × 14.5 cm). National Gallery of Art, Washington. Ailsa Mellon Bruce Collection.

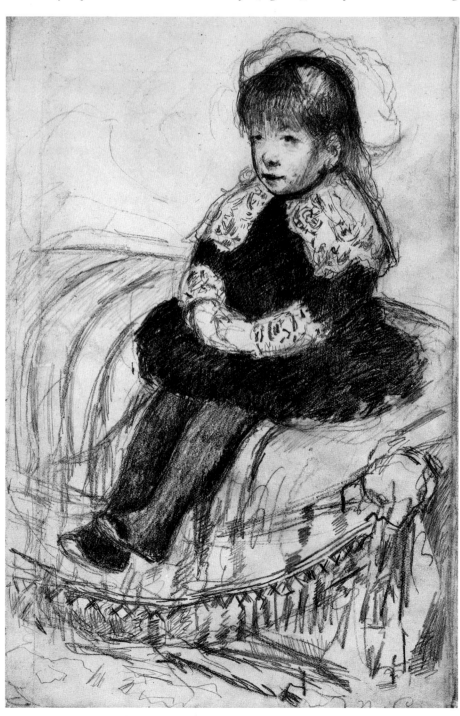

by Mary Cassatt (1845–1926). Dark tonal masses, the result of pressing hard on the pencil, are juxtaposed with lines of incisive movement and subtle tonality.

Medardo Rosso (1858–1928), an Italian sculptor, achieved very different results with this medium. In *Effect of a Man Walking Down the Street* (Fig. **2.7**), the street is represented by broad strokes made with his pencil point held parallel to the paper surface. The material reality of this street scene fades into a formless visual world described by the graphite's soft, silvery gray tones.

2.7 Medardo Rosso, *Effect of a Man Walking Down the Street*, c. 1895. Pencil on card, 7 × 3½ in (17.7 × 9.1 cm). Museo Rosso, Barzia.

PROJECT 2

Exploring Graphite

MATERIALS: 9 by 12 inch sheets of medium-weight bond paper, an assortment of soft to medium-hard graphite drawing tools.

For this exercise we will use bond drawing paper in order to get an idea of how this material differs from newsprint and because it will accept vigorous drawing efforts without tearing.

Using one of the softer drawing pencils such as a grade 6B, explore graphite's tonal range by making a series of closely spaced horizontal lines, beginning with the lightest marks and gradually pressing harder on the instrument until its darkest mark is achieved. Next, sharpen your pencil and freely experiment with line qualities that can be achieved by varying your angle and pressure (Fig. **2.8**). Try making some vigorously drawn lines that cross each other and create varying textures and tones.

For the moment forget your preconceived notions of what a drawing should look like and concentrate on the task at hand. You will find that you enter a mode of thought and activity far removed from logic-based thinking. By doing these activities you are developing response patterns that are necessary in order to draw with fluency and ease. If you lose yourself in concentration you will find that only after you stop are you aware of the time that has elapsed. You have participated in a form of spatial and visual thinking that is based more on holistic thought patterns than analytical reasoning. In future drawing sessions try to regularly enter this visual thought mode and suspend fully conscious analytical reasoning until after the drawing session.

2.8 Graphite exercise.

SHOPPING LIST OF BASIC SUPPLIES

- One basswood or masonite drawing board, 20 by 26 inches

- Newsprint pad, 18 by 25 inches

- White bond drawing pad, 18 by 24 inches

- An assortment.of graphite drawing pencils (4B, 6B, 8B) and other solid graphite drawing instruments

- Packet of vine charcoal (soft) and various grades of compressed charcoal

- Black chalk

- Conté crayon (black)

- Sanguine red conté crayon

- Heavy metal clips to hold paper to the board

- Kneaded eraser

- Soft pencil eraser

- Chamois

- India ink

- A medium-sized round sable-hair brush – #8 or 10 (or substitute an inexpensive medium Japanese squirrel-hair brush)

- Drafting tape (a form of masking tape with a weaker adhesive that is less likely to tear the drawing paper)

- Push-pins

- Ballpoints and assorted markers

- Square stick of litho crayon

- Carpenter's marking crayon

PERSONALIZED SHOPPING LIST

Your instructor may have his or her own list of specific art supplies to get you started. Use the space provided below to note these materials.

3 SEEING AND RESPONDING

Now that you have first-hand experience of the nature of basic drawing materials and how they interact, you are ready to begin working from a subject. At first it is important to focus your attention on the process rather than the product. These exercises are designed to teach you ways of seeing and responding that will form the foundation for future work in drawing. You may not initially produce the kind of drawings that you eventually hope to do, but these sessions are important because, later, they will enable you to visually respond to what you see in meaningful ways. Just as student musicians need to learn scales and the basic theories of harmony to gain control of their instruments, so you need to learn the rudimentary language of drawing. In order to fully commit these visual patterns of thought to memory, you need to consciously develop skills of thinking and responding that will later be used unconsciously and with greater ease and fluency.

GESTURE DRAWING

One basic concept unites all forms of drawing. They are all created by hand-held instruments that move across the surface of the drawing, leaving behind a record of their movement. This movement, or kinetic activity, is inherent to the nature of drawing. The use of gesture drawing techniques is one of the best ways to approach the expression of motion.

The term "gesture" refers to the kind of rapidly drawn line we might make in order to record or visualize basic visual information in a short period of time. Eugène Delacroix (1798–1863) probably completed *Arab Attacking a Panther* (Fig. **3.1**) within minutes as a preliminary sketch for what would eventually become a large, elaborate painting with lots of detail. This gesture drawing is full of energy, conveying the dramatic action of a mounted horseman swinging his sword at a crouching panther. Here Delacroix was searching for the essential visual gestures or basic elements that would express his ideas with great economy. Gesture is concerned with communicating the essence of an idea, not its fine points.

The gestural line is also a means of recording on paper not only what we see but how we see it. Quickly drawn lines mimic the rapid back and forth, up and down movement our eyes make as we visually explore a new form. Using our hand, arm, and upper torso to make rapid gestural lines, we can define important characteristics of the subject we wish to draw – its basic shapes, proportions, and its general position in space. This type of drawing does not concentrate on details, but responds instead with quickly drawn lines to the forms we perceive.

Gestures are dynamically and atmospherically captured in *A Clown* (Fig. **3.2**), a charcoal and watercolor drawing by Honoré Daumier

3.1 (opposite) Eugène Delacroix, *Arab Attacking a Panther*, 19th century. Graphite on white paper, 9½ × 8 in (24 × 20.4 cm). Fogg Art Museum, Harvard University. Bequest of Meta and Paul J. Sachs.

3.2 Honoré Daumier, *A Clown*, 19th century. Charcoal and watercolor, 14⅜ × 10 in (36.5 × 25.4 cm). The Metropolitan Museum of Art, New York. Rogers Fund. #27.152.2.

3.3 Auguste Rodin, *Cambodian Dancer*, 1906. Pencil and watercolor drawing on paper. Philadelphia Museum of Art. Gift of Jules E. Mastbaum.

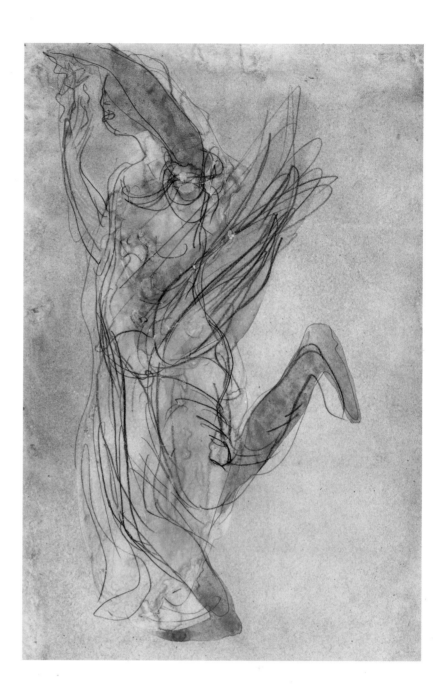

3.4 (opposite) Alberto Giacometti, *Portrait of an Interior*, 1955. Pencil on paper, 19¾ × 12⅞ in (50 × 32.6 cm). The Museum of Modern Art, New York.

(1798–1897); the quickly drawn lines evoke movement rather than record detail.

In an animated gesture drawing of a Cambodian dancer, Auguste Rodin (1840–1917) captures the essence of her body and drapery in motion through quickly perceived and swiftly flowing lines (Fig. **3.3**). Gesture does not solely record the edges or *contours* of the form (a technique explored in Chapter 4, "Line"). The gesture method seeks to communicate something essential about the subject in an economic and dynamic way. Naturally you want to make drawings that are accurate, but mastering the concepts of gesture drawing will increase your capacity to do work that is more fluent and expressive than visually "correct."

The Swiss artist Alberto Giacometti (1901–66) used energetic and searching lines to visually link all the contents of a room in *Portrait of an Interior* (Fig. **3.4**). Through Giacometti's relentlessly searching and interpenetrating lines the inanimate objects in the room are unified and brought to life. Notice the way all the visual elements in this scene appear to be connected to each other to form a unified whole.

3.5 (left) Bedsheet draped over cardboard boxes.

3.6 (right) Student Drawing. Marisol Torres, Felician College. Charcoal, 24 × 19 in (60.9 × 48.2 cm).

PROJECT 3

Gesture Drawing

MATERIALS: 18 by 24 inch newsprint paper, vine charcoal or conté crayon.

Create your still-life subject by draping a white or solid pastel bedsheet over three or four randomly positioned, medium-size cardboard cartons, preferably set against a bare wall (Fig. **3.5**). If possible arrange the lighting so that a strong unidirectional light (such as a window, or spotlight and reflector) illuminates the subject. This will create strongly contrasting shadows and *highlights*, making it easier to perceive the three-dimensional character of the subject and to respond to it with massed gesture.

Before you begin to draw, take a few minutes to study the scene. Where are some of the most prominent visual shapes in this arrangement? Try to view the subject as complete, comprising the various interrelated parts. Since we are concerned with rapidly responding to the forms in front of us, we must not let ourselves become bogged down with minor detail. For this reason there is a time limit of two to three minutes for this exercise. Hold the charcoal in a relaxed way, study the subject, and allow your hand and arm to follow your eyes as they move over the forms of the still-life (Fig. **3.6**).

Because gestural response should be spontaneous, make sure you use the full dimensions of your newsprint pad. Avoid unconsciously placing a small drawing in the center of a large sheet of paper but rather consciously maximize the range of your arm movements in order to make full use of the paper. Look for major movements that run through the entire scene and record them with gestural lines. In this assignment it is better to err on the side of boldness than timidity.

Once you feel comfortable with this exercise, try putting to use what you have learned from the exercises that explored the pressure-sensitive nature of

charcoal. To register dark undercut folds, press harder. Minor creases should be drawn with less pressure. Changing the angle of the charcoal against the paper will also change the width of the line. Develop a "push" and "pull" response to the subject. Changing the intensity of the line might be coordinated with the object's changes in depth or direction.

After you have made a series of short, timed drawings, stop and take a look at them. Could your lines be more flowing and expressive? Have you sufficiently emphasized major divisions in the form? Are you using the whole page? Shift your position to avoid monotony and visual familiarity. Make several more gesture drawings, keeping in mind the previous instructions. Think of the lines as uncoiled strings that follow the forms and fold of the subject. Be aware of the natural movement of your eyes as you trace these flowing forms. For the time being, forget about how accurate these drawings are and concentrate on the linear movements of the gesture lines.

PROJECT 4

The Unification of Gesture

MATERIALS: 18 by 24 inch newsprint paper, vine charcoal or conté crayon.

This exercise is designed to make you more aware of how all the visual elements in your drawing could be organized to work together in harmony. This arrangement of your drawing's shapes, spaces, lines, and tones is referred to as its "composition." One of the earmarks of an effective drawing is the way it unifies all its elements to create a feeling of wholeness and completion.

Look for several objects that have simple, uncomplicated shapes such as vases, books, and a shoe-box. (Ignore any advertising labels on the boxes. We are responding to the three-dimensional forms, not the surface design.)

Take some care in arranging your still-life subjects and place them in a group on top of a table in an uncluttered area where the light is good. Arrange some touching one another and some at short and medium distances. Stand back and view this as an informal composition rather than a collection of objects.

We will do a series of three- to five-minute poses for this still-life. Since the shapes of these objects probably do not relate to each other visually, we will have to create this effect with our gestural responses. Pay particular attention to how lines and marks might visually connect and spatially integrate these unrelated objects. We should be able to look at the drawing and see the still-life objects as a unified grouping.

Avoid placing small drawings of these objects in the center of the page. As you draw, allow your eye to travel across one form and on to the one next to it. Respond freely with your charcoal as you mimic the movement of your eyes.

In these initial exercises remember not to dwell on details. We are developing spontaneous response patterns to drawing that will be put to use later in more controlled ways. Stay with these gestural drawing exercises until you feel you have gained some proficiency. It would make sense to thoroughly explore the possibilities of basic exercises such as this one before continuing. Keep in mind, as you progress from one project to the next, that returning to earlier exercises will not be a waste of time. Drawing skills are cumulative, and over time our experience enables us to handle increasingly complex problems.

GENERAL GUIDELINES

Here is a summary of guidelines to remember as you work on the drawing projects in this chapter and throughout the book.

Position yourself comfortably and allow plenty of space to move your arms freely when working on a drawing.

Unless directed otherwise, use 18 by 24 inch paper (newsprint or bond).

Consider the physical parameters of your subject in relationship to the format or edges of your drawing paper before starting to draw.

Use the entire drawing space of your paper. Do not place small drawings in the center.

Exploit the full range of tones and marks your drawing instrument is capable of making.

Practice keeping your eye on the subject while your hand responds with motions that enscribe the forms on the paper.

Avoid cardboard cut-out outlining in gesture drawing. Use lines that visually "touch" the subject in many places, not only its outer edges.

3.7 Rembrandt van Rijn, *Elephant*, c. 1637. Black chalk, 9¹³⁄₁₆ × 14 in (24.9 × 35.6 cm). Albertina, Vienna.

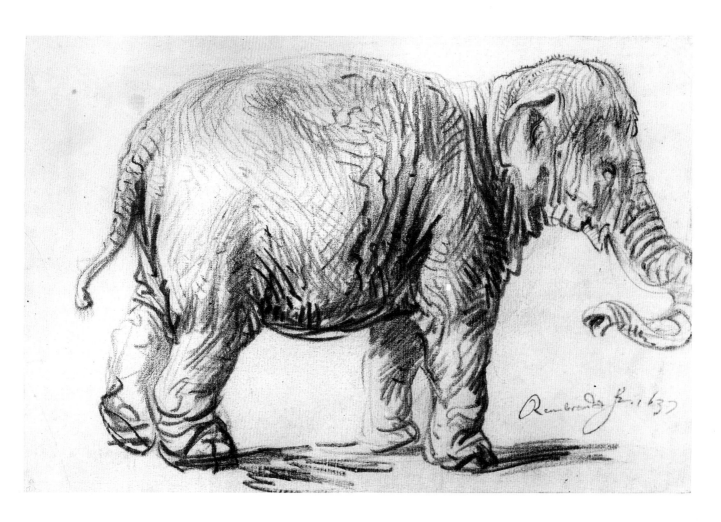

PROJECT 5

Using Massed Gesture Lines

MATERIALS: 18 by 24 inch newsprint paper, vine charcoal.

In this project you will use *massed gesture lines* to quickly block in shadow areas and broadly define areas of light and dark in your subject. The time limit on this assignment should be between five and eight minutes.

Your choice of subject and the way you light it will play an important role in the success of this assignment. Use simple household objects similar to those used in Project 4. Illuminate this still-life with a strong unidirectional light source from a lightbulb and aluminum reflector to produce strong highlights and deep shadows. This will make it easier for you to perceive the basic divisions of light and dark in the subject and to respond to them with massed gesture lines.

Begin by lightly indicating the basic visual structure of the still-life with quick exploratory lines. Do not emphasize the edges of forms but explore the inner and outer structure of these three-dimensional objects. At this stage you are roughly determining where the major shapes are and how they relate to the physical dimensions of your paper. Holding your stick of charcoal at a 45 degree angle to produce thicker lines, make a series of close parallel lines that correspond to some of the deepest shadows in the subject. Avoid holding the charcoal completely parallel to the paper surface because the marks created by this technique tend to be smudgy and have no definition. By varying the thickness, density, and closeness of these lines, we can control how light or dark the tonal area becomes. Stay within the time limit to avoid overworking details; the idea here is to spatially describe the forms in your drawing through the means of dark and light tones. Your response should be spontaneous, direct, and bold. Take care not to cover the entire drawing surface with tones and lines. The contrasting effect of dark to light tones will be diminished. Make the paper work for you, let it represent the highlights in the subject. Rembrandt's drawing of an elephant (Fig. **3.7**) was done using the technique of massed chalk lines. Notice the way he creates the illusion of form through the interplay of dark and light tonalities.

After a few warm-up drawings change your position and before beginning to draw take note of where the darkest shadows are in the subject. What sections fall into the range of middle tones? Where should you leave the paper untouched to represent highlights?

Now that you have gained some experience with this process, practice integrating the spontaneous gestural lines you used in Project 3 with the massed-line technique of this exercise. Figures **3.8** and **3.9** show two student drawings that make use of massed gesture lines. Again do not measure the success of your drawing by how accurate and finished it looks – that issue will be resolved with time. Strive for an extended range of tones that varies from the lightest line to the darkest passages.

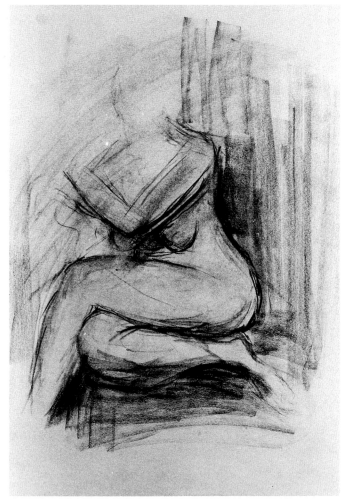

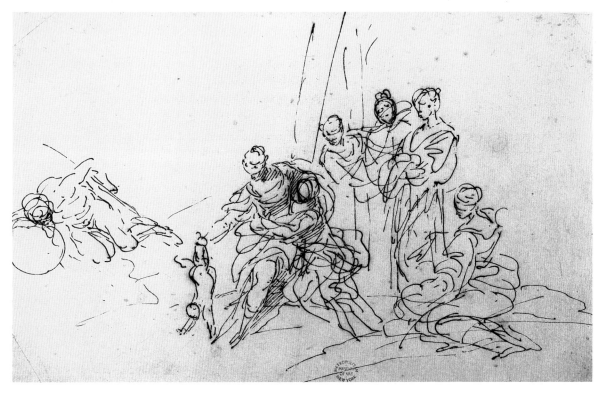

PROJECT 6

Making Continuous Line Drawings

MATERIALS: 18 by 24 inch newsprint or bond paper, a soft, broad-point graphite pencil.

For this assignment create an effective drawing subject by draping a white bedsheet over a high-backed living-room chair. Arrange the folds so that they form continuous, intersecting patterns (Fig. **3.10**), pinning folds together in order to achieve interesting visual effects.

3.10 Folds arranged in continuous patterns.

The solid graphite drawing instrument mentioned earlier is an idea tool for continuous line drawing because of the ease with which it glides over the surface of the paper (graphite is naturally slippery and is used as a dry lubricant for metal parts). The aim of this assignment is to construct a drawing that appears to have been made from one continuous line, developing the ability to coordinate the art of seeing with the process of drawing. Before you begin to draw, allow your eyes to freely roam and explore the physical dimensions of the still-life.

When you are ready to start drawing, keep your eyes on the subject and repeat this viewing process, but this time, making sure your pencil remains in continuous contact with the paper, synchronize the movement of your eyes with the continuous pencil lines. A good strategy is to convince yourself that you are touching the still-life with your pencil, drawing anything that your pencil could rest on and be guided along. You may momentarily stop the movement of the drawing instrument and look down at your drawing, but keep the graphite in contact with the paper until your resume drawing. This may seem to be an awkward method, but with practice you will be able to better coordinate your eye movements with the movement of your drawing instrument. By constantly looking up and down you are impeding the continuity of perception and you are actually drawing from memory rather than direct experience.

The time limit on this assignment should be about six to eight minutes.

Donato Creti (1671–1749), an Italian artist, made use of continuous line drawing techniques in this fluid study titled *Thetis Dipping the Infant Achilles into the Waters of the Styx* (Fix. **3.11**).

3.8 (opposite, left) Student Drawing. Anon., San José State University. Charcoal, 40 × 26 in (101.5 × 66 cm).

3.9 (opposite, right) Student Drawing. Cherry Tatum, San Francisco State University. Charcoal, 24 × 18 in (61 × 46.7 cm).

3.11 (opposite, below) Donato Creti, *Thetis Dipping the Infant Achilles into the Waters of the Styx.* Pen and brown ink, 6½ × 10⅚ in (16.9 × 27.6 cm). The Metropolitan Museum of Art, New York. Gift of Cornelius Vanderbilt. #80.3.369.

Contemporary artists like Mel Bochner (b. 1940) have used similar techniques to produce striking drawings that probe visual perceptions and create feelings of movement and spatial continuity (Fig. **3.12**).

INTEGRATING GESTURE DRAWING TECHNIQUES

Now that you have gained some preliminary experience in manipulating and controlling your drawing materials and you have learned to respond visually to various subjects, it is time to integrate and combine the various gestural techniques. Much of your previous effort was directed toward learning response patterns rather than achieving accurate representations. This assignment stresses combining many of the aspects of previous exercises, such as spontaneous gesture, mass gesture, and continuous line drawing, with a greater attention to accurate description.

The time limit on this series should range anywhere from ten to twenty minutes. Within this time-frame stay with the drawing as long as you do not become bogged down with minute detail. The object is to preserve some of the dynamic visual effects you achieved in the initial exercises and to combine them with greater concern for overall organization and accurate description.

In his incongruous drawing of a Campbell's soup can stuffed with dollar bills (Fig. **3.13**) Andy Warhol (1928–87) reveals a technique that effectively integrates quick gesture drawing with careful placement of forms and accurate description. The vigorous gesture lines in the upper half of the drawing contrast nicely with the freely drawn design elements of the soup can and the tightly rolled wad of bills in the foreground.

3.12 Mel Bochner, *Number Two*, 1981. Charcoal and conté crayon on sized canvas, 92 × 74 in (233.7 × 187.9 cm). Courtesy, Sonnabend, New York.

3.13 Andy Warhol, *Campbell's Soup Can and Dollar Bills*, 1962. Pencil and watercolor, 24 × 18 in (61 × 45.7 cm). Collection, Roy and Dorothy Lichtenstein, New York.

PROJECT 7

Sustained Gesture Study

MATERIALS: 18 by 24 inch newsprint or bond paper, vine charcoal or graphite stick.

For this assignment create an appropriate still-life by using a circular or rectangular wastepaper container and placing a few crumpled sheets of newsprint on it. This, coupled with some effective lighting, should make a challenging subject to draw. Take the time to study the still-life before you begin to work. Give some thought to how you will arrange the lines and shapes on your drawing surface.

Begin by very lightly indicating on the paper where major forms will be located on the drawing plane. Since your first tentative marks will be faint, you can easily erase or draw over them later in the session when you are more sure of the position of the various elements. Do not become too restrained with your drawing technique. Once you feel confident about the position of a form, use vigorous, bold gesture lines. Vary your drawing methodology. As in the Warhol drawing some passages could be very free and sketchy and others more carefully delineated. We are searching for a balance in this series between the loose and the controlled, the spontaneous and the planned.

After you have completed several drawings, take a break and review your results. Pay particular attention to the character of the lines or marks. Are they all the same tonality, the same size? Could you improve the visual qualities of your drawing by making the marks more varied and more responsive?

Review the general guidelines presented on page 68 and make a checklist of areas you want to improve. Are you using the entire space of your drawing surface? (This does not mean filling it in but making appropriate use of all of the space.) Take note of how the Warhol drawing in Figure **3.13** organizes areas of linear activity with visually quiet space.

Another important factor is the "cardboard cut-out" syndrome, a common occurrence in student drawings. Lines should search and explore the full three-dimensionality of the forms and not merely outline them. Make note of the basic improvements you wish to make in figure drawings and work toward putting these changes into effect. By the same token, take stock of the elements that work and continue to emphasize these qualities.

CONSTRUCTION METHODS

So far we have concentrated on spontaneously responding to the visual forms in front of us with quickly perceived gestural lines and marks. Accuracy of description and proportion in these beginning exercises were of less importance than developing a rapport between the act of seeing and the process of drawing. We were also learning to observe, condense, and record what we saw within strict time limits. Many of these techniques are frequently used by artists when they draw from life in sketchbooks. Often in these situations there is a need to produce drawings rapidly and with a minimum of reworking – the world is moving too quickly for studied efforts. But many of the visual effects of gesture drawing are prized by artists even when they are working in their studio because these gestural lines have visual quali-

ties that are uniquely expressive. For instance, the vigorous and graceful lines of the untitled drawing by Willem de Kooning (1904–97) convey a sense of power and dynamism that correspond to many aspects of contemporary life (Fig. **3.14**).

Despite the outward appearance of casual improvisation in de Kooning's drawing, his work shows great control and careful structuring. He organized visual components in such a way that they have the appearance of spontaneity. Years of practice enabled him to achieve the feeling of freshly perceived graphic expression even if he worked on a drawing or painting on and off for years (see also Chapter 12).

In order to begin to develop the fluency of visual thought that results in an effective structure of ideas, we must have a working knowledge of how drawings are constructed. Another basic approach to drawing is to slowly and methodically respond to what we see in terms of planning, compositional structure, emphasis, and the analysis of visual relationships. Once you have gained experience with conscious planning, or construction methods, you will later be able to perform all of these analytical decisions almost without being conscious of using them. When the immediacy of gestural visual response is teamed with meaningful organization and structure, we will have achieved a synthesis of thought that is the hallmark of effective drawings.

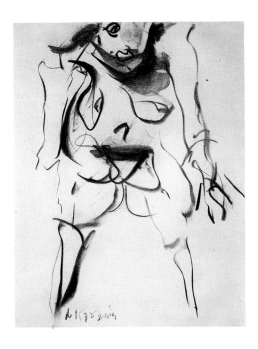

3.14 Willem de Kooning, *Untitled*, 1968. Charcoal on tracing paper, 24 × 18¾ in (60.9 × 47.5 cm). The Museum of Modern Art, New York. Gift of the Artist.

PROJECT 8

Blocking out a Drawing

MATERIALS: 18 by 24 inch newsprint or bond paper, vine charcoal or soft graphite pencil (wide-point).

To create a still-life that offers a variety of sizes and shapes, select a group of four or five moderately sized household objects, such as lamp shades, cereal boxes, or toasters, and place them on a supporting surface such as a table or chair. Organize them in an informal, clustered way, avoiding even, symmetrical spacing (Fig. **3.15**). In these exercises we will explore ways of consciously analyzing and graphically interpreting visual information.

Pick an angle of the still-life that appeals to you and get into a comfortable drawing position. Try not to work longer than twenty or thirty minutes on one drawing. Before making a mark on the paper, carefully examine the objects in front of you and consider them in relation to your drawing *format*. All the objects in your still-life should visually fit within the drawing format; some of them should come quite close to at least three edges of the paper. What part of the arrangement will come close to the top of the page? What object approaches the bottom edge of the drawing? What about the left and right limits? Begin by placing a light mark with your charcoal or pencil at specific points on the paper to indicate these parameters. At this stage of construction we are not interested in describing objects as much as we are concerned with determining their spatial and proportional relationships with each other and the dimensions of the paper. After carefully examining the still-life, visualize an imaginary line going from one of the parameter points you have chosen to another. On your paper lightly make an actual line between these points. Keep visually comparing and checking the angle and proportional length of the envisioned line in relation to the actual drawn line. Make corrections over your previously drawn lines as you begin to note their true positions. Continue to analyze and block out the relationships of all the objects in the still-life. What you will arrive at is a series of lines that analytically define the spatial and proportional structure of the still-life. Figures **3.16**, **3.17**, and **3.18** offer examples of what your progression might look like.

Pay particular attention to the space between the objects you have selected to draw. These negative spaces are as important as the objects themselves in terms of defining the compositional space of the drawing. What you will have created in this drawing session is a "map" describing the visual terrain of your still-life. The concept of a map is explored further in Chapter 9, "Creativity and Visual Thinking." Classical drawing seeks to present forms and spaces to the viewer in a coherent, logical way. When you have developed the ability to control and manipulate what you see, you will have the freedom to creatively invent and organize anything you can imagine.

3.15 Household objects arranged into a still-life.

3.16 (left) Sequential steps in blocking out a drawing (1).

3.17 (right) Sequential steps in blocking out a drawing (2).

3.18 Sequential steps in blocking out a drawing (3).

PROJECT 9

Integration of Analysis and Gesture

MATERIALS: 18 by 24 inch newsprint or bond paper, vine charcoal or graphite pencil. Rearrange the still-life used in Project 8.

Now that you have gained experience analytically blocking out a composition, we will use this technique to create a skeletal structure upon which your gestural drawing is based. In this way we can combine accuracy of proportion and compositional refinement with more spontaneous lines.

Begin the drawing by determining the basic compositional organization as you did in Project 8. Make a series of horizontal and vertical lines that define the heights, widths, and general shapes of all the still-life objects and the negative space that surrounds them. These lines should continue past the objects, sometimes to the edge of the page. Keep these lines light because later you may want to draw over them and make them darker at crucial points.

Use this guide as a basis for a gestural drawing that explores some of the details of the still-life. Do not erase the preliminary lines that helped you define the composition; they reveal the visual thinking that went into the drawing and enable the viewer to share in the process of discovery.

3.19 Student Drawing. Rosemary Thompson, Felician College. Graphite, 23¾ × 18 in (60.3 × 45.7 cm).

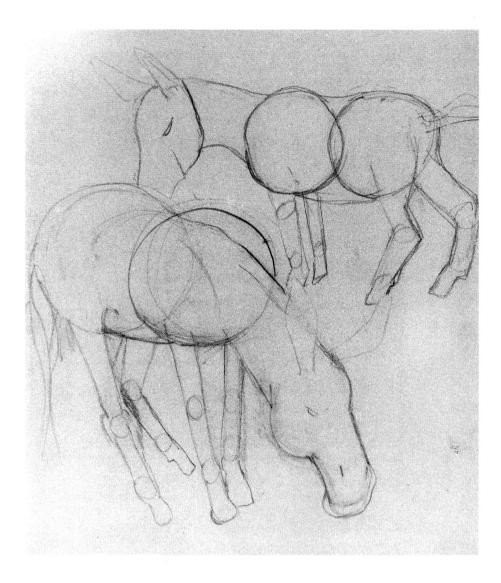

Rosemary Thompson's student drawing (Fig. **3.19**) makes effective use of analytic drawing methods to create visual structures upon which she can further refine her composition. The large circles indicating body mass and structure and the smaller circles describing places where the legs are jointed aid her description of the donkeys' forms.

Later, as you gain proficiency with visualizing how a drawing might be organized, you might use fewer actual lines to plan its composition. Much of this analytic planning will be done unconsciously.

PROJECT 10

Sighting with a Pencil

MATERIALS: 18 by 24 inch bond paper, a 6B drawing pencil or conté crayon, a sharpened writing pencil.

Much of the difficulty of achieving accurate proportions in our drawings is because what we know about an object gets in the way of what we see. For instance, we may know that the top of a certain kitchen table is square. But,

rectangle. Yet when we draw the table we will tend to make its top square. In order to help us perceive spatial relationships and determine the correct angles and line positions, certain techniques and mechanical aids can be very helpful.

Find a rectangular kitchen or dining-room table that is convenient for you to draw. Sit down about 8 to 10 feet away from the table at an angle where the sides of the table do not appear parallel to the bottom of your page. Hold your *sighting* pencil at a consistent full arm's length (this is important because if your arm is sometimes bent you will introduce unwanted measurement variables) and position it parallel to the bottom edge of your drawing paper. Close one eye, and keeping the pencil at this angle, move it up until it visually appears to touch the bottom of the table leg nearest to you (Fig. **3.20**). Now it is possible to more objectively observe the angles of the table legs and the box sides in relationship to the bottom of your page. You can also use the sighting pencil held upright like a plumb line, to determine vertical alignments. Although our goal is to be able to overcome the impediment of misperception in drawing by training our mind, eye, and hand, this mechanical device can help us correct initial mistakes.

We can also use this technique to optically measure the relative proportions of shapes found in our still-life. For instance, many drawing students might at first have trouble correctly drawing the top of a table such as the one seen in Figure **3.20**.

Once again, holding the pencil in your outstretched hand, measure the length of the table leg nearest to you by visually placing the pencil point at the top of the leg and placing your thumbnail at the position that corresponds to the bottom (Fig. **3.21**). Keeping your thumb in this position with your arm still fully outstretched, compare the length of this leg with other visual measurements of the table, such as the table top. In this way you can objectively measure all the proportions of your subject and align them correctly on your drawing.

Using this sighting method, accurately draw the composition you created in Project 8, paying particular attention to horizontal and vertical angles and relative proportions.

3.20 (left) Sighting with a pencil to determine angles.

3.21 (right) Sighting with a pencil to determine proportions.

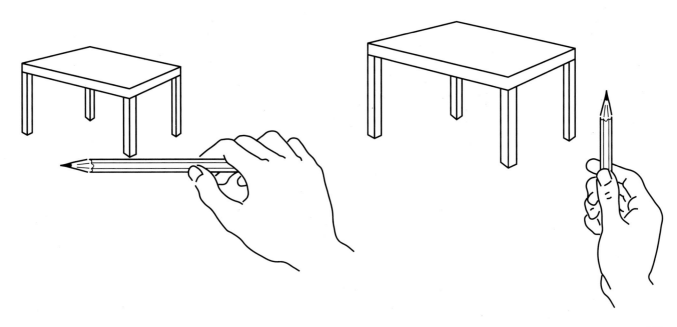

PROJECT 11

Analyzing Complex Forms

MATERIALS: 18 by 24 inch bond paper, vine charcoal or a 6B graphite pencil.

Once you have gained a modest proficiency with the sighting pencil, purposely choose a complex subject to draw such as an opened umbrella, the blades of an electric fan, or a bicycle. Begin by blocking out the general composition of the subject and then use the pencil-sighting method to determine the exact position of shape and angles. There is no time limit on this exercise; take as much time as you need, organizing the details carefully.

VISUAL EMPHASIS

Even the simplest of drawing subjects presents us with an enormous amount of visual information – seemingly infinite gradations of light and dark values, complex and simple shapes, surface textures, and in general a wealth of spatial detail. A camera records all the light-based information passing through its lens. By contrast a drawing might show us less but tell us more because of the way artists edit visual information and emphasize only those features important to the theme or concept.

Larry Rivers, an American artist born in 1923, created a particularly expressive portrait of Edwin Denby by selectively focusing on specific facial features and eliminating or only suggesting others (Fig. **3.22**). Bold, gestural lines define sections of the figure's head and shoulder, while softer, finely hatched pencil lines describe lips, nose, and eyes, perhaps the most important areas of a portrait drawing. Large areas of the paper are left untouched and these sections act as a contrast to the complex,

3.22 Larry Rivers, *Portrait of Edwin Denby III*, 1953. Pencil, 16⅜ × 19¼ in (42 × 50 cm). Collection, The Museum of Modern Art, New York. Anonymous gift.

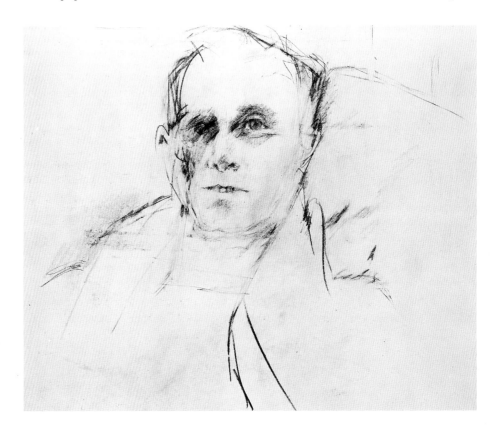

visually active passages. By consciously emphasizing and playing down various visual elements of Denby's features, Rivers creates a haunting portrait that appears to be half-imaginary, half-representational.

When a drawing presents us with a lot of undifferentiated visual information we may find it monotonous and dull. Rosemary Thompson, a beginning student, makes effective use of visual emphasis in her drawing (Fig. **3.23**) to counter this potential problem. By making the ceramic vase and some of the vertical forms significantly darker than other elements in this drawing, she creates interesting visual juxtapositions and encourages us to look carefully at her composition.

3.23 Student Drawing. Rosemary Thompson, Felician College. India ink, 10¾ × 10 in (27.3 × 25.4 cm).

PROJECT 12

Selective Focus

MATERIALS: 18 by 24 inch bond paper, soft graphite pencil or vine charcoal.

Using objects found in your house or apartment, create a still-life that combines a variety of unusual shapes and themes. You may wish to use the white sheet as in earlier sessions since it has enormous flexibility and can simplify or embellish a drawing subject. If possible, choose objects that have some personal meaning to you that could be juxtaposed with other thematically expressive objects, for instance, a childhood collection of teddy bears could be combined with other memorabilia to create interesting visual and thematic possibilities. The incongruity of some of these objects might lead to drawing ideas you would not otherwise have conceived of. Use your imagination and take some time to create a still-life that encourages involvement on all levels of thought, thematic as well as visual.

Remember that interesting subjects do not guarantee effective drawings. You will need to fully exploit the visual principles and elements that we have been learning in order to make the drawings themselves interesting.

No strict time limit is set on this assignment but be aware of the pitfalls of dwelling too long on any detail or section. Generally it should take you an hour or two to complete this drawing.

Once the subject material is arranged to your satisfaction and the lighting is complete, examine the subject from several angles. What drawing position seems to offer the most interesting compositional possibilities? What preliminary thoughts do you have about emphasizing or playing down various components in the still-life? The primary objective of this drawing is to experiment with visual selection and emphasis. Think carefully about what is drawn, how it is drawn, where it is placed, and just as importantly, what is left out or only tentatively suggested.

Lightly block in key points of the composition and define where the outer limits of the drawing will be. Slowly begin to develop detail in areas that are significant to you. Let the drawing activity gradually grow over the entire surface of the paper, taking care not to let any one area develop too rapidly. As the drawing evolves, step back for a minute and consider the total composition. Are certain areas in need of more development? What about the open spaces of the drawing; are they contributing to the overall effect?

During this drawing project we need to be particularly conscious of the effect of the composition as a whole. Avoid automatically placing your main focal

points in the center of the page unless this is an important part of your compositional theme, otherwise you may inadvertently produce a dull, static arrangement. Larry Rivers (Fig. **3.22**) placed the figure's head off-center near the upper edge of the composition. Similarly, the focal point of Rosemary Thompson's drawing (Fig. **3.23**) is placed off-center. This visual organization creates an interesting tension between the empty space of the drawing and its selectively drawn details. As you draw, think carefully about what sections will be emphasized. What supportive role will other details play? What visual components could be suggested with just a few lines? Figures **3.24** and **3.25** illustrate two successful student responses to the issues of selective focus and visual editing.

3.24 Student Drawing, Richard Stockton College. Charcoal, 30 × 22⅛ in (76.2 × 56.4 cm).

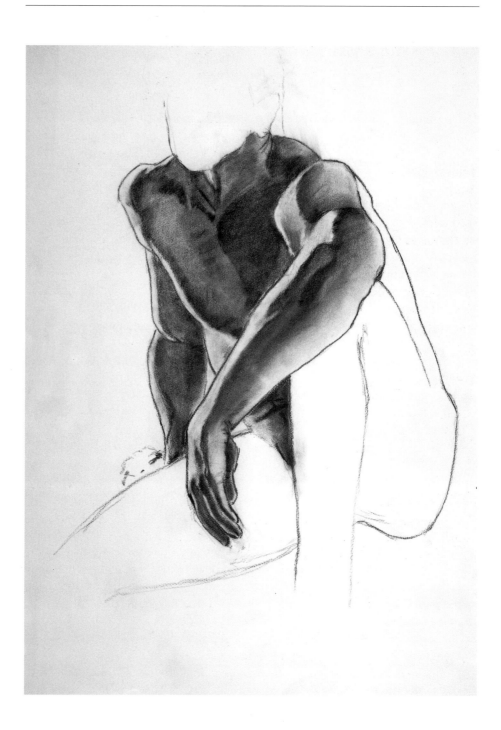

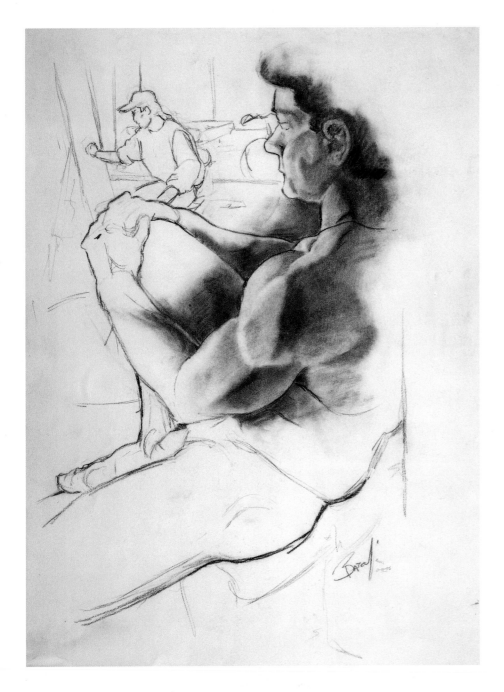

By now you should have a clearer understanding of some of the basic visual concepts and skills you will need to learn in order to draw with confidence and fluency. Sitting down in front of a subject with a blank sheet of drawing paper in front of you should not be the intimidating experience it might have been in the past. Future chapters will build upon this foundation and allow you to begin to express your ideas with more assurance and skill.

4 LINE

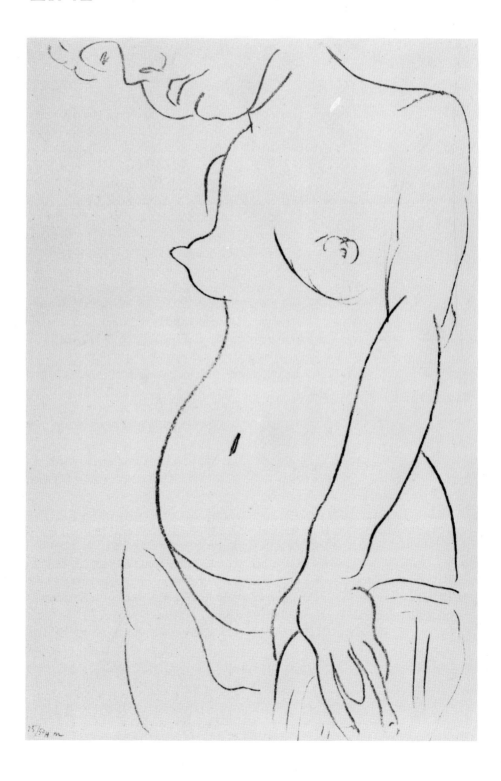

Although all the visual elements play key roles in the drawing process, line is one of the artist's most versatile and important graphic tools. There is virtually no form, concept, or emotion that cannot be expressed with line. Artists from the beginnings of recorded history to the present day have appreciated the extraordinary virtuosity of line and have used it in countless ways. This chapter will introduce you to many of the basic ways in which line can be put to creative and expressive use.

Before we begin our exploration of line it is important to realize that lines do not exist in the natural world. They are a graphic concept, first invented to communicate symbolic visual ideas and later used in the West to describe three-dimensional forms on a two-dimensional surface. Learning to draw effectively means gaining a fuller understanding of how lines work and how they can be used to achieve a variety of visual effects.

THE CONTOUR LINE

One of the most basic types of line that the artist uses to describe three-dimensional forms on a two-dimensional surface is the *contour line*. Such lines follow the edges of shapes and clearly define the various volumes and parts of the whole form.

Contour lines differ from the gestural lines explored in the beginning exercises of the previous chapter in a few important ways. Gestural lines are used to visually express the basic shapes, movement, and feel of the forms we are drawing. By contrast, contour lines more accurately describe the exact shape of forms by carefully recording the placement of their edges or contours.

Henri Matisse (1869–1954) made sensuous use of contour line drawing in his *Three Quarter Nude, Head Partly Showing* (Fig. **4.1**). Notice how the lines in this transfer lithograph respond to the various edges of the body and the overlapping muscles by following the contours of these forms as they flow across one another. The artist, however, is not merely making a cardboard outline of the model but is quite sensitive to the way forms overlap and move away from and toward us, communicating this three-dimensionality by occasionally leaving gaps between forms. This is evident in the upper right arm and where the model's right breast appears in front of the right shoulder.

Matisse also changes the weight of the line and controls the way it starts and stops, devices which help create the illusion that we are viewing a form that exists in three-dimensional space.

Benny Andrews's (b. 1930) pen and ink drawing of a small-town Southern policeman is both witty and elegant (Fig. **4.2**). The precise lines cut assuredly through the surface plane of

4.1 Henri Matisse, *Three-Quarter Nude, Head Partly Showing*, 1913. Transfer lithograph, 19¾ × 12 in (50.2 × 30.5 cm). Collection, The Museum of Modern Art, New York. Frank Crowninshield Fund.

4.2 Benny Andrews, *The Law*, 1972. Pen and ink on paper, 18 × 12 in (45.7 × 30.5 cm). Courtesy, ACA Galleries, New York.

the paper and reveal a wealth of pertinent detail. Andrews has meaningfully exaggerated the perspective – we seem to be both looking up at the policeman and staring directly at his expansive belly. The success of this drawing stems largely from the attention given to the small head and rotund body, the bristling hair on the policeman's forearms and the precise rendering of his very visible service revolver. To a young black man growing up in Georgia, an archetypal local policeman like this one must have conjured a myriad of feelings and fears. Given some time and distance, Andrews has made apt use of his drawing skill to humorously caricature this small-town cop. The contrast between the thin contour lines and the expanses of open paper create dramatic visual effects in this deceptively simple drawing.

PROJECT 13

Exploring Contour Lines

MATERIALS: 18 by 24 inch medium-weight bond paper, a sharpened medium to soft graphite pencil.

Create a still-life by arranging irregular objects such as a pair of shoes, a handbag, or some leather gloves on a table top. Avoid symmetrical objects but any other objects that provide interesting spatial relationships will do. Before beginning to draw, carefully observe the shapes of the objects and how their various parts overlap.

Plan the drawing so that elements of your still-life are distributed throughout the picture plane with some close to but not touching the edge of the paper. Do not draw this set-up from a distance but move your drawing board close to the still-life in order to develop an intimate and tactile understanding of it, that is, an understanding based on touch. Keeping your eye on the subject, start with any edge, and follow the contours of the objects with continuous lines. Try to feel that you are not just looking at but are also touching the objects with your moving pencil. There is no time limit on this drawing, observation and accuracy are primary factors in this exercise. Respond to subtle changes in the edges with corresponding movements of your drawing instrument. When you come to the juncture where one object or section of an object disappears behind another, stop. Take a few seconds to compare your drawing with the subject. Begin drawing the visible contour of the partially hidden object until it too disappears behind another form. Your proportions may be off but do not be overly concerned. What we want to focus on in this section is the use of contour lines that respond to the constantly varying edges of the three-dimensional forms. After you have made several contour drawings, change the arrangement of the still-life materials and do several more.

Another good variant of this project would be to use organic forms such as bananas or green peppers to introduce variety. Rubber tree plants and other indoor vegetation with large, well-defined leaves would also make appropriate subjects for contour drawing.

Contour lines are capable of a variety of visual effects. The student drawings shown in Figures **4.3** and **4.4** give us some idea of the visual effects it is possible to achieve using this basic linear drawing technique.

PROJECT 14

Contour Lines of Varying Tone

MATERIALS: 18 by 24 inch bond paper, vine charcoal, compressed charcoal, or soft graphite.

This drawing session will explore the effects of contour lines that vary in terms of how light or dark they are.

Choose drawing subjects that are basically curvilinear in shape: vases, tubular objects, plates, sections of cut logs, or the rubber tree plant suggested in the Project 13 would be appropriate. The task is to describe these forms with contour lines that vary in tonal weight. As you follow the contour of the subject, vary the pressure you exert on your charcoal or graphite in response to the three-dimensionality of the forms: as they come toward you, increase the pressure to create sharp, dark lines; as they move away from you, make the contour line gradually lighter to signal this spatial change. Another drawing technique to put into practice is to leave a small gap between lines that indicate overlapping forms. The distance of this gap could indicate the degree of separation: where forms are close to one another, the gap might be non-existent or narrow; where the distance between forms is great, the gap might be larger. Go back and look again at the Matisse drawing in Figure **4.1**, and take special note of how the artist used this technique to achieve his spatial effects.

In his fluid contour drawing of a nude (Fig. **4.5**) the French-American sculptor Gaston Lachaise (1882–1935) makes effective use of continuously varying linear tones to describe the voluptuous three-dimensional form of his female model. Contour line in the hands of this artist achieves visual effects that are anything but flat and "cut-out" in appearance.

After this drawing session take the time to analyze your drawings and make mental notes about what you can do in future contour drawings to exploit more fully the possibilities of this technique.

4.3 (left) Student Drawing. Anon., San Francisco State University. Felt marker, 18 × 24 in (46 × 61 cm).

4.4 (right) Student Drawing. Jolly Earle, Sonoma State University. Graphite, 24 × 16 in (61 × 40.6 cm).

4.5 Gaston Lachaise, *Standing Woman with Drapery*, c. 1929–31. Pencil, 18 × 12 in (45.7 × 30.5 cm). Collection, The Museum of Modern Art, New York. Gift of Edward M.M. Warburg.

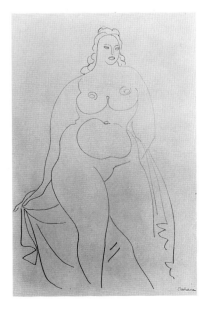

CROSS-CONTOUR DRAWING

Until now we have investigated a linear drawing technique that describes the edges of forms carefully and deliberately. But artists also make use of a more spontaneous variation of contour drawing called *cross-contour*. In this type of drawing lines follow the edges, or contours, and also come through and across the forms. By using this technique, we can accurately record information not just about the outer edge of a three-dimensional form but its inner dimensions as well. By following the contours of a form from its edge inward, we can plot the exact three-dimensional form of our subject.

Dürer's drawing of a young steer (Fig. **4.6**), which dates from c. 1495, uses cross-contour lines to delineate with meticulous detail the animal's skeletal and muscular structure. Notice how the direction of these lines responds to every nuance of the steer's body and how easily we can spatially read these lines as they describe the three-dimensional form.

This centuries-old linear technique is still in use today. Paul Cadmus, an American artist born in 1904, made extensive use of cross-contour lines in *Gilding the Acrobats* (Fig. **4.7**). This pen and ink drawing describes the back-stage preparations of a traveling circus as acrobats are gilded with gold paint just before their performance. The short cross-contour lines follow the curvature of the muscles and clothing folds from a variety of angles and directions, enabling us to read the scene three-dimensionally.

4.6 Albrecht Dürer, *Young Steer*, c. 1495. Pen and black ink on paper, 6⅘ × 5½ in (17.5 × 14 cm). Art Institute of Chicago, Clarence Buckingham Collection.

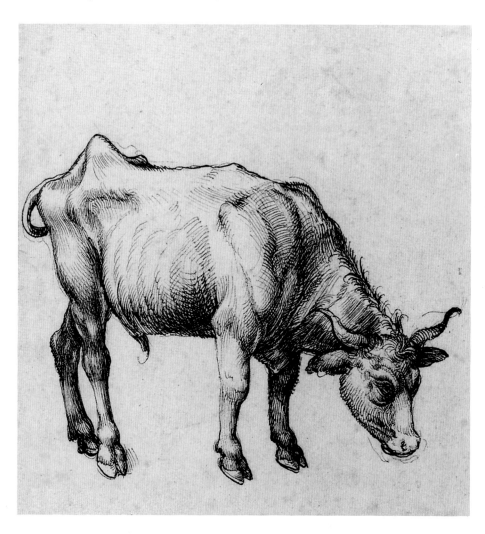

4.7 Paul Cadmus, *Gilding the Acrobats*, 1930. Pen, ink, and white chalk on paper, 15¾ × 10½ in (40 × 26.6 cm). Robert Hull Fleming Museum, University of Vermont.

PROJECT 15

Exploring Cross-Contour Lines

MATERIALS: 18 by 24 inch newsprint or bond paper, vine charcoal or soft graphite pencil.

Set up a still-life using large-leafed indoor plants – again, a rubber tree plant would be ideal. Undirectional lighting would be very helpful to reveal the forms and aid your drawing efforts. If you have an architect's lamp or floodlight in a clamp-on fixture, direct them on the plants. Using parallel line, follow the vertical and horizontal contours of the leaves and stems. To indicate shadow areas, make the lines in those areas darker and place them closer together. Use areas of blank paper to indicate highlights and light tones. Take another look at the illustrations featuring cross-contour lines (Figs. **4.6** and **4.7**). Notice the way in which Dürer and Cadmus selectively used lines that follow the contour without covering the entire surface of the paper with lines. You may wish to creatively apply what you have learned so far with linear drawing techniques in projects of your own choosing. The drawings illustrated in Figures **4.8** and **4.9** show what students have achieved using this basic technique.

4.8 Student Drawing. Sophie Vareadoz, San Francisco State University. Charcoal, 18 × 24 in (45.7 × 60.9 cm).

LINE QUALITIES

In the opening section of this chapter we explored some of the ways in which line could be used to objectively describe three-dimensional forms and space. But lines are also capable of making visual statements that are personally expressive. Like every handwritten signature, every artist's linear style is distinctive. Everything affects the quality of a line: the choice of drawing instrument, the surface characteristics of the paper, and the ways in which the artist's hand moves across the paper

4.9 Student Drawing. Julie Houghton, School of the Art Institute of Chicago. Charcoal, 36 × 24 in (91.4 × 61 cm).

and manipulates the drawing materials. The following examples of line quality represent some of the more important categories and styles.

Tonal Variation

The conté crayon drawing shown in Figure **4.10**, a preliminary study for the painting *Nighthawks* by Edward Hopper (1882–1967), uses strong line contrasts to establish the melancholy mood of a large city in the middle of the night. Thin

4.10 Edward Hopper, *Study for Nighthawks*, 1942. Conté crayon on paper, 8½ × 11 in (21.6 × 27.9 cm). Collection, Whitney Museum of American Art, New York. Bequest of Josephine N. Hopper.

vertical lines which describe the lighted window sections are contrasted with the dark, forceful horizontal lines representing the darkened facade of the buildings. This tonal juxtaposition helps communicate the psychological feelings of isolation and loneliness Hopper was interested in expressing.

Among the pencil drawings of Jacopo Carucci, known as Pontormo (1494–1557), is one of a young boy, in which a curious mixture of light, delicate lines that fade into the background work with heavier, more dynamic passages (Fig. **4.11**). The contour lines constantly vary in terms of their tone and thickness. The result is an arresting example of the stylistic shift from the standards of the High Renaissance toward Mannerism, of which Pontormo became one of the chief exponents.

4.11 Pontormo (Jacopo Carucci), *Nude Boy*, 1556–7. Red pencil over traces of black pencil, 16¼ × 10⅛ in (40.5 × 26.2 cm). Uffizi, Florence.

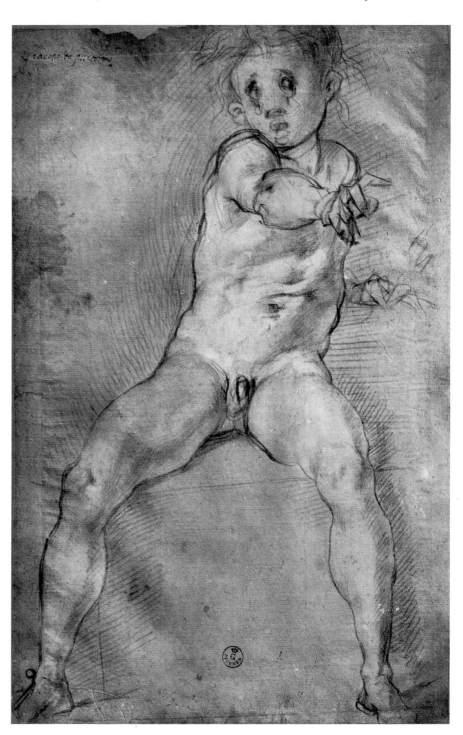

PROJECT 16

Line and Tone

MATERIALS: 18 by 24 inch newsprint or bond paper, vine charcoal, compressed charcoal, or soft graphite pencil.

Choose still-life subjects that will produce strong contrasts of light and dark with special lighting. Using a clamp-on 100 watt spotlight to illuminate your subject will help create the visual effects you are after. Try doing this assignment in your home at night, with artificial lights creating dramatic pools of light and darkened areas.

Before you begin to draw, analyze your subject and anticipate where the lightest and darkest areas might be located. After you have blocked out the general organization of the composition, explore the ability of line to create a mood and evoke certain feelings. As you evaluate the results of this exercise, ask yourself if you could have exaggerated the difference between the light and dark areas to further heighten the visual effects. Do another drawing using the same theme and see how far this concept can be taken. The student drawings in Figures **4.12** and **4.13** show some of the ways line can be manipulated to express tone.

4.12 Student Drawing. Lynn Ross, Sonoma State University. Charcoal, 24 × 18 in (60.9 × 45.7 cm).

4.13 Student Drawing. Bruce Brems, Bucks County Community College, PA. Charcoal and pencil, 16 × 19 in (40.6 × 48.2 cm). ·

4.14 Kao, *Kanzan*, 14th century. Brush and ink on paper, 40¼ × 12¼ in (102.5 × 30.9 cm). Freer Gallery of Art, Smithsonian Institution, Washington, DC.

Calligraphic Line

Calligraphic lines are free-flowing lines that make use of the graceful loops and complex curves that our wrists, arms, and upper body can make as we manipulate our drawing instruments. Calligraphy means "beautiful writing" and, as we learned in Chapter 1, the history of drawing is very much connected to the art of hand-writing.

The strongest and most direct relationships between the process of writing and the art of drawing exist in the Orient. Historically, Chinese and Japanese artists were all steeped in strong traditions of calligraphy. Kao, a Chinese artist who lived during the fourteenth century, used bold, expressive brush and ink lines to create his portrait of Kanzan, a legendary hermit (Fig. **4.14**). The sweeping lines that describe the figure's upper torso, clothing, and hanging belt are quite similar to the thick and thin brush lines used in drawing Chinese ideograms.

The visual effects of our drawings very much depend on the interactions of the drawing tool, the medium, and the physical movements our hand and body makes. Drawing and dance are two artforms that share concerns for aesthetically pleasing movement. The motion of our drawing brush or crayon over the paper leaves behind a record of its movement. Just such a visual record is evident in a *gouache* (a form of opaque watercolor) and brush drawing I made in 1990 (Fig. **4.15**). The sharply curved brushstrokes and fluid lines of this drawing could only have been made by the special movements of hand and wrists working in concert with the drawing instrument and media.

PROJECT 17

Exploring Calligraphic Line

MATERIALS: Heavy-weight bond paper or smooth watercolor paper cut to a moderate size, a 2 inch varnish brush, India ink, and a shallow tray.

Drape a white sheet over a table lamp or other moderately sized object, and arrange the folds to create sweeping vertical and horizontal movements. Hold your paper so that it is in a vertical, or portrait (longer in height than in width), format. These exercises in calligraphic line drawing depend to a certain extent on speed of execution, so they should be timed. Do not take longer than four or five minutes to complete these studies. If you labor over and rework them they will lose the sense of immediacy toward which we are striving.

Place some of the India ink in a shallow tray or cup. Dip the large brush in the ink (about half an inch) and respond kinetically, that is, with the movement of your own body, to the visual movements you perceive in the drapery folds. Do not try to make a detailed rendering of the subject but use the visual movements in the still-life as an inspiration for your exploration of calligraphy. Look at the flowing shapes in the subject and quickly move the ink-laden brush in response to what you see. Experiment with various methods of handling the brush: try gradually lifting the brush off the paper while your hand is still in motion and see how the line responds when you roll the brush in your hand as you draw. Pause between strokes to look at the drawing and to see which areas need further work and where your next linear passage should be.

Try this same exercise with pieces of vine and compressed charcoal that have been sharpened into chisel-edged instruments, and notice how they respond to various drawing angles and pressures.

4.15 Howard Smagula, *Law in Relation to Murder*, 1990. Watercolor and gouache, 9½ × 5½ in (24 × 14 cm). Courtesy, the artist.

4.16 Apache, *Suns and Ceremonial Personages*, Arizona, late 19th century. Painted deerskin. Smithsonian Institution, Washington, DC.

Expressive Line

The expressive nature of line is a constantly changing element of drawing. By varying line weight, shape, spacing, direction, and visual rhythms the possibilities for artistic expression are endless.

Suns and Ceremonial Personages (Fig. **4.16**), a late nineteenth-century Native American drawing on deerskin, makes use of particularly dynamic juxtapositions of lines and linear shapes. Each element of this drawing symbolically depicts some aspects of Apache cultural beliefs and spiritual life. Religious concepts important to the tribe are visually communicated by the bold animated forms that radiate from the central "sun," presenting us with a compelling vision of Native American ceremonial art.

Umberto Boccioni's *Study for the Dynamic Force of the Cyclist* (Fig. **4.17**) was completed in 1913 and visually communicates the concept of motion and power. Boccioni (1882–1916) was one of the founding members of the Futurist movement, a group of Italian artists who glorified the modern concepts of energy, speed, and danger. The implied motion of a racing cyclist is expressed in this drawing through the use of energetically drawn sweeping lines and overlapping elliptical shapes.

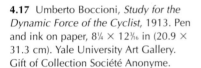

PROJECT 18

Exploring Lines that Imply Motion

MATERIALS: Bond paper, pen and ink or india ink and brush.

For this drawing assignment we will make use of a bicycle as our still-life. The mechanical function of a bicycle is to move; and although the object we are using to draw from is not moving we will emphasize its kinetic potential, that is its potential for motion, in our drawings. Using the bicycle form as a point of departure, create a series of drawings that expresses movement or visual activity. You might become inspired by the visual dynamics of *Suns and Ceremonial Personages* (Fig. **4.16**) and activate your composition with bold juxtapositions of linear spaces and shapes.

Boccioni's drawing (Fig. **4.17**) also offers a role model for your drawing in terms of the way he selectively emphasized certain elements of the bicycle and rider and ignored others. Boccioni was drawing the speed and motion of the racer, not his position on the race track.

The main goal of this drawing project is to explore the dynamic, expressive possibilities of line and space. The student examples illustrated in Figures **4.18** and **4.19** reveal some of the visual effects that can be achieved through the use of expressive line.

4.17 Umberto Boccioni, *Study for the Dynamic Force of the Cyclist*, 1913. Pen and ink on paper, 8¼ × 12⁵⁄₁₆ in (20.9 × 31.3 cm). Yale University Art Gallery. Gift of Collection Société Anonyme.

Lyric Lines

The quality of lyric line that Odilon Redon (1840–1916) used in his lithograph of a tree (Fig. **4.20**) invites thoughtful, contemplative study. The delicate traceries of the leaves create dappled patterns that suggest the peaceful experience of the countryside. Rather than attempting to draw each leaf, Redon emphasizes groupings of leaves that he juxtaposes against the open space of the paper.

The late sixteenth-century Persian drawing of a noble lady in Figure **4.21** evokes similar feelings through the use of gracefully curving lines and subtle tonal nuances.

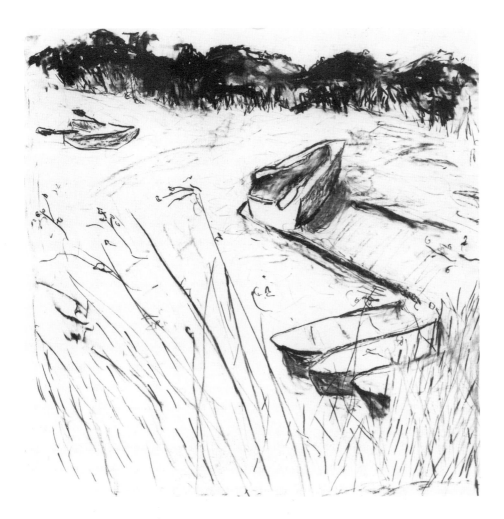

4.18 Student Drawing. David Blankenship, San Francisco State University. Charcoal, 26 × 28 in (66 × 71.1 cm).

4.19 Student Drawing. Anon., San Francisco State University. Felt-tip marker, 18 × 24 in (45.7 × 60.9 cm).

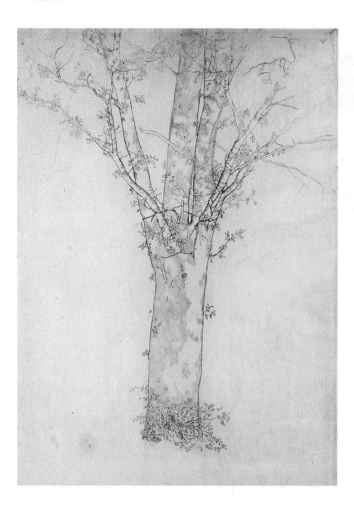

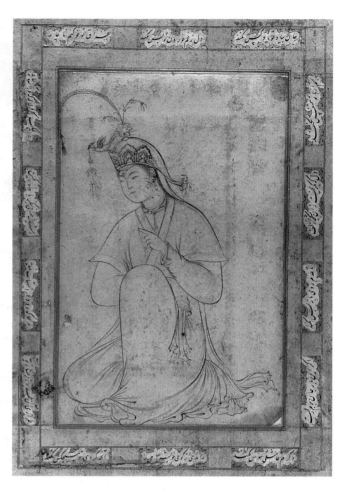

4.20 (left) Odilon Redon, *The Tree*, 1892. Lithograph, 18¾ × 12½ in (7.6 × 31.75 cm). Museum of Fine Arts, Boston. Bequest of W.G. Russell Allen.

4.21 (right) Anon., *Portrait of a Noble Lady with Elaborate Headgear*, Near East, Persia, Safavid Period, end 16th century. Louvre, Paris.

PROJECT 19

Exploring Lyric Line

MATERIALS: Bond paper, medium-hard graphite pencil with a sharpened point, a chisel edge or fine nib pen with India ink.

Find an isolated tree in a location convenient for you to draw. Using your sharpened pencil, sketch in some light guidelines that will help you plan the organization of your drawing. With carefully selected, lightly drawn lines, emphasize selected portions of the tree. The image of the tree or parts of the tree should seem to be embedded in the paper. The overall visual effect we are interested in achieving with this drawing project is one of delicacy and lightness. Much of the lyric quality of Redon's tree drawing (Fig. **4.20**) is achieved through lines and forms that appear to emerge tentatively from beneath the surface of the paper.

Another appropriate subject for this exercise in lyric line would be to obtain some fancy sea-shells with gracefully curving lines. Arrange them on a small

table, position yourself close to it, and respond with simple flowing lines similar to the Persian drawing in Figure **4.21**. An interesting choice of drawing instrument for your shell drawing would be a chisel-edge pen nib and India ink. This tool would vary the thickness of the line as it was dawn across the paper at different angles. If you use this pen nib, take some time to explore the way the lines it makes vary according to the angle it is held at.

Study the linear techniques of Figures **4.20** and **4.21** and then invent your own repetitive marks to interpret your subjects. Remember we are more interested in evoking a mood of feeling through the use of lyric lines and marks than describing everything we see. Be selective. Emphasize forms that interest you and be aware of the overall compositional effect of your drawing. Figure **4.22** illustrates one student's response to this type of assignment.

4.22 Student Drawing. Doug Cerzosimo, Bucks County Community College, PA. Ballpoint pen 17 × 14 in (43.1 × 35.5 cm).

Fluid Line

Daumier was best known for his socially conscious satirical drawings that regularly appeared in Parisian papers. In a sense, he was a pioneering political cartoonist long before the term was coined. Since many of his drawings were done directly from life, without the use of posed studio models, Daumier developed a rapid, fluid style of drawing that enabled him to capture the fleeting realities of street life. His drawing *Family Scene* (Fig. **4.23**) shows a businessman coming home after work and greeting his young child in front of their home. Daumier builds up masses of intertwined lines to induce dark tonal areas while isolated thin, sinuous lines suggest aspects of the landscape and a building.

4.23 Honoré Daumier, *Family Scene*, c. 1867–70. Pen, black ink, brush, and gray wash on ivory wove paper, 8½ × 8 in (21.6 × 20.5 cm). The Art Institute of Chicago. Helen Regenstein Collection.

PROJECT 20

Exploring Fluid Line

MATERIALS: Medium-sized bond sketchbook, rollerball black ink pen or other suitable drawing medium.

Go to a coffee shop, park, café, student lounge, or other place where people are engaged in activity and you can remain fairly inconspicuous. Keeping your eyes on the subjects, quickly describe their basic forms and gestural movement using searching, fluid lines. You do not have to use a strict continuous line technique, but to achieve the fluid linear quality we are after the majority of lines should appear to be connected. Once you have defined the basic composition, you can go back into the drawing to define details and indicate shadow areas. You will need to work quickly, however, recording your general impression of the scene rather than focusing on details. Background elements (which probably should be kept to a minimum) can be added later when your subjects move.

Line Variation

Using ink and a brush that was attached to a long extension shaft, David Hockney (b. 1937) placed his drawing surface on the floor and drew standing up to create the distinctive lines of *Celia Musing* (Fig. **4.24**). Although there are relatively few lines, the artist gets the most out of each one by constantly varying its character and width. As the line follows the vertical contours of the subjects, it appears and disappears with rhythmic variation, creating dynamic visual effects.

4.24 David Hockney, *Celia Musing*, 1979. Lithograph, 40 × 30 in (102 × 75 cm). © David Hockney.

PROJECT 21

Varying the Width and Character of Lines

MATERIALS: 18 by 24 inch medium bond paper or smooth watercolor paper, India ink, #10 round sable-hair brush, a 3 to 4 foot section of wooden dowel (about ½ inch in diameter), and masking tape.

Create a simple still-life that interests you – a few flowers placed in a vase would do quite well for this assignment. Or ask a fellow student to take turns posing so that you can draw each other.

Using a long-handled brush extension, we will draw standing up with the paper on the floor in front of us. Measure the length of the wooden dowel needed to make an extension handle for your brush. Tape the brush to the wooden extension and use it to do a series of drawings from a standing position. By changing the way we manipulate our drawing instrument, we can modify the character and expressive possibilities of the mark. This type of drawing project needs to limit the number of lines used in order to call attention to the distinctive mark employed. Vary the character and width of the lines by controlling the amount of ink on the brush and the pressure of the drawing instrument. Experiment with other techniques to see what kind of expressive line qualities result. For instance, you could try drawing with a long, square rod of balsa wood dipped in ink to see what other visual effects are possible. Experiment with unconventional drawing instruments and see how the line quality changes as you vary techniques and media.

Hatching and Cross-Hatching

Tonal variations and modeling can also be introduced in line drawing through the use of *hatching* and *cross-hatching*. Hatching uses parallel lines which basically run in one angle or direction. Andrea Mantegna (1431–1506), court painter to the Gonzaga family at Mantua, made this drawing of the *Madonna and Child* (Fig. **4.25**) with parallel hatch lines that create different tonal variations.

Cross-hatching is a technique that makes use of criss-crossing parallel lines to establish shapes and tones. Giorgio Morandi (1890–1964) used parallel lines that intersect (cross-hatching) in his haunting landscape drawing (Fig. **4.26**). Both drawings create tones by controlling the proximity of each line to the other – the closer the spaces, the denser the tone.

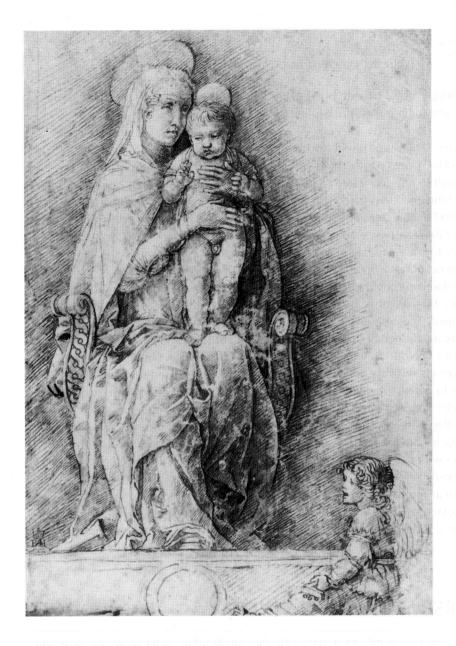

4.26 Giorgio Morandi, *Landscape*, 1933. Etching printed in black, 8¹⁄₁₆ × 11¹³⁄₁₆ in (20.5 × 30 cm). Collection, The Museum of Modern Art, New York. Abby Aldrich Rockefeller Fund.

4.27 Crumpled paper bag.

PROJECT 22

Exploring Hatching and Cross-Hatching

MATERIALS: 18 by 24 inch bond paper (cut down to a smaller size if you desire), pen and India ink or black rollerball pen.

Create a table-top still life by opening up and standing on its base a large brown or white paper bag (the kind you might get at a supermarket). Crumple it enough to put distinctive crease marks in it (Fig. **4.27**). We are going to use hatching and cross-hatching techniques to indicate the fragmented planes created by the creasing. This is one project where the lighting will profoundly affect the way we perceive and draw our subject.

Try to place the bag near a strong unidirectional light source such as a window, or use a spotlight to create distinctive shadows.

Before you begin to draw, refer to the Mantegna drawing (Fig. **4.25**), and notice how the artist used hatch lines to indicate the folds of the Madonna's garment. The creases of the paper bag are similar in structure to these folds. Using a light pencil line, indicate where major folds and shapes occur. Do not make a contour drawing of all the folds and fill them in with hatch lines. Only tentatively indicate the parameters of the composition and use parallel hatch lines to define the details. Take your time and proceed at an even, steady pace.

After you have gained some familiarity with this technique, try cross-hatching. The directions of the criss-crossing lines should relate to the angles of the facets on the paper bag. Do not cover the entire surface of your drawing paper with hatch lines but let the blank paper represent the highlights. Note the deepest shadows. This is where your darkest marks should be registered.

Great subtlety of tone can be achieved by controlling how close the ink lines are spaced. Go slowly; remember you can always add more parallel lines to make a section darker but you cannot remove them to lighten that area.

PERSONAL LINEAR STYLE

Sometimes artists talk about the particular "handwriting" other artists use in drawing. What is referred is not the way they sign their name but the special linear character-istics of their drawings. Jacob Lawrence (b. 1917), a well-known African–American artist, developed a drawing style that was unmistakably his own. Thematically, Lawrence's art is infused with a strong social ethic.

Struggle No. 2 (Fig. **4.28**) illustrates the special line qualities that characterize his drawings. In this piece a mounted rider careers through a crowd, creating havoc. Strong fuzzy-edged lines define the horseman with choppy rhythms. Thinner, smoother lines represent the unfortunate individuals struggling against their mounted adversary. The linear qualities of Lawrence's marks reinforce the thematic content of the drawing.

The line quality in Ida Applebroog's drawings (Fig. **4.29**) is quite different from that of Lawrence's. Instead of constantly varying, choppy lines, Applebroog (b. 1929) makes use of long, thick, even strokes that vary little in width. With these distinctive lines, she creates simple diagrammatic images that document the mundane existence of everyday life. Her lines assume the mechanical character of popular commercial illustrations that one might see on matchbook covers or in the

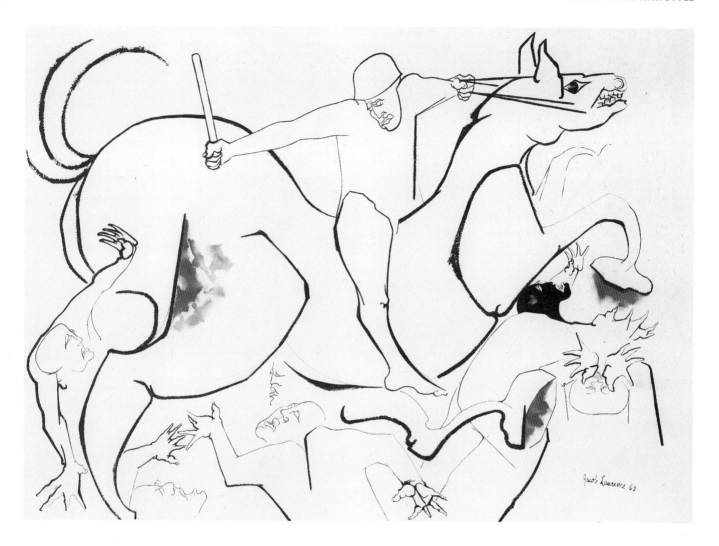

4.28 (above) Jacob Lawrence, *Struggle No. 2*, 1965. Ink and gouache on paper, 22¼ × 30¾ in (56.4 × 78.1 cm). Seattle Art Museum. Courtesy, Jacob and Gwendolyn Lawrence Foundation.

4.29 (left) Ida Applebroog, *Hotel Taft*, 1978–80. Ink and rhoplex on vellum, 2 panels, each 7 × 4½ ft (2.1 × 1.3 m). Courtesy, Ronald Feldman Fine Arts, New York.

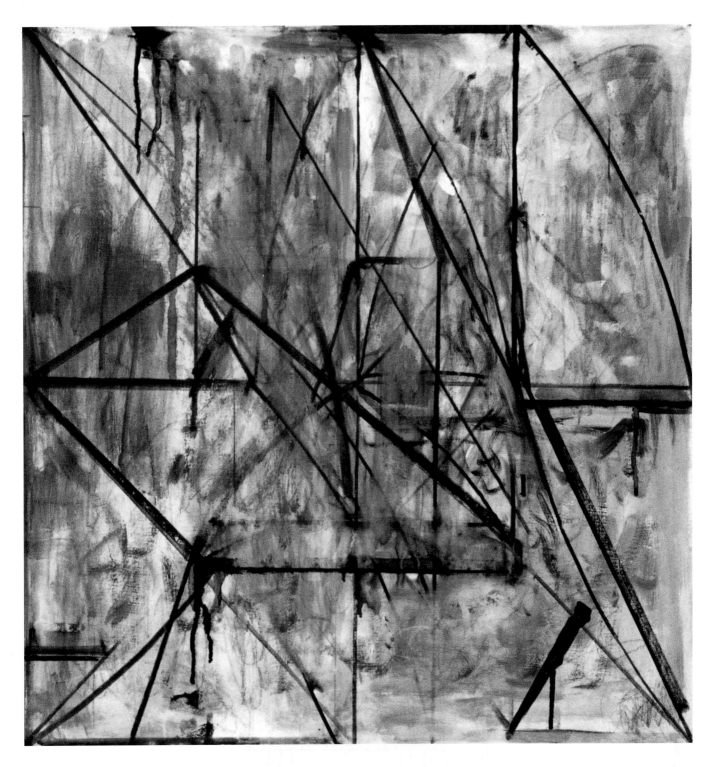

4.30 Jake Berthot, *Untitled #3*, 1992. Ink and gesso on paper, 22 × 21 in (55.9 × 53.3 cm). Courtesy, McKee Gallery, New York.

telephone yellow pages. This technique creates a feeling that we are witnessing a slice of urban life in its aspects of social isolation and anonymity. Even the composition of her drawing, the lone figures in separate panels, reinforces this reading of her work and fits in beautifully with her special linear style.

The ink and gesso drawing by Jake Berthot (b. 1939) seen in Figure **4.30** has the tonal complexity of a painting, yet it inherently relies on complex and highly personal linear elements to create its visual effects. Lines of varying widths and tones create an interlocking matrix of space that draws us in and captivates our imagination.

PROJECT 23

Developing a Personal Linear Style

MATERIALS: Bond paper and drawing medium of your choice.

The drawings by Lawrence, Applebroog, and Berthot express three distinctive linear styles. No one can expect a new student to develop the graphic identity of these artists overnight, but it is not too early to begin to explore expressive drawing styles toward which you are naturally inclined.

Now is a good time to review the drawing assignments you completed in this chapter about line. As you go over them, take out those that particularly interest you. What type of line was used in these drawings? Clarify in your mind the linear qualities that you find appealing. Re-create the conditions used to make these selected drawings and do a series of drawings that explore specific line qualities. Suppress for a time too strict a judgment about your work. Make a commitment to the process of drawing, returning to the same subject often to fully explore certain ideas, techniques, or materials. Return to the same general idea and exhaust every possibility. Continued involvement with a theme or idea will eventually enable you to make the breakthroughs that distinguish personally expressive work. Applying what we have learned in a creative way is the greatest challenge of all and one that will continue as long as we work in the medium of drawing.

5 VALUE

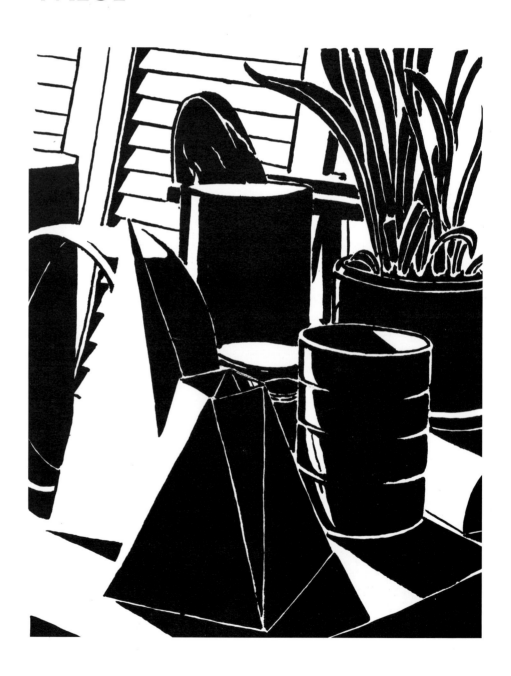

(opposite) Student Drawing. Henry
Sheving, San Francisco State University.
Brush and ink, 13¼ x 10½ in (33.7 x
26.7 cm).

5.1 (above) A 10-point value scale.

Every object we see is made visible because of the way it interacts with light. A smooth, white form reflects most of the light falling on its surface while matt black objects absorb a great deal of the light that reaches them. The range of light and dark tones that exists between the whitest white and the blackest black is referred to as the *value* scale (Fig. **5.1**). These tones are not to be confused with the object's color or *hue*. A red and a blue vase for instance, could easily have the same value, that is, possess the same lightness or darkness of tone. If we took a black-and-white photograph of these two colored vases, they would look identical in the monochrome print. Black-and-white film registers only the amount of light reflected off an object, not the color of the light.

Since the majority of drawings are made with varying tonal marks on a white surface, it is important to train yourself to distinguish value relationships from color. This is not terribly difficult to do, and with experience you should be able to control the range of light and dark values found in your drawings.

VALUE RELATIONSHIPS

Light falling on a form can produce up to six distinct tonal categories: highlight, light, shadow, core of shadow, reflected light, and cast shadow. The illustration in Figure **5.2** reveals the position and structure of these tonal areas as they appear on a white ball that is illuminated by a strong unidirectional source of light. Because the spherical form has no right angles to create sharp shadows, tones gradually fade from light to dark and vice-versa. Even though the light source is not visible in Figure **5.2**, we can tell by the direction of shadows that it is located to our left and parallel to the surface the ball rests on. If the light were positioned higher, the shadow cast by the ball would be shorter in length. This analysis is called "light-logic" and can be used to work out the value relationships in drawings done from your imagination.

5.2 Tonal categories.

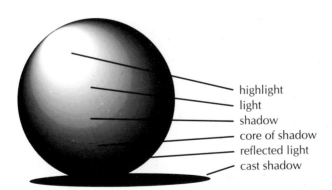

- highlight
- light
- shadow
- core of shadow
- reflected light
- cast shadow

PROJECT 24

Exploring Value Relationships

MATERIALS: Medium-weight bond paper, soft graphite pencils or vine charcoal.

In this drawing project we will create a special still-life and use it to explore ways in which we can express the full range of values in our drawings. Place two or three large sheets of white paper on a table top near a window with natural light or an indirect source of artificial light. The idea is to have a strong but diffused source of illumination lighting still-life subjects. On this surface place three or four eggs. In order to see how they respond to changing directions of light, slowly turn the piece of paper they rest on. Notice how the shadows and highlights assume different positions as the three-dimensional forms move in relation to the light's direction.

Arrange the eggs in a grouping that you find interesting. Before you begin to concentrate on the value scale of the drawing, establish the general compositional structure with light marks or lines. Remember to make effective use of the entire paper and avoid small drawings that end up in the center.

Once the drawing is blocked in, carefully observe where the highlights are located. Since the paper is white, its unmarked surface will represent these highlights. Where are the deepest shadows? This is where the darkest tones you can register with your graphite or charcoal will be. The two poles of the value spectrum have been charted, but many intermediate gradations need to be established. Using a series of light, overlapping hatch marks, follow the curvature of the eggs and begin to build gradations of value that correspond to the lighting effects seen in the still-life in front of you. Gradually build up the dark tones, stepping back from time to time to evaluate what you have established. It is easy to make an area darker later if necessary. Keep observing how the light responds to the three-dimensional surface of the eggs.

Martha Alf's (b. 1930) drawing, *Tomato #1* (Fig. **5.3**), explores the way light interacts with the rounded, organic form of the vegetable as it sits on a table. Lynn Ross's student drawing shown in Figure **5.4** also makes effective use of value relationships to define various three-dimensional objects in space.

5.3 (left) Martha Alf, *Tomato #1*, 1978–9. Graphite on paper, 12 × 18 in (30.5 × 45.7 cm). Collection, O'Melveny and Myers, Los Angeles. Courtesy, Newspace, Los Angeles.

5.4 (right) Student Drawing. Lynn Ross, Sonoma State University. Charcoal, 18 × 24 in (45.7 × 60.9 cm).

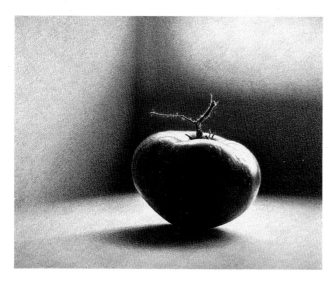

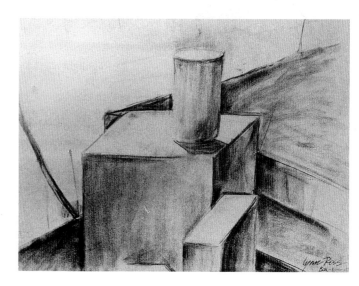

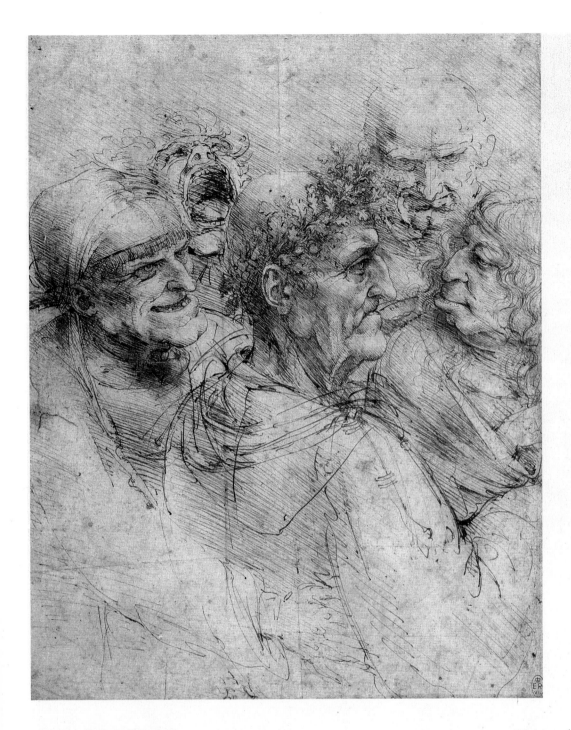

CHIAROSCURO

In their quest to accurately describe the position of forms in space, Renaissance artists perfected a methodical use of tonal values in drawing that corresponds to the way light and shadow define our perception of three-dimensional forms. This is known as *chiaroscuro*. Chiaroscuro is an Italian term that refers to the opposition of dark and light tones in drawing to create the illusion of space: "chiaro" means light, "oscuro" means dark.

Leonardo da Vinci's *Five Grotesque Heads* (Fig. **5.5**) is a clear example of chiaroscuro drawing effects. While the figures' garments are defined through linear means, their heads and features are expressed by well-defined highlights, middle tones, and deep shadows.

111

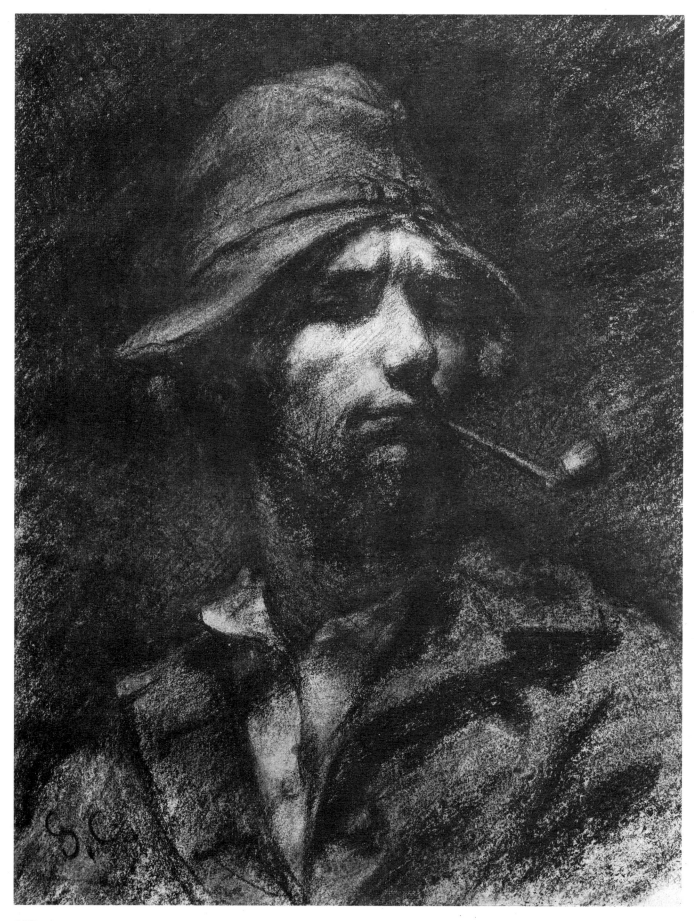

Courbet's authoritative use of black chalk produces striking chiaroscuro in his *Self-Portrait with a Pipe* (Fig. **5.6**). Out of a dark and mysterious background the head and features of the artist emerge. Courbet reserves the use of the lightest tone, or highlights, for his features, thus focusing our attention on this important aspect of the self-portrait.

Similarly, Allison Hinsons's student drawing (Fig. **5.7**) uses chiaroscuro's juxtapositions of light and dark. Recording the effects of a strong light source coming at an oblique angle from below, she achieves dramatic interplays of light and dark values.

5.6 (opposite) Gustave Courbet, *Self-Portrait with a Pipe*, c. 1849. Black chalk on paper, 11½ × 8¾ in (29.2 × 22.2 cm). Collection, Wadsworth Atheneum. Gift of James Junius Goodwin.

5.7 Student Drawing. Allison Hinsons, Bucks County Community College, PA. Charcoal, 20 × 13 in (50.8 × 33 cm).

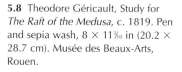

PROJECT 25

Exploring Chiaroscuro

MATERIALS: Medium-weight bond paper, soft graphite pencils, vine charcoal, or conté crayon

Create a table-top still-life that lends itself to exploring chiaroscuro: arrange five to seven kitchen implements on a white table top – eggbeaters, spatulas, ladles, etc. Lighting will play an important role in this assignment; make sure there are sharply undercut areas that create deep shadows. Use a strong unidirectional source such as a clamp-on aluminium reflector and 100 watt bulb and make sure the light rakes across the still-life at an oblique angle, thus creating clear highlights and a variety of dark values from medium to dark. Remember it is the opposition of light and dark values that creates the effect of chiaroscuro and make sure the white of the unmarked paper is functioning effectively to represent your highlights.

HIGH-CONTRAST VALUES

Brush and ink are a particularly effective combination for working with high-contrast values in drawing. No other instruments can achieve such intense blacks and easily flowing variably thick lines and shapes. There is also something appealing about the ease with which the liquid ink flows on the paper, creating vivid contrasts between the black shapes and the white spaces of the paper.

The study for *The Raft of the Medusa* (Fig. **5.8**) by Theodore Géricault (1791–1824) makes dramatic use of brush and ink to achieve a dynamic composition. Géricault's bold interplay of black-and-white shapes evokes the jubilant emotions the shipwrecked sailors on the raft must have felt when they first spotted their rescue vessel on the horizon. Thin lines in the foreground and in the makeshift mast contrast with the writhing black shapes created by brush and ink.

Working with brush and ink, however, requires some confidence, or at least a willingness to accept what you have done. Once the ink touches the paper and is absorbed, no erasure of the mark can be made short of cutting a section out of the

5.8 Theodore Géricault, Study for *The Raft of the Medusa*, c. 1819. Pen and sepia wash, 8 × 11⅗₀ in (20.2 × 28.7 cm). Musée des Beaux-Arts, Rouen.

drawing. The key to controlled, easy application of ink is the brush itself. One of the best all-purpose instruments to work with is a number 8 or 10 round, sable-hair brush that naturally shapes itself to a fine point when wet – at least the better ones do. Because of the rarity of fine quality red sable, and the skilled labor needed to properly form this tool, a good brush sells for what seems to be an exorbitant price. It is well worth the cost to serious students of drawing for nothing else will do exactly what this fine instrument can accomplish. For one thing, a number 8 or 10 sable-hair brush will do the work of many smaller brushes made out of cheaper materials. And it retains its shape much better than other natural hairs. It should last for many years.

For visual impact and graphic expression, artists frequently make use of heightened contrast and strong tonal juxtapositions, often setting the blackest shapes against the pure white negative shapes of the paper. Claude Gelée (1600–82), known as Lorraine, created this dramatic ink and wash drawing of a landscape bathed in brilliant sunlight with deep impenetrable shadows (Fig. **5.9**). Such tonal exaggeration was the beginning of a new, more subjectively expressive interpretation of nature that is a hallmark of modern drawing traditions.

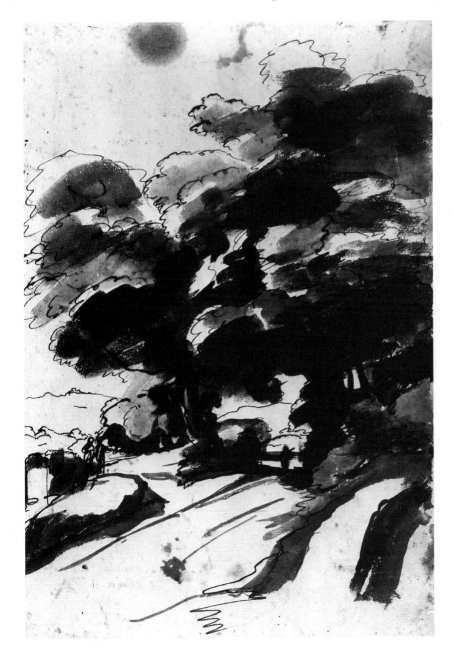

5.9 Claude Lorraine, *Road through a Wood*, 1630s? Brown wash, 12⅜ × 8½ in (31.4 × 21.6 cm). British Museum, London.

PROJECT 26

Exploring High-Contrast Value Relationships

MATERIALS: 18 by 24 inch medium- to heavy-weight bond paper, India ink, #10 round sable-hair brush.

This project will explore the expressive possibilities of drawings that make use of high-contrast value relationships. Look around your house for a group of angular objects that are small enough to be used in a still-life. If you have difficulty finding suitable forms, you may use small shoe-boxes or other cardboard containers. Lighting will also be an important factor in this drawing assignment: use a floodlight or other strong, unidirectional light source to create bright highlights and deep shadows. Study the set-up and note the negative and positive shape arrangements that could work together to define the composition. You may wish first to indicate the major shape configurations with extremely light lines from a hard pencil. However, do not overwork the preliminary blocking in of the shapes. Colored-in pencil outlines do not have the immediacy of brush and ink shapes directly perceived and drawn. Use the brush to create black shapes and thin lines that work in concert with the white paper. Vary the size of the inked areas to avoid monotony. Midway through the drawing stand back and observe the interplay of white and black shapes. What could you add to make the negative shapes of the paper play a more active role? The student drawing in Figure **5.10** illustrates a response to this type of high-contrast drawing assignment.

5.10 Student Drawing. Henry Sheving, San Francisco State University. Brush and ink, 13¼ × 10½ in (33.7 × 26.7 cm).

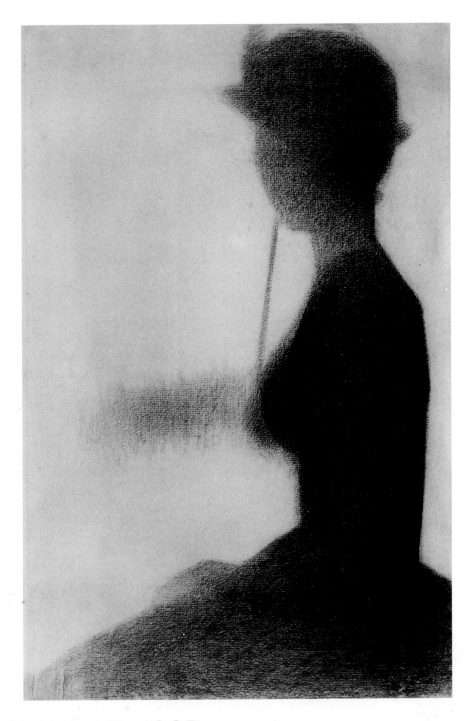

5.11 Georges Seurat, *Seated Woman with Parasol*, c. 1885. Conté crayon, 18⅞ × 12⅜ in (48 × 31.5 cm). Art Institute of Chicago.

VALUE AND MOOD

The expressive possibilities that can be achieved with the control and manipulation of value are limitless. Every drawing tool and type of paper has its own set of characteristics that can be exploited to achieve special effects. Since light plays such a profound role in the governing of our moods and perceptions, it stands to reason that value is a primary means by which artists create moods and evoke feelings.

Georges Suerat (1859–91), one of the major Post-Impressionists, made extensive use of conté crayon and textured paper to create haunting, atmospheric drawings that seem to freeze figures in a timeless monumentality (Fig. **5.11**). Instead of using lines, Suerat worked with the natural texture of his paper to create visual effects that are now referred to as "pointillist" (this term refers to the small dot structure of the

5.12 Enrique Chagoya, *When Paradise Arrived*, 1989. Charcoal and pastel on paper, 80 × 80 in (203.2 × 203.2 cm). René Veronica di Rosa Foundation. Courtesy, Gallery Paule Anglim, San Francisco.

drawing). Where he pressed heavily on the paper, his conté crayon filled in the high and low textures of the paper. Where he pressed lightly, only the high points of the paper were marked, leaving the depressions untouched. The isolated, somewhat flattened figure is bathed in an ethereal light that erodes the edges of the form and seems to be in the process of dissolving it.

Enrique Chagoya (b. 1953), a Mexican–American artist, uses tonal effects to evoke a mood that is quite different from Suerat's drawing. The stark contrasts between the dark and light tones in this drawing (Fig. **5.12**) serve as a means of conveying the artist's political sentiments: a large, dark, and menacing hand is about to flick away a small bare-foot girl. Chagoya's commentary on what he believes to be the colonialist

5.13 Jean-François Millet, *Twilight*, late 19th century. Black conté crayon and pastel on paper, 19⅞ × 15⅜ in (50.5 × 38.9 cm). Museum of Fine Arts, Boston. Gift of Quincy Adams Shaw.

relationship between the U.S.A. and Mexico is clearly expressed through this drawing. The size differences and tonal contrasts of the images in this charcoal drawing go a long way toward expressing the aggressive power of the U.S.A. and the helplessness of Mexico.

The crayon and pastel drawing of shepherds tending their flock at twilight (Fig. **5.13**) by Jean-François Millet (1814–75), reveals a masterful handling of close-valued tones and shapes. Millet, who grew up in rural surroundings, suggests the timeless nature of preindustrial farm life in this evocative and moody rendering of the day's end.

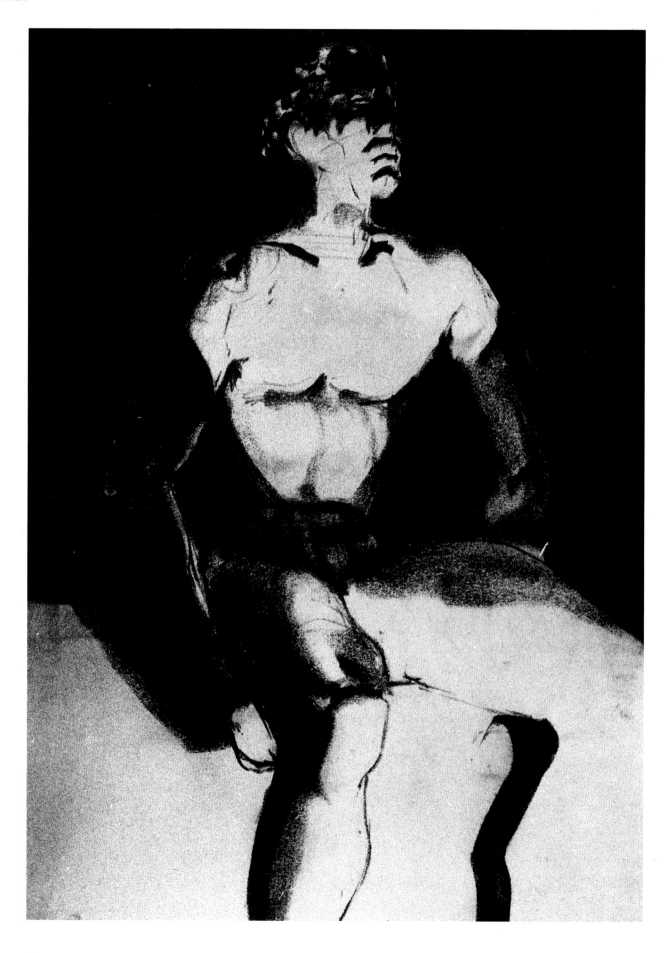

PROJECT 27

Using Value to Convey Moods

MATERIALS: Medium-weight bond paper (use a format size you are comfortable with), conté crayon, graphite, or other pressure-sensitive drawing instruments.

The object of this drawing exercise is to explore the way light affects our psychological perceptions. Since reflected light and lighting are important aspects of value, we will create special conditions for drawing which enhance our sensitivity to this important element.

This assignment must be done after dark or in a room that can be effectively blacked out during daylight hours. Extinguish all other lights except for a small lamp placed on a table or dresser top. Focus your drawing efforts toward rendering the way light spills downward underneath the open shade. If necessary you may wish to wrap some black paper around the shade to cut down on light transmission and thus emphasize the contrast between light and dark areas. The concept behind this series is to create a mood with value relationships through the manipulation of black-and-white tonalities.

Take note of the various ways in which light falls in your home, your neighborhood, or your school. When you come across a particular effect that interests you, explore its possibilities through drawings that emphasize value relationships. You may also wish to create special lighting effects with artificial lights and objects that have a special meaning for you. This is an opportunity to work with visual and conceptual interests that are uniquely your own. Remember, we are interested in focusing the ability of drawing to create moods and express visual concerns. The drawings of T.C. Stevenson (Fig. **5.14**) and Barbara Hale (Fig. **5.15**), both students, reveal some of the expressive visual effects possible through control and manipulation of value.

5.14 (opposite) Student Drawing. T. C. Stevenson, Sonoma State University. Charcoal, 24 × 18 in (60.9 × 45.7 cm).

5.15 Student Drawing. Barbara Hale, San José State University. Charcoal, 40 × 26 in (101.6 × 66 cm).

5.16 Wayne Thiebaud, *Nude in Chrome Chair*, 1976. Charcoal on paper, 30⅛ × 22⅜ in (76.5 × 57.8 cm). Private Collection.

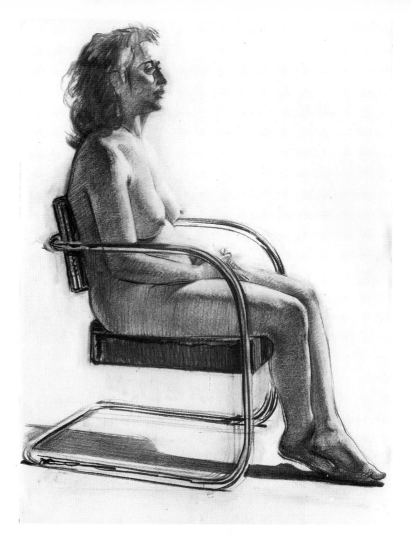

VALUE AND SPACE

Value relationships also play an important role in the way drawings define form and space. Wayne Thiebaud's (b. 1920) drawing, *Nude in Chrome Chair* (Fig. **5.16**), establishes with clarity the position of the sitting figure. Through the careful control of value the artist enables us to read the spatial position of the woman's body in relation to the forms of the chair. Thiebaud continually juxtaposes light tones against dark tones to establish the position of forms. For instance, notice the way the three-dimensional form of the top of the leg closest to us is established by placing a light tone next to a darker one.

The Indian drawing of c. 1630 in Figure **5.17** also uses value relationships to define space, but these forms exist in a relatively shallow space. The form of the elephant is accurately described but its silhouetted pose and delicate value gradations emphasize iconographic rather than a literal representation of this magnificent beast.

PROJECT 28

Exploring Space with Value

MATERIALS: Medium-weight bond paper, drawing medium of your choice.

Create a still-life composed of geometric and curvilinear forms. Lighting is important in this project because we will rely on the way light interacts with three-dimensional objects to define space. Arrange a group of objects, some in front of others. Notice the way the juxtaposition of light and dark areas enables

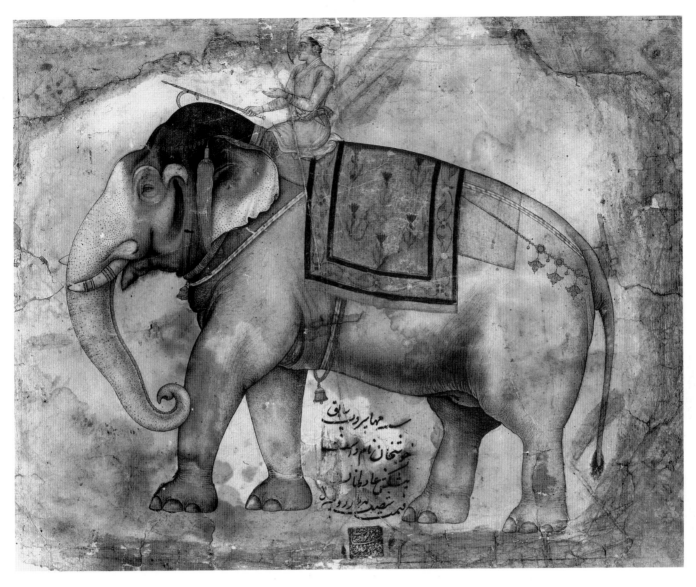

us to see the objects as three-dimensional forms. Remember to reserve open areas of the paper that correspond to the highlights in your still-life. Take your time. This type of drawing demands slow and patient work and depends on the opposition of dark and light values to work. The student response seen in Figure **5.18** is a well-thought-out composition that makes use of carefully adjusted tonal relationships. If you want to try this ink drawing technique you might make use of a fine-line fiber-tipped marking pen available at art supply and stationery stores.

5.17 *Prince dara Shikok on the Imperial Elephant, named Mahabir Deb*, c. 1630. Brush drawing in India ink tinted with gold and watercolors, 13 × 16½ in (33 × 41.9 cm). Victoria and Albert Museum, London.

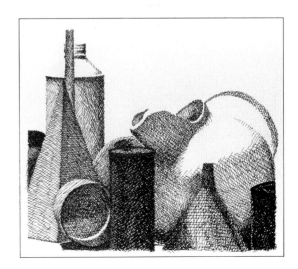

5.18 Student Drawing. Anon., San Francisco State University. Pen and ink, 7 × 8 in (17.8 × 20.3 cm).

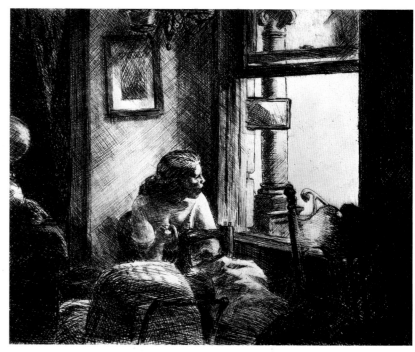

5.19 (left) Odilon Redon, *The Day*, Plate VI from *Dreams*, 1891. Lithograph printed in black, 8¼ × 6⅛ in (21 × 15.5 cm). The Museum of Modern Art, New York. Collection of Lillie P. Bliss.

5.20 (right) Edward Hopper, *East Side Interior*, 1922. Etching, 7⅞ × 9⅞ in (20 × 25 cm). Collection, The Museum of Modern Art, New York. Gift of Abby Aldrich Rockefeller.

INTERIOR AND EXTERIOR LIGHT

The quality of light that illuminates a subject plays an important role in the way we perceive forms. Strong, direct light, the kind we might experience out of doors on a sunny day, creates strong contrasts between highlights and shadows. Indoor lighting on the whole is softer and more diffused because artificial light sources are rarely as strong as sunlight; and light tends to bounce off walls and ceilings before it reaches us. But these conditions are changeable. Sometimes on cloudy days daylight can be quite soft and indirect or, conversely, indoor lighting can be sharp and contrastable if you are working with high-wattage illumination. Since light is such an important ingredient of the visual arts, take note of the quality of lighting as you move from interior to exterior spaces.

Especially since the Renaissance, certain artists have been fascinated with representing both interior and exterior space in the same drawing. Because of the difference in light between these two spaces, value contrasts were often emphasized to create the desired effect. Redon's lithograph *The Day* (Fig. **5.19**) creates the illusion that we are standing in a darkened room near a window that faces a tree. The juxtaposition of the dark enveloping interior and the brilliant expanse of the outdoors is striking. Three precise criss-crossing lines economically suggest window panes and reinforce the illusion of a portal leading to the outside world. A faint section of the floor and strange floating globular shapes are the only details visible in the interior space and relieve what would otherwise be a solid black field. This limiting of visual information in the interior serves to lead our eyes through the window and spotlights the outside tree.

PROJECT 29

Exploring Interior and Exterior Light

MATERIALS: Bond paper or medium-textured charcoal paper, conté crayon or drawing medium of your choice.

This drawing project will explore the value contrasts of interior and exterior light. Find a corner in your home or in another building where light from a window creates interesting visual effects. You may wish, so to speak, to lead us through the window – as in the Redon lithograph (Fig. **5.19**) – and focus on the outdoor scene. Another alternative is to emphasize the quality of interior light that occurs around windows. Hopper's *East Side Interior* (Fig. **5.20**) relies on the dramatic value contrasts that occur when dimly lit interiors are flooded by exterior light. Whatever theme or subject matter you choose, remember that the object of this exercise is to explore the way value contributes to the effectiveness of your drawings. Claudia Hottman's student drawing in Figure **5.21** clearly responds to the light falling on her model with rich visual juxtapositions of black-and-white shapes.

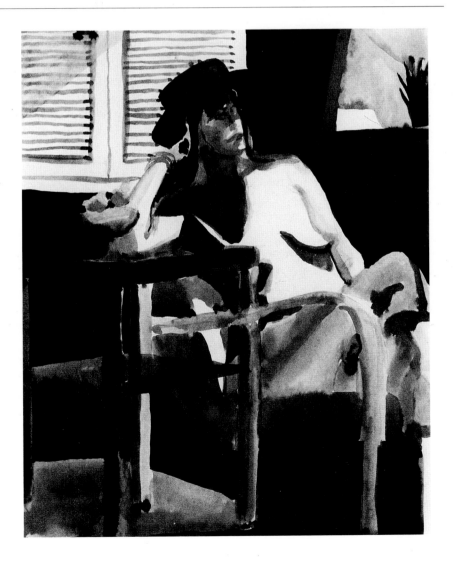

5.21 Student Drawing. Claudia Hottman, San Francisco State University. Brush and ink, 17 × 14 in (43.2 × 35.5 cm).

5.22 Robert Cumming, *Berlin Brazil*, 1987. Lithograph on black paper with silk screen, 48 × 37½ in (121.9 × 95.3 cm). Courtesy, the artist.

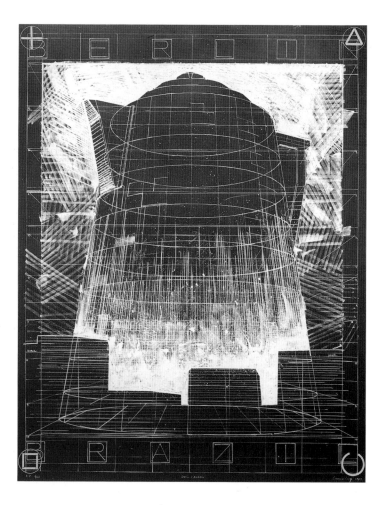

VALUE REVERSAL

The great majority of drawings are done using black marks on white paper. This convention has become so accepted that most of us would not readily consider doing a drawing using white marks on a dark surface. But this technique of value reversal comprises yet another way in which value can affect moods and special themes.

Robert Cumming's (b. 1943) witty *Berlin Brazil* (Fig. **5.22**), a lithograph of 1987, takes on a certain visual power and majesty largely through its use of white lines on a black ground. Certainly, this would be an attractive print done in the conventional mode of black marks on a white surface, but reversing the values creates a special air of mystery and strength.

In *Two Maps II* (Fig. **5.23**) Jasper Johns (b. 1930) makes use of value reversal to achieve a distinctive, ghostlike quality. The white-lined state borders of the maps force us to question commonplace cartographical images of the United States.

Paula Modersohn-Becker (1876–1907) was an important precursor of the German Expressionist style. The dramatic juxtaposition of values in her *Portrait of a Peasant Woman* (Fig. **5.24**) suggests the harshness of life and the inherent strength of this rural woman. Out of a somber black rectangle her features subtly emerge. They are read as light marks set against a black background. The overall effect is that of someone emerging from darkness toward light.

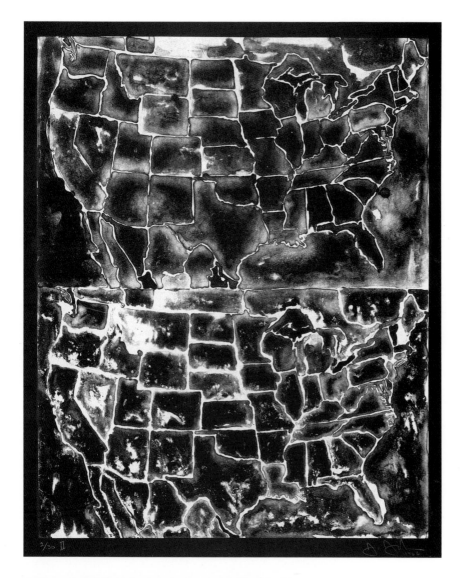

5.23 Jasper Johns, *Two Maps II*, 1966. Lithograph, 33 × 26½ in (83.8 × 67.3 cm). Collection, The Metropolitan Museum of Art, New York. Gift of the Florence and Joseph I. Singer Collection. #68.749.

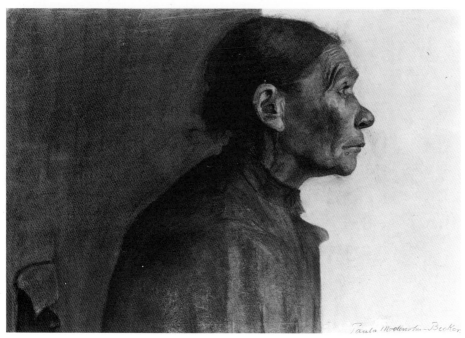

5.24 Paula Modersohn-Becker, *Portrait of a Peasant Woman*, 1900. Charcoal on buff wove paper, 17 × 25 in (43.3 × 63.9 cm). The Art Institute of Chicago. Gift of the Donnelly Family.

PROJECT 30

Exploring Value Reversal

MATERIALS: Black charcoal paper or any other dark-toned drawing paper, white pastel or white chalk pencil.

Create a still-life that offers well-defined and distinct highlights and shadow areas. Your aluminum reflector and floodlight will come in handy for this assignment. Either arrange a few sheets of crumpled paper on a table top or make use of some drapery material placed over a vase or a table lamp.

In order to more fully explore value we will reverse the normal value relationship of black marks on a white sheet of paper. Using the black drawing paper and the white pastel pencil, make a drawing of the still-life as if you were using a graphite pencil on white paper. Shadows will be represented with white marks, the darker the shadow area the whiter the marks. The resulting drawing should look something like a photographic negative in which light values are reversed.

VALUE AND PATTERN

Vija Celmins's (b. 1939) drawing *Long Ocean 3* (Fig. **5.25**) makes use of contrasting value patterns to create the illusion we are viewing a section of the sea. The term *pattern* in this context refers to the repetitive shapes that range in tone from white to black. Although Celmins presents us with a seemingly repetitive field, the variety of shapes and the interplay of forms are quite hypnotic and compelling. Within this rectangular composition, complex visual rhythms are created and organized into patterns. Note how some sections of the drawing feature black shapes on a white ground (at the top left) and other sections (the bottom right, for example) show light-toned wave crests on a black background.

5.25 Vija Celmins, *Long Ocean 3*, 1979. Pencil. Courtesy, David McKee Gallery.

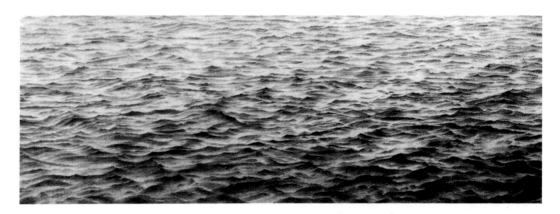

PROJECT 31

Exploring Pattern with Value

MATERIALS: Bond paper, drawing medium of your choice.

Search for patterns created by the interaction of light on three-dimensional surfaces that you could use as visual sources for a drawing. For example, you might do a drawing of the way sunlight filtering through blinds affects your perceptions of forms, or the greatly magnified texture of a stucco wall. This assignment should also make you more visually aware of your environment and help you to discover ways in which visual phenomena can be used as subject matter in your drawings.

EXPRESSIVE USE OF VALUE

As we have seen throughout this chapter, value relationships play a variety of roles in the art of drawing, from describing three-dimensional forms to expressing moods and feelings. By controlling the illusion of light, you can use value to express a host of complex ideas and sensibilities. As a very broad generalization, it might be true to say that predominantly dark drawings suggest mystery, foreboding, and power, while light-toned drawings evoke lyricism and sensitivity. The specific effects of each drawing of course depend on many factors. The range of expressive possibilities offered by the use of value in drawing is unlimited.

Much of the dramatic power of *Dempsey Through the Ropes* (Fig. **5.26**), a drawing by George W. Bellows (1882–1925), is derived from the strong interplay of

5.26 George Wesley Bellows, *Dempsey Through the Ropes*, 1923. Black crayon, 21½ × 19⅜ in (54.6 × 50 cm). The Metropolitan Museum of Art, New York. Rogers Fund. #25.107.1.

5.27 Julian Schnabel, *Dream*, 1983. Sugar-lift etching, 54 × 72 in (137.2 × 182.9 cm). Published by Parasol Press Ltd., New York.

5.28 René Magritte, *The Thought Which Sees*, 1965. Graphite, 15¾ × 11⅝ in (40 × 29.5 cm). Collection, The Museum of Modern Art, New York. Gift of Mr. and Mrs. Charles B. Benenson.

black values against white. Bellows belonged to a group of painters known as the Ashcan school (also known as the New York Realists); these artists produced not only scenes of everyday activities in urban centers, but scenes of overcrowded slums and ghettos. This scene of a prize fight, however, focuses on a spectacle that had become popular during the 1920s. It captures, like a high-speed camera image, the exact moment when one opponent knocks his adversary through the ropes into the audience. The intensely black ground with the fighters and some members of the audience spotlighted in white creates a mood that expresses the excitement and action of this sporting event.

The American Julian Schnabel (b. 1951), who is associated with new forms of Expressionism, uses thick, black lines and sharply defined white areas in *Dream* (Fig. **5.27**) to suggest a variety of religious themes: crosses, Christ being crucified, a Jewish star. Closely spaced, vigorous brushstrokes all suggest a highly charged (and ambiguous) emotional state.

The Belgian, René Magritte (1898–1967), used value to explore the mysteries of light and the natural cycles òf day and night in his drawing *The Thought Which Sees* (Fig. **5.28**). Two silhouetted outlines of a man in a bowler hat dominate this composition. One is dark and represents night while the light section represents day. Different scenes are represented within these cut-outs. "Night" features a crescent moon and house with lighted windows, while "day" allows us an ocean view with breaking surf and a cloud-dappled sky. Through the symbolic and perceptual use of value Magritte creates a dreamlike impression of night and day.

PROJECT 32

Exploring Expressive Use of Value

MATERIALS: Bond drawing paper or toned charcoal paper, drawing media of your choice.

Using Magritte's drawing *The Thought Which Sees* (Fig. **5.28**) as an inspirational model, create a drawing that confounds normal visual perceptions of night and day, light and dark. Draw some elements of a landscape or cityscape as if they were seen at night while others simultaneously exist in broad daylight.

Make another drawing that emphasizes the distinct shadows cast by objects when the sun is shining brightly. Take particular notice of the effects of light as you go about your everyday activities. Try reversing or heightening the value relationships that you are able to observe. Be aware of how the mood of the drawing shifts and is determined by the way you manipulate and control the dark and light areas of your drawing. For instance, the student drawings in Figures **5.29** and **5.30** rely heavily on effective value relationships to create aesthetic moods and to communicate many of their visual concerns.

Like line, value is one of the most basic visual elements in the repertoire of drawing. Learning to control and manipulate this element is crucial to the expressiveness of your drawings. Much depends on the mood and visual presence created by the drawing's juxtapositions of light and dark, and the overall tonal harmony of the work. A sound understanding of this important element will enable you to more fully articulate visual ideas.

5.29 (left) Student Drawing. Jeff Richards, San Francisco State University. Ink and charcoal, 14 × 17 in (35.6 × 43.2 cm).

5.30 (right) Student Drawing. Candace Maas, San Francisco State University. Charcoal, 15 × 14 in (38.1 × 35.6 cm).

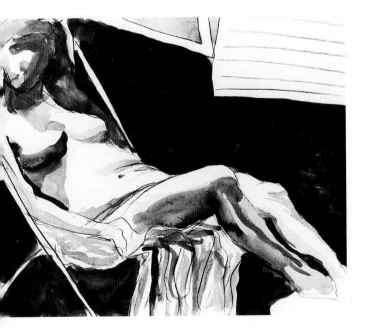

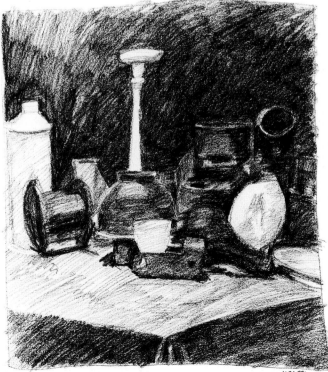

131

6 **TEXTURE**

The visual richness of the world is a result of many complex and interdependent factors: not only do we perceive colors, forms, space, and light and dark values, but tactile qualities (qualities associated with touch) as well. Often we can tell whether a surface is soft, hard, smooth, or rough just by looking at it. *Texture* plays an important role in the visual arts because tactile qualities are associated with many feelings and perceptions. You may be attracted to a certain tweed jacket because of the rich texture of its handwoven fabric; the mirror-smooth surface of a pond at dusk evokes feelings of tranquility and calm, while the rough surface of a wind-swept ocean conveys forcefulness and strength. Learning to control and use texture in our drawings enables us to more fully express our ideas and visual concerns.

DEFINING TEXTURE

Within the context of drawing there are two types of texture: "actual" and "visual." Actual texture refers to the three-dimensional surfaces of forms we might draw, such as the rough bark of a tree, or to the tactile qualities of our drawing materials, for instance soft charcoal and rough-surfaced paper. Actual textures such as these are tangible, i.e. they can be felt physically. By contrast, visual textures are illusions of roughness or smoothness created by artists through the way they manipulate their material and the visual elements. In Giambattista Piranesi's (1720–78) *Woman Carrying a Baby* (Fig. **6.1**), for example, the sharp contrasts of black ink and white paper and the vigorous linear hatch marks energize the drawing with complex visual textures, which contribute greatly to the impression of liveliness. (Piranesi is discussed further in Chapter 8, "Perspective.") Used with skill, texture can enhance the visual and thematic expressiveness of a drawing.

ACTUAL TEXTURE

One way to experience actual texture is to make a series of drawing studies by placing your paper on top of textured surfaces, such as tree bark or rough concrete, and rubbing a piece of graphite across the surface of the paper. The three-dimensional texture beneath the paper will be recorded by the graphite. This process is called *rubbing* or *frottage*. Robert Indiana (b. 1928) used this technique in *The Great American Dream: New York* (Fig. **6.2**). Rather than relying on found texture, Indiana created a shallow relief template out of cardboard letters and forms, which he glued onto a heavier board. This artist is inspired by the vast array of signs and billboards that are now so much a part of the American landscape – and consumer-oriented society. Once Indiana completed his relief construction, he positioned his drawing paper on top of the shallow letter forms and with colored crayon made a series of diagonal hatch lines that recorded the three-dimensional surfaces beneath the paper.

Another way to make use of actual texture in drawing is to draw on material other than paper. As noted in the Introduction (see Fig. **0.5**), Whitfield Lovell makes use of naturally weathered wood surfaces to create charcoal portraits of African–Americans his wishes to commemorate (Fig. **6.3**). *Brethren* is a compelling and dignified drawing portrait visually and thematically enhanced by peeling paint and actual objects collaged on to the wood surface.

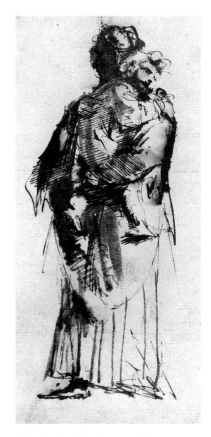

6.1 Giambattista Piranesi, *Woman Carrying a Baby*, c. 1743. Pen and brush with ink, 6⅘ × 3⁹⁄₁₀ in (17.4 × 10 cm). Ashmolean Museum, Oxford.

6.2 (opposite) Robert Indiana, *The Great American Dream: New York*, 1966. Colored crayon and frottage on paper, 39½ × 26 in (100.3 × 66 cm). Collection, Whitney Museum of American Art, New York. Gift of Norman Dubrow.

6.3 Whitfield Lovell, *Brethren*, 2000. Charcoal and collage on wood, knife, 26 × 24½ in (66 × 62.2 cm). Private Collection. Courtesy, D.C. Moore Gallery, New York.

TEXTUAL INTERACTION OF DRAWING MATERIALS

When various drawing media and special papers interact they produce different textural effects. Now would be a good time to systematically explore these textural interactions and catalog them in your mind for future use.

PROJECT 33

Experiencing Textures

MATERIALS: Obtain the greatest variety of drawing media and papers.

Spend an hour or so in a specialist art supply store browsing among the drawing materials and looking at the selection of fine papers sold by the sheet. Within your budgetary limits, buy a generous selection of chalks, crayons, pencils, pen nibs, etc. that you do not already own. Select a range of papers from the roughest watercolor paper to the smoothest hot-press illustration. Cut the paper into 5 by 7 inch sections and see how different drawing tools respond to various surfaces. Look around your house for unconventional materials that could be used to make distinctive marks: small pieces of sponge or twigs dipped in ink, or pieces of natural charcoal from your fireplace. One drawing instructor of mine delighted in telling his students how he had spontaneously made a very successful drawing using a common beverage straw dipped in ink.

The texture of drawing media is important to an artist's visual expression. It would be impossible to imagine Seurat's dramatic conté crayon drawing (Fig. **6.4**) of this urban scene in winter rendered with light pencil lines on a smooth illustration board. So much of the thematic content to this drawing appears to be bound to the

6.4 Georges Seurat, *Place de la Concorde, Winter*, 1882–3. Conté crayon, 9⅛ × 12 in (23.2 × 30.7 cm). Solomon R. Guggenheim Museum, New York. Gift of Solomon R. Guggenheim. Photograph: David Heald.

PROJECT 34

Rough-Textured Media

MATERIALS: Handmade paper or rough watercolor paper, chalk, charcoal, or crayons.

This project will enable you to experience the expressive possibilities of textural drawing media. Choose a subject that would benefit from the textural effects generated by the special materials used in this assignment: tree bark, shrubbery, and landscapes with groves of trees would make good subjects but don't feel limited by these choices alone. Try and use the textures created by your drawing tool and the rough paper surface to express the visual aspects of your subject.

roughly scrawled crayon marks as they interact with the hills and valleys of the handmade paper. Almost all of Seurat's mature drawings rely on this textual interplay between the soft black crayon and the roughness of his special paper.

The finely gradated drawing (Fig. **6.5**) by John Newman (b. 1952) represents an unusual realm of the texture spectrum. Created mainly with pastel and graphite on a smooth-surfaced paper, this drawing appears to explore the molecular and atomic realties that lurk beneath the visible surface of the world. The smooth textures of smudged pastel on a smooth-surfaced paper offer the control needed to express mathematically ordered space.

6.5 John Newman, *Untitled*, 1990. Chalk, pastel, china marker, and pencil on paper, 54 × 43 in (137 × 109.2 cm). Courtesy, Nolan/Eckman Gallery, New York.

PROJECT 35

Smooth-Textured Media

MATERIALS: Moderately hard graphite drawing pencils such as a 1H (see Chapter 2); a smooth-surfaced rag paper such as cold- or hot-press illustration board.

This project will explore the expressive possibilities of smooth papers and relatively hard graphite drawing instruments. In view of these concerns, select still-life objects that have smooth and perhaps reflective surfaces. A solid color silk scarf draped over a small cardboard box and softly illuminated would make a good subject for this assignment. The general effects you should strive for in this drawing are gentle tonal gradations and subtle contrasts. Toward that end, merge and blend the pencil marks on the smooth surface into passages that do not call attention to individual lines.

Another drawing process that makes use of actual textures is *collage*. This term refers to the technique of attaching materials, such as fabric and paper, to the surface of the drawing.

The African–American artist Romare Bearden (1911–88), whose work is discussed in more detail, in Chapter 12, produced many visually lush and textural collages. His *Patchwork Quilt* (Fig. **6.6**), which pieces together sections of fabric much as an actual quilt might, features an image of a sleeping woman on top of the multi-colored textile patterns.

6.6 Romare Bearden, *Patchwork Quilt*, 1970. Collage, 35¾ × 47⅞ in (90.8 × 121.6 cm). Collection, The Museum of Modern Art, New York. Blanchette Rockefeller Fund.

VISUAL TEXTURE

Unlike the actual three-dimensional surfaces and materials we have just explored, visual textures achieve their effects through the illusion or simulation of roughness or smoothness. Most artists make use of visual textures to reinforce thematic concepts and to communicate important visual concerns. In order to further define what we mean by visual texture and to illustrate its range of expressive possibilities, we will compare two portrait drawings, one roughly, almost violently textured, and the other mysteriously smooth and elusive in feeling.

In the 1940s Jean Dubuffet (1901–85) became fascinated with drawings by mental patients, prisoners, children, and rural folk-artists. Impressed with the visual and psychological power of these works, which he found lacking in most professional art, Dubuffet adapted many of the stylistic features found in these so called "primitive" artforms to his own work. His *Portrait of Henri Michaux* (Fig. **6.7**) is striking in its directness and sharply inscribed visual textures – in fact it appears to be carved rather than drawn. This effect is achieved through the use of a "scratchboard" drawing technique, which involves coating a special paper with India ink and later scraping the dry ink away with sharp instruments. This technique produces an

6.8 John Graham, *Study after Celia*, 1944–5. Pencil on tracing paper, 23 × 18⅞ in (58.4 × 47.9 cm). Collection, The Museum of Modern Art, New York. Collection of Joan and Lester Avnet.

extremely fine and well-defined line. Dubuffet's drawing technique is ideally matched to his thematic interests with the dynamic visual textures of the scratched lines reinforcing his interest in powerful psychological effects.

By contrast, the visual textures in John Graham's *Study after Celia* (Fig. **6.8**) are smooth and seamless. Graham (1881–1961), born Ivan Gratianovich Dombrovski, managed to escape from Russia to Poland and eventually made his way to New York City in 1920. The withdrawn, mystical quality of *Study after Celia* is quite different from the brutal forcefulness of Dubuffet's portrait, yet is no less psychologically probing. Few individual drawing marks are discernible. Carefully blended pencil lines create massed tones that fade from light to dark. The model's bulging eyes and her penetrating gaze suggest an inner turmoil held in check only by great effort. Graham's use of smooth visual textures works in striking contrast to the disquieting demeanour of his subject to create a drawing of high drama and tension.

PROJECT 36

Creating Soft and Sharp Textures

MATERIALS: Bond drawing paper, graphite, vine charcoal, pen and India ink, or sable-hair brush and ink.

This project will allow you to further explore the expressive drawing possibilities of visual texture. In order to experience the full spectrum of textural effects you will work from two contrasting still-lifes: a group of feathers or a fur coat, and a spiny cactus plant. It is possible to achieve a large range of textural effects with most drawing media; you will have a limitless range of expressions by combining and juxtaposing visually sharp and soft textures within the same drawing. For this project, however, we will explore the polar extremes of textual effects.

For your first drawing create a still-life with some medium-size feathers or a fur coat if you can borrow one. Both the feather and the fur are inherently soft and visually express this textural quality. The watercolor on silk in Figure **6.9** shows how special textural effects can be used toward aesthetic ends. The soft visual texture of the monkey's fur contrasts with the sharply drawn branches and leaves.

Graphite and vine charcoal are probably the best materials to use for this soft-texture project because they can easily be made to appear indistinct and diffused. Before you begin this assignment review the illustration of John Graham's blended graphite drawing in Figure **6.8**.

6.9 Hashimoto Kansetsu, *Monkeys*, 20th century. Watercolor on silk, 19 × 22 in (48.2 × 55 cm). The Metropolitan Museum of Art, New York. Exchange 1952, #52.160.4.

6.10 Ernst Ludwig Kirchner, *Self-Portrait under the Influence of Morphine*. Pencil, pen and ink, 15¼ × 20 in (38 × 50 cm). Brücke Museum, Berlin. Photo: Roman März.

For your cactus drawing, choose a drawing medium capable of producing sharp tonal contrasts. India ink would be ideal. Unlike the soft, blurred effects of the feather or fur drawing, you are now trying to achieve bold contrasts of value and vigorous linear elements. Ernst Ludwig Kirchner (1880–1938), a key figure in German Expressionism, created an extraordinary self-portrait using pencil, pen, and ink (Fig. **6.10**). Its overall effect is psychologically quite abrasive and grating. Titled *Self-Portrait under the Influence of Morphine*, it conveys a raw-nerved anguish through agitated linear movement.

After reviewing the drawings by Kirchner and Dubuffet (Fig. **6.7**), start your drawing of the cactus, remembering that style is not dependent on what you draw but on *how* you draw. You could also choose to do your soft-drawing of feathers or fur in this mode. Two qualities to keep in mind if you do this are angular shapes and strong value contrasts.

The student drawings in Figures **6.11** and **6.12** also make use of contrasting textures to create different visual and psychological effects. C. Brazil's still-life evokes a dreamy, contemplative mood with softly blended tones, while Rita Christen's abstract drawing exploits contrasts in its explosive patterns.

6.11 Student Drawing. C. Brazil, San Francisco State University. Charcoal, 22 × 23 in (55.8 × 58.4 cm).

6.12 Student Drawing. Rita M. Christen, San José State University. Charcoal, 26 × 40 in (66 × 101.6 cm).

TEXTURE AND SPACE

Visual textures can also help to define and manipulate space in a drawing. Through the juxtaposition of contrasting textures, artists can create the illusion of deep space on a two-dimensional drawing surface. Van Gogh's *The Crau from Montmajour* (Fig. **6.13**) makes use of an extraordinary range of visual textures that help to reinforce the illusion of a landscape spread out before us. The penstrokes in the *foreground* are broad and widely spaced, creating rough textures; those in the background, however, are smaller and more closely spaced.

Visual textures can also be used to create an illusion of flatness and reinforce the two-dimensionality of the *picture plane* (the designated area of the drawing surface). Moroccan Jacob El Hanani (b. 1947) created flat patterns within a subtle grid pattern in his ink drawing, *Untitled* (Fig. **6.14**). These slightly varying parallel lines create a surface that, from a distance, read as a subtle modulating gray tone.

6.13 Vincent van Gogh, *The Crau from Montmajour*, 1888. Reed and fine pen with light brown ink over black chalk, 19⅛ × 23⅞ in (49 × 61 cm). British Museum, London.

6.14 Jacob El Hanani, *Untitled*, 1999. Ink on paper, 6 × 6 in (15.2 × 15.2 cm). Nicole Klagsbrun Gallery, New York.

PROJECT 37

Creating the Illusion of Space with Texture

MATERIALS: Bond paper, drawing medium of your choice.

Working from an actual or imaginary landscape, create a unified composition that explores the spatial effects of juxtaposed textures. You may wish to reinforce the flatness of the drawing surface – as in El Hanani's drawing (Fig. **6.14**) – or create illusions of three-dimensional space using a method similar to van Gogh's (Fig. **6.13**). Before you begin this assignment refer to illustrations of landscape drawings that appear in this and other books to familiarize yourself with the traditions of this drawing genre. Try combining the use of textures in conjunction with your own developing techniques and themes. For example, you may wish to combine soft visual textures with rough ones. Do not be afraid to experiment; often the juxtaposition of seemingly disparate visual elements and thematic concepts can lead to creative insights in your personal work. Janine Kellehren's student landscape drawing (Fig. **6.15**) appropriately exploits the textures produced with brush and ink on a rough watercolor paper.

6.15 Student Drawing. Janine Kellehren, School of the Art Institute of Chicago. Brush and ink, 13 × 11 in (33 × 27.9 cm).

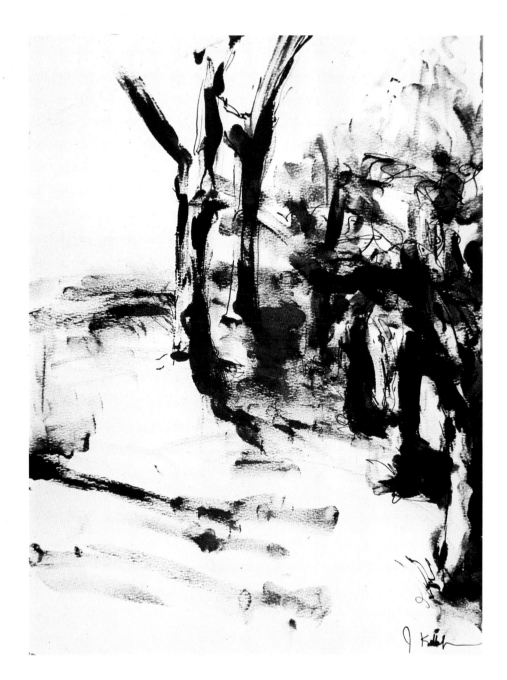

TEXTURAL HARMONIES AND RHYTHMS

As artists mature, their work usually evolves into distinctive styles that reflect their choice of themes, materials, ways of using space and visual rhythms. Frequently the work they produce becomes unmistakably their own, in large part because of the textural patterns found in their work. *Flower-Sucker* (Fig. **6.16**) by Jane Hammond (b. 1950) employs a dizzying array of media and drawing processes to achieve its effects: graphite, rubber stamps, color photocopies, transfer, and gouache. Despite the mixture of images and marks, the drawing is perceived as a harmonious structure, alive with dynamic movement yet coordinated and unified.

By contrast, Fairfield Porter's (1907–75) *Study for the Door to the Woods* (Fig. **6.17**), evokes the quiet feeling of summertime in the countryside; thin, looping lines create lyric visual textures that suggest a world far removed from the hectic pace of urban life. Porter has created a matrix of open and closed spaces in this drawing that gives us an impressionistic view of trees intermingled with shrubbery and thick vegetation.

6.16 Jane Hammond, *Flower-Sucker*, 1991. Graphite, rubber stamps, color photocopy, solvent, transfer, acrylic, and gouache on rice paper. Courtesy, the artist and Galerie LeLong, New York.

6.17 Fairfield Porter, *Study for the Door to the Woods*, c. 1972. Ink on paper, 13½ × 10¼ in (34.3 × 26.1 cm). Collection, Whitney Museum of American Art, New York. Gift of Alex Katz.

6.18 Philip Taaffe, *Line Drawing*, 1990. Pencil on paper, 28 × 40 in (71.1 × 101.6 cm). Courtesy, the artist.

Philip Taaffe, an American artist who now lives in Naples, Italy, used complex interlocking negative and positive shapes to create a vigorous graphite drawing on paper (Fig. **6.18**). Taaffe has created an overall visual field activated by textural rhythms and complex harmonics. Everything seems interconnected and we are drawn into a thicket of agitated organic shapes and rhythmic arcs.

One aspect of actual texture we have not discussed so far is the surface texture of papers artists use for their drawings. Elizabeth Murray (see Fig. **0.3**) made effective use of the natural texture of her drawing paper in *Shake* (Fig. **6.19**). By sometimes dragging the broad side of her charcoal across the drawing surface, Murray created an evocative work that effectively makes use of both visual textures and the actual texture of the paper.

6.19 Elizabeth Murray, *Shake*, 1979. Charcoal on paper, 46½ × 38 in (118.1 × 96.5 cm). Whitney Museum of American Art, New York. Purchase with funds from Joel and Anne Ehrenkranz.

PROJECT 38

Integrating a Variety of Textures

MATERIALS: Bond paper, drawing medium of your choice.

Working from a still-life incorporating a wide variety of materials, do a series of drawings that integrates and synthesizes textural concerns. Spend some time beforehand collecting appropriate materials. Strong visual contrasts will create interesting visual possibilities, for instance, items like barbed wire, a section of silk cloth, steel-wool, a handful of nails, cotton balls, dirt, straw, plastics, and dried leaves would make a marvelous mixture of textures and surfaces. Do not haphazardly throw these materials together but create a composition. That is, select and choose only those items that create interesting juxtapositions in terms of the amount of texture and its placement.

Before you begin to draw, take the time to review the illustrations and concepts in this chapter and the drawings you have done from the assignments on texture. Analyze how each artist's work uses visual textures to express specific thematic concerns and to create unique spaces. As you review your own work, select those drawings that you feel were particularly successful. What worked in these drawings? Consciously make note of these techniques and principles and try to keep them in mind as you work on this and future assignments.

Doing meaningful work in drawing means developing a working vocabulary of visual elements and concepts: the way you use a medium, your thematic interests, and the way you organize marks and compositional space. By consistently pursuing an idea over time, your unconscious mind is programmed to think about the drawing problems you are grappling with on a variety of levels.

After you have spent some time creating a drawing arrangement that supports your exploration of textural effects, take your time and slowly develop a drawing that integrates and incorporates a variety of visual textures; soft, sharp, smooth, abrasive, shiny, and dull. Do not give equal visual emphasis to each texture. This might in the long run prove uninteresting. Vary the amounts. For instance, try using a large amount of rough texture with small passages of softly diffused tonalities.

Do not become discouraged by the results of your first efforts. By concentrating on the drawing process and the solving of visual problems, rather than finished products, you will be paving the way toward future success. The professional work illustrating this book looks polished and effortless in terms of technical control and professional achievement. Behind this art, however, lies much developmental work, false starts, and sheer practice.

The student drawings shown in Figures **6.20** and **6.21** both make effective use of textural elements. The textures created by the interactions of drawing instruments, media, and the visual qualities of the subject matter are almost infinite.

Put up some of your first drawings from this assignment in a place where you will see them frequently as you go about your daily activities. After a while you will probably notice elements in them that you will want to emphasize and use in future drawings. Conversely you will also notice ways in which they can be improved. The process of drawing is essentially an evolutionary activity that over time sharpens our visual capacity and heightens our awareness, returning again and again to familiar places enables us to see things in new ways and with new understandings.

6.20 Student Drawing. Stephanie Ridard, San José State University. Charcoal, 26 × 40 in (66 × 101.6 cm).

6.21 Student Drawing. Lisa Iagawa, San José State University. Ink, 18 × 24 in (45.7 × 61 cm).

Composition and Space

Successful drawings do more than render accurately what the artist sees. They invariably define space in personal ways and organize all of the drawing's elements, such as line, shape, value, and texture into unified, harmonious compositions. "Composition" is a term that refers to the way all the visual elements are used and has nothing to do with the choice of subject matter or the media used.

The principles of visual organization that govern a drawing's composition include balance, placement, rhythm, repetition, and variation. It is important to remember that these basic principles are guidelines that determine the way spaces and forms are organized, not inflexible rules. All the compositional principles outlined in this chapter are constantly redefined by artists to suit specific purposes. For instance, although you might be cautioned about placing an image in the center of the paper because it might result in a static composition, some drawings do just this and achieve favorable results. In such cases, the artists knew what they were doing when they broke the rules. In order to manipulate compositional guidelines successfully, we must first learn the underlying theories that govern them. Then we are free to either follow their direction or meaningfully contradict them.

One test of a drawing's composition is its completeness – nothing can be added or taken away without seriously affecting its balance or wholeness. In a successful composition everything works in harmony, with no single element more important than the arrangement of visual components. In terms of the "language of drawing," composition functions as a grammatical force, ensuring that every element plays a meaningful role. The aims of this chapter are to familiarize you with the basic principles of composition and the expressive possibilities or organizing space.

CHOOSING A FORMAT

The first drawing decision you make when you begin a new assignment – beside choosing your media or subject – is to select a format. Format refers to the proportional relationship of the paper's length to its height. Most students use the standard 18 by 24 inch paper pad format in a horizontal or vertical position. This proportion of length to width, whereby the smaller measurement is to the larger as the larger is to the sum of the two, is known as the "golden mean." Whether we position this standard rectangular sheet of paper vertically or horizontally depends on the nature of what we are drawing or what effect we would like to achieve. If you are drawing a still-life that stretches along a table top, positioning your paper horizontally might be appropriate. Drawing a standing figure, however, might call for vertical positioning of the paper.

Because paper is easily cut, there is no reason not to alter the standard format of the pad paper to suit your expressive drawing needs. Let your creative intentions be your guide in helping you determine the format and placement of the paper.

Vertical formats work well for obvious reasons when drawing tall buildings. In 1921, the German architect Ludwig Mies van der Rohe (1886–1969) did a project drawing of a skyscraper (Fig. **7.1**) that visually communicated the soaring, transcendent nature of this revolutionary architectural form. Thrusting skyward, this image of a glass-sheathed skyscraper embodied the architect's vision of how modern materials and building techniques can express contemporary ideas.

On the other hand, horizontal formats are better suited to ground-level subjects and tend to work well with sweeping panoramas. Because our eyes, set side by side, tend to naturally sweep back and forth horizontally as we walk, these formats are effective with landscape motifs. The elongated shape of the paper that Rembrandt used in *A Winter Landscape* (Fig. **7.2**) seems perfectly suited to the austerity of the flat Dutch countryside. With a few deft strokes of his pen and brush, Rembrandt

7.1 (opposite) Ludwig Mies van der Rohe, *Friedrichstrasse Skyscraper*, 1921, presentation perspective (north and east sides). Charcoal and pencil on brown paper, 68¼ × 48 in (173.5 × 122 cm). The Mies van der Rohe archive. The Museum of Modern Art, New York. Gift of the architect.

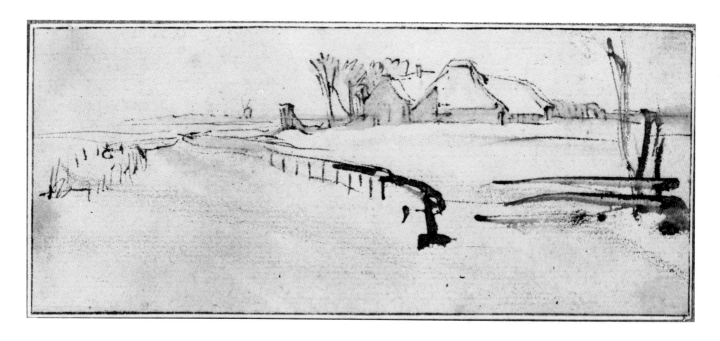

7.2 Rembrandt van Rijn. *A Winter Landscape*, c. 1648–52. Pen, brush, and brown ink on cream paper, 2½ × 6¼ in (7 × 16 cm). Fogg Art Museum, Harvard University. Bequest of Charles Alexander Loeser.

takes us spatially from the thick, dark, sweeping lines that represent the fence in the foreground to the houses in mid-ground and then to the faint windmill in the far distance.

Square formats can also be used effectively, as is clear in an example by Käthe Kollwitz (1867–1945). In her sensitive graphite portrait of a young girl and her sheltering mother (Fig. **7.3**), the child's soft features and the more sharply defined maternal hands are "center stage."

7.3 Käthe Kollwitz, *Head of a Sleeping Child in the Hands of its Mother*, study for the etching *Downtrodden*, 1901–15. Pencil, 8¼ × 8¼ in (20.7 × 20.8 cm). Kupferstich-Kabinett, Staatliche Kunstsammlungen, Dresden.

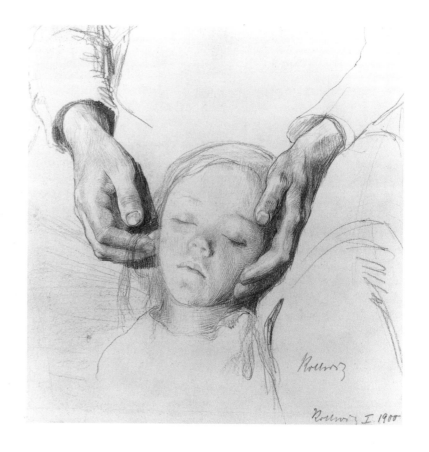

PROJECT 39

Exaggerated Formats

MATERIALS: Medium-weight bond paper, drawing medium of your choice.

During this session you will plan and create a drawing on an elongated format that takes into consideration the special visual qualities of your subject. The format of this drawing should be at least 2½ times as wide as it is high. You can either cut the paper to size or define the format with light pencil lines on a standard sheet of paper.

Our subject for this series of drawings will be a broom – a self-evidently elongated object. For your first drawing you will need to decide whether to position the broom vertically or horizontally (you will reverse positions in the next drawing, so do not agonize over this decision). Plan your format to accommodate and respond to the elongated shape of the broom.

After you have explored the drawing possibilities of the horizontal or vertical format, alternate the position. What special visual opportunities does each format hold? What orientation seems more interesting and relevant to you? Do several more drawings to explore these exaggerated formats and refine your ideas.

To help you visualize format, you may wish to make a simple sighting device to help you with composition. Cut two L-shaped sections out of a 10 by 10 inch piece of matboard. By placing these two sections together at right angles you can create a rectangular window of variable proportions (Fig. **7.4**). Remember, the format of a drawing controls the basic visual movement of our eyes as we scan the surface. Horizontal formats tend to lead our eyes left and right and vertical formats usually cause the eye to move up and down.

Whatever your choice of subject matter, when appropriate, make sure you exploit the special compositional formats. The student drawings shown in Figures **7.5** and **7.6** both respond compositionally to their unique formats. Maria Trimbell's pen and ink still-life drawing creates predominantly horizontal eye movements while Suzanne Slattery's drawing emphasizes vertical eye movement.

7.4 Sighting device made with two L-shaped pieces of matboard.

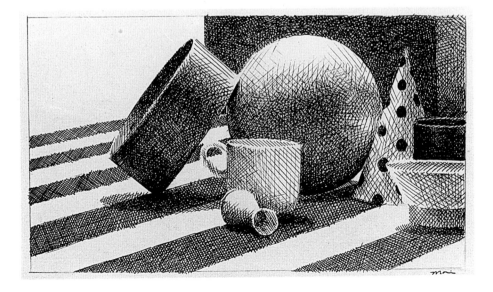

7.5 Student Drawing. Maria Trimbell, San Francisco State University. Pen and ink, 3½ × 6½ in (8.8 × 16.5 cm).

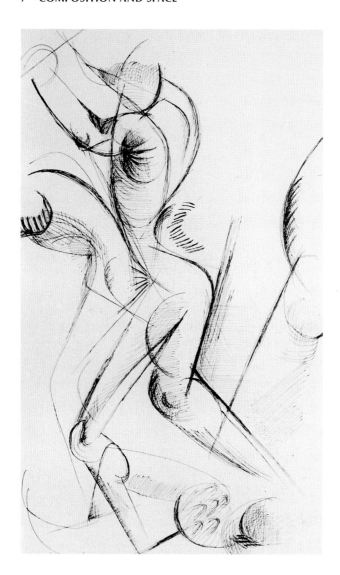

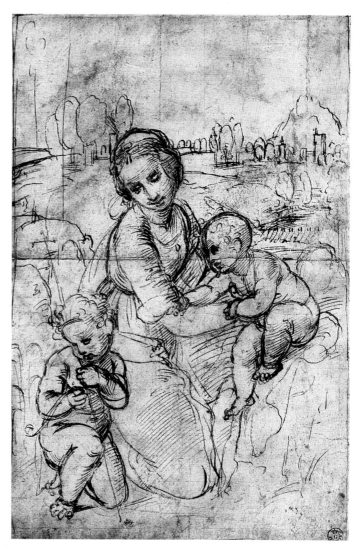

7.6 (left) Student Drawing. Suzanne Slattery, Bucks County Community College, PA. Pen and ink, 20 × 12 in (50.8 × 30.5 cm).

7.7 (right) Raphael, *Study for the Madonna Eszterhazy*, c. 1505–10. Pen and yellowish ink and pencil, 11⅖ × 7½ in (28.5 × 19.1 cm). Uffizi, Florence.

CONCEPTS OF SPACE

In compositional terms there are two distinct ways in which space can be represented. We can either create an illusion of three-dimensional space (this has been the strategy in the West since the Renaissance), or we can acknowledge and exploit the reality of a drawing's flat surface – also referred to as the picture plane.

Raphael's *Study for the Madonna Eszterhazy* (Fig. **7.7**) illustrates quite clearly the traditional Western conception of space. One of the masters of the High Renaissance, Raphael (1483–1520) creates the illusion that we are viewing a scene that contains three figures in the foreground and that a landscape extends beyond in the background. Through a variety of visual means such as cross-contour lines and the careful control of light and dark tones, the artist enables us to read the forms of this drawing as three-dimensional objects that exist in deep space.

The second concept of space in drawing acknowledges and accepts the innate flatness of the drawing surface. Many contemporary artists are interested in abstract or conceptual concerns that have nothing to do with realistic representation. Eva Hesse (1936–70) worked with a grid structure and concentric discs in the untitled pencil and wash drawing seen in Figure **7.8**. The softly pulsating discs create their own hermetic, two-dimensional space.

7.8 Eva Hesse, *Untitled*, 1966. Pencil and wash, 11⅞ × 9⅛ in (30.2 × 23.4 cm). The Museum of Modern Art, New York. Gift of Mr. and Mrs. Herbert Fischbach.

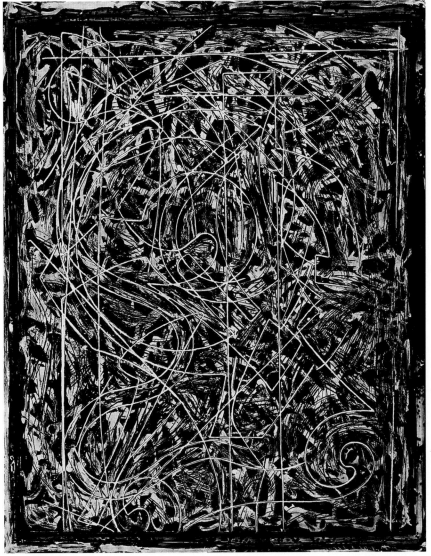

7.9 Frank Stella, *Talladega Three I* from the series *Circuits*, 1982. Etching, 66 × 51⅜ in (167.7 × 130.5 cm). The Museum of Modern Art, New York. Jeanne C. Thayer and John D. Turner Funds. Printed and published by Tyler Graphics, New York.

Frank Stella also reaffirms the flatness of the picture plane in his print titled *Talladega Three I* (Fig. **7.9**). This composition is based on the track designs of several automobile racing tracks Stella had visited as a spectator. He has represented them, however, not as they might be perceived visually during a race, but as flat, diagrammatic illustrations of their track design. Stella has conceptually evoked the speed and looping rhythms of a racing track on the flat surface of the paper.

PLACEMENT

No hard and fast rules define the arrangement of shapes and spaces in a composition. Generally their placement is determined by the visual concepts the artist wants to express and the forms that will be emphasized. Artists seek to create lively, interconnected spaces that allow the viewer to find interesting elements to compare throughout the composition. This is why you may sometimes be cautioned about placing a single image in the middle of the page as you may be limiting the visual movements of your composition. But sometimes artists ignore this guideline and still produce successful drawings. William Allan's watercolor drawing *Rainbow Trout – Muir Creek* of 1972 (Fig. **7.10**) demonstrates the conditional nature of design principles that govern factors such as placement. The trout is deliberately placed in the center of the paper, where it stands in isolated splendor, a mythical idealization of this fisherman's dream.

7.10 William Allan, *Rainbow Trout – Muir Creek*, 1972. Watercolor on paper, 18½ × 25¾ in (47 × 65.4 cm). Whitney Museum of American Art, New York. Purchase with funds from Richard and Dorothy Rodgers Fund.

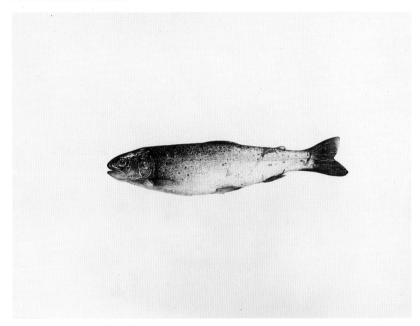

7.11 Wayne Thiebaud, *Untitled (Lipsticks)*, 1972. Pastel on paper, 17 × 20 in (43.1 × 50.8 cm). Courtesy, Allan Stone Gallery, New York.

Wayne Thiebaud's drawing *Untitled (Lipsticks)* (Fig. **7.11**), also of 1972, makes use of a decentralized structure. Some of the lipsticks are grouped quite close to one another, others are widely spaced; some stand upright and some lie on the table top, pointing in various directions. By carefully arranging the placement of these objects throughout the space of the drawing, the artist creates a dynamic composition that holds our interest.

PROJECT 40

Placement

MATERIALS: Medium-weight bond or other suitable drawing paper, drawing medium of your choice.

Assemble a collection of small objects that can be comfortably arranged on a table top. Spend some time moving these objects around and observing how the composition is affected by the changes you make. To help create an effective arrangement, you may want to make a cut-out cardboard window (similar to the one demonstrated on page 153) that is the same shape as your working format.

Do a group of drawings that explores the compositional effects of placement. Try different arrangements. Spread some objects across the table and place others in a tight group. As an exercise in central placement, select an object that interests you and make a detailed drawing of it in the center of the paper. How much space you leave around it will greatly affect your results, so plan the ratio of drawn image to empty space carefully.

NEGATIVE AND POSITIVE SPACE

Many students, when they first begin to draw, regard the white space of their paper as a neutral backdrop upon which their drawing is placed But, in most effective drawings, artists have conceived of the white space of the paper as an integral part of the drawing and an equal partner in the development of the artwork's space.

When we draw a still-life, for instance, the objects themselves can be considered the positive forms while the space between the objects become the negative space. A culture that greatly values materialism is predisposed to accentuate things. Do not be misled by the term "negative," the value of this negative space cannot be underestimated. The room you are reading this book in is as important for what it contains as for what is not there – the negative space of the building. Architecture is an artform that relies overwhelmingly on the interplay of positive and negative space to create buildings that are functional as well as beautiful. Effective drawings rely on this symbiotic relationship of negative to positive forms to create visually and conceptually involving spaces.

The oilstick on paper drawing (Fig. **7.12**) done by Melissa Meyer (b. 1947) in 1990 offers a clear example of the interaction of negative and positive shapes. It can be perceived either as black forms on a white ground or white forms on a black background. Meyer purposefully works with this kind of spatial ambiguity to create an involving experience for the viewer, who goes back and forth between these two modes. The white and black shapes are tightly knit into the very fiber of the drawing and metaphorically cannot be easily lifted off of the surface.

Not all negative and positive spatial interactions are as overt as these. Most good drawings, however, do subtly rely on the interaction of negative and positive shapes

7.12 Melissa Meyer, *Untitled*, 1990. Oilstick on paper, 60 × 44½ in (152.4 × 113 cm). Collection Kenneth L. Freed. Courtesy, the artist.

157

to activate the entire surface of the drawing. When you learn to make both positive and negative shapes work for you, the effectiveness of your drawings will be greatly improved.

To further illustrate how negative and positive spaces are incorporated in drawings, let us look at Rembrandt's *Canal and Bridge beside a Tall Tree* (Fig. **7.13**), a masterful example of how negative and positive shapes can be selectively and economically tied together. To help you see these relationships, study the diagram version (Fig. **7.14**). Note how the white paper surrounding the tree in the center becomes air and deep space; the shape to the left of the canal becomes a field; and the white mound between the bridge and the sitting girl becomes part of the dike and foreground. There are many important negative shapes in this drawing; see how many you can find. Now that you are aware of these interactions go through the illustrations in this book and see how various artists make use of negative and positive space.

7.13 Rembrandt van Rijn, *Canal and Bridges beside a Tall Tree*. Pen and brown ink, brown wash, 5⅝ × 9⅝ in (14 × 24 cm). Pierpont Morgan Library, New York.

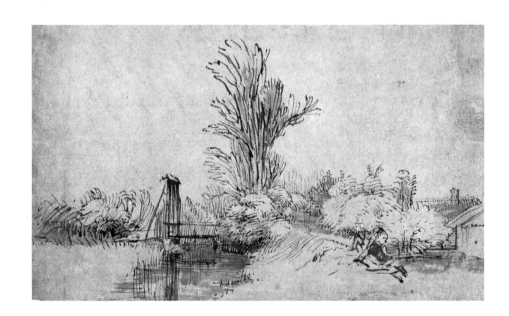

7.14 Diagram of 7.13 showing negative-positive space.

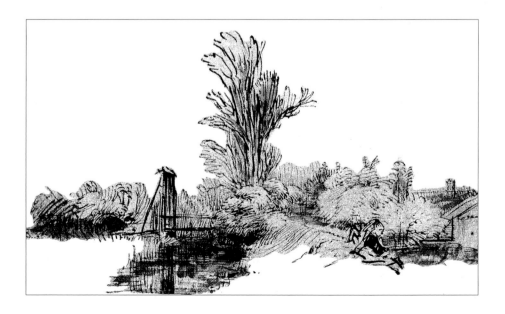

BALANCE

In terms of organization, balance is one of the most significant elements of composition. We can immediately see when a drawing has lost its equilibrium. Spatial relationships are awkward and seem to be visually unbalanced. When a composition is in balance all elements appear to work in harmony.

Balance falls into two broad categories, symmetrical and asymmetrical. But in practice many works of art manifest both symmetrical and asymmetrical elements.

Symmetrical balance is achieved by dividing a format in half (either horizontally or vertically) and placing identical visual elements on each side of the dividing line. Agnes Denes (see also Fig. **1.38**) uses elements of symmetrical balance in her precisionist drawing of 1978, *Pascal's Perfect Probability Pyramid: The Reflection* (Fig. **7.15**). Because the reflected bottom half of the drawing is lighter than the top half, the result is one of "near symmetry." For compositional reasons, drawings are rarely strictly symmetrical.

Asymmetrical balance occurs when unequal elements are harmoniously organized. *Four C Clamps* (Fig. **7.16**), for instance, a lithograph by Jim Dine (b. 1935), balances a small dark section at the top of the composition with a large white space of unmarked paper. As asymmetric balance usually results in dynamic spatial relationships, it is used far more frequently than symmetrical balance.

7.15 (far left) Agnes Denes, *Pascal's Perfect Probability Pyramid: The Reflection*, Study for *Glass Pyramid in Reflecting Pool*, 1978. Ink on vellum, 31 × 24½ in (78.7 × 62.3 cm). Collection, Kunsthalle, Nuremberg, Germany. Courtesy, the artist.

7.16 (left) Jim Dine, *Four C Clamps*, 1962. Lithograph printed in green, 18⅞ × 11¼ in (48 × 28.5 cm). The Museum of Modern Art, New York. Gift of the Celeste and Armand Bartos Foundation.

PROJECT 41

Exploring Balance

MATERIALS: Bond or other suitable drawing paper, charcoal, graphite, or brush and ink.

The aim of this project is to make you more aware of the vital role balance plays in the compositional process. Since asymmetric balance is more widely used, we will focus our efforts in this direction (if the problem of symmetric balance intrigues you, by all means pursue this interest in conjunction with this assignment). To create a suitable still-life, line up a row of coffee cups on a table top. Keep in mind the drawing objective: the exploration of compositional elements that affect visual balance. Place the cups in the upper portion of the

drawing's picture plane. How asymmetric in balance can you make your drawing before it loses its unity? Jim Dine's *Four C Clamps* (Fig. **7.16**) appears to have reached the compositional limits of asymmetric balance with its densely black upper portion achieving an equilibrium with the large open space below. Any changes in the amount or position of the dark shapes or in the amount of open space would shift the precarious balance Dine has achieved.

Keep playing with the relationships between drawn sections and open space in your drawing until you have achieved a satisfying arrangement. The student drawings shown in Figures **7.17** and **7.18** both make use of asymmetric composition.

7.17 (left) Student Drawing. Ken Gully, San José State University. Graphite, 18 × 24 in (45.7 × 60.9 cm).

7.18 (right) Student Drawing. Michelle Tan, San Francisco State University. Charcoal, 24 × 18 in (60.9 × 45.7 cm).

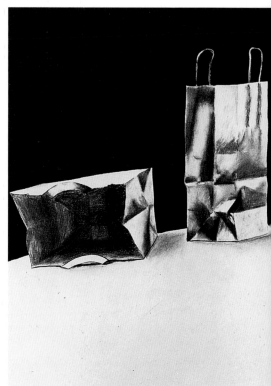

7.19 (opposite, left) Auguste Rodin, *The Embrace*, late 19th century. Pencil outline with watercolor washes, 13 × 9½ in (32.9 × 24 cm). Ashmolean Museum, Oxford.

7.20 (opposite, right) Pablo Picasso, *Head of a Woman*, 1909. Gouache over black chalk, 24½ × 18⅝ in (61.8 × 47.8 cm). The Art Institute of Chicago. Memorial Collection of Charles Hutchinson.

7.21 (opposite, below) Sol LeWitt, *All crossing combinations of arcs from corners, arcs from sides, straight lines, not straight lines, and broken lines placed at random*, Jan. 25, 1972. Ink on paper. Courtesy, John Weber Gallery, New York.

RHYTHM AND REPETITION

The elements of rhythm and repetition are closely related. The word "rhythm," generally applied to patterns of speech and music, denotes the recurrent alternation of strong and weak elements in the flow of sound and silence. As adopted in the visual arts, it refers to the pattern of movements created by the way marks and spaces are organized. The repetition of such patterns can enhance expressive effects and bring about compositional unity. Rodin's drawing *The Embrace* (Fig. **7.19**) makes use of flowing, curvilinear rhythms. The embracing couple's bodies are visually intertwined and fused into a single form of curves and twists. The black masses of watercolor, which represent their hair, stand out dramatically against the rhythms of the lines describing their bodies.

By contrast, Picasso's forceful *Head of a Woman* (Fig. **7.20**) expresses quite a different theme rhythmically. Instead of graceful linear movements, Picasso presents us with brusque, jagged rhythms that dramatically oppose each other and create compelling visual and psychological tensions.

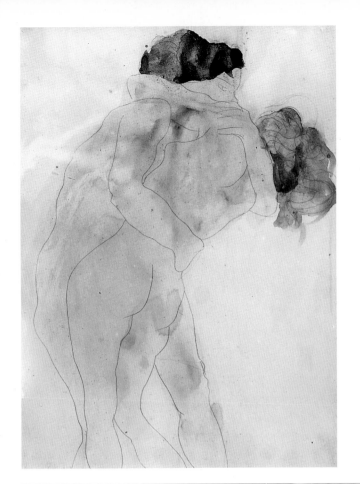

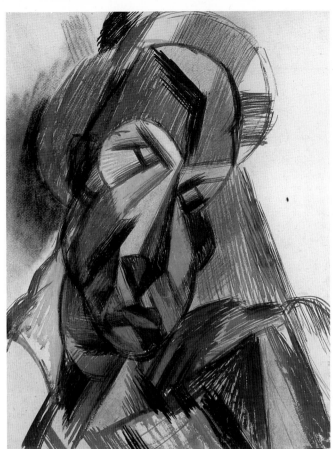

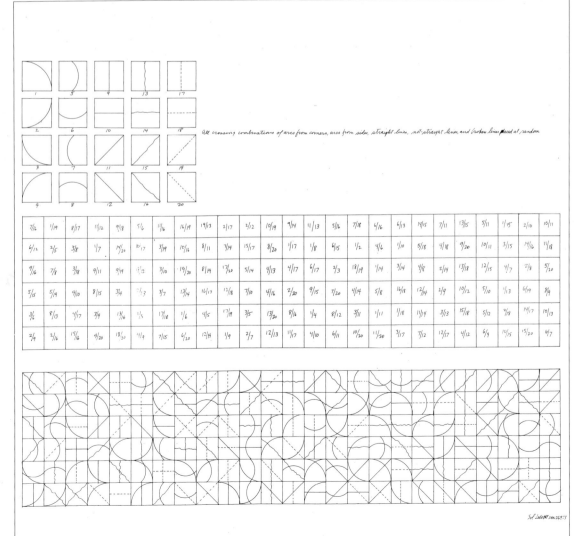

All crossing combinations of arcs from corners, arcs from sides, straight lines, not-straight lines, and broken lines placed at random.

7.22 (opposite) Federico Barocci, Copy of *The Visitation*. Pen, ink, wash, and chalk on paper, 15⅜ × 11¹/₁₀ in (39.6 × 28.3 cm). Royal Library, Windsor Castle. Reproduced by gracious permission of Her Majesty Queen Elizabeth II.

The element of repetition is clearly revealed in a drawing by Sol LeWitt (b. 1928), *All crossing combinations of arcs from corners, arcs from sides, straight lines, not straight lines, and broken lines placed at random* (Fig. **7.21**). As part of his creative process the artist uses the title as a set of instructions for creating the drawing. Visual clarity, precision, and order are high priorities for LeWitt and the variations of the arcs and straight lines creates a feeling of harmony and mathematical order.

PROJECT 42

Exploring Rhythm and Repetition

MATERIALS: Bond paper, medium or soft graphite pencils or pen and India ink.

Create a composition with rhythmic patterns using straight lines that follow a specific program. Write a short descriptive statement, similar to the LeWitt title used for Figure **7.21** that establishes the visual procedure you will use to create your rhythmic drawing. For example, you might divide the picture plane into a grid and draw lines from the corners of the inner rectangles to the corners of the paper. Keep the formula simple and concentrate on creating an interesting composition of intersecting lines that vary in spacing and density. Remember that you are primarily interested in the expression and repetition of rhythms. This purpose should guide you in the creation of your drawing.

THE REVISION PROCESS

No matter how carefully we plan our composition, it will always be subject to revision or change, both while we are in the process of drawing and later when we analyze our work in preparation for future drawings. Rarely are drawings complete in the artist's mind before the idea is committed to paper. The entire process of drawing can be summarized as one of visual statement, revision, restatement, until the artist considers the idea worked out, at least for the time being.

One of the most fascinating aspects of drawing is the way in which drawings clearly reveal the visual thinking that went into a work of art. Federico Barocci (c. 1535–1612), known particularly for his altarpieces, made an extraordinary number of preliminary drawings as preparation for his highly detailed paintings. Many clients admired his work but complained of his slowness and deliberation. In 1582 he was commissioned to do a large painting of *The Visitation* for the church of Santa Maria in Valicella, Rome. Barocci's first rough draft (Fig. **7.23**) sketchily describes the meeting of the Virgin and St. Elizabeth. They are positioned slightly off-center in a horizontal format. The artist made revisions directly on the drawing by simply redrawing his corrections over the previous lines. Notice the changed positions of the figure to the right.

Later Barocci used live models to pose for him while he worked out the exact anatomical proportions and body posture that he would use to represent St. Joseph. Detailed studies of a man's hand grasping a cloth sack are juxtaposed with studies of the saint's crouching position (Fig. **7.24**).

In this detailed rendering of the final composition (Fig. **7.22**) we can see that Barocci eventually changed the composition to a vertical format and further refined the positions of all of the major characters. The feeling of joyous welcome expressed by his subjects, however, is still evident in the final drawing.

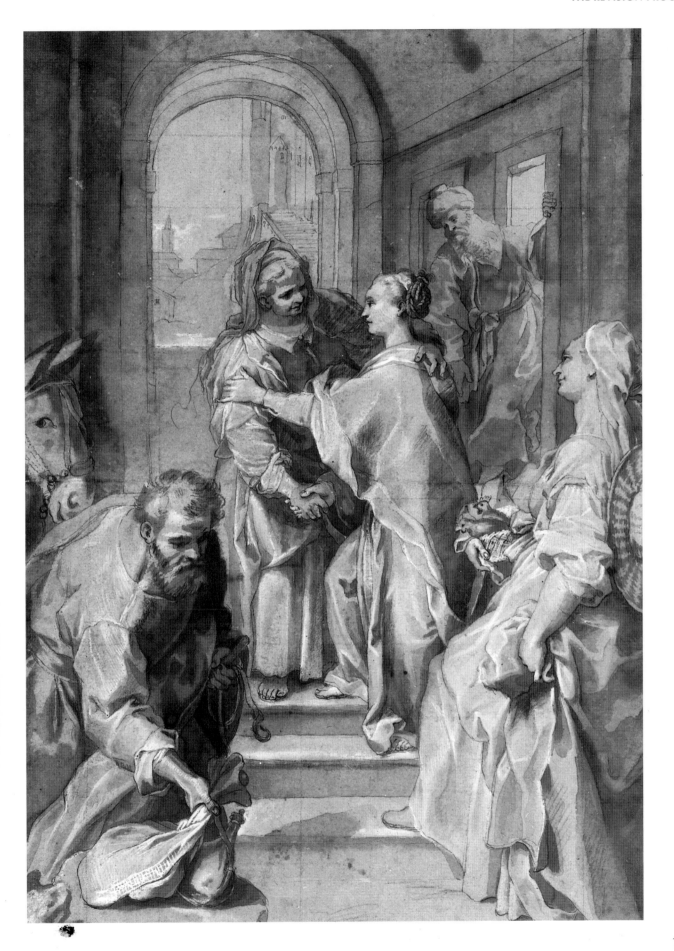

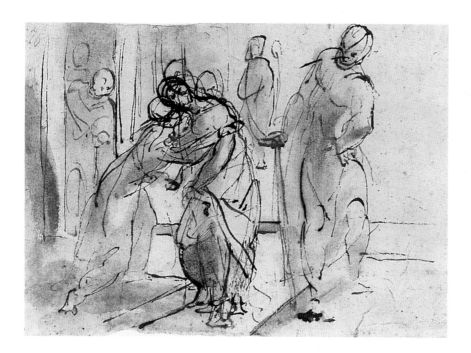

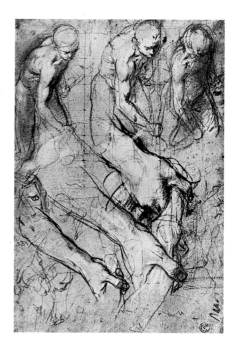

7.23 (left) Federico Barocci, Study for *The Visitation*. Pen, ink, and wash, 4⅗ × 6½ in (11.7 × 16.6 cm). Rijksmuseum, Amsterdam.

7.24 (right) Federico Barocci, *Nude Studies for St. Joseph*. Chalk on paper, 16½ × 11¹/₁₀ in (42 × 28.3 cm). Uffizi, Florence.

EVALUATING YOUR COMPOSITIONS

The point of this chapter is to make you aware of the compositional strategies you might use in your drawings. Here is a checklist to help you evaluate work you have done and guide you in future drawings.

- Is the format appropriate? Which format would best suit the composition – vertical, horizontal, or square?
- Are you concerned with illusions of three-dimensional space? If so, what could you do to reinforce these illusions?
- Is the placement of objects or forms working? Could things be rearranged to produce a more effective composition?
- Are negative and positive spatial relations in harmony? Are your positive shapes working with negative shapes?
- What about the balance of your composition? Did you wish to use symmetric or asymmetric balance or a combination of the two?

COMPOSITIONAL ANALYSIS

One of the best ways to continue to enhance your awareness of composition is to look at other drawings and to analyze their formal structure. View a wide range of work: drawings by fellow students, by master draftsmen and contemporary artists. Nothing can replace the experience of viewing original drawings rather than printed reproductions. We notice their actual size and subtle tonalities; the experience is immediate. Although looking alone will not make you a better draftsperson, it will help enlarge your aesthetic and technical repertoire.

Let us now analyze two drawings, focusing on the artists' compositional decisions. For his drawing *Girl with Tulips* (Fig. **7.25**) Matisse chose a rectangular format close to the golden mean. Pyramidal lines extending from the model's head help determine its placement relative to the shoulders. Faint lines to the left of her head reveal an earlier, now changed, positioning. Part of the head extends past the upper limit

7.25 Henri Matisse, *Girl with Tulips (Jeanne Vaderin)*, Issy-les Moulineaux, 1910. Charcoal on buff paper, 28¾ × 23 in (73 × 58.4 cm). Collection, The Museum of Modern Art, New York. Bequest of Lillie P. Bliss.

of the drawing, which suggests a continuation of the form outside the picture plane. Three-dimensional space is suggested by the way in which the lines follow the contours of the girl's body and the contours of the flower pot and dish. Notice how Matisse considered the effects of negative and positive space: the head and two elbows of the model touch the edges of the paper, creating strong negative shapes on both sides of the figure. In terms of balance, he has placed the woman off the center axis to create more dynamic spatial interactions. Also, to avoid static symmetry, the elbow to our left is much more pronounced than the other. Repetition of lines that describe the body sets up lively rhythms. The process of revision is directly built into this drawing: we are offered multiple points of view simultaneously.

Picasso's compositional study for *Guernica* (Fig. **7.26**) similarly explores various organizational possibilities, but differs from the Matisse in many ways, primarily in being laden with political overtones. In 1937, during the Spanish Civil War, the Spanish Republican government in exile asked Picasso to paint a mural about the conflict for the Paris International Exposition. Picasso agreed but did not make

7.26 (right) Pablo Picasso, Compositional study for *Guernica*, 1937. Pencil on white paper, 9½ × 17⅞ in (24.1 × 45.5 cm). Museo Nacional. Centro de Arte Reina Sofía, Madrid.

7.27 (below) Pablo Picasso, *Guernica*, 1937. Oil on canvas, 11 ft 6 in × 25 ft 8 in (3.5 × 7.8 m). Museo Nacional. Centro de Arte Reina Sofía, Madrid.

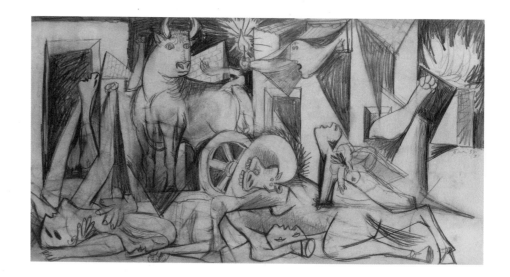

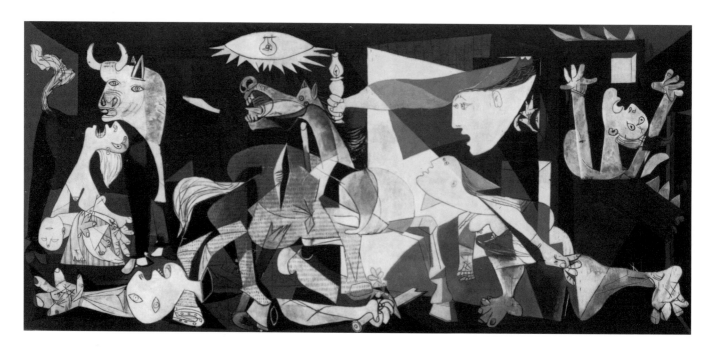

This chapter will guide and assist you in learning to apply the principles of *perspective* to your drawings. Essentially, perspective is nothing more than a systematic method of determining the placement of forms in space. The theory of perspective is based on a few simple principles that help the artist to describe deep three-dimensional space on a flat surface. Certainly there are technically complex situations involving perspective that test the skill of professional artists. Yet many subjects involving simple perspective are relatively straightforward and manageable for the beginning and intermediate student. In fact, if you have drawn the cardboard boxes in previous assignments, you have already made use of perspective in your drawings.

Perspective refers to all of the visual techniques that create illusions of three-dimensional space on a two-dimensional surface. Historically, artists from many cultures and eras have been employing various forms of perspective since the beginning of recorded time. When perspective is mentioned today, however, what usually comes to mind is a specific technique or architectural drawing that originated during the Italian Renaissance (Fig. **8.1**).

Florence in the fifteenth century was an exciting center of learning and artistic activity and it was the home of two well-known architects credited with first formulating the rules of perspective, Filippo Brunelleschi (1377–1446) and Leone Battista Alberti (1404–72). In 1435 Alberti wrote a seminal treatise on painting, titled *Della Pittura*, which contained the first printed description of the mathematically proportioned system of perspective. Other early Italian artists who experimented with and

(opposite) Charles Sheeler, *Delmonico Building*, 1926. Lithograph, 9¾ × 6¹¹⁄₁₆ in (24.8 × 17 cm). The Museum of Modern Art, New York. Gift of Abby Aldrich Rockefeller.

8.1 Etienne Duperac, *View of the Campidoglio*, 1569. Engraving. The Metropolitan Museum of Art, New York. Harris Brisbane Dick Fund. #41.72(1).

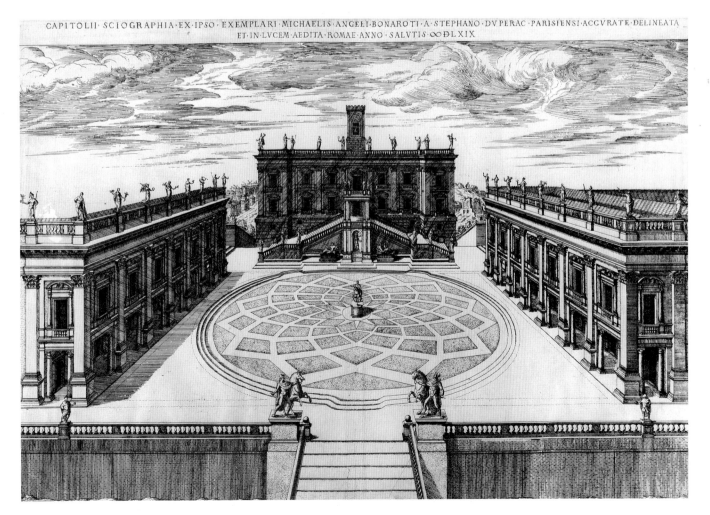

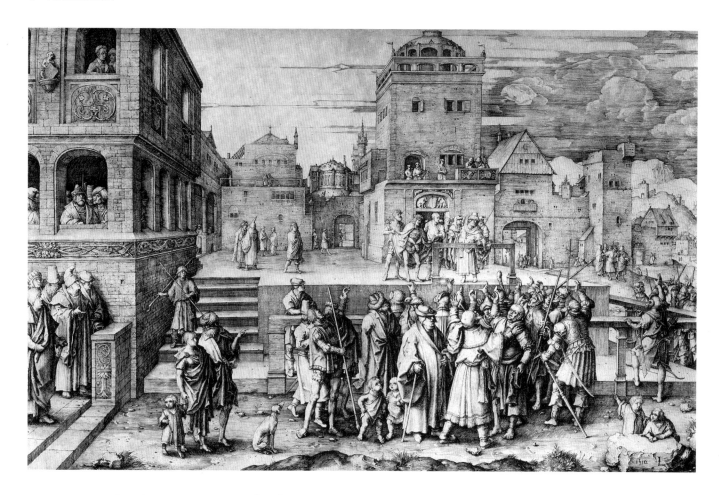

8.2 Lucas van Leyden, *Christ Presented to the People*, c. 1510. Engraving. The Metropolitan Museum of Art, New York. Harris Brisbane Dick Fund. #27.54.4.

refined perspective were Donatello, Masaccio, Uccello, Leonardo, and Piero della Francesca – a who's who list of Renaissance artists. The development of perspective was an important step in the evolution of Western attempts at pictorial realism and has played a major role in art from the fifteenth century to the present day.

In order to comprehend perspective, it is necessary to understand the optical principles upon which it is built. The technique of linear perspective is essentially based on three important features of our visual perception. First, as objects recede in the distance, they appear to become smaller. Forms close to the viewer tend to obscure and overlap more distant objects. A third quality of linear perspective (actually a consequence of the first point) is that parallel lines appear to converge at a point in the distance called a *vanishing point*. All these characteristics of linear perspective can be seen in the Renaissance perspective drawing of Figure **8.2**.

Claes Oldenburg's *Proposed Colossal Monument for Central Park, New York: Moving Pool Balls* (Fig. **8.3**) convincingly creates the illusion of immense replicas of billiard balls in grassy fields. The balls become smaller as they approach the horizon. The inclusion of New York's buildings in tiny scale along the horizon indicates that the billiard balls are meant to be read as spheres many feet high rather than inches in diameter.

LINEAR PERSPECTIVE

Linear perspective is dependent on maintaining a single, fixed point of view. That means that the person drawing remains at an exact, unchanging position in space. One of the first somewhat artificial constraints placed upon us is that our drawing position is unwavering. In theory, you should not move the position of your head

while you are making a perspective drawing, especially not if you are drawing objects in perspective at close range in a studio. Moving even a foot or so will significantly alter the perspective of the drawing, so practice maintaining a fixed position relative to what you are drawing.

Another important consideration is to limit the angle of vision. Normal peripheral vision allows us to easily take in a panorama of 180 degrees. But it is quite difficult to represent a panoramic scene in perspective. Practically speaking, we should limit the scope of the scene to something between 60 and 80 degrees. Artists call this limited point of view the *cone of vision* (Fig. **8.4**).

8.3 Claes Oldenburg, *Proposed Colossal Monument for Central Park, New York: Moving Pool Balls*, 1967. Pencil and watercolor, 22 × 30 in (56 × 76 cm). Menil Collection, Houston. Reproduced with permission of the artist.

8.4 Cone of vision.

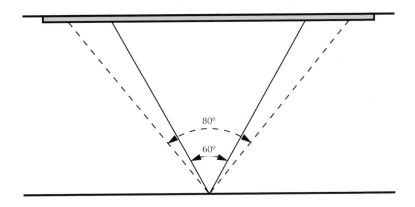

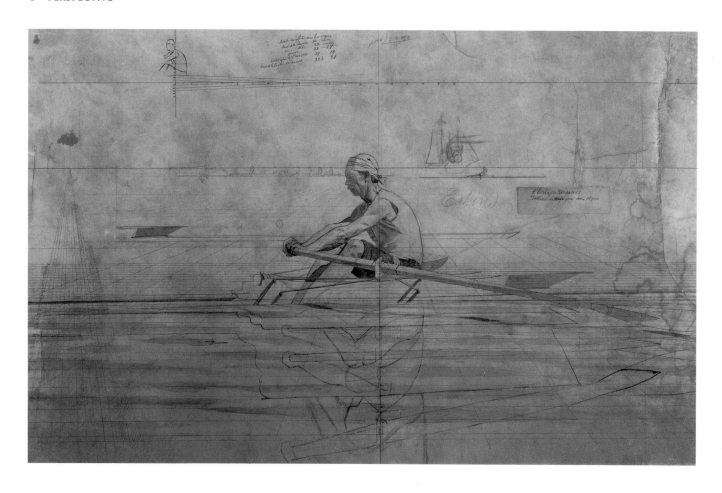

8.5 Thomas Eakins, *Perspective Studies for "John Biglen in a Single Scull,"* c. 1873. Pencil, pen, and wash on two sheets of buff paper joined together, 27⅜ × 45³⁄₁₆ in (69.5 × 114.7 cm). Museum of Fine Arts, Boston. Gift of Cornelius V. Whitney.

One of the most important elements that the perspective drawer needs to establish is the horizon line or the eye level. In a landscape or seascape, the horizon line is where the land or sea appear to meet the sky. It is important to establish this line even though it may be obscured by hills or buildings. When we are drawing inside, perhaps a still-life set up on a table, instead of the horizon line we would need to establish the eye-level line. If we are seated on a chair, the eye-level line in the room would be determined by drawing an imaginary line on the wall opposite us, at the same height from the floor plane as our eyes are. To help you determine where the eye-level horizon is, you could get a stick, place it directly in front of you, and make a mark at the level your eyes are at. You could then place this marked stick upright and flat against the wall in the background.

Among the other terms applied to perspective drawing is the ground plane, which refers to the flat area on which the artist stands; this area can stretch to the horizon. The exact point at which the artists stands is called the station point. If we draw an imaginary line, parallel to the ground plane, from the station point directly to the horizon (or eye-level) line, the point at which they intersect is called the center of vision.

Sometimes, to aid their perspective drawing efforts, artists establish an imaginary grid based on the geometric rules of perspective. Important principles of perspective drawing are clearly revealed in a study by American artist Thomas Eakins (1844–1916), showing a man called John Biglen rowing in a single scull (Fig. **8.5**). The horizon line runs across the picture plane and cuts through the rower's head, just above his forehead. The vanishing point in this one-point perspective study is on the back of his head. Through laying out these points, Eakins made a precise geometric grid to help him determine the correct perspective for his composition.

ONE-POINT PERSPECTIVE

Basically linear perspective construction falls into three categories: *one-point, two-point*, and *three-point perspective*, which refers simply to the number of vanishing points used in the drawing.

One-point perspective is the simplest and most commonly used mode of the three. When the objects we are drawing, boxes for example, are directly in front of us, with some sides of the forms parallel to the bottom of our drawing paper, the receding parallel sides of the boxes – should they extend for a distance – appear to converge at a singe point on the horizon, the vanishing point (Fig. **8.6**). Artists use this form of perspective to delineate space within exterior and interior architectural settings. Antonio López García (b. 1936), for example, used one-point perspective to record the simple, austere details of a kitchen (Fig. **8.7**). The eye-level line in this drawing is just below the top left corner of the cabinet in the center of the wall directly in front of us. This point is approximately five feet from the surface plane of the floor. Remember, linear perspective depends on maintaining a fixed and specific point of view. Had the artist made the drawing from a stepladder, the position of the eye-level vanishing point would be significantly different. When we change our position in space relative to a fixed object, the visual organization and spatial relationships also change.

As an exercise in discovering some important features of perspective, take a piece of tracing paper and place it over García's drawing of the kitchen. Using a ruler, draw pencil lines from the geometric edges of forms receding from us: the floor and ceiling lines; the cabinets and shelving to the right. They will converge at a point just to the left of the top of the built-in cabinet (Fig. **8.8**).

8.6 (above) One-point perspective.

8.7 (below, left) Antonio López García, *Cocina en Tomelloso (The Kitchen in Tomelloso)*, 1975–80. Pencil, 29⅛ × 24 in (74.2 × 60.9 cm). New York. Private Collection. Courtesy, Marlborough Art Gallery, New York.

8.8 (below, right) Diagram of converging vanishing points in 8.7.

eye level vanishing point

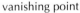

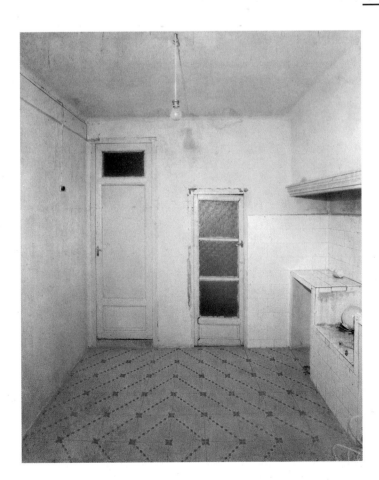

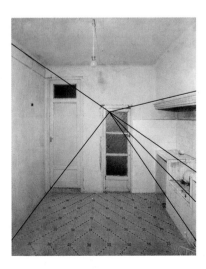

PROJECT 43

Using One-Point Perspective

MATERIALS: bond paper, medium graphite pencil (or vine charcoal), 18 inch aluminium rule.

You will need to find a drawing situation that lends itself to one-point perspective. A long hallway at your school or a kitchen scene similar to that in Figure **8.7** would work quite well. Remember, one-point perspective involves parallel lines moving away from us and converging at an imaginary point on the horizon line or eye level (see also Fig. **8.6**). If you are using a long hallway, position yourself directly in the middle of the hall. If you are drawing a kitchen, make sure your position in the room is similar to García's (Fig. **8.7**). The far wall should be parallel to the bottom edge of your paper. If you like you can construct a perspective grid similar to the one that Eakins created (Fig. **8.5**).

Do two or more drawings of whichever scene you have chosen to explore. For each drawing, change your eye level relative to the floor or ground plane. Locate the vanishing point at the eye level of each drawing and plot the converging angles to meet at this imaginary point.

TWO-POINT PERSPECTIVE

Two-point perspective is used by artists when no single surface of the subject is parallel to the horizontal plane of the drawing paper. For instance, if we were to position a cardboard box so that one of its corners was directly facing us, the parallel sides of the box would converge toward two vanishing points on the horizon (Fig. **8.9**).

A drawing of an old-time cookstove (Fig. **8.10**) by Thomas Hart Benton (1889–1975) makes effective use of this kind of perspective. Done in preparation for a large mural painting documenting Midwestern farm life, the vertical lines of the drawing remain parallel to the picture plane, while both sides of the stove (like the sides of the box in Figure **8.9**) lead to two vanishing points on the horizon. Benton drew from an eye level above the cooking surface of the stove. This angle accentuates the effect of the stove receding in space and makes for a dynamic composition.

8.9 (left) Two-point perspective.

8.10 (right) Thomas Hart Benton, *Cookstove*, Study for the "Kansas City" mural, 1936. From *Farming Segment*. Lyman Field and United Missouri Bank, N.A., co-Trustees of Thomas Hart Benton and Rita P. Benton Testamentary Trusts.

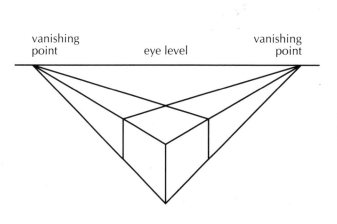

PROJECT 44

Using Two-Point Perspective

MATERIALS: Tracing paper, bond drawing paper, medium graphite pencil (or vine charcoal), masking tape, yardstick.

Find a table that you can move easily to suit your needs – a small kitchen table, for example. Position the table so that one of its corners is directly facing you. No side of the table should be parallel to the sides of your drawing paper. In order to prevent the composition from being dull, place some square objects on the table. Rectangular pans and baking tins would be appropriate and would fit the theme of the drawing. Position yourself so that your eye level is above the top of the table, planning to place the drawing in the bottom portion of the paper. Get fairly close to the table to exaggerate the difference between the parallel receding planes. When your drawing is complete, place the tracing paper over the paper, hinge it and make an exploratory diagram following the two converging vanishing points. Depending on your drawing position (and the resulting horizon line), the vanishing points may converge beyond the paper. Mastering two-point perspective takes practice and some patience but your ability to draw geometric forms in perspective should increase the more you work at it.

THREE-POINT PERSPECTIVE

Three-point perspective is used more rarely than the other two linear perspective systems. But you should at least be familiar with how to use it and its expressive potential. Three-point perspective is required, for instance, when we draw a tall building from a position close to its base. In addition to the two horizontal vanishing points (explored in project 44) the top of the building appears to be converging at a third vanishing point.

Charles Sheeler (1883–1965) communicates the dynamic forces at play in a modern city through the use of three-point perspective and the strong angular interplay of black-and-white shapes in his drawing of the *Delmonico Building* (Fig. **8.11**). As the building rises, the sides nearest the viewer appear to narrow. If you wish to explore this specialized perspective, take your sketchbook to a downtown urban area and do a series of drawings from this environment.

MULTIPLE PERSPECTIVES

For centuries artists have creatively manipulated and distorted perspectives to achieve expressive goals. In his print *Summer* (Fig. **8.12**), Pieter Brueghel the Elder (c. 1524/30–69) meaningfully distorts the perspective in order to reveal more than can be seen from a single vantage point. Brueghel is known for his extraordinarily detailed compositions documenting the organization of life and work around the natural progression of the four seasons. In order to show more of the land in the background while maximizing detail in the foreground, Brueghel tilts the background up and toward us almost as if it were painted scenery in a theatrical production.

The important thing to remember about perspective is that it should always serve the expressive needs of the artist. As you gain visual control over your subject, you will be able to exercise more creative and expressive options.

8.11 Charles Sheeler, *Delmonico Building*, 1926. Lithograph, 9¾ × 6¹¹⁄₁₆ in (24.8 × 17 cm). Collection, The Museum of Modern Art, New York. Gift of Abby Aldrich Rockefeller.

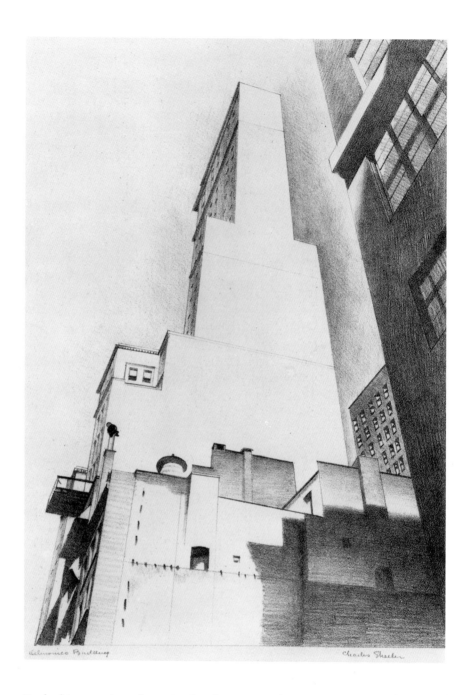

Stacked perspective refers to a drawing system that juxtaposes several views of a subject one on top of the other. Giambattista Piranesi (1720–78), a Venetian polymath, was obsessed by the city of Rome during a period when it lay in great poverty and ruin. He created almost one thousand five hundred large, highly detailed etchings of deteriorating buildings and architectural details. In his *Diagram of Temple Construction* (Fig. **8.13**), multiple perspectives are presented to us within a single format. Dramatic shifts in space are achieved by placing a drawing of an entire temple in the central panel with enlarged construction details in the top and bottom panels.

The German artist Franz Marc (1880–1916) also used spatial distortions and ambiguity through the manipulation of perspective. His woodcut *Riding School* (Fig. **8.14**) bombards our senses with the feeling that we are viewing a scene full of motion. It has an interlocking network of negative and positive shapes that seem to be drawn in a variety of perspectives. It is impossible to determine with any certainty the spatial position of many of the elements.

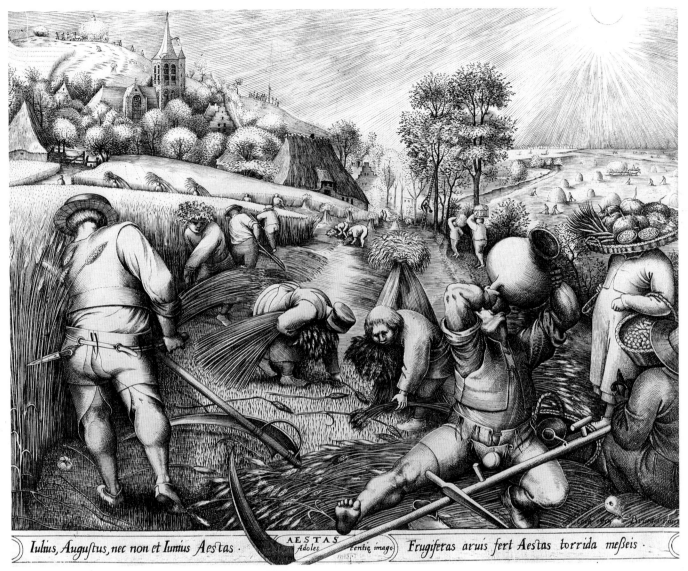

Iulius, Augustus, nec non et Iunius Aestas . AESTAS *Adoles* *sentiq imago* *Frugiferas aruis fert Aestas torrida meßeis .*

8.12 Pieter Brueghel, *Summer*, 16th century. Engraving, 8¹⁵⁄₁₆ × 11⅝⁄₁₆ in (22.7 × 28.7 cm). The Metropolitan Museum of Art, New York. Harris Brisbane Dick Fund. #26.72.23.

PROJECT 45

Exploring Multiple Perspectives

MATERIALS: Bond paper, drawing medium of your choice.

To create a composition with a variety of simultaneous viewpoints and perspectives, choose any household appliance with several parts. Imagine that this object has exploded and that its pieces are flying in all directions. Some sections of these tools might be drawn large and in full detail, while others might be made smaller and in the distance.

Another approach to this project would be to divide the drawing plane into rectangular sections and create a series of small drawings within a drawing. Each division could represent an unusual angle and perspective of the subject. Remember to vary the scale and viewpoint to avoid monotonous compositions.

8.13 Giambattista Piranesi, *Diagram of Temple Construction*, Plate 24 from *Della Magnificienza*, 1761. Etching. The Metropolitan Museum of Art, New York. #41.71.1(7).

8.14 Franz Marc, *Riding School*, 1913. Woodcut, 10⅝ × 11¾ in (26.9 × 29.9 cm). The Museum of Modern Art, New York. Gift of Abby Aldrich Rockefeller.

ATMOSPHERIC PERSPECTIVE

Atmospheric or *aerial perspective* is used to achieve a sense of depth. Spatial illusions are created by controlling the sharpness and relative contrast of receding forms in a drawing. Foreground shapes are rendered more distinct and in sharper focus than those representing forms in the far distance. Natural atmospheric conditions (usually moisture in the air) cause distant objects to appear hazy and lighter in tone than those in the foreground. Dürer used this type of drawing perspective to make the castle a convincing part of the background (Fig. **8.15**). By contrast, the rocky outcrops in the foreground are sharp and distinct, indicating a great spatial separation.

PROJECT 46

Using Atmospheric Perspective

MATERIALS: Bond paper, drawing medium of your choice.

Find an outdoor vantage point that offers subject matter both in the foreground and distant background. Depending on how far away they are, and on atmospheric conditions, distant forms should appear lighter and less distinct than objects that are near to us. Exaggerate the value differences between the foreground and background in order to create the illusion of depth. Also remember to use more detail in the foreground and to draw with sharper focus.

8.15 (above) Albrecht Dürer, *Rocky Landscape with Castle*, 1494–5. Pen and ink. Albertina, Vienna.

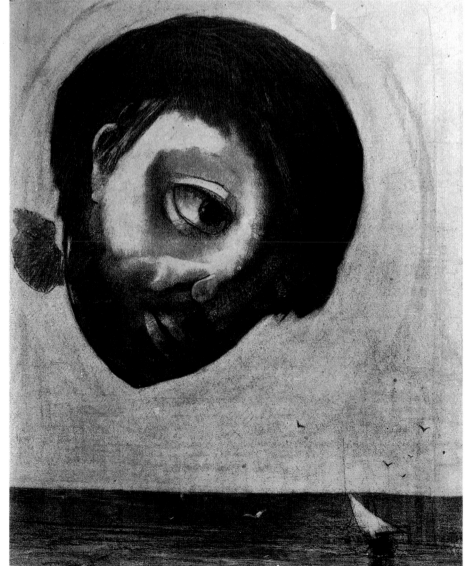

8.16 Odilon Redon, *Winged Head above the Water*, c. 1880. Charcoal, 18¾ × 14⅝ in (47.6 × 37.1 cm). The Art Institute of Chicago. David Adler Collection.

SCALE AND PERSPECTIVE

The ultimate purpose of learning to control space and represent three-dimensional forms through various perspective systems is to allow us to freely explore our visual ideas and communicate our interests. *Scale*, the size relationships that exist between various objects, is an important element in perspective. Without scale variations there would be no perspective. Remember that the optical basis of perspective depends on the phenomenon of objects appearing to get smaller as they recede in space.

Sometimes artists purposefully manipulate scale and perspective in order to express thematic concerns and imaginary visions. Redon's charcoal drawing *Winged Head above the Water* (Fig. **8.16**) juxtaposes an image of an enormous detached head that floats over an ordinary seascape with a sailboat. Seen separately, the two components of the drawing, the head and the ocean, are relatively unremarkable. By placing them together in this manner, however, they interact to produce strange effects. Scale manipulation creates a magical scene out of otherwise ordinary subjects.

Scale and perspective were also used expressively in van Gogh's watercolor and gouache drawing *Corridor in an Asylum* (Fig. **8.17**), which seems to convey a feeling of anxiety and entrapment. Placing the far end of the corridor almost directly in the center of the composition has curious effects. The tiny portal in the distance draws us in to the composition and makes us believe that this darkened corridor is closing in on us.

8.17 Vincent van Gogh, *Corridor in an Asylum*, 1889. Gouache and watercolor on paper, 24⅛ × 18⅝ in (61.3 × 47.3 cm). Bequest of Abby Aldrich Rockefeller. The Metropolitan Museum of Art, New York. #48.190.2.

181

PROJECT 47

Manipulating Scale and Perspective

MATERIALS: Bond paper, drawing medium of your choice.

Make a drawing of your room or other indoor architectural setting in which you explore the expressive possibilities of perspective. Whether large or small, perhaps the size of your room or the way it is set up might suggest thematic possibilities. Certain classrooms might also inspire you to manipulate scale and perspective in your drawings. The concept behind this assignment is to experiment with the elements of scale and perspective in personally expressive ways. Take some chances and see how far you can develop your ideas.

8.18 Giambattisa Piranesi, *The Prisons*, c. 1760–1. Etching, 21½ × 16 in (55 × 41 cm). The Metropolitan Museum of Art, New York. Rogers Fund. #41.71.1(8).

IMAGINATIVE PERSPECTIVES

While Renaissance artists used perspective to focus on the rational representation of forms in space, artists have also purposefully used aspects of perspective to create ambiguous and disquieting visions that defy rational interpretation.

Along with his voluminous documentary drawings of Rome's faded glories, Piranesi made a series of etchings called *The Prisons*. Using all the techniques of classical perspective, he created potent visual metaphors for humanity's darker side (Fig. **8.18**). Space and scale are out of kilter. Human figures are dwarfed and oppressed by an elaborate machinery that seems bent on the domination of man. Circular stairs that spiral skyward, bridges that end in mid-air, and ramps that arbitrarily criss-cross the cluttered prison cavern suggest a world controlled by madness

8.19 M.C. Escher, *Relativity*, 1953. Lithograph, 10¾ × 11½ in (27.3 × 29.2 cm). © 2001 Cordon Art B.V. Baarn, Holland. All rights reserved.

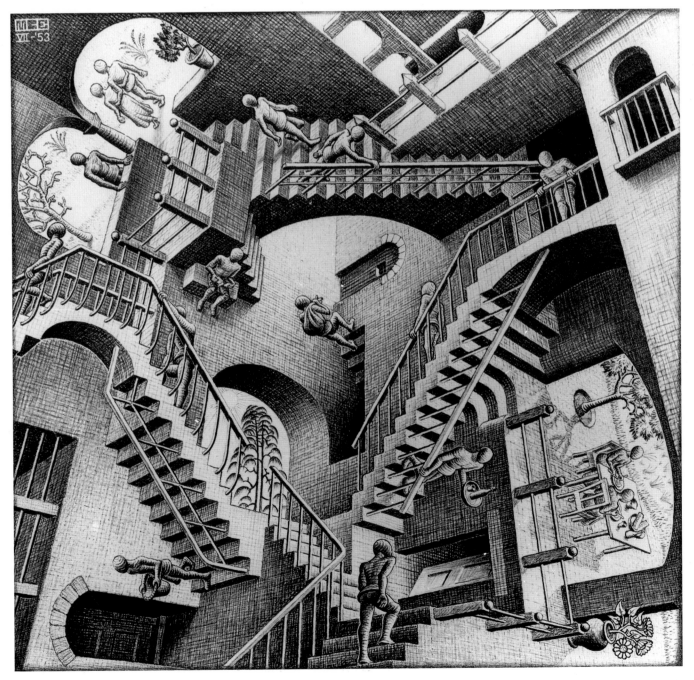

8.20 Paul Klee, *Perspective of an Occupied Room*, 1921. Watercolor on paper mounted on cardboard, 19 × 12½ in (48.5 × 31.7 cm). Kunstmuseum, Bern. Paul Klee Stiftung.

and conceit. This symbolic conceptualization of a prison, with its dark, ambiguous spaces and confusing architectural plan, prophesies a fearful vision of mechanized hell in the modern world.

The drawings of M.C. Escher (1898–1972) also make use of purposeful distortions of perspective. The world according to Escher behaves in startling and unpredictable ways. Rivers might flow uphill and interior spaces might suddenly be transformed into exterior forms. Escher, best known for his enigmatic visual puzzles, realized clearly that perspective was a means of playing tricks: he could contradict

his illusions several times within a single composition (Fig. **8.19**). The more we look at Escher's print *Relativity*, the less we trust the illusions of his perspective.

Sometimes perspective is distorted in order to express ideological concerns. Paul Klee (1879–1940) drew *Perspective of an Occupied Room* (Fig. **8.20**) while teaching at the avant-garde German school of art, the Bauhaus, in the early 1920s. During this period some members of the Dutch *De Stijl* movement were adversely critical of the Bauhaus. Advocating strict adherence to perspective and the use of absolutely straight lines, these *De Stijl* artists sought to suppress the individuality of personal expression for what they considered to be the good of collective society. Klee's drawing, in which figures are shown flattened against the floor and walls, offers an ironic commentary on such a rigid point of view. Obviously in disagreement with the rejection of Expressionism by *De Stijl* artists, Klee created this drawing showing individuals ludicrously subordinated to the artificial laws of perspective.

Special perspectives or vantage points are often used to achieve certain visual and psychological tensions. For example, in *Rabbit on a Chair* (Fig. **8.21**) Lucian Freud (b. 1922) depicts the rabbit as if suspended in mid-air, apparently floating against a richly textured background of vertical and horizontal lines that represent the wicker chair.

8.21 Lucian Freud, *Rabbit on a Chair*, 1944. Conté pencil and crayon, 17¾ × 11¾ in (45 × 30 cm). Courtesy, James Kirkman Ltd., London.

8.22 Student Drawing. Rita M. Christen,
San José State University. Charcoal,
40 × 26 in (101 × 66 cm).

PROJECT 48

Using Perspective Creatively

MATERIALS: Bond paper, drawing medium of your choice.

Use the concepts and skills you have learned in this chapter to develop a group of drawings that approaches the use of space and perspective in personally meaningful ways. Like Freud (Fig. **8.21**), you may wish to work from a distinctive angle. Or you may wish to experiment with ambiguous, convoluted spatial arrangements, seemingly impossible perspectives, or purposeful distortions. Once you have learned the laws of perspective, they will become another visual element in your repertoire to be used, reshaped, or transformed. The student drawings of Rita Christen (Fig. **8.22**) and Pam Mandel (Fig. **8.23**) both control and manipulate perspective to create expressive visual effects.

8.23 Student Drawing. Pam Mandel, San José State University. Charcoal, 26 × 40 in (66 × 101 cm).

CIRCULAR FORMS

Although we usually associate perspective with the drawing of rectangular forms in space, circular objects obey the same laws of perspective and offer similar challenges and learning opportunities for the drawing student.

You may have already experienced the difficulty of drawing bowls, glasses, vases, and other circular objects in previous assignments. Many people find it hard to get the round openings of these objects to look correct. They are usually either too sharply pointed, bluntly rounded, or drawn in an inconsistent way (Fig. **8.24**).

Before we begin to learn to draw circular objects in space, there are some important characteristics of these forms that we should be aware of. Unless we look directly down the opening of a circular vessel such as a drinking glass, the circular form we perceive assumes the shape of a partially flattened circle or *ellipse*. Take an empty drinking glass and hold it away from you in your outstretched hand. Begin by looking directly into the opening of the glass. This is the only position in which the opening will appear truly round. Slowly bring the glass to a vertical position. Each step reveals a gradually flattening ellipse until only a straight line is evident when the lip is horizontal (Fig. **8.25**).

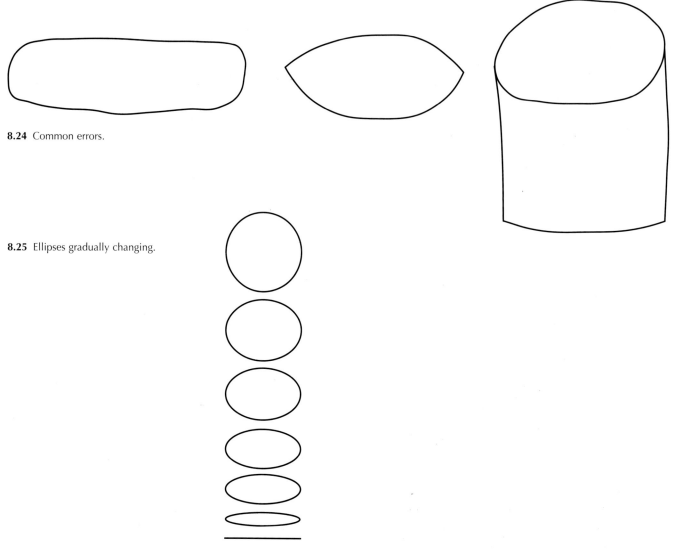

8.24 Common errors.

8.25 Ellipses gradually changing.

PROJECT 49

Learning to Draw Circular Forms in Perspective

MATERIALS: Bond paper, black felt-tip marker, soft graphite pencil, thin cardboard, scissors, masking tape.

Since ellipses are the result of circular forms seen in perspective, we will make a series of circular drawing diagrams to aid our learning. Assemble a group of round objects of varying sizes. Ceramic vases, bowls, plates, cups, and clay flower pots make suitable subjects for this assignment. Choose three or four round vessels that offer variation of scale and shape. Place them upside down on the cardboard and with a felt-tip marker trace their circular tops. In order to better understand the structure of ellipses, we will create circular diagrams to aid our perception. Using a ruler, draw a square that tightly encompasses the circle. Then draw bisecting vertical and horizontal lines that divide the square and circle into four equal parts (Fig. **8.26**). Cut the squares out with scissors and place these cardboard diagrams on top of their respective vessels, lining up the traced shape with the openings; secure them with pieces of masking tape. Then arrange the objects in a composition that you find pleasing.

The diagrammed circles, with their horizontal and vertical dimensions revealed, should prove easier to draw. Concentrate on how the shape of the circle is affected by the angle of your vision, how, the more oblique your angle, the narrower the ellipse. Take your time with this exercise and focus on drawing the openings of the vessels in correct perspective. Be aware of the common errors illustrated in Figure **8.24** and avoid pointed ends and sausage-like shapes.

8.26 Circular pattern.

Minor axis

8.27 Ellipse.

Major axis

189

PROJECT 50

Further Practice Drawing Ellipses

MATERIALS: Bond paper, graphite pencil or vine charcoal.

Now that you have a better understanding of the spatial structure of circles and ellipses, you can take the diagrams off the circular objects and draw them unaided. This time arrange some of the round forms so that they lie on their side, angled in different directions. If you still experience difficulty in getting the ellipses to look correct, make this simple diagram on your drawing to check its proportions: map the ellipse in terms of two basic measurements, the major axis and the minor axis (Fig. **8.27**). The major axis is the longest dimension of the ellipse, with the minor axis bisecting it. Remember that the axes always bisect each other at right angles. With the aid of this information, careful observation, and some practice you should soon be able to master the challenge of drawing circular forms in perspective. The student drawing in Figure **8.28** uses the circular and elliptical forms of tires to create an intriguing composition.

8.28 Student Drawing. Anon., San José State University. Charcoal, 26 × 40 in (66 × 101 cm).

At this point the thought of working in perspective should prove far less daunting than it seemed at the beginning of the chapter. You now have a much broader knowledge of perspective and realize that it is not just a system based on complex mathematical calculations but a logical and remarkably expressive means of describing forms and ordering space.

(opposite) William Kentridge, Drawing from *Felix in Exile*, 1994. Charcoal and pastel on paper, 47 x 59 in (120 x 150 cm). Courtesy, Marian Goodman Gallery, New York.

—PART III—
CREATIVE EXPRESSIONS

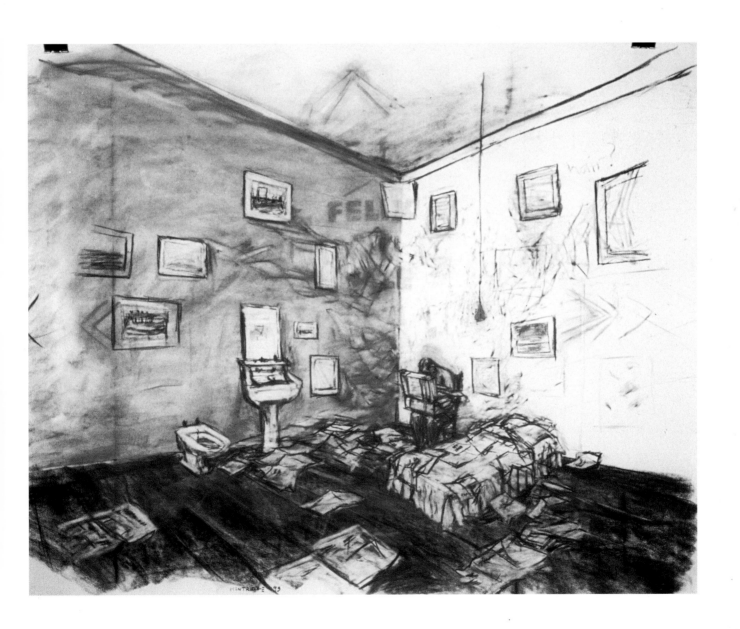

9 CREATIVITY AND VISUAL THINKING

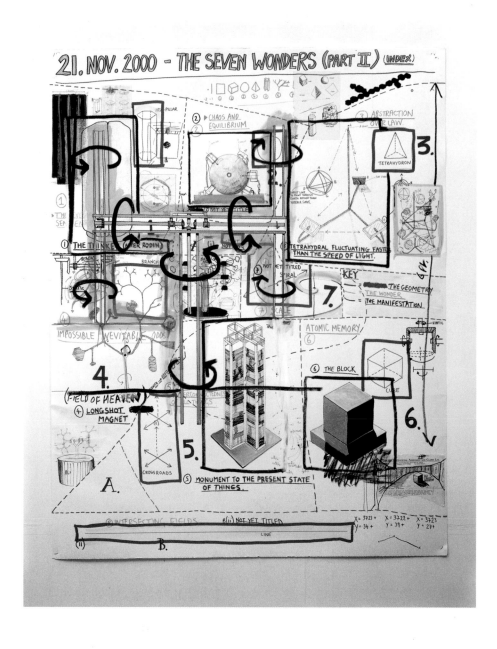

This is a short chapter, not because the issue of creativity and visual thinking are peripheral to the drawing process – the opposite is true – but because we are focused on doing creative work rather than learning about it from a strictly theoretical point of view. In this chapter we will examine creativity as a process that can be learned and put into practice. Through a series of drawing experiences and exercises we shall aim to expand our knowledge of how anyone can approach the creative process openly and with success. Now that you have gained some experience with fundamental drawing techniques, it is time to apply these skills toward personally meaningful and creative goals.

9.1 Keith Tyson, *The Seven Wonders (Part II) (Index)*, studio wall drawing, 2000. Mixed media on paper, 61¾ × 49⅝ in (156.9 × 125.9 cm). Courtesy, Anthony Reynolds Gallery, London.

KEITH TYSON

As an example, or model, of creativity let us take a look at how one particularly inventive visual artist thinks and responds. Keith Tyson, a thirty-two year old British artist whose work appeared in the prestigious 2001 Venice Biennale, creates imaginative pieces that deal with the relationship between art and technology. Tyson believes that his art can function in a variety of seemingly incongruent realities: magic and science; the realms of free will and absolute determinism. Often in Tyson's art exceedingly logical conclusions are drawn from illogical postulates. For instance, he has created a series of what he calls "spell books." *The Wine of Life Swapping* "spell changes" an ordinary bottle of wine into a potion with great powers. According to this spell book, whenever you drink from this magically transformed wine "the world is destroyed and everyone is reborn with a new set of memories." Tyson likens belief in the power of this wine to a child's wondrous belief in magic, often discarded as foolish and irrelevant when one reaches adulthood. Creative people seem to share a highly developed sense of play and an ability to believe in the apparently implausible.

His creative activity moves easily beween spell books and a computer-assisted piece he called "Artmachine." Using special software, Tyson developed a semi-computerized algorithm that was designed to search worldwide information databases and write what he called "iterations" – artmaking processes that Tyson would sort through, edit, and do his best to fulfill. Many "iterations" were impossible to realize but others were quite specific and concrete: Artmachine issued instructions to create a sculpture, leave it submerged on the seabed for sixteen yeas, then raise it, seal it, and paint it gloss white. "My work is fundamentally a kind of research," the artist explains, "and my current project, *The Seven Wonders* (Fig. **9.1**), experiments with certain scientific and philosophical concepts I find wondrous" (*Artforum*, April 2001, p. 113).

This drawing, which the artist subtitles *Index*, is indeed a synthesis of the kind of interdisciplinary thinking that he pursues. It teems with diagrams and phrases that allude to scientific theories and it gives visual form to the invisible forces of the physical world and universe: "chaos and equilibrium;" "atomic memory;" "the geometry, the wonder, the manifestation" (*Artforum*, April 2001, p. 13). In Tyson's mind this drawing does not just illustrate the realities of our world – the work of art is a veritable manifestation of them. He does not create an impenetrable boundary between his cerebral construct and the physical reality of the world – they are viewed as mutually interdependent.

Tyson is committed to the concept that drawing *The Seven Wonders* will subtly but surely change the world – mind influencing matter. Before creating this piece he performed an art action that clearly expressed the concept of "causal interconnectedness." One morning, just before rush hour in a Central London train station, he bought all the newsstand's morning newspapers, "denying the commuters their

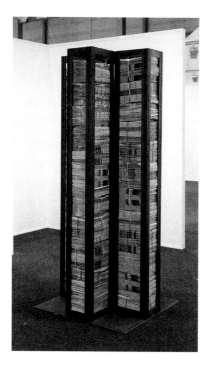

9.2 Keith Tyson, *Monument to the Present State of Things*, 2000. Steel and newspapers, 10 ft × 3 ft (2.5 × 0.9 m). Courtesy, Anthony Reynolds Gallery, London.

papers and subtly changing the course of their lives." Tyson titled the resultant piece *Monument to the Present State of Things* (Fig. **9.2**) and went on to discuss its implications: "Newspapers record history, and my removing them fractionally changed history – though some scientific theories suggest that time is all worked out; it could travel either way, if it weren't for entropy" (*Artforum*, April 2001, p. 13).

The creative impulse behind Tyson's work stems from a love of ideas and wondering "what if." For him, boundaries exist only to be crossed and recrossed until the original divisions are obliterated. Tyson has developed a way of thinking – we might call it creative displacement – that defies logic and embraces the improbable. "The thing I love about art," he discloses, "is that unlike science, it's tolerant of contradictions. I can work in whatever paradigm I choose – psychoanalytic, magical, spiritual, whatever. It's not about whether cultural systems 'explain' scientific theory or vice-versa – I'm dead against either-ors; I'm a great embracer of complexity, grayness, fuzzy logic. Loose parameters always lead to more interesting results" (*Artforum*, April 2001, p. 13).

The rest of this chapter explores many aspects of visual thinking and creativity, with suggestions of ways in which you can develop your own visual creativity.

INSIDE THE CREATIVE PROCESS

While no one can teach you creativity the way you were taught multiplication tables or the rules of grammar, it is a learnable thought process that responds favorably to practice and application. In the first place creativity is not the exclusive property of the arts. Everyone comes up with creative problem-solving in the face of difficult situations. We are going to focus on the kind of creative thinking that can be applied to the drawing process.

Many books and studies have been written about creativity, some of them offering rather muddled advice on how to approach it. But when extraneous and redundant elements are filtered out, it is generally agreed that there are four sequential stages to the process of creativity and problem-solving: preparation, analysis, incubation, and evaluation. Here is a brief outline of how each stage functions and how they might relate to the practice of drawing.

Drawing skills and technical competence are essential elements to creative work. Preparation gives us the necessary tools to do meaningful work with the language of drawing. Even if we had great ideas for drawing we would need the means to express them. Learning to build on basic skills is an on-going activity – we never arrive at an ultimate level of accomplishment.

Analysis takes place on both a conscious and unconscious level. While you are in the act of drawing you are lost in a consuming process of holistic thought and reflexive response. If you have developed some drawing skills you use them in an unconscious way as you adjust, correct, and direct your drawing efforts with seemingly little conscious thought. It is like driving a car. When we first learn to drive we are very conscious of steering, speed control, and braking, as if they were separate entities. After we have gained some experience, these functions become synthesized, almost automatic – our unconscious mind assumes much control. On a conscious level, analytic thought comes in to play. When a drawing is complete or is at a decisive stage, we consciously ask ourselves such questions as should this section be darker?; should another passage be added?; could the composition be improved? And if we are working on a series of drawings, we analyze the outcome of a particular drawing in terms of the direction of the group.

If you are developing new ideas or wish to change the compositional direction of your work, the incubation stage can be invaluable. This is when you stop

consciously thinking about how to solve a problem. Take a few days away from the problem, work on an unrelated task, give the autopilot of your mind free reign. The chances are that after a break, a suitable solution presents itself. This "time out" is necessary for the mind to unconsciously sort out, process, and pull together all the information it is dealing with. Creativity favors persistent efforts over time.

The last phase, the evaluation, or critical response phase, is best applied after the completion of a group of drawings. To use this stage of the creative process too heavily while you are actively working might interrupt your drawing rhythm and impede your flow. Another reason to avoid critical evaluation during the active drawing stage is that you might become too judgmental, get discouraged and find it difficult to continue. Smooth, creative flow is dependent on forging links: relating drawing to concepts, media to tasks, and process to outcomes.

These stages of the creative process are inevitably circular in nature. Evaluation, rather than being the end of the process, leads back to the drawing board and further efforts. Learn from your work. What went right? What went wrong? What should we do about it? This is a life-long process of discovery and invention. Reinvent your drawings in a systematic way; let your drawings redefine you.

CREATIVE THINKING ZONES

Experts who have studied the creative process from a variety of angles insist that one of the key attributes of people who consistently do creative work is their ability to combine and juxtapose ordinary things in extraordinary ways. It's as if these people are seeing what we all see (or perhaps do not see), but are thinking about and interacting with these things from different vantage points. They seem to be able to operate from within a different "zone" or perceptual state of mind. Here are seven creative thinking zones that you can enter and perhaps profitably benefit from.

WHO ARE WE? ZONE

A large part of what defines us as humans is that we are constantly on the move and lookout for opportunity. This was true in the distant past and is perhaps even more of a reality today. Sometimes that means leaving what had been our home and beginning a new adventure in a new land. Even Native Americans originated elsewhere: they crossed a frozen land bridge in the Arctic some thirty-five thousand years ago. Two compelling questions engage every living person: who are we and where did we come from? To explore your own self-discovery zone, it is helpful to talk to family members, gather old photographs and stories, view family mementos. Get on the internet, go to the library, look at maps and read articles about your ethnic heritage. Use this visual and conceptual information to create a series of drawings. Photos of grandparents, great-uncles and aunts, or your parents as children, make particularly good starting points. Juxtapose your life with what you imagine of these earlier lives.

Arshile Gorky (1905–48) made use of this creative zone when he drew *The Artist and his Mother* (Fig. **9.3**). This drawing had much to do with his growth and maturation as an artist. Gorky arrived in America as a fifteen-year-old penniless immigrant from Armenia in 1920. At that time he was called Vosdanig Mahoog Adoian; he later changed his name to Arshile Gorky (Gorky is the Russian word for "bitter") and went on to become one of the most influential artists of the New York School of painting. This drawing was based on a photograph of young Vosdanig with his mother; it was

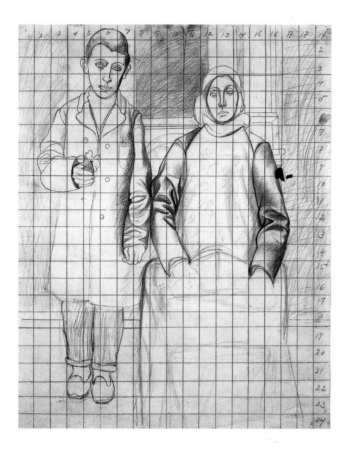

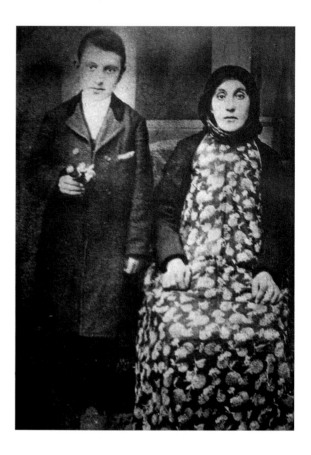

9.3 (left) Arshile Gorky, *The Artist and His Mother*, 1926–36. Graphite on squared paper, 24 × 19 in (60.9 × 48.2 cm). National Gallery of Art, Washington, DC. Ailsa Mellon Bruce Fund.

9.4 (right) Photograph of Gorky and his mother, Armenia, 1910.

made to be sent to the artist's father, who had already moved to America hoping to make enough money to bring his family to the new world (Fig. **9.4**).

What is your story about? What family concerns are important to you? Drawing can help you discover and celebrate your uniqueness.

TRANSFORMATION ZONE

While you are in this state of mind you should be focused on change. Think reverse ground drawing (white chalk marks on black paper), change formats, draw things upside down, draw rain on a sunny day, change day into night, change perspectives, change line qualities, change drawing instruments (make your own), and change tonal structures. Why should drawings be on paper? Why should we draw on a flat piece of paper? Draw on three-dimensional objects. Transform your beliefs about drawing. Transform objects, space, reality. What would your drawing be if it could be anything it wanted to be?

NEW USES FOR OLD ZONE

Our contemporary world is largely defined by market forces and their products, many of which seem to have a very short shelf-life. This means that the field of solid waste disposal is on the cusp of both scientific and cultural relevance. As an exercise in cultural anthropology and creative pluralism, take your notebook around with you for a week, noting what is thrown away and jotting down ideas about how to use these things in new ways. Make drawings of how you would creatively recycle these discards. Humor might be a potent ingredient in this zone.

American Earthwork artist Robert Smithson (1938–73) thought a lot about aesthetic recycling. He envisioned his art as a "resource that mediates between the ecologist and the industrialist. Ecology and industry are not one way streets," he wrote, "rather they should be cross-roads. Art can help to provide the needed dialectic between them." In the last two years of his life (he died in an airplane crash while viewing one of his Earthworks) he presented proposal after proposal for land reclamation projects to a variety of giant corporations who had devastated the land-scape – U.S. Steel, Kennecott Copper, Union Carbide – all to no avail. Along with these carefully worked out proposals came drawings that graphically described the transformation of ruin into art. Figure **9.5** is a multimedia drawing that was part of a reclamation project for the Bingham Copper mining pit in Utah. What visual proposal could you devise for an environment badly in need of transformation?

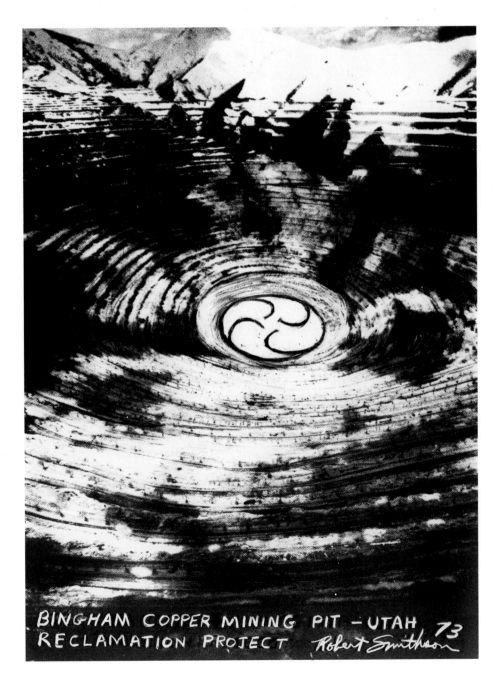

9.5 Robert Smithson, *Bingham Copper Mining Pit – Utah Reclamation Project*, 1973. Wax pencil, tape, plastic overlay, photostat, grease pencil, tape. The Metropolitan Museum of Art, New York. Estate of Robert Smithson. Courtesy, James Cohan Gallery, New York.

MUSIC ZONE

No one can dispute the power of music to affect our thinking. Most people have had the experience of a popular song, for example, staying lodged in the mind – at least until another "hit" comes along. The contemporary Austrian writer Peter Handke, in his novel *Short Letter, Long Farewell*, chronicles a group of European tourists traveling through America. They were amazed at the way rock music and "oldies" were constantly played in car radios and in restaurants. One of them commented that these popular songs are like hymns in terms of the way they embodied beliefs and expressed sensibilities. You have hymns enough for a lifetime, he told his American friends.

Listen to your favorite popular song. Why do you think it strikes a chord in you? Make several drawings that express the meanings of the song. You can be literal or abstract, narrative (linear) or descriptive (work with simultaneous imagery). Project yourself into it. Choose some larger-scale music, whether symphonic or jazz, and respond to it with lines, forms, colors, and textures that relate to the musical rhythms and harmonies. Let the music dictate the form.

MAP ZONE

A map is a diagrammatic representation that can serve as a guide to an area as large as a continent, country, or town; as a conceptual construct, it might not involve physical scale at all, for example as a blueprint illustrating processes as complex as thinking. The map is not the territory – it helps us comprehend the territory. Use this zone to invent an elaborate world of interrelated occurrences that unfold simultaneously on paper. Devise a visual map that helps you achieve some goal in your life. Build in uncertainty and dead ends. Use the map to figure how you will overcome obstacles and reach your goals.

Keith Tyson's *Seven Wonders* drawing (Fig. **9.1**) is a diagrammatic map of sorts. You could create a visual map to explore any field of study you are engaged in. Remember a map uses symbolic visualization to represent a two-dimensional model of something; it is therefore unlikely to consist of a single image.

MAGNIFICATION ZONE

This zone calls for a sharpening of your perceptual ability. Imagine yourself the size of an ant making your way through a lawn. Imagine you are a blade of grass in a forest of green stems. Imagine yourself as a drop of dew on one of the blades of grass. Albert Einstein (1879–1955), while he was developing the theory of relativity, imagined what it would be like to ride on a beam of light at the ultimate speed that anything in the universe can travel at. Strange things would happen. Time would almost cease to function or at least your Swiss watch would be dramatically slowed down relative to the same watch ticking away in Geneva (Einstein's famous equation, $E = mc^2$, emerged from this creative thought). Creative visualization was essential to the development of what was arguably the most important scientific discovery of the twentieth century. Einstein had changed our fundamental understanding of time and thus changed the way we viewed the universe and how it functioned.

Look at the ordinary things around you through an ordinary magnifying glass: new textures and hidden structures are revealed; new visual identities are perceived.

Let this experience transport you out of the realm of ordinary perception into an imagined world of your own making. Now that you see ordinary things in a new light, what kind of drawings would you make?

THE FUTURE ZONE

This zone is limitless. It is pure negative space waiting to be filled by our positive presence. Make it happen. Life, death, new forms of entertainment far beyond computer games – all of these possibilities float about unanchored by any sense of certainty. Now is the time to join Keith Tyson in his love of "grayness and fuzzy logic." Anything is possible. Allow yourself to be captivated by the most improbable imaginings. Drawings are not photographs – they are pure and simple products of the mind, visions that seek the truth through the manifestation of beautiful illusions. As Picasso proclaimed, "art is a lie that tells the truth." What sort of "lies" interest you?

In 1929 the architect Raymond J. M. Hood created a visionary drawing of how New York City might look in the future (Fig. **9.6**). Hood was concerned about the building boom in New York and the ever-increasing traffic congestion. His plan makes extensive use of overpasses and underpasses that would allow the unimpeded flow of cars and people. This imaginary, wide-angle view of four enormously

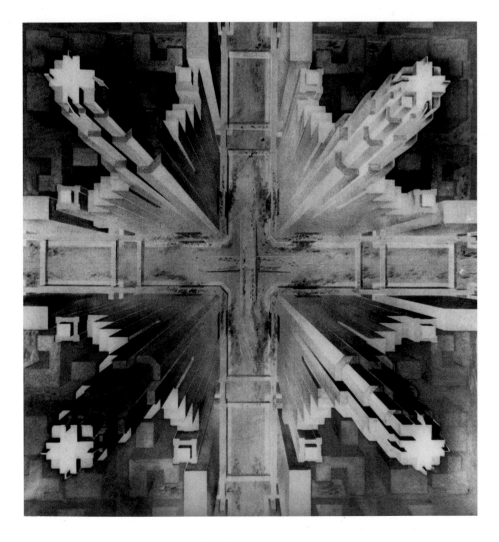

9.6 Raymond J. M. Hood, *A Busy Manhattan Corner: Aerial View, Visionary Plan*, 1929. Watercolor, 7¾ × 7⅜ in (19.7 × 18.9 cm). New York Historical Society.

high towers captures the essence of the twentieth century's premier city. And, while Hood's concept of hidden roadways never materialized, his drawing still has an immediacy and tangibility that prove haunting even in the actual future that the architect hoped to influence.

Now is the time for you to invent your own creative zones. You can do this by devising new belief systems through expressions of your personal values and special interests. Take us with you, show us that you "see." The creativity that defines you as a unique person in a crowded world is waiting to emerge. Name it, draw it, become it.

9.7 Leonardo da Vinci, *Flying Machine*, 15th century. Scala, Florence.

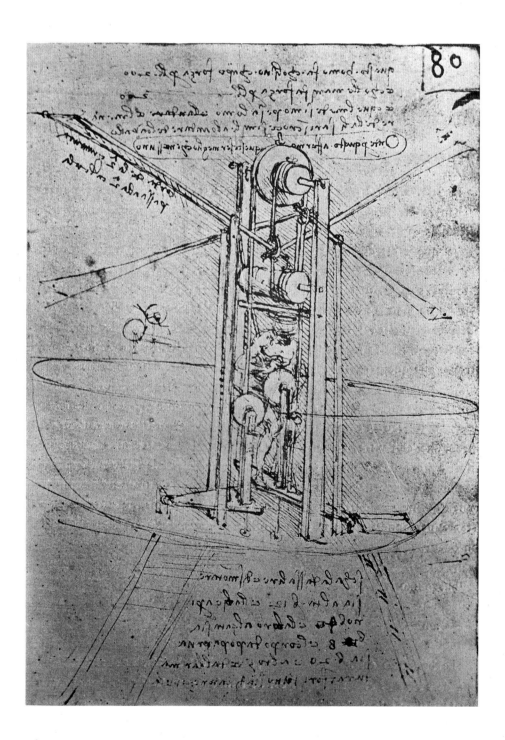

OVERCOMING CREATIVE BLOCKS

Everyone at some time or another has faced the frustration of staring at a blank piece of paper, not knowing how to get started. Face it, this happens to a lot of people, even celebrated artists. Failure and uncertainty are intimate friends of the creative process. These faceless monsters must be transformed into allies that guide us toward successful outcomes. There are some strategies we can make use of, however, to overcome these obstacles and help us realize our creative potential.

Basically there are three major blocks that inhibit creative problem solving:

- Emotional Blocks
- Perceptual Blocks
- Cultural Blocks

Perhaps the most common is the emotional block, when fear of failure and insecurity sabotage our efforts to succeed. Emotional insecurity is probably the most crippling and all-encompassing obstacle to creative solutions. Too often when the end product does not meet our expectations we are discouraged to the point of paralysis and defeat. For this reason your drawing efforts must focus on the process, not the product. You must concentrate on the tasks at hand and suspend critical judgment of the results. Paradoxically, the more you forget about making the perfect drawing, the better your work will become.

The perceptual block is a result of failing to understand the problem or missing potential solutions because the conventions of our thinking limit our perception. Try to see the nature of the problem with fresh eyes. Assumptions in our mind override that part of the brain that is willing to play with new ideas or to try new strategies. Often when we approach a problem with conventional, rigid thinking, it is difficult to find a solution. The process of drawing has long been used to sharpen perception and aid creative thinking.

Cultural blocks have to do with an excessive need for conformity and with the limits social constraints place on our thinking. Hundreds of years before "rational" people even dreamed of human flight, Leonardo da Vinci made a drawing for a flying machine (Fig. **9.7**). Through an ingenious feat of imagination, he envisaged a device that would take mechanical advantage of the fact that air was really like an ultra-thin liquid. Screw propellers had been invented for some time and propelled a boat through dense, liquid water. Why couldn't a similar device propel us through air? Since air cannot be seen, Leonardo depicted it in this drawing through closely spaced diagonals surrounding the propeller blades of his machine. Once air was visualized, or relabeled as a tangible substance, it was possible for the artist to conceive of a screw mechanism that would pull the machine upward, just as a propeller moves a ship through water.

The following puzzle illustrates the perceptual limits we place on thinking. Without lifting your pencil off the paper draw no more than four straight lines that cross through all nine dots below.

The solution can be found in Appendix II, but try solving this puzzle before you look it up.

A surprising number of people are unable to solve this puzzle, in large part because of their preconceptions. The instructions say nothing against going beyond the parameter of the dots, yet to succeed with this puzzle you must draw some lines well beyond the outer edges of the dots.

When you feel you have reached a perceptual barrier it helps to revitalize your thinking with a process called "brainstorming."

BRAINSTORMING /ONE

Brainstorming is a technique for creative problem-solving that is widely used today by everyone from business people to scientists and artists. One of the primary rules for brainstorming is to initially avoid any prejudgment. First define the issues in your mind – perhaps you have run out of stimulating things to draw, or you want to embark on something more adventurous than you have attempted so far. Write down every idea that comes to mind, even those that might appear ludicrous (it is surprising how often seemingly foolish thoughts can lead to creative results). When you have a substantial list of ideas, select your favorite ones and map out how you would implement them.

To a certain extent, how we think and what we believe in is determined by a set of cultural limitations: the pervasive environments of family, school, and society greatly modify the way in which we behave. In order to do creative work in general you must be open to new possibilities and develop flexible attitudes and ways of thinking. Studying the drawings of cultures outside our own sphere of experience and learning about their beliefs and customs helps us expand our world and enriches our being. Stepping outside our cultural world even helps us understand the nature of our own society on a more profound basis.

CREATION MYTHS /ONE

All civilizations have creation myths, and most cultural historians would agree that these are the most important of all myths, for they are concerned with the ultimate meaning of everything, not just on this planet but in the entire universe. Find out what other civilizations, both past and present, believed was the way in which the world and its inhabitants were created. There are many distinguished books by anthropologists, philosophers and theologians, of many religions that explore this fascinating field. I recommend Marie-Luise von Franz's *Creation Myths* (Boston: Shambala, 1995) in particular.

After reading about how various cultures believe the world was formed, look at the artworks these societies have produced. Are their basic beliefs reflected in their works of art? Choose one or two creation stories and do a series of drawings that expresses these belief systems. Diversity of thought is a hallmark of creativity. Our knowledge of past and present cultures represents a vast storehouse of information, which can lead to new ways of thinking about age-old problems.

If you are not already familiar with them, do some research on current scientific theories about the creation of the universe. Can they be considered modern creation myths? Make some drawings that deal with the "Big Bang" and "Steady

State" cosmological theories. Come up with your own creation myths and develop them diagrammatically on paper.

Here are more practical things you can do when you think you have reached a creative impasse.

- Instead of waiting for inspiration to emerge out of the blue, set up a reasonable work schedule and stick to it. Good work habits cut through temporary blocks. Suspend some of your judgment about what is successful.
- Determine if the problem is physical. Perhaps lack of sleep and a heavy work load are taking their toll. Take a break and do something you enjoy.
- Show your drawings to a friend and describe what you were trying to achieve in each one. In the process of telling someone else what is important, you will also clarify your aims to yourself.
- Go to gallery exhibitions of contemporary art and visit museums to look at their drawing collections. Spend an afternoon at the library going through art and drawing books. There is always something to learn. Seeing stimulating work gets your own creative energy flowing.
- Take a past drawing that you feel is unsuccessful and "deconstruct" it by cutting it up and rearranging sections along with additional lines and shapes.
- Transform an old concept into a new beginning. Recycle drawings, ideas, attitudes; regenerate energy.

Now that you have explored some new perspectives of thinking we must continue to apply our efforts toward personally expressive drawings. The next three chapters focus on issues such as the role of color in drawing, traditional themes, and the thematic development of ideas.

10 EXPLORING COLOR

Color has always been one of the most powerful elements of the visual arts. Usually, one of the first things we notice about a work of art is the overall effect of its color. Because of technological advances in communication media such as television, film, and magazines we have come to expect color visuals as a matter of course. Partly in response to this heightened presence of color in the media, and because of the availability of many different color drawing instruments, artists today often make use of color media as an integral part of the drawing process.

LIGHT AND COLOR

Professional interest in the phenomenon of color is not limited to the visual arts. Scientists in the disciplines of physics, physiology, and psychology are concerned with exploring such issues as the physical behaviour of light, the way color is perceived by the optical system, and the effects color has on our feelings and moods. Since we are concerned with the way color enhances the drawing process, we will explore this phenomenon from an aesthetic and visual point of view.

Compared with other visual elements such as composition, line, and texture, color is perhaps the most intuitive and personally expressive visual element you will work with. Attempts to formally analyze and codify how color affects us produce dubious results: blues, for instance, can be perceived as restful and soothing as well as expressing an emotional depression. Because of the wide range of individual associations we bring to any work of art, our response to color varies significantly.

An important concept to keep in mind when working with color is its ephemeral nature. Color does not exist in any material form like charcoal and paper but is entirely a product of light. When we talk about colors we are really referring to our physiological perception of colored light. Light is a visible form of electro-magnetic radiation and its frequency, or rate of vibration, determines what color we perceive. Sunlight, or "white" light, contains all the colors of the rainbow. This can easily be proven with a simple experiment. When sunlight passes through a glass prism, it is separated into the full spectrum of colors – violet, indigo, blue, green, yellow, orange, and red.

The way our visual system perceives colored light is somewhat mysterious. When light moves through space and enters the inner eye, it is converted into electro-chemical energy by retinal receptors, which then transmit encoded impulses through the optic nerve. Finally, the brain processes and interprets these signals in complex ways that are still not fully understood.

(opposite) Jasper Johns, *Cicada*, 1980. Ink and oil on plastic, 30⅛ × 22½ in (76.5 × 57 cm). Collection of Frederick M. Nicholas, California. Courtesy, Leo Castelli Gallery, New York.

204

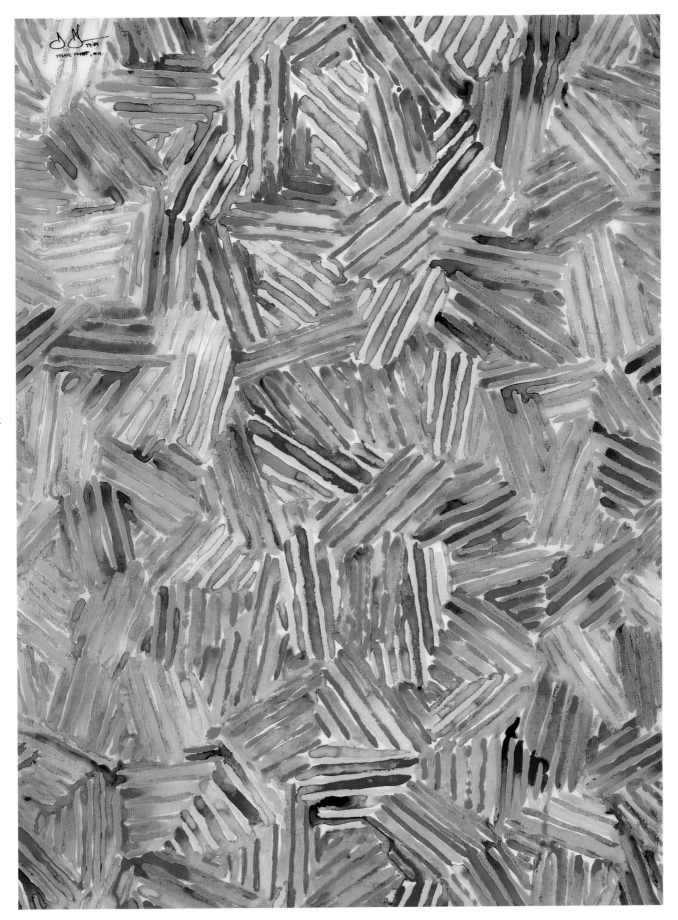

DEFINING COLOR

In order to discuss and meaningfully work with color, artists need to have an accepted vocabulary and labeling system to be able to compare and contrast the interaction of various colors. For centuries individual artists evolved personal color systems and theories which they applied to their work with varying degrees of success. It was not until 1905, however, when Albert Munsell, an artist with a keen interest in color organization, published a standardized, workable system of color description and notation.

COLOR THEORY

Munsell knew that it would be pointless to describe how colors interact if the essential elements of color could not be isolated, defined, and named. Using as a model our standardized musical notation system, which defines sounds in terms of pitch, intensity, and duration, Munsell determined that color had three distinct dimensions which we call hue, value, and intensity. He refers to the specific name of a color such as red, yellow, or blue. A circular arrangement of colors called the Munsell *color wheel* (Fig. **10.1**) is used by art professionals to display the twelve major hues artists work with.

Value is a term that refers to how light or dark the color is. Chapter 5 also deals with value but that chapter focuses on the lightness and darkness of the color black. When white or black pigments are added to a color this affects its value (Fig. **10.2**). Values of the color red can be expressed as a light pink or a dark maroon.

Intensity is a term that describes a color's degree of *saturation*, or strength. Red, for instance, can be made more vividly or less vividly red. If we added some gray to a pigment we would be lowering its intensity (Fig. **10.2**).

The *primary colors*, red, blue, and yellow, are the basic colors that cannot be mixed from any other. The *secondary colors*, orange, green, and purple, are created

10.1 The color wheel, showing the primary colors (1), the secondary colors (2), and the tertiary colors (3).

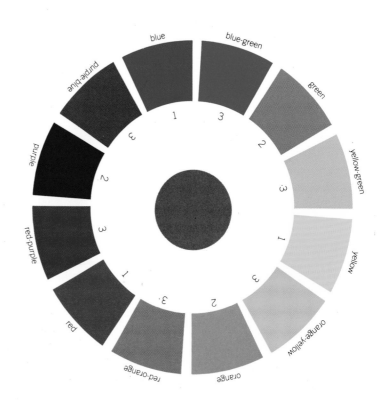

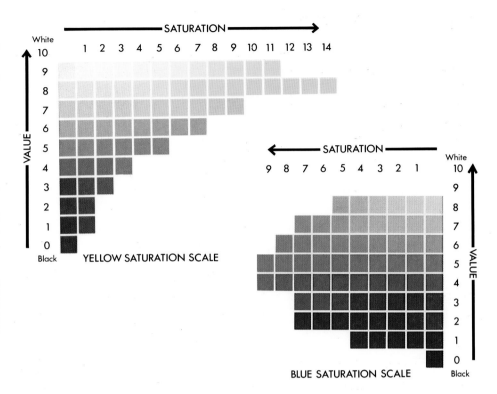

10.2 Value and saturation scales for the colors blue and yellow.

by mixing together two primary colors on the color wheel (Fig. **10.1**). These six colors form a concise and elementary range, but by mixing adjacent primary and secondary colors in varying amounts (and with the addition of white and black), we can create almost limitless *intermediate* or *tertiary* hues.

Complementary colors are those colors that are positioned opposite each other on the color wheel (red and green, blue and orange for example). The juxtaposition of complementary colors in artworks can have startling effects.

Two more important terms that we should become acquainted with before we start to work with color media are "warm" colors and "cool" colors. Yellow, orange, red, and red-purple are examples of warm colors. Green, blue, and purple fall into the cool category. Basically if you divide the color wheel in half horizontally, the colors on the bottom of the wheel would be considered warm and the colors on the top would be cool.

This is just a rudimentary guide to the terminology and theory of color, but it is an important prelude to understanding and working with this involving visual element.

SKETCHING WITH COLOR

Before your plunge into the use of full-spectrum color you might want to consider the dictum that "less is more." In other words, start by experimenting with one or two colors as you might use charcoal or graphite. The choice of paper will be very important; it will determine what ground color will interact with the color media you use. You might want to explore tinted papers that come in a variety of muted colors suitable for drawing with either monochromatic instruments or a variety of hues. An off-white paper – perhaps a natural buff or a tan color – will go well with your color media. Consider preparing your own tinted paper. To do this you will need some heavy-weight rag paper and thinly diluted watercolor paint. Degas prepared his own pink-toned paper for this sketch of a ballet dancer – one of his

10.3 Edgar Degas, *Dancer*, c. 1880. Pastel, 15 x 11 in (39.4 x 27.8 cm). Louvre, Paris. Photo: J. L'hoir.

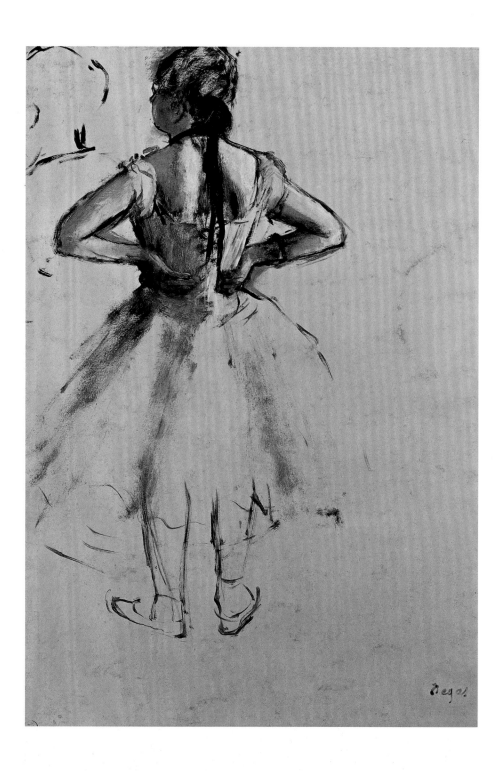

favorite subjects (Fig. **10.3**). With great economy of means, he used only three colors in this masterful study: dark black-brown hues for the main body; pale green-blue highlights on the upper torso; and the distinctive pink of the paper. Note the subtle dry brush passages in the skirt that combine with the dark browns and light green-blue colors to create a wispy look, an effect achieved by applying the oil colors with a bristle brush.

Weather permitting, try sketching out of doors on tinted charcoal paper with pastel or colored pencil. If you have access to a life-drawing class, choose a heavy-weight paper and try an oil or gouache sketch, using a very limited palette.

COLOR MEDIA

The list of color drawing media available to contemporary artists today is staggering. Along with traditional materials such as pastels and watercolors, newly developed tools such as water soluble felt-tip markers, oil pastels, colored pencils, and hybrid media of all kinds are used by the modern artist. Few art professionals feel limited to the use of any single color medium, and it is common for artists to combine a variety of materials in personally expressive ways.

When working with color drawing media in this chapter, do not disregard the basic drawing practices you have already mastered. Using the element of color in conjunction with the sound drawing principles you have been using for some time will enable you to enhance the expressive range of your work.

Color drawing media can be divided into two categories: dry and wet. Colored pencils, crayons, pastel and oil-stick crayons are among the most widely used dry materials today (and perhaps the easiest to control). These instruments can, for the most part, be applied just as you would graphite and charcoal. By overlapping with

10.4 Paul Gauguin, *Tahitian Woman*, 1891–3. Pastel on paper, 15⅜ × 11⅞ in (39 × 30.2 cm). The Metropolitan Museum of Art, New York. Bequest of Miss Adelaide Milton de Groot. #67.187.13.

different colors, special *chromatic* effects can be obtained. Pastel, for instance, can be applied, smudged with your fingers, fixed with an aerosol fixative (be sure to observe the health precautions outlined in Chapter 2) and drawn over to achieve rich and varied color effects.

When Gauguin went to Tahiti to escape what he felt were the old and stifling conventions of Europe, he discovered a world of lush and dazzling color quite different from his native France. In this pastel drawing of a Tahitian woman (Fig. **10.4**) Gauguin contrasts the shiny black hair and warm brown flesh tone of his model with an almost fluorescent passage of hot pink in the upper right. Gauguin took color far beyond naturalistic concerns and used it for symbolic effect. The pink that appears in this drawing (and regularly in his Tahitian series) seems to symbolize the lost paradise on earth Gauguin sought in these warm tropic islands. While the drawing is of an individual woman, it also can be read as the portrait of a proud group of people Gauguin found living in harmony with their environment.

Many colored drawing instruments can be used just as you might use *monochromatic* materials such as graphite and black crayons, producing drawings in which only tonal variations of one color are present. Using colored pencils, for instance, should not prove difficult from a technical point of view. The main challenge here is to make appropriate use of their color properties.

While Frank Stella was working on a series of complex geometric paintings in the early 1960s he made extensive use of colored pencil drawings to work out problems of color design and scale. In his study for *Gray Scramble Concentric Squares* (Fig. **10.5**) he explores themes of central imagery and symmetrical organization. He

10.5 Frank Stella, Study for *Gray Scramble Concentric Squares*, detail, 1967. Pastel and pencil. Öffentliche Kunstsammlung, Basel.

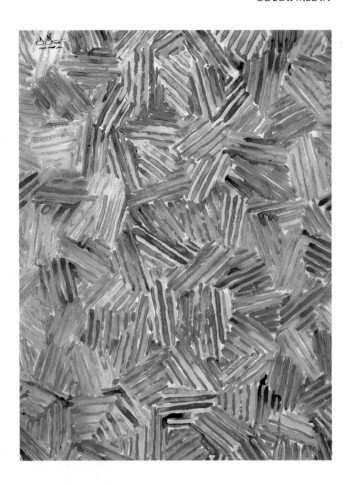

would quickly and efficiently refine his ideas on graph paper before committing them to canvas formats (some of them over 8 feet square).

Color media also come in a wide range of wet forms. Some of the most popular drawing materials in this category are watercolor, gouache, colored inks, and artist quality felt-tip markers. In addition, most forms of paint can be used to draw with by diluting them with the appropriate *solvent* and using a round, pointed brush to apply them.

Watercolor and gouache produce effects similar to those of ink wash drawings. One of the most aesthetically satisfying qualities of watercolor as a drawing medium is its translucency. Eric Fischl (b. 1948) created this large-scale watercolor drawing – 60 inches high by 40 inches across – by first laying on a thin transparent layer of diluted orange pigment (Fig. **10.6**). Once the wash had dried, he established dark black-brown and red-orange passages that defined the form of the figure with pigment-saturated solutions of paint. The body appears to be frozen in mid-action, a quality enhanced by the liquid nature of this drawing medium.

Inks are now available in a full range of colors including some that can be used on sheets of translucent paper. Jasper Johns made use of these special inks on such a plastic support to create *Cicada* (Fig. **10.7**). To prevent the ink from beading on the non-absorbent plastic, solvent is added to the formula. The ink therefore bonds to the surface chemically, rather than being absorbed (as it is on paper), an effect that Johns exploited to produce his subtle interplays of color and pattern.

There are many more materials that can be used for color drawing than we have mentioned here. As you gain experience and confidence, and your personal vision matures, you will probably discover a variety of color media you like to work with.

10.6 (left) Eric Fischl, *Untitled*, 2000. Watercolor on paper, 60 × 40 in (152.4 × 101.6 cm). Courtesy, the artist.

10.7 (right) Jasper Johns, *Cicada*, 1980. Ink and oil on plastic, 30⅛ × 22½ in (76.5 × 57 cm). Collection of Frederick M. Nicholas, California. Courtesy, Leo Castelli Gallery, New York.

COLOR ORCHESTRATION

No hard and fast laws govern the use of color. Color seems to work most meaningfully when it contributes to the visual impact of the drawing and when it achieves personally expressive visual goals. Color is also arguably one of the most emotionally based visual elements, so it might make sense to work with it intuitively rather than in a logical way.

In order to use color effectively, it is necessary to understand some of the factors that affect its usage. Before you begin to explore *full-spectrum color* it is important to understand that you have been using color since the very first day you picked up a stick of charcoal or used a graphite pencil, instruments which produce monochromatic color. Although we will explore the expressive possibilities of multicolored drawing media, be aware that monochromatic color is in no way inferior.

Along with the new visual opportunities of color come new responsibilities. For instance, when more than one color is used, you will have to decide how to relate the colors within the composition. This process of organizing the way colors are arranged in a composition is known as "color orchestration." As we increase the number of colors in our composition, this issue plays an ever more vital role in the organization of the drawing.

An important concept to keep in mind while we explore color is that of *chromatic integration*. Try to use color in such a way that it becomes an integral part of the drawing process. Avoid coloring in a drawing after you have taken it to a state of completion with pencil or pen. A better idea would be to make any preliminary sketching on the drawing with the color media you are using.

Working with the element of color in the drawing process also brings up the issue of quantity. How much of a certain color we use becomes as important as the exact hue and value. In general, drawings that use equal amounts of each color (something beginners have a tendency to do) often become too balanced and static in terms of color orchestration. This is similar to the issue of balance that was examined in Chapter 7, "Composition and Space."

10.8 Pablo Picasso, *Brooding Woman*, 1904. Watercolor on paper, 10⅝ × 14½ in (26.7 × 36.6 cm). The Museum of Modern Art, New York. Gift of Mr. and Mrs. Werner E. Josten.

CLOSE-HUED COLOR

We shall now explore the expressive possibilities that can be derived from the careful exploitation of one basic color and its secondary family of colors. By skillfully varying the value, intensity, and chromatic range of a single color, it is possible to achieve surprisingly rich coloristic effects.

From 1901 until late 1904 Picasso's work focused on human misery and an insistent use of the color blue in a manner that has caused these years to become known as his "Blue Period." His art at this time was largely inspired by his interest in Symbolist concerns, conceptually going beyond issues of realism. In his watercolor *Brooding Woman* (Fig. **10.8**) the blue is associated with dejection and melancholy. Like all the characters portrayed in his "Blue Period," this woman is poverty-stricken, a lonely outcast of Parisian life (Picasso was undergoing his own financial struggles at the time).

Blues range from the palest green-blue to intense blue-blacks and magenta-blues. The color experience is so involving and rich in *Brooding Woman* that we are not immediately aware of Picasso's limited range of color. The compelling mood generated by this drawing is testimony to the effectiveness of close-hued color. Picasso seems to achieve more with less in this evocative drawing and we never feel the absence of other colors.

Compare the palette of Jonathan Dosinee's student drawing (Fig. **10.9**) with Picasso's sober "Blue Period" study: by contrast, this drawing makes use of colors in the warm spectrum; subtle variations of close-hued oranges and yellows prevail in a unified composition.

10.9 Student Drawing. Jonathan Dosinee, Richard Stockton College. Pastel, 25⅝ × 19⅝ in (65 × 49.8 cm).

PROJECT 51

Closely Related Colors

MATERIALS: Bond paper, four of five pastels or colored crayons of closely related colors (a selection of greens or oranges, for example).

Make a landscape drawing and interpret the forms and elements primarily through the means of colors that are near each other on the color wheel (Fig. **10.1**, secondary colors). If the drawing is done in the spring or summer you will need an assortment of green colors. Autumn would probably necessitate using pastels in the orange-red range. When you work with color, think in terms of quantity. Experiment by varying the amounts of each color used. For instance you might use a large mass of one color accented by small amounts of close-hued color.

VISUAL EMPHASIS AND COLOR

While the Dutch artist Hendrick Goltzius (1558–1616) was traveling through Italy, he made several large chalk portraits of artists he met there. His portrait of the sculptor Giambologna (Fig. **10.10**) is a wonderful example of how modest amounts of color can enliven a drawing and create a new visual dimension. Vigorous chalk marks in the body area are juxtaposed with meticulous detail and subtle color washes in the subject's features. Remarkably, although the drawing seems to be in full color, Goltzius achieves his effects with pale reddish and greenish watercolor washes, charcoal, and red chalk. The selective use of color focuses our attention on the features of the sitter and achieves great expressive effects.

10.10 (left) Hendrick Goltzius, *Portrait of Giambologna*, 1591. Charcoal, red chalk, and wash, 14¾ × 12 in (37 × 30 cm). Teylers Museum, Haarlem, Netherlands.

10.11 (right) David Hockney, *Celia in a Black Dress with White Flowers*, 1972. Crayon, 17 × 14 in (43.2 × 35.6 cm). © David Hockney.

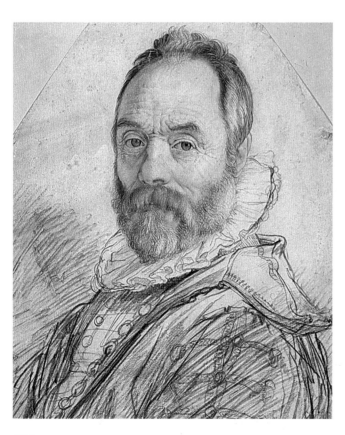

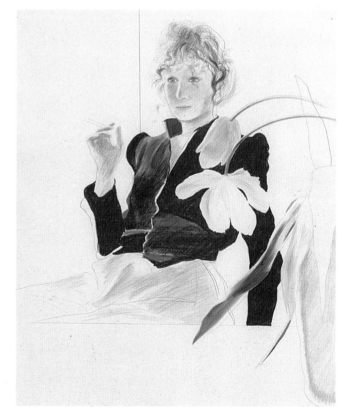

Hockney's *Celia in a Black Dress with White Flowers* (Fig. **10.11**) also makes economic use of color to achieve dramatic results. Large expanses of white paper contrast with dark values of black and green. Hockney reserves the use of the delicate red-blue tones for his model's features and sections of flowers. Note how the use of color is limited both in terms of quantity and variety.

PROJECT 52

Using Colored Pencils

MATERIALS: Bond paper, three or four different colored pencils.

Create a still-life with several objects that offer interesting spatial or compositional attributes. Choose one of the objects to emphasize through the selective use of color. This object, or section of the object, should be highlighted with a more intense or complex use of color. Make sure that other areas of the drawing are defined and compositionally supportive of the entire drawing. The primary objective of this assignment is to use color as a new means of ordering and highlighting visual information.

DRAWING WITH PASTEL

So far we have limited our selection of colors in order to learn how to begin to organize the element of color in our drawings. There are, however, a large number of colors available for drawing and with care they can be used with success. Media such as watercolor, pastels and colored pencils come in an extraordinary range of hues and are capable of producing coloristic effects fully as rich as those of acrylic or oil painting. Pastels, a form of high-quality artist's chalk, lend themselves particularly well to exploring the interaction of color in the drawing process.

Wayne Thiebaud has for years celebrated the visual beauty of commonplace objects in an American environment, for example rows of cakes lined up in a bakery

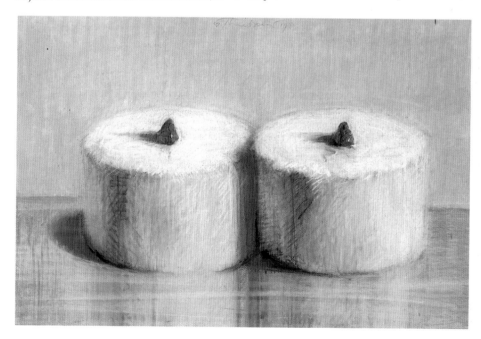

10.12 Wayne Thiebaud, *Twin Cakes*, 1980. Pastel, 16 × 23 in (40.6 × 58.4 cm). Courtesy, Allan Stone Gallery, New York.

window, or gum-ball machines that might be found in a corner grocery store. Despite his choice of ordinary, everyday objects, his visual treatment of them is extraordinary. Witness his pastel drawing titled *Twin Cakes* (Fig. **10.12**), in which full advantage is taken of the pure pigment used in the manufacture of artist's quality pastels (because there is no oil binder used in pastel crayons, the colors are even more vivid than paint). From a ground of pale pinks, greens, and blues, the cakes are set off through the use of shadows created by medium tones of gray and dark blue. Another important color is the bright red which represents the strawberry topping on each cake.

PROJECT 53

Using Pastels

MATERIALS: Tinted drawing paper, selected pastels.

For this assignment you will need some tinted drawing paper from a well-stocked art supply store. These papers come in a variety of light to medium colors such as blue, green, and cream (you might like to purchase a sheet of black paper, which would make a dramatic ground for any pastel color). Also these tinted papers usually have a special "tooth" or texture that makes them particularly well suited for pastel. Using a tinted paper will save you from laboriously coloring the paper in order to avoid the problem of working with subtle color on a glaring white background.

Pastels can be bought either individually or in sets of various sizes. At the very minimum you should have about eight colors covering the primaries and some of the secondaries. One thing to remember when you work with pastels is that they can be mixed and combined on the paper. With an assortment of eight basic colors you have the ability to mix a great number of hues.

Layering is the key to effective work with pastel. Spray fixative used between layers of different pastel prevents the colors from mixing and allows vibrant juxtapositions of complementary hues.

To create an appropriate drawing arrangement for this exploration, go through your closet and select brightly colored articles of clothing. Arrange them on a neutral background – either a white wall or on a table covered with paper or a white sheet. Men's ties with vivid color and geometric patterns make excellent subjects for this assignment. Other articles of clothing, such as women's hats and dresses, or brightly colored tee-shirts arranged on hangers, would be equally suitable. Do not create a wall-to-wall arrangement of colored articles. Using too many brightly colored articles might create an overload of color and diminish the chromatic effect of a few intensely colored objects.

WATERCOLOR AND INK

Watercolor and ink are among the most widely used color drawing media. No doubt their popularity has much to do with their great versatility. Watercolors lend themselves to a variety of drawing techniques and methods: they can be used in large masses or *washes*, or they can create lines.

Italian artist Sandro Chia (b. 1936) makes bold use of watercolor in *The Poetic Image* (Fig. **10.13**). This work also features pencil and charcoal lines but clearly the

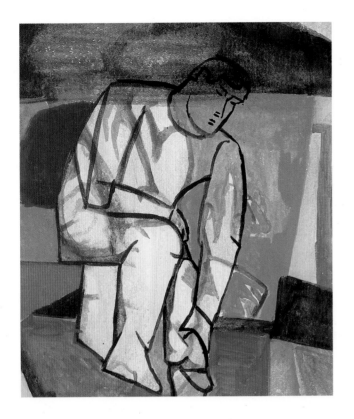

vivid watercolor passages of orange, blue, and green dominate and control the composition. There is a fresh and spontaneous quality to this drawing that takes advantage of the special qualities of the medium. Chia's style has centered on combinations of Classical images (the Roman youth sensually posed) and modernist devices such as the bold geometric shapes of color.

Colored inks are similar to watercolor. Brice Marden (b. 1938) created this study (Fig. **10.14**) in gouache, graphite, and ink, using a basically symmetrical structure of the vertical and horizontal line. But Marden plays with the formality of this composition by allowing "accidents" to happen in a consistent and controlled way. Some lines are regular and drawn with a ruler; others are irregular and transformed into ink splotches. The result is both simple and complex; carefully planned, yet spontaneous.

10.13 Sandro Chia, *The Poetic Image*, 1989. Gouache on cardboard, 22⅞ × 20½ in (58.1 × 52 cm). Courtesy, Sperone Westwater Gallery, New York.

10.14 Brice Marden, *Painting Study 4*, 1984. Gouache, graphite, ink, and oil on paper, 14⅞ × 12⅝ in (38 × 31.8 cm). Courtesy, Mary Boone Gallery, New York.

PROJECT 54

Drawing with Watercolor and Ink

MATERIALS: Rag watercolor paper (140 lb. weight), watercolor tubes of suitable colors and/or colored inks.

This project gives you a wide latitude in terms of theme. We are primarily interested in exploring the special qualities and color interactions of watercolors and inks. One word of caution: if you want to make some preliminary pencil lines to help you block out your composition, keep them light. This might avoid your drawing looking as if it were colored in within the lines. Better yet, do your preliminary sketch with lightly tinted watercolor and a small brush and you will not have to visually integrate a second material within your composition.

PSYCHOLOGY AND COLOR: SYMBOLISM AND EXPRESSIONISM

Color has become integral to the drawing discipline largely because of its capacity to influence our psychological sensibilities. Symbolic and expressionistic concerns are two driving forces in the art world today and the element of color is perfectly suited to communicate wordlessly to us through works of art. Color is now freed, for the most part, from the constraints of naturalism and now plays a central role in the establishment of mood; it is also a primary means of personal expression. The effects of color seem to go directly to the center of our feelings, bypassing logic and conscious analysis.

Perhaps one of the most famous images of the Modern Era is *The Scream* (Fig. **10.15**) by the Norwegian Edvard Munch (1863–1944). This colored oil, pastel, and casein drawing on cardboard is unforgettable for its evocation of anxiety and panic. Every visual element contributes to this emotionally charged state: the madly

10.15 Edvard Munch, *The Scream*, 1893. Oil, pastel, and casein on cardboard, 35¾ × 29 in (90.8 × 73.7 cm). National Gallery, Oslo. Photo: J. Lathion.

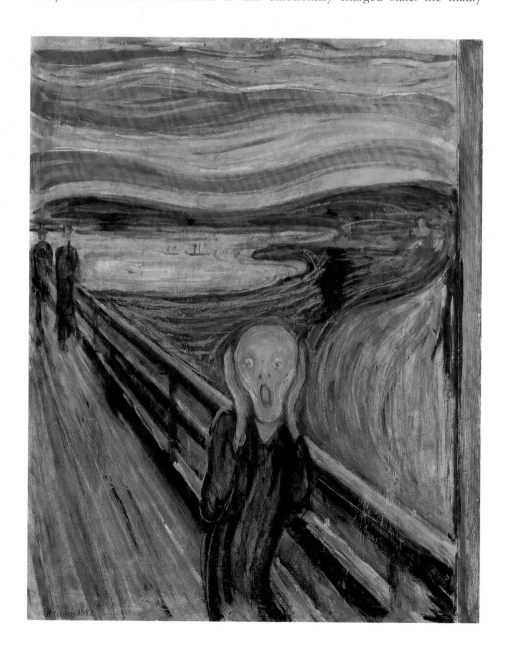

10.16 Emil Nolde, *Evening Landscape, North Friesland*. Watercolor, 13 × 18½ in (33.3 × 47.1 cm). Ada and Emil Nolde Foundation, Stiftung Seebüll.

plunging perspective of the road; the strangely distorted body and head, mouth open in a perpetual howl; the spatially distended and swirling landscape; and the sky, burning and spilling over into the foreground. This is a work of great psychological depth, full of symbolic overtones. Munch himself scrawled across one of his painted versions that only a madman was capable of producing such a work. This is not a landscape, it is an evocation of a state of mind – a very disturbing state of mind. The origins of *The Scream* are rooted in an experience that Munch recorded in his diary. One evening while he was walking with two friends along the Oslo Fiord, he was overcome by a sunset. "I stood there trembling with fright," he wrote, "and I felt a loud unending scream piercing nature." Munch succeeds in translating these feelings onto paper and thus pierces our psyches as well.

Emil Nolde (1867–1956), a German-Danish artist, helped form modern attitudes toward color. Nolde was particularly interested in the way art could be used to create images "more beautiful than anything seen." His watercolor drawing *Evening Landscape, North Friesland* (Fig. **10.16**) glows with colors of such intensity that even the most dramatic of real sunsets seem pale in comparison. The careful control of color relationships creates the effect of a light source that seems to radiate from within the paper, an effect achieved through the manipulation of color and value. Nolde also makes effective use of complementary colors, juxtaposing blues and oranges, reds and greens, and violets and yellows. Despite Nolde's obvious references to the natural landscape, this drawing clearly presents us with an image that goes beyond naturalism and suggests the inner world of the artist's imagination.

10.17 Howard Smagula, *On the Moral Improvement of Mankind*, 1997. Watercolor, gouache, pastel, charcoal, on printed page. 5½ × 9¼ in (13.9 × 23.5 cm). Courtesy, the artist.

PROJECT 55

Imaginary Landscape with Heightened Color

MATERIALS: Watercolor paper, #10 sable-hair brush, watercolors of your choice.

Be sure to purchase a heavy- to medium-weight watercolor paper for this project in order to minimize warping of the paper when the water-laden pigment is brushed on. You may wish to buy individual watercolor pigments in the colors of your choice rather than buy a set.

Before you begin this project, acquaint yourself with some of the structural elements of various landscape drawings. You may wish to make a rough preparatory sketch on separate paper. Put it away, however, when you begin your imaginary landscape.

Work directly on the paper with the watercolor (if you must make some preliminary guide marks, use pencil lines so light that only you notice them). We want to explore the interplay of color masses and tonality, so keep detail to a minimum.

Basically, the landscape motif should become a structural device through which we explore the interaction of color. Begin with light-toned washes, since these can be easily gone over later with darker-toned colors. Keep in mind the mood you are trying to express – this drawing should be read as a color statement rather than a descriptive analysis of trees, hills, and fields. A landscapular space can be suggested by using horizontal shapes of various widths stacked one on top of one another. Take another look at the Nolde watercolor drawing in Figure **10.16** and notice how its basic visual structure resembles the configuration mentioned above.

MIXED-MEDIA COLOR

So far we have discussed and worked on dry and wet color media separately. But there is no reason not to use several different color drawing tools within the same piece. Of course one of the pitfalls to this approach is the possibility of creating compositions that lack unity. But it is worth taking a chance that chaos will rule – you will learn something valuable in the process.

On the Moral Improvement of Mankind (Fig. **10.17**) is a mixed-media drawing I made of a nineteenth-century book page. Considering the heady subject matter of the text, I wanted to work with drawn forms that suggest timeless cosmological states – an almost impossible notion that I allowed myself to entertain. First I transformed the visual identity of the white page with transparent washes of dilute watercolor and gouache. It was important to be able to read through these transparent fields of color. Then I worked charcoal and pastel onto the surface of the page. Three layers of information coexist in a tenuous relationship: the printed text, transparent color fields, and dynamic linear movements created with pastel. The opaque linear passages cover some of the writing on this piece and work in counterpoint to the easily read sections stained with translucent color.

Luis Jimenez (b. 1940) also combined wet and dry media to produce *Homeless Set Adrift (after Géricault)* (Fig. **10.18**), a watercolor and colored pencil drawing that refers to Géricault's *The Raft of the Medusa* (a study for this painting is reproduced in Figure **5.8**). This allusion to an image of people lost and adrift in a raft is used to comment on the plight of homeless people in our society. The people in Jimenez's

10.18 Luis Jimenez, *Homeless Set Adrift (after Géricault)*, 1996. Watercolor and colored pencil on paper, 47½ × 52½ in (120.6 × 133.3 cm). Courtesy, Moody Gallery, Houston.

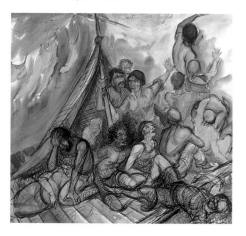

drawing are as lost as Géricault's – adrift and in danger in an American sea of prosperity. The genesis of this drawing reveals the keen social conscience of its maker. In 1996, when Jimenez was examining an outdoor site in Houston for a sculpture commission, he found an encampment of people on the plot. The artist believed that the reason he and other sculptors had been invited to create sculpture for this space was to "clean it up," causing the homeless to be driven away. Jimenez changed his original plans and submitted a proposal for a sculpture depicting people housed in makeshift tents reminiscent of the tattered sail on the raft of the Medusa. The artist succeeds in making the watercolor and colored pencil elements work well together. Loose washes of color establish the basic forms and the colored pencil work describes important details.

PROJECT 56

Mixed-Media Drawing

MATERIALS: 11 by 14 inch pad of heavy-weight bond paper or watercolor paper, an assortment of at least three color media that you will combine in one drawing.

This might be a good time to try using colored markers along with dry materials such as pastel and colored pencil. If you do use markers for this project, be careful about the type you buy. Avoid markers that use hydrocarbon solvents (the kind with a strong aromatic odor). The fumes of these markers are harmful and they probably contain dyes that will fade with exposure to light. Find a good art supply store and seek the advice of a knowledgeable salesperson. The markers you are looking for should have an odorless water base and use non-fading pigments.

Before you start, think about the role each of the colored drawing media might play. Watercolor could be used to establish large color areas and to block out the drawing. Other instruments might be capable of finer detail and so could be used within the broad areas of watercolor wash. Take some chances. Do something you haven't done before. We can never tell where things might lead us.

Always aim for the most efficient use of a limited amount of color rather than attempt to use every color in your possession. Study the work of accomplished colorists and notice that, typically, relatively few colors are used. Each color, however, has probably been greatly varied in terms of value, intensity, and quantity.

The psychological and symbolic effects that can be achieved with color are probably the most compelling reasons to use this visual element in your drawings. By controlling the selection and placement of color, you can greatly affect the way the viewer's eyes move across a picture plane and the way a composition is read. In future assignments keep the possibility of using color in mind.

11 EXPLORING THEMES

Our study so far has been mostly concerned with technical and conceptual issues such as the use of line and value, and on the organization of these elements within the picture plane. Certainly these are important, even crucial, issues for someone learning to draw. But technical mastery and virtuosity alone leave us cold, without the personal insights, obsessions, and deep involvement that distinguish the truly memorable image from the merely competent. Take a close look at some drawings by your favorite artists. What aspects of their work do you find most compelling and engaging? Most likely you would focus on the subjective way they defined and interpreted particular themes or the personal way in which the drawings enliven those themes.

This chapter will take a look at how a variety of artists have interpreted a group of themes that figure greatly in Western drawing traditions, for example still-lifes, figures and portraits, and the landscape. The material in this section encourages you to investigate these themes for yourself and to begin to form and express your own responses in terms of individual interests and obsessions. Not every thematic category and project will strike a chord with you. This is good because it means you are beginning to respond and draw from personal needs and concerns rather than as an abstract technical exercise. The aim is for you to discover more and more about your own likes and dislikes, and the special ways in which only you express them.

SKETCHING AND SKETCHBOOKS

If you have not already made a habit of regularly drawing in a portable sketchbook, now is the time to do so. Quite simply, the more you draw, the more accomplished you become. If you carry a sketchbook with you at all times, slack periods in the day can often be transformed into short, productive drawing sessions. Do not be overly selective in terms of what you draw. Try and find interesting visual and conceptual avenues to explore in seemingly mundane subjects. The challenge of sketching a variety of scenes will stimulate your imagination and lead to the development of new ideas. In fact, the broader the range of visual material, the better. After you have filled up a sketchbook, determine what compositional or visual elements you find yourself returning to, regardless of the subject matter. This will provide you with some knowledge about your own interpretive insights and what concerns affect you.

Artists' sketchbooks often offer intimate glimpses of their special concerns and aesthetic interests. Sometimes the insights gleaned from studying sketchbooks are clearer than those found when viewing finished works.

For most artists, sketching is an integral part of the creative process. Sketchbooks function as a means of examining their environment, developing ideas, and analyzing images they would like to use in finished works of art.

Manet's *Seated Woman Wearing a Soft Hat* (Fig. **11.1**) is a drawing from one of his sketchbooks used to record visual details and sensations that he would later develop in his studio. The features of the woman in this sketch are played down and great detail is lavished on the visual structure of her hat. Note the formal visual elements in Manet's drawings such as pattern, value, and the organization of marks on the flat surface of the picture plane.

A sketchbook is also an ideal place to work on specific drawing concerns or themes. When Tim Stolzenberger, a student, realized that he needed more practice drawing hands, he filled several pages of his sketchbook with studies of this complex part of our anatomy (Fig. **11.2**).

The informal activity of sketching is equally important for professional artists. While this form of visual note taking may lack the finish of more ambitious works, it often allows artists to develop ideas more freely than in any other medium. Jackson

11.1 (opposite) Edouard Manet, *Seated Woman Wearing a Soft Hat*, c. 1875. Graphite and ink wash on wove graph paper, 7⅛ × 4¾ in (18.6 × 12 cm). Fine Arts Museum of San Francisco. Achenbach Foundation for Graphic Arts. Bequest of Ruth Haas Lilienthal.

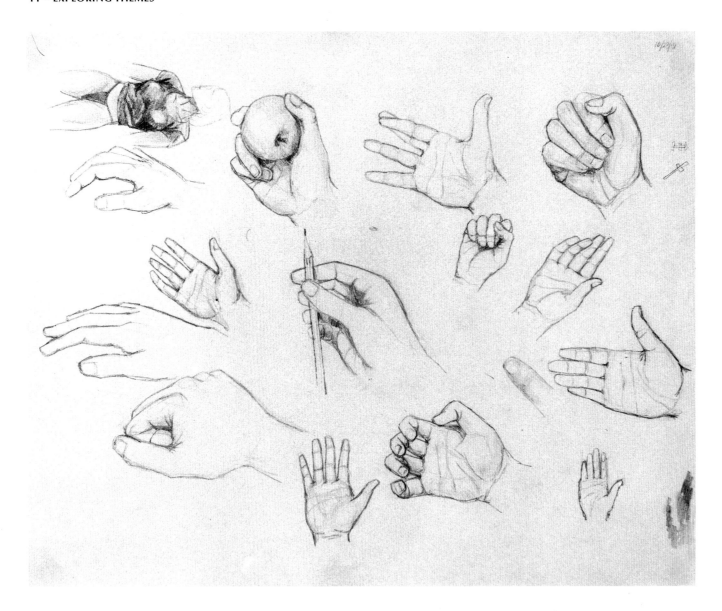

11.2 Student Drawing. Tim
Stolzenberger, Felician College.
Graphite, 17 × 18.5 in (43.2 × 47 cm).

PROJECT 57

A Sketchbook Series

MATERIALS: A 9 by 12 inch spiral-bound sketchbook, an assortment of pencils,
pens, and markers.

Carry this sketchbook with you as a matter of habit and make a point of drawing
in it every day. Soon, you will see the emergence of a certain style of visual note
taking and you will return to places that were particularly rewarding to draw.
You might like the bustle of activity at a favorite restaurant or the quiet solitude
of your home late in the evening. Try different drawing instruments. Soft pencils
might work well or you might prefer the precise line of pen and ink. Specific
themes and concepts should naturally emerge out of this on-going process of
looking, thinking, and drawing. Learn to use your sketchbook as a means of
exploring and developing ideas that will enable you to create a body of work
that is unique to you.

11.3 Jackson Pollock, *Untitled*, c. 1939–42. India ink on paper, 18 × 13⅞ in (45.7 × 35.2 cm). Whitney Museum of American Art, New York. Purchase with funds from the Julia B. Engel Purchase Fund and the Drawing Committee.

Pollock (1912–56) took advantage of this freedom and used the process of informal drawing to refine and develop his aesthetic sensibility. Pollock's untitled sketch (Fig. **11.3**) exemplifies his transition from being a regionalist painter to becoming one of the founders of Abstract Expressionism. The beginnings of his overall field compositions can be seen in the way the sketch page is evenly filled with stylized figures.

STILL-LIFES

For a variety of reasons many of the assignments in this book have made use of the still-life as a drawing subject. Objects within our immediate environment are readily available and we can control the arrangements of these subjects with ease. Still-life drawings allow for the conscious exploration of new directions in form and composition. Those by Cézanne played an important role in the development of Cubism. *Vase with Flowers* (Fig. **11.4**) illustrates how he could push the compositional aspects of drawing to the limit. Here, Cézanne transforms the untouched paper into foreground, background, and even into the solid forms of the vase and flowers. During his lifetime many critics misunderstood his work, dismissing it because it

11.4 (left) Paul Cézanne, *Vase with Flowers*, c. 1890. Watercolour and graphite, 18 × 11.8 in (46 × 30 cm). Fitzwilliam Museum, Cambridge.

11.5 (right) Alberto Giacometti, *Still-Life*, 1948. Pencil on paper, 19¼ × 12½ in (49 × 32 cm). The Modern Art Museum of Fort Worth. Gift of B. Gerald Cantor.

appeared to be unfinished. One of Cézanne's greatest accomplishments as an artist was to change the way we perceive the visual and conceptual relationship between the white paper and the marks arranged on its surface.

Giacometti was also intrigued with the still-life. His pencil drawing of a vase of flowers on a table relentlessly explores the complex spatial configurations and visual relationships of these commonplace objects within his study (Fig, **11.5**). Unlike the crystalline ordering of forms in the Cézanne still-life (Fig. **11.4**), Giacometti's drawing anxiously searches for the edges of forms. Lines have been drawn and redrawn countless times so that the paper vibrates with a raw energy and nervousness that poignantly reflects Giacometti's existential doubts and psychological uncertainty.

Gordon Cook, a West Coast artist and printmaker, worked in a classical mode yet managed to breathe new life into the genre of still-life floral arrangements. Cook earned his living as a commercial typesetter, and he brought the same concern for detail and precise spatial organization from that job into his accomplished drawings and etchings. *Chrysanthemums & Baby's Breath* (Fig. **11.6**) explores with great care the many organic forms of his floral composition. Cook usually did these etchings in one sitting. Early in the evening he would pick the flowers from his garden, place them in a handy container and with almost a single line trace the complex contours before him. By contrast, the vessel holding the plants is drawn with stippled marks that create gently shaded tones. Cook also made fine compositional use of the container's shadows which interestingly assume triangular shapes.

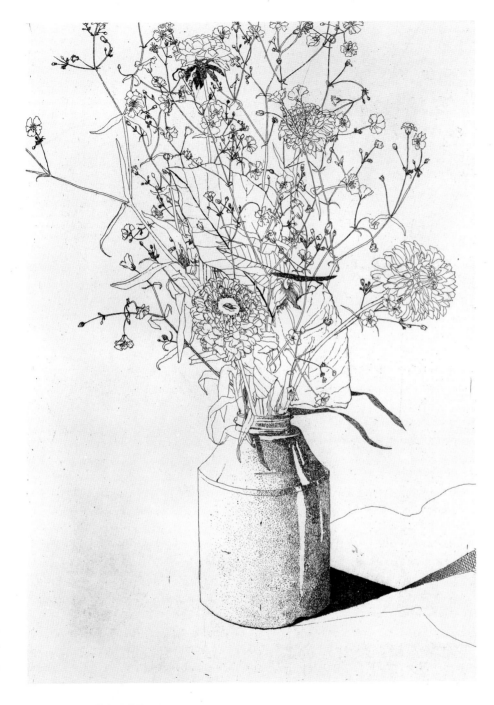

11.6 Gordon Cook, *Chrysanthemums & Baby's Breath*, 1967. Etching, 20⅝ × 14¾ in (52.3 × 37.4 cm). From *Gordon Cook, Twenty Etchings: 1957–1968*, Limestone Press, San Francisco and Houston Fine Art Press, Houston. Courtesy, Hine Inc.

PROJECT 58

A Floral Still-Life

MATERIALS: Bond or rag paper, drawing medium of your choice.

Assemble a floral arrangement in a simple vase, place it on a table and arrange your lighting.

The last three illustrations (Figs **11.4**, **11.5**, and **11.6**) reveal some of the interpretive possibilities a vase of flowers suggested to three very different artists. Visually respond to your own floral still-life in ways that are based on any of the three styles that we looked at. Cézanne drew the flowers in terms of semi-abstract, interlocking negative and positive forms. Giacometti, in keeping with

his aesthetic vision, interpreted the flowers as an integral part of the environment, while Cook brought a precisionist point of view to the floral still-life with accurately drawn contour lines and carefully modulated tonal variations.

No doubt at times you feel that your subject (or lack of subject) holds you back: if only a certain object or scene were available, your work would be more inspired and effective. This is natural and certainly contains an element of truth. Often we do better when we are involved with our subject. But part of the discipline of learning to draw is to be able to exploit creative opportunities that exist in ordinary objects and scenes. The next group of drawings reveal how a variety of artists have transformed objects we view every day into source material for their art.

Among the drawings of John Singer Sargent (1856–1924), an American artist who worked mostly in London, is one of an ordinary motorcycle (Fig. **11.7**). Rather than draw the motorcycle in profile, Sargent positioned it so that it directly faces us, creating a foreshortened view. Consequently, the front wheel is shown as an elliptical form that dramatically recedes in space. Strong tonal contrasts play an important expressive role in this drawing. The thick, dark lines in the foreground contrast effectively with thinner lines that represent forms in the background.

Thomas Hart Benton used common chemistry lab equipment for a drawing (Fig. **11.8**) done in preparation for a large mural commission in Kansas City. Scientists see and work with similar equipment every day and probably would not consider it suitable material for a work of art. Benton, however, became fascinated with the linear complexity of these vessels and tubes and created a fascinating drawing out of this prosaic visual material.

As mentioned in Chapter 8, Claes Oldenburg is a master at visually transforming consumer items. His lithograph *Soft Screw in Waterfall* (Fig. **11.9**) envisions a common household screw, greatly enlarged in scale and to be made of an implausible soft material, is placed under a cascading waterfall. Oldenburg's fantastic pop monuments come to life in his drawings at least as convincingly as when they are fabricated on a grand scale. Some critics feel his project drawings surpass the

11.7 (left) John Singer Sargent, *Sketch for a Motorcycle*, 1918. Pencil on cream wove paper, 6⅞ × 4⅞ in (17.5 × 12.4 cm). Collection, The Corcoran Gallery of Art, Washington, D.C. Gift of Miss Emily Sargent and Mrs. Violet Sargent Ormond.

11.8 (right) Thomas Hart Benton, *Lab Equipment*, Study for the "Kansas City" mural, 1936. From *Farming Segment*. Lyman Field and United Missouri Bank, N.A., co-Trustees of Thomas Hart Benton and Rita P. Benton Testamentary Trusts.

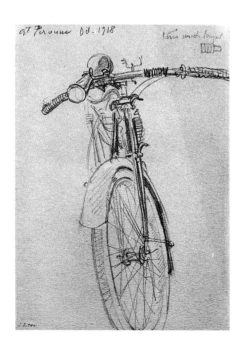

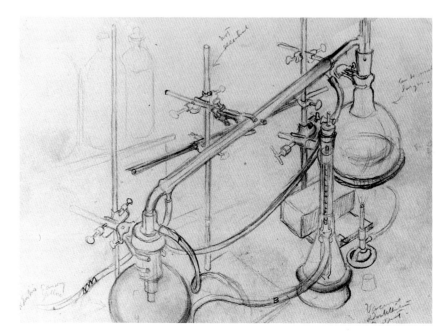

11.9 Claes Oldenburg, *Soft Screw in Waterfall*, 1975–6. Lithograph (aluminium) printed in black on Roll Arches paper. 67½ × 45 in (171.5 × 113.4 cm). Published by Gemini GEL, Los Angeles. Reproduced with permission of the artist.

11.10 James Dine, *Untitled, Tool Series (5-Bladed Saw)*, 1973. Charcoal and graphite on buff paper, 25⅝ × 19⅞ in (65.1 × 50.2 cm). Collection, The Museum of Modern Art, New York. Gift of the Robert Lehman Foundation Inc.

constructed pieces, in part because they require more active mental participation on the part of the viewer than his full-size sculptures. Contributing to the overall effect of this drawing are Oldenburg's vigorous and expressive lines which give life to its theme.

Jim Dine, discussed in Chapter 7, has made a charcoal and mixed-media drawing of a carpenter's handsaw (Fig. **11.10**) that presents us with a very different mood from that of Oldenburg's fanciful visions. The saw is portrayed as an archaic and dangerous implement, more of a potential weapon than a tool of creation. Much of this psychological effect stems from the dark and hairy niche it hangs in. Somber tones and subdued highlights have been carefully employed to create an atmosphere hinting at latent violence.

PROJECT 59

Out of the Ordinary

MATERIALS: Bond or rag paper, drawing medium of your choice.

Take several objects that you see and use every day and link them together visually. You might want to make use of unusual perspectives or angles, juxtapositions of scale, or place them in a special visual environment. One of the challenges of drawing creatively is to change the way we think about something and discover new aspects of these objects that we had not been aware of before.

11.11 Georges Braque, *Still Life with Glass, Violin, and Sheet Music*, 1913. Oil and charcoal on canvas, 25⅛ × 36 in (64.5 × 91.4 cm). Walraf-Richartz Museum, Cologne, Germany. Photo: Rheinisches Bildarchiv.

One of the greatest strengths of the still-life as a drawing subject is its flexibility. During the early days of the modern movement, artists made use of this characteristic to further their experiments with graphic form and composition. In his Cubist works Braque often interpreted three-dimensional forms in terms of overlapping and interconnected flat planes. Fragmented details of a violin, glass, and sheet music appear throughout his still-life shown in Figure **11.11**. Significantly Braque used an oval format for this work, no doubt intrigued by the contrast between the geometric forms within the composition and its curvilinear parameter. Traditional perspective is not used here. Instead, there is a feeling of limited depth that draws attention to the complex, flat network of cubistic shapes and interlocking lines.

In his drawing of a chair and pitcher (Fig. **11.12**) Egon Schiele (1890–1918) shifts our normal viewing angle of these common objects, depicting them as if they were suspended in air above our heads, eliciting a response of disorientation.

Janet Fish's pastel drawing of supermarket fruit (Fig. **11.13**) imparts a wry, contemporary twist to the centuries-old tradition of drawing and painting still-lifes of fruit. The most distinctive aspect of this drawing is the fruit's packaging, expressed through the highlights of the plastic film and the paperboard tray. Even

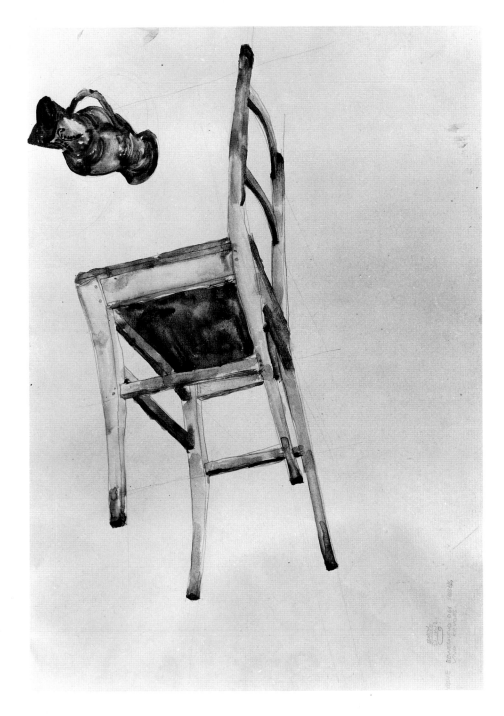

11.12 Egon Schiele, *Organic Movement of Chair and Pitcher*, 1912. Pencil and watercolor, 18⅞ × 12⅛ in (48 × 31 cm). Albertina, Vienna.

11.13 Janet Fish, *Pears*, 1972. Pastel on paper, 30 × 22 in (76.2 × 55.8 cm). Courtesy, Robert Miller Gallery, New York.

the arrangement of the fruit comments on the mechanized nature of our times – they are lined up in even rows, as if straight from a factory assembly line.

By now it is obvious that the greatest advantage of the still-life is that it allows the artists to use the arrangement of various shapes and space relationships as a visual starting point from which a broad range of interpretive possibilities can emerge and take form.

THE FIGURE

No other subject in the history of drawing appears with such frequency as the figure. Among the main reasons for this is the inevitable fact that humanity has always been fascinated with the meaning of its own image, a preoccupation evident in countless examples from Egyptian papyrus drawings to contemporary figure studies. Furthermore, the figure is an eminently practical drawing subject. The human body can be arranged in endless configurations and, when combined with various props, makes for challenging and interesting subject matter.

Like any visual theme the figure can be expressed in a variety of drawing styles, limited only by the attitudes and interests of the artist. Degas, for example, liked the "awkwardness" of real life scenes and liked to record day-to-day actions. He was greatly influenced by the complex spatial organization of Japanese prints. Although critics placed him in the Impressionist camp, he always thought of himself as a realist. All of these aesthetic and thematic issues can be seen in his drawing of a gentleman visiting a cotton broker's office (Fig. **11.14**). The strong, briefly stated diagonal lines suggest a whirl of business activity that surrounds the contemplative, stationary figure.

Claudio Bravo's two-part lithograph *Fur Coat Front and Back* (Fig. **11.15**) has a completely different approach to the figure. The two opposite views of his subject are rendered with great skill and in meticulous detail. In a superrealist style, using a fine-nibbed pen and a small brush and ink, the artist has created a drawing that alludes to northern Renaissance realism yet which in terms of its conceptual overtones is decidedly modern.

The proportions and measurement of the body were studied with particular interest during the Renaissance. Hans Holbein the Younger (c. 1460/65–1524) made a fascinating study of heads and hands on a single sheet (Fig. **11.16**). As exercises in anatomical understanding, they were conceived and framed in geometrical terms. In this era keen visual analysis predominates over psychological interpretation. Notice the way the hand is drawn at the bottom right of the drawing: its jointed sections are envisioned as mechanical forms, outlining their essential shapes. When you do your own drawings from the figure, keep this drawing in mind since it should help you to describe the human form with accuracy.

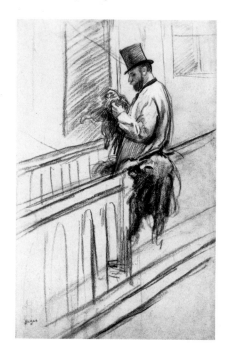

11.14 Edgar Degas, *Monsieur Hermann de Clermont on the Balcony of Cotton Broker Michel Musson's Office, New Orleans*, 1872–3. Chalk, 18⅞ × 12⅜ in (48 × 31.5 cm). Statens Museum for Kunst, Copenhagen.

11.15 Claudio Bravo, *Fur Coat Front and Back*, 1976. Lithograph, 2 sheets together, each 37¹³⁄₁₆ × 22⅜ in (96 × 56.8 cm). Collection, The Museum of Modern Art, New York. Latin-American Fund.

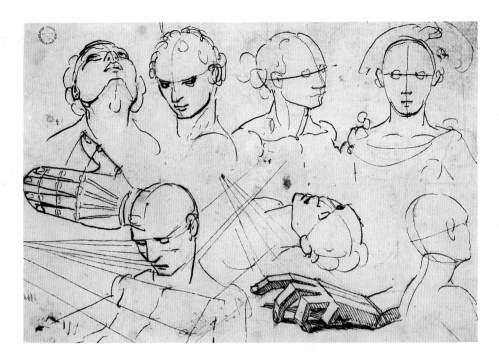

11.16 Hans Holbein the Younger, *Sheet of Studies of Heads and Hands*. Pen and black ink, 5 × 7⅜ in (12.8 × 19.2 cm). Kunstmuseum, Basel, Switzerland.

The figure is conceived in Dubuffet's *Man with a Hat in a Landscape* (Fig. **11.17**) is barely discernible and assumes a ghostlike presence. Dubuffet was greatly influenced by primitive art and the work of the insane. In this drawing there is no clear distinction between figure and ground, the landscape and the man. Everything appears to be made from a seething mass of scratchy ink lines and calligraphic marks that vary in thickness.

11.17 Jean Dubuffet, *Figure with a Hat in a Landscape*, 1960, from the series "Drawings in India Ink and Wash." Pen and ink on paper, 12 × 9⅜ (30.4 × 23.7 cm). Collection, The Museum of Modern Art, New York. Joan and Lester Avnet Collection.

11.18 Alexander Archipenko, *Figure in Movement*, 1913. Crayon, pencil, and collage, 18¾ × 12⅜ in (47.6 × 31.4 cm). The Museum of Modern Art, New York. Gift of Perls Galleries.

Alexander Archipenko (1887–1964), an American sculptor of Russian origin, further abstracts the human form in his collage drawing *Figure in Movement* (Fig. **11.18**). Head, torso, arms, and legs have been interpreted through flat, stylized forms that are subtly shaded in order to create the illusion of slightly curved shallow shapes. Crayon lines visually interact with these geometric shapes to create visual tensions and the implications of movement and change.

THE NUDE

As a subject for art, the nude has been ubiquitous in the West since the time of the Ancient Greeks (except for the Middle Ages, when religious ideology frowned upon representations of nude figures). As drawing students you may be able to take advantages of life drawing classes, in which a nude model is hired to pose for the class. Many of the techniques and visual elements we have learned about can be applied to drawing the naked body. Your instructor will provide guidance in your life drawing efforts. If it is an "open studio" class with no instructor, begin with some short warm-up drawings, five to ten minutes in length. Longer poses after the warm-up period will allow you to develop more detail. Do not forget the fundamentals you have learned: draw compositionally to the whole format; make a brief, light sketch that provides a framework for the drawing; and do not start from the head and fill the drawing in as you go down the page. To start with, you should probably limit each pose to thirty minutes. As you become more experienced, time could be extended in the interests of creating more developed compositional work.

Seated Nude One Leg Up (Fig. **11.19**) by the American Richard Diebenkorn (1922–93) has strong compositional elements. Note the geometric structures included in the background, the angular pose of the figure, and the way in which they are integrated.

As discussed in Chapter 4, Gaston Lachaise, by contrast, was fascinated by the spatial dimensions and three-dimensional form of the human body. *Nude* (Fig. **11.20**) portrays a female model of ample proportions, a modern fertility goddess of sorts, in surging, rhythmic contour lines that create the illusion of a human form in space. In this drawing line is used as if it were a flexible metal wire that could be bent and shaped three-dimensionally.

11.19 Richard Diebenkorn, *Seated Nude One Leg Up*, 1965. Charcoal on paper, 17 × 14 in (43.2 × 35.5 cm). Courtesy, M. Knoedler & Co., Inc., New York.

11.20 Gaston Lachaise, *Nude*, c. 1930. Pencil on paper, 19 × 12 in (48.3 × 30.5 cm). The Metropolitan Museum of Art, New York. Gift of George T. Delacorte, Jr. #57.75.2.

11.21 Auguste Rodin, *Figure Disrobing.*
Pencil, 12³/₁₀ × 7⅞ in (31 × 20 cm).
Kennedy Fund. The Metropolitan
Museum of Art, New York. #10.66.1.

11.22 (below, left) Student Drawing by
Heather Ackerman. Graphite and
charcoal, 22 × 30 in (55.88 × 76.2 cm).

11.23 (below, right) Student Drawing
by Heather Ackerman. Graphite
and charcoal, 23 × 33 in (58.42 ×
83.82 cm).

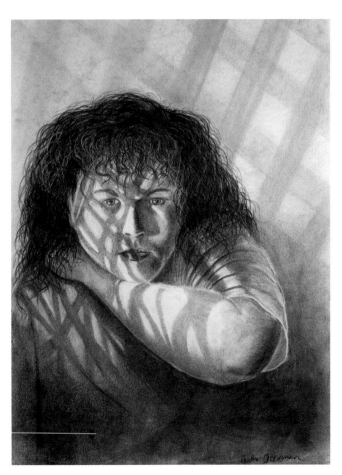

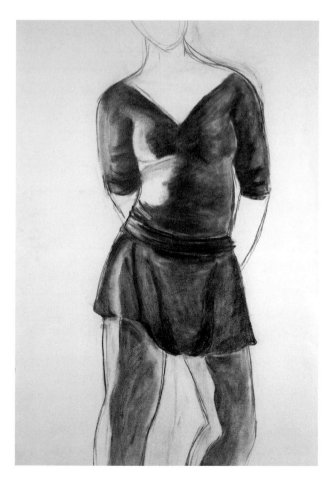

Rodin's quick study of a model disrobing (Fig. **11.21**) captures the human body in motion. Long, gracefully arching lines (the legs and lower torso) are juxtaposed with energetic diagonal lines above that represent her moving hands as she takes her clothes off for a modeling session. This expressive figure drawing was finished in a matter of minutes.

The student drawings in Figures **11.22** and **11.23** were done in a life drawing class and both are extended studies worked on for hours rather than minutes. In the long run the time it takes to finish a drawing is irrelevant – the only thing that counts is the result.

The next project will enable you to try your hand at figure drawing.

PROJECT 60

Interpreting the Figure

MATERIALS: Bond or rag paper, drawing media of your choice.

Persuade a friend or group of friends to pose for you. Better still, exchange posing sessions with a fellow student with whom you can share ideas and enthusiasms.

Choose an aesthetic approach used in one of the figure drawing examples discussed above, or apply concepts and interests you have previously worked with to this figure assignment. You may wish to isolate the figure from the environment or to place it firmly within the visual and thematic context of a special place or room. Do a series of figure drawings that returns to the same general pose or particular place. Between drawing sessions analyze your work and take note of its strengths and weaknesses. Focus on the positive aspects of your best drawings, the way they successfully control value or use calligraphic line, for example, and reinforce these qualities in the next drawing.

PORTRAITS AND SELF-PORTRAITS

For centuries portrait drawings have been an important part of an artist's repertoire of themes. During the Middle Ages and Renaissance portraits were commissioned by nobility and later by the newly evolving class of merchant princes and wealthy industrialists. With the development of photography, pictorial likenesses of nearly everyone, not just the wealthy, became affordable. Modern drawing traditions reflect this technological change since the artist will attempt to express concepts and sensibilities in a portrait drawing that go beyond the visual documentation of someone's features. The form and function of portrait drawing for the most part has evolved along with the social and technological face of society.

In 1832, just before photography became widely available, Jean-Auguste Dominique Ingres (1780–1867) completed a portrait drawing of his client Louis Bertin (Fig. **11.24**). Ingres loved to do grand paintings of historical subjects, but in retrospect his greatest gift – and steadiest source of income – was portraiture. Lavish attention is paid to Bertin's features, which are created from finely wrought pencil hatching. By contrast, his upper body is spontaneously rendered with thick, rough, vigorous strokes.

Umberto Boccioni, who was associated with the Futurist movement (see Chapter 4), approached his portrait model from a different aesthetic perspective. Futurist

11.24 Jean-Auguste Dominique Ingres, *Louis Bertin*, 1832. Pencil drawing, 12¾ × 9½ in (32 × 24 cm). Louvre, Paris.

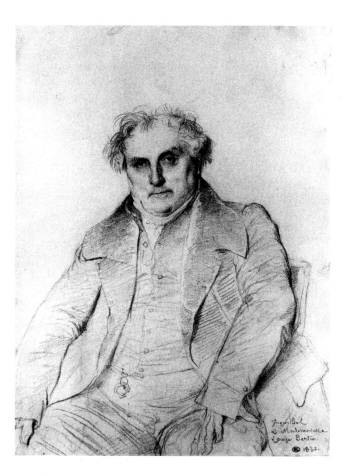

11.25 Umberto Boccioni, *Head of a Woman (Ines)*, 1909. Pencil on ivory wove paper, 15 × 15½ in (38.1 × 39.4 cm). The Art Institute of Chicago. Collection of Margaret Day Blake.

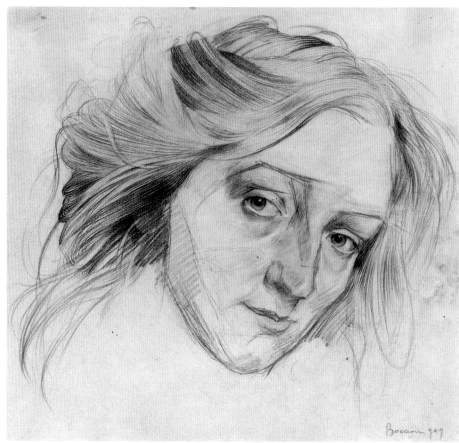

artists were keenly interested in concepts of mechanization, and the beauty and speed of new machines such as automobiles and locomotives. Boccioni's portrait of his mistress Ines (Fig. **11.25**) thus incorporates ideas about speed and change: her head is at an angle and her hair is represented in a series of swiftly flowing forms. Movement is also implied by the shifting geometric planes of her features, which exhibit overtones of Cubism. Ines looks directly at us in a marvelously personal and confrontational way.

Along with portraits of family, friends, and clients, artists have always turned their vision inward to create self-portraits. William H. Johnson (1901–70), an African-American artist, drew the self-portrait shown in Figure **11.26**. The lively, free-flowing watercolor passages that define his features stand in marked contrast to the thin, fluid lines across the white space at the bottom of the paper. During the 1930s Johnson was based in Denmark, also traveling throughout Europe and North Africa. This self-portrait seems to capture an appropriate spirit of adventure.

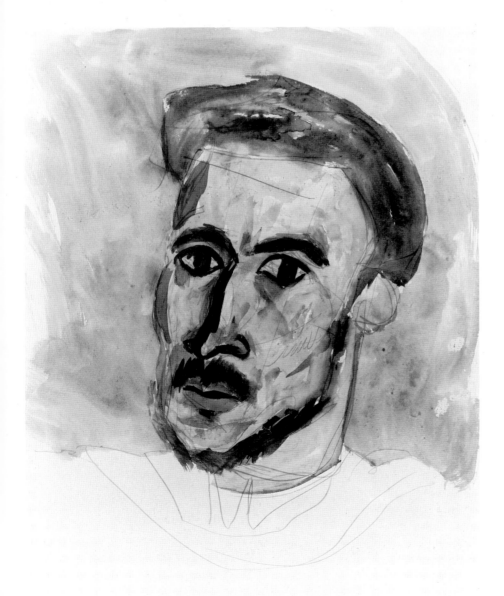

11.26 William H. Johnson, *Self-Portrait*, c. 1931–8. Watercolor on paper, 15 × 11½ in (38.1 × 29.2 cm). Hampton University Museum, Virginia.

11.27 Käthe Kollwitz, *Self-Portrait*, 1934. Lithograph, 8⅟₁₆ × 7³⁄₁₆ in (21.9 × 18.2 cm). Philadelphia Museum of Art. Gift of Dr. and Mrs. William Wolgin.

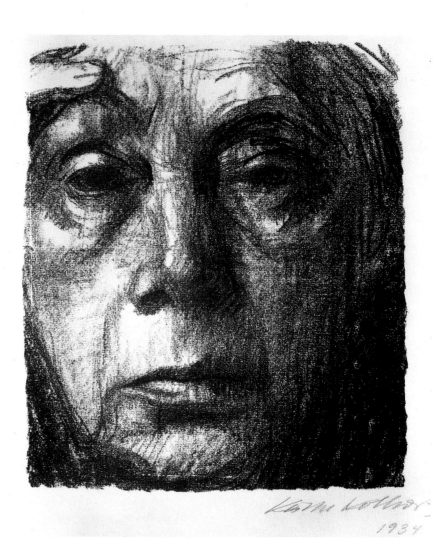

Käthe Kollwitz moved in for a close-up (to use filmic terms) in her compelling self-portrait (Fig. **11.27**). All unwanted background detail in this lithograph is eliminated; nothing distracts from her prominent features, which emerge from a mass of vigorously drawn lines, directly confronting the viewer with a penetrating and haunting gaze.

The American artist and author Faith Ringgold (b. 1934) commemorated Josephine Baker, a black dancer who took Europe by storm in the 1920s when she moved there from the U.S.A. *Jo Baker's Birthday* (Fig. **11.28**), a full-figure composition that includes elements of Matisse-like surroundings, celebrates Baker's triumphs and difficulties, her courage, tenacity, and joy of life. On the day she began the portrait, Ringgold wrote:

> *Her beautiful body is lying à la six-quatre-deux on her chaise longue. It is her birthday so she is resting before the party . . . How did she become une grande dame français? I don't know how, but I do know why – she had no other choice she could live with. Coming from the poorest of the poor with only her pieds dansants, her dancing feet to make her feel alive as she had to keep moving.*

Although Baker died in 1975, her presence remains alive in many portraits (including a painting by Picasso, who called her the modern Nefertiti). A good portrait tells us more than just how a person looks – it tells us something about who they are.

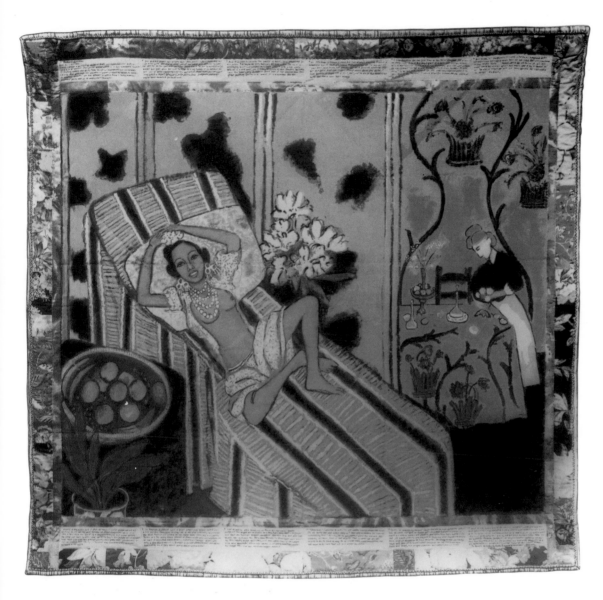

PROJECT 61

A Portrait and a Self-Portrait

MATERIALS: Bond or rag paper, drawing media of your choice.

Persuade a friend or family member to pose for you. Do not work from a photograph as this kind of visual information is limited and you will be translating information that is already two-dimensional in nature. In preparation for this project, review reproductions of portrait drawings to familiarize yourself with the genre.

Next try doing a self-portrait using two mirrors. Place one mirror directly in front of you and the other one at a 45 degree angle to your right of left. By using two mirrors you will be able to draw a three-quarter view without looking back and forth too much. Lighting will also play an important role: notice how the appearance of your features changes as the lighting shifts. This project requires careful observation and accuracy of description. Take your time and block out the space relationships of your head and torso.

11.28 Faith Ringgold, *Jo Baker's Birthday*, 1995. Silkscreen, edition 20, 17½ × 16¼ in (44.4 × 41.3 cm). ACA Galleries, New York.

11.29 Claude Lorraine, *View of a Lake near Rome*, c.1640. Bister wash, 7⅜ × 10¾ in (18.5 × 26.8 cm). British Museum, London.

THE LANDSCAPE

The natural world is one of the most compelling visual sources of art. Humanity's place in the order of things has always been measured by its relationship to the environment. When artists draw the landscape, they are drawing the world in all its rich diversity and meaning.

Claude Lorraine was infatuated with the beauty of the countryside just outside Rome. Through countless paintings and drawings he celebrated this pastoral region perhaps more thoroughly than any native Italian artist. His *View of a Lake near Rome* (Fig. **11.29**), done in brush and *bister* wash (a brown-toned ink), captures the evening light on the water among the umbrella pines and cypresses. The interpretation is lush and romantic.

By contrast, van Gogh's landscape drawings are characterized by visual fields of pulsating, linear energy. In his *Fountain in the Hospital Garden* (Fig. **11.30**), a profusion of nervous lines describe trees, grass, and shrubs. Nature dominates this scene despite the fact that the fountain and other architectural details are prominent. Organic elements far surpass those of the built environment.

Richard Mayhew, a contemporary African-American artist, used pen and ink for his *Sonata in D Minor* (Fig. **11.31**), a lyrical, dreamlike landscape of a gently rolling meadow. The spaces between the short lines and looping arcs are carefully controlled to modulate tonal densities. Dark areas in this drawing have tightly packed lines and loops, while lighter tones are created by wider spacing.

The landscape can also be symbolically expressed. An imaginary landscape was the theme of a series of drawings I made titled *Sea Clouds over Tezontepec (After Wallace Stevens)* (Fig. **11.32**). This gouache and watercolor drawing evokes the feeling of atmosphere, sky, and clouds without literal rendering. Floating near the center of the composition is a geometric shape that suggests an immense planar object suspended in the air. Tonal gradations of watercolor replicate the subtle variations of light that characterize the sky during certain times of the day. The combination of cloudlike shapes and luminous washes juxtaposed with geometric shapes creates an imaginary landscape with mysterious overtones.

11.31 Richard Mayhew, *Sonata in D Minor*, 1970. Pen and ink on paper, 22 × 30 in (55.8 × 76.2 cm). Courtesy, Midtown-Payson Galleries, New York.

11.32 Howard Smagula, *Sea Clouds over Tezontepec (After Wallace Stevens)*, 1991. Watercolor and gouache, 8 × 6 in (20.3 × 15.2 cm). Courtesy, the artist.

PROJECT 62

Landscape Drawing

MATERIALS: Bond or rag paper, compressed charcoal, graphite, or pen and ink.

Make two drawings based on landscape space: one that follows the traditions of landscape drawing and one that presents an imaginary view of the natural world.

Before you begin the first drawing, familiarize yourself with the basic elements of landscape drawing. Study examples in galleries and museums as well as reproductions in books. Take note of how different artists have interpreted elements such as sky, earth, open space, and the configurations of trees, hills, and meadows. If you live in a city, plan a drawing trip to the countryside or visit a large park in your region.

For the drawing of an imaginary landscape, take the standard elements used in your first drawing (sky, earth, mountains, trees, and grass) and interpret them in new ways. Visual juxtaposition is the key to the effectiveness of this drawing. Scale relationships can also be manipulated toward favorable ends. If we viewed the landscape from an ant's scale and perspective, we would perceive a very different and strangely ordered world.

THE URBAN ENVIRONMENT

During the nineteenth and twentieth centuries industrialization transformed the landscape for most people in the Western world. When we look outside our windows today, we are more likely to be confronted by buildings and busy city streets than by pastoral views of mountains and streams.

By responding to their immediate environment, artists can choose to portray scenes of everyday life in countless ways. The crowded environment of New York, for example, inspired Isabel Bishop (1902–88) to capture the human drama and poignancy of a mother and child waiting late at night in a train station (Fig. **11.33**). The woman remains motionless so as not to disturb her child's sleep and she stares into space, lost in contemplation.

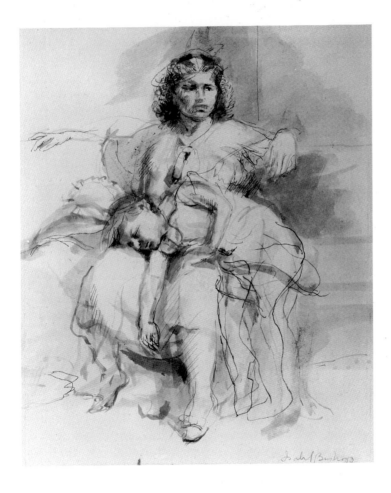

11.33 Isabel Bishop, *Waiting*, 1935. Ink on paper, 7⅛ × 6 in (18.1 × 15.2 cm). Collection, Whitney Museum of American Art, New York. Purchase.

One of the most famous paintings symbolizing the isolation and loneliness typical of large industrialized cities is Edward Hopper's *Nighthawks* (Hopper's study for this painting is reproduced in Figure **4.10**). The painting shows a few lone individuals drinking coffee in a diner during the early hours of the morning. The American sculptor Red Grooms (b. 1937) returns to the scene of Hopper's all-night diner but visits it during the light of day. *Night Hawks Revisited* (Fig. **11.34**) is a good-natured spoof of the painting. Hopper is portrayed in this drawing with his hand on a coffee mug staring directly at us, while Grooms depicts himself as the

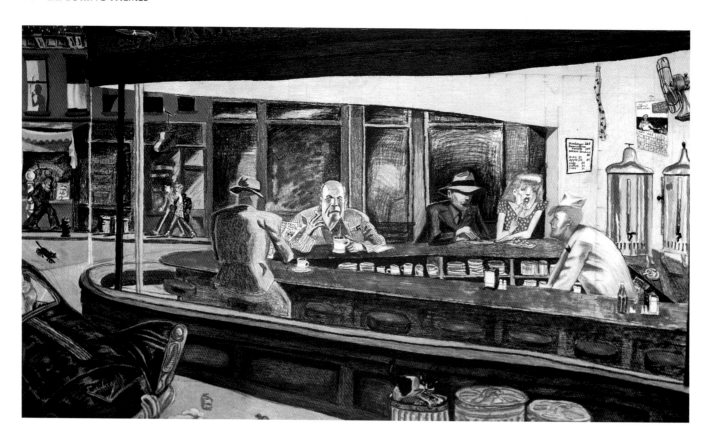

11.34 Red Grooms, *Night Hawks Revisited*, 1980. Colored pencil on paper, 44½ × 75¼ in (113 × 191.1 cm). Collection Red Grooms, New York. Courtesy Marlborough Gallery, New York.

PROJECT 63

The Urban Experience

MATERIALS: Bond or rag paper, drawing media of your choice.

Before you begin to explore this theme on paper, take some time to reexperience the sensations and sights of an urban environment. If you live in the suburbs, visit a shopping mall near your home. These commercial architectural spaces re-create the atmosphere of a city to serve the shopping needs of less densely populated areas. What strikes you as interesting about these environments? Take some notes, both verbal and visual, in preparation for a series of drawings that explores your personal perceptions of urban life. Do you feel that cities are too crowded and confusing? Or are you attracted to and stimulated by the sights and activities? These are only two polarized reactions to the urban environment. Express your attitudes about modern life in the city in your drawings. For instance, by making the space compressed and the composition dynamic, you can communicate one aspect of the urban environment. What can you tell about other artists' attitudes toward urban life and living? Compare Hopper's *Nighthawks* (see Fig. **4.10**) with Grooms's version (Fig. **11.34**) of the same subject. How do these drawings reflect different viewpoints? This series of drawings should explore your attitudes about the city and modern urban experiences in personal terms.

harried counterman struggling to fill the orders of his customers. This version of *Nighthawks* is played strictly for laughs as many slapstick details show: flypaper hangs from the grease-encrusted ceiling; a multi-legged cat races across the street to join its pal on the garbage can; and a black limousine with ludicrous tail-fins is parked outside. Comparing these two, *Nighthawk* drawings makes us aware of the wide range of expressive possibilities that exist within similar thematic subjects.

Many of the genres explored in this chapter can, of course, be combined – the figure within the landscape, the portrait within the urban environment.

Nature has been a consistent source – some say the only source – for the making of art. No one sees the world exactly as you do. This is one of the most compelling reasons to draw – to explore your perceptions and to give form to your concepts and feelings.

12 IMAGE AND IDEA

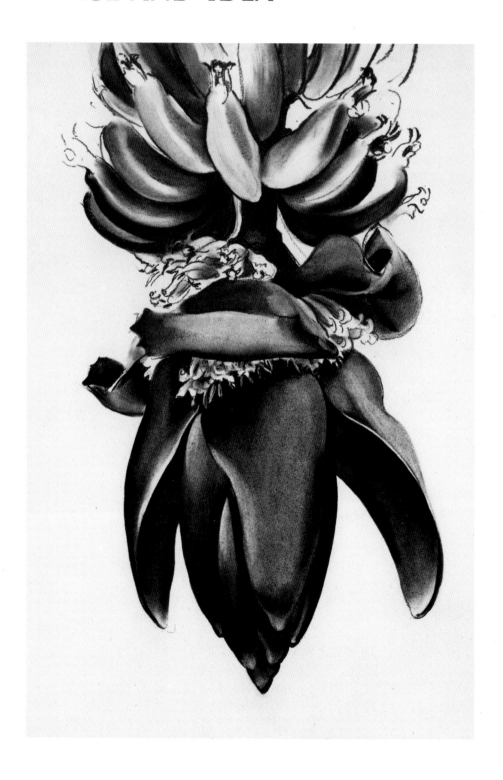

Alarge proportion of your efforts so far have focused on the acquisition of basic drawing skills and the application of these techniques toward solving a wide variety of visual problems. It is now time to begin to think about how you might apply the skills you have learned toward producing more personally expressive drawings.

At this point you are no longer a beginner, yet you are probably not prepared to continue to work entirely on your own. Anyone beginning the study of art today faces a bewildering array of choices in terms of drawing styles and aesthetic directions. The issue of what to do becomes as important as how to do it. Often what hinders students is not a lack of drawing skills, but confusion about the conceptual and thematic role of their work.

This chapter offers representative examples of ways in which professional artists have developed ideas and have expressed them visually. Individual artists are examined to reveal the close relationship between thematic interests and graphic technique. Through these examples and the accompanying projects, you will have the opportunity to further explore the expressive potential of the drawing process.

GEORGIA O'KEEFFE

The drawings and paintings of Georgia O'Keeffe (1887–1986) have achieved a cultural status and popularity enjoyed by few twentieth-century individuals. Although very much a modernist, O'Keeffe never strayed far from nature in terms of her thematic inspiration. The origins of all her artworks are based on keen observation of the natural world. The special light of the desert high country in New Mexico (where she lived and worked), the intricate sculptural form of a sea-shell, and the delicate structure of flowers are all specific subjects that she transformed in her drawings and paintings into monumental yet intimate images. These are not mirror-images of nature. Almost from the beginning of her career, this pioneering artist saw the underlying structure of nature beneath the surface of the organic forms she drew. The distilled and heightened essence of the natural forms she chose are shaped into deceptively simple abstractions that conjure a broad range of feelings.

Born in Sun Prairie, Wisconsin, O'Keeffe attended the School of the Art Institute of Chicago for a year. After studying at the New York Art Students League, she took an art course taught by Alan Bement at the University of Virginia. Bement introduced her to the writings of Arthur Wesley Dow, who taught at Teachers College, Columbia University. From 1914 to 1915 O'Keeffe was enrolled in Dow's class and absorbed his ideas about art. Contrary to the popular thinking of this era, Dow did not stress three-dimensional illusion and realism: his system of composition was based on contrasts of light and dark forms that were flattened and organized into compositions reminiscent of Chinese and Oriental art. As a former curator of Japanese prints at the Boston Museum of Fine Arts, Dow admired the way Oriental artists expressed the elemental forces of nature through simplified, stylized forms.

Banana Flower No. 1 (Fig. **12.1**) illustrates O'Keeffe's ability to transform natural forms into works of art which do not simply imitate nature but symbolize the presence of nature. By drawing the flower tightly cropped and visually detached from the rest of the plant, O'Keeffe emphasizes the sculptural aspects of these forms and enables us to see them in new ways. Because of this approach we do not immediately read this image as a flower. The complex, curved organic forms remind us of the muscle structure of the human body and a host of other biologically based forms. Transformed by the carefully modulated tonalities of the charcoal and the magnified view, O'Keeffe's banana flower takes on a timeless feeling of power and strength that belies the reality of its fragile, organic flesh.

12.1 (opposite) Georgia O'Keeffe, *Banana Flower No. 1*, 1933. Charcoal on paper, 22 × 15 in (55 × 38.1 cm). Collection of Arkansas Arts Center Foundation.

Calla Lily (Fig. **12.2**) expresses the same themes of transformation and abstraction apparent in *Banana Flower No. 1*. Soft, billowing, cloudlike flower-forms fuse into one formless organic shape that floats within the pristine space of the paper. Through this compositional structure the "flowers" are conceptually isolated from the biological realities of generation, maturation, and decay.

Red Calla (Fig. **12.3**) is a continuation of O'Keeffe's transformative vision of nature. Drawn shortly after *Calla Lily*, it extends her use of simplified, bold visual forms. Unlike the self-contained centralized forms of *Calla Lily*, *Red Calla* appears to unfold and embrace the space around it. In the process this drawing creates lively negative shapes using untouched portions of the paper ground created by the irregular forms of the flowers' petals and leaves. Delicate watercolor washes are juxtaposed with strong tonal contrasts in this composition to create a self-contained reality related to but not dependent on the reality of everyday perception. This balance between the world our eyes perceive and the world our mind constructs accounts for O'Keeffe's unique and convincing vision.

12.2 (below, left) Georgia O'Keeffe, *Calla Lily*, 1919. Watercolor on paper, 23 × 12⅞ in (58.4 × 32.5 cm). Columbus Museum of Art, Derby Fund.

12.3 (below, right) Georgia O'Keeffe, *Red Calla*, c. 1920. Watercolor, 19⅜ × 13 in (49 × 33 cm). Yale University Art Gallery. Gift of George Hopper Fitch.

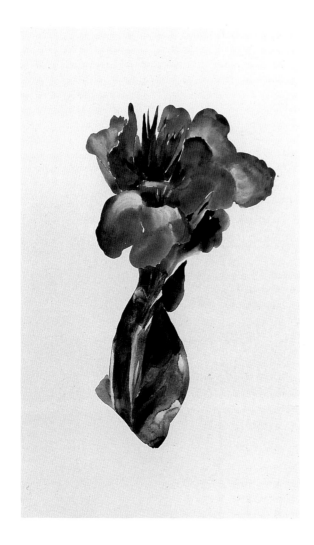

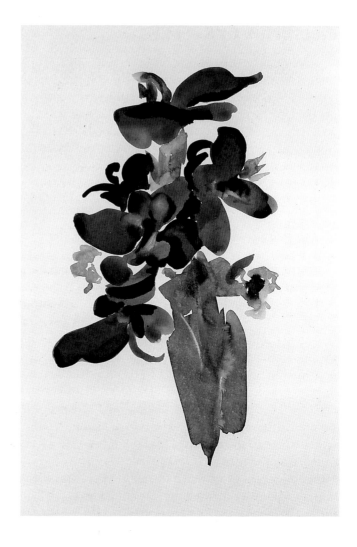

PROJECT 64

A Selective Vision

MATERIALS: Rag or bond drawing paper, drawing medium of your choice.

This assignment explores the creative role played by your point of view, both literal and aesthetic. Choose as your subject a flower, sea-shell, bone, or other natural object that you find beautiful. Isolate this object on a white ground and position yourself close to the subject. Do not draw the entire form. Find the exact perspective and magnification that transforms this organic form into a semi-abstract composition. A viewer should be able to identify the form you have drawn, whether or not you have accentuated its sculptural form and organizational structure.

WILLEM DE KOONING

In the early 1950s, Willem de Kooning began a famous series of drawings and paintings on the theme of "woman." These drawings were to bring together in a remarkable way his three previous thematic concerns: pure abstraction, the female figure, and the landscape. By introducing the semi-abstract image of a woman into his art and combining it with elements of his abstract style, de Kooning shocked staunch followers of the New York School for whom recognizable imagery was taboo. Through the use of his "woman" image, however, de Kooning managed to maintain his connection to purely abstract visual elements while at the same time making appropriate uses of classic themes of Western art: the female idol and the madonna image. In an interview in 1960 de Kooning had this to say about his "woman" image:

> The *Women* had to do with the female painted through all the ages, all those idols, maybe I was stuck to a certain element; I couldn't go on. It did one thing for me: it eliminated composition, arrangement, relationships, light – all this silly talk about line, color and form – because that was the thing I wanted to get hold of, I put it in the center of the canvas because there was no reason to put it a bit on the side. So I thought I might as well stick to the idea that it's got two eyes, a nose and mouth and neck.

Although de Kooning was greatly interested in the concept of the female image as it was perceived through history, his "woman" series also functioned as a thematic basis, allowing the artist the freedom to create new compositional arrangements.

Since the 1930s de Kooning used the visual effects of collage (as well as actual collage techniques) in many of his drawings and paintings. Flat, overlapping shapes reminiscent of the collage process are found in quite a few paintings. The first six paintings of his "woman" series began as drawings on paper. Early images in the 1950s were made by cutting up drawings of the female figure into sections and

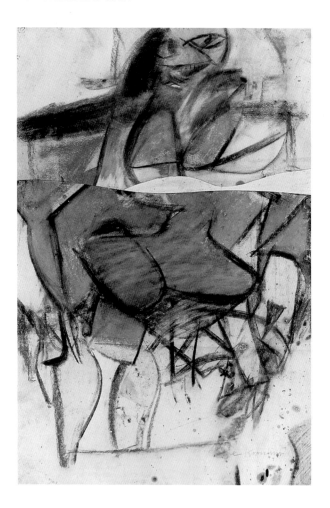

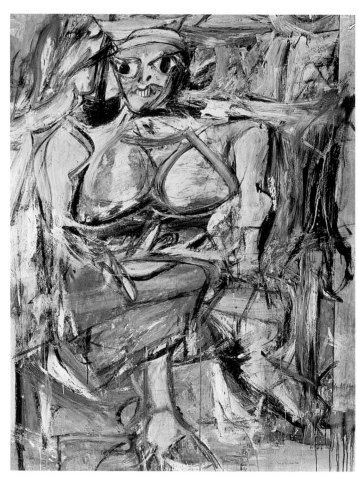

12.4 (left) Willem de Kooning, *Woman*, c. 1952. Graphite and charcoal. Musée National d'Art Moderne, Centre Georges Pompidou, Paris.

12.5 (right) Willem de Kooning, *Woman I*, 1950–2. Oil on canvas, 6ft 3⅞ in × 58 in (192.7 × 147.3 cm). Collection, The Museum of Modern Art, New York. Purchase.

pasting together purposefully mismatched images. The drawing seen in Figure **12.4** was completed using just such a method. The image of a woman is reduced to such semi-abstract anatomical elements as the eyes, the mouth, the breasts, and the arms. These body parts are defined by angular, disjointed lines which are sometimes blurred by rubbing and erasing. The result is part figural, part abstract; the feeling of force and brutality is reminiscent of the German Expressionists.

Woman I (Fig. **12.5**) reveals how various elements of his "woman" theme are incorporated into a large and fully developed oil painting. Drawing was a way for de Kooning to quickly and efficiently explore compositional ideas and ways in which the anatomy of this terrifying idol could be visually expressed. The woman in this painting emerges out of a seething mass of angular lines and shapes. Her almond-shaped eyes and sneering mouth are trademarks of the whole series. All of de Kooning's drawings and paintings in this particular series exist halfway between figurative and abstract art, combining relevant aspects of each mode.

PROJECT 65

Abstracting an Image

MATERIALS: Rag or bond paper, drawing medium of your choice.

Choose a single object, place it in the center of your composition, and develop a series of semi-abstract drawings from it. In each successive drawing try to isolate some visual and thematic feature of the object's form and develop this aspect. You may wish to use highly energized calligraphic lines that are blurred and reworked (as in de Kooning's drawings), or you may use any drawing style and method that you feel is appropriate for the expression of your concept.

ALICE NEEL

Throughout her long and productive career, Alice Neel (1900–84) painted and drew psychologically piercing portraits of the broadest imaginable range of individuals – artists, writers, wealthy business people, the underclass of Spanish Harlem, lovers, friends, museum curators, married couples, and even a brush salesman whose features intrigued her. Neel collected "souls," as she put it, and decided to "paint a human comedy – such as Balzac had done in literature." Living in New York, in the heart of Spanish Harlem, for twenty-five years, Neel aimed to represent the psychological presence of her sitters through vigorous linework and facial expressions that were far from the norm. Paraphrasing Cézanne's comment that he loved to paint people who have grown old naturally in the country, Neel said that she loved to paint people mutilated and beaten up by the rat race in New York.

Neel's drawing of Stephen Brown (Fig. **12.6**) reveals a young man whose anxious gaze confronts us in a particularly poignant and direct way. The visual qualities of her line reinforce this reading. The sharp, nervously energized lines focus our attention on the sitter's features and body position. Other visual elements of this drawing play an important supportive role but they do not distract from the subject's expression.

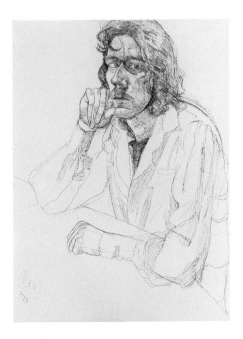

12.6 Alice Neel, *Stephen Brown*, 1973. Ink on paper, 31½ × 24 in (80 × 60.9 cm). Courtesy, Robert Miller Gallery, New York.

Neel believed that all good art has abstract elements but her prime motivation was a concern to communicate the human condition and reveal something about our collective psyche. In *The Youth* (Fig. **12.7**) the subject of the portrait leans toward us in a gesture that might be interpreted as slightly apprehensive. He seems anxious to please and was no doubt flattered that Neel invited him to pose. This lithograph makes particularly effective use of visual emphasis. The dark mass of hair contrasts with the sketchy linear passages of the young man's shoulder and legs. These shifts of visual activity lend a spontaneity and life to the portrait that would be impossible to achieve if all the areas were evenly worked. Selected areas are sketchy and less finished than others.

Neel's figures are far removed from the idealized and flattering images that one finds in most conventional portraits. She was quick to proclaim that she never painted on commission and repeated Whistler's wry observation that "a portrait is a likeness in which there is something wrong with the mouth." Free from the potentially restrictive demands of clients, Neel created an amazing body of portraiture that comes alive in ways that are quite unpredictable.

Neel preferred to paint and draw her subjects in her studio rather than on their terrain, though her personality allowed them to relax and prevented them from assuming a lifeless public demeanor. As something of a "method" artist, during the drawing session she would assume the identity of the sitter for a few hours. "When they leave and I'm finished, I feel disoriented. I have no self. I don't know who or

12.7 Alice Neel, *The Youth*, 1982. Color lithograph on papier d'Arches, 38 × 24 in (96.5 × 63.5 cm). Courtesy, Eleanor Ettinger Inc., New York.

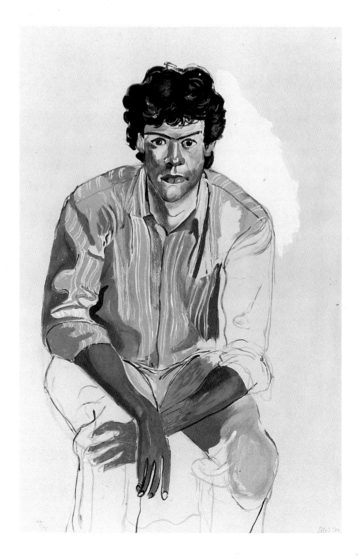

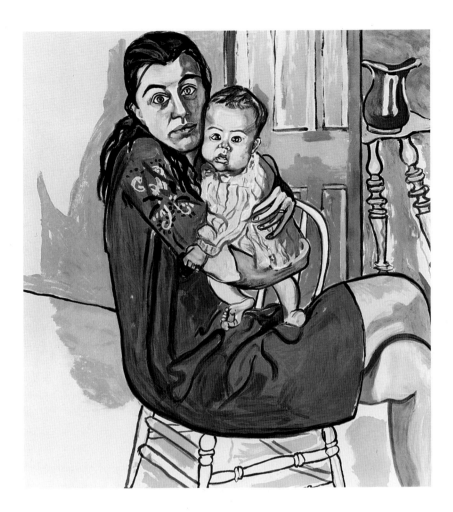

what I am. It's terrible, this feeling, but it just comes because of this powerful identification I make with the person. But that's what makes a good portrait."

Because of her refusal to accept commissions, Neel often portrayed friends and family, especially her daughter-in-law Nancy, who was also Neel's business manager. This drawing of Nancy and her infant daughter Olivia (Fig. **12.8**) is one of Neel's most unusual portraits. Nancy's wide-eyed stare as she tightly clutches her child sets up unexpected psychological overtones in the viewer's mind. Was Nancy as frightened as she seems during the sitting or did Neel's admitted tendency to merge her own psyche with that of the sitter account for this apparent anxiety? Perhaps the sight of her new grandchild unconsciously reminded Neel of the death of her own year-old baby from diphtheria in the 1920s and the conflicts she faced during her career between care of her children and the demands of her profession. These questions do not need to be answered, however, to appreciate the intensity of feeling we get in front of any of her portraits. Although the images she presents us with may not always strike us as flattering, we do sense the absolute individuality of each person she portrays.

PROJECT 66

An Interpretive Portrait

MATERIALS: Rag or medium-weight bond paper, drawing media of your choice.

The main objective of this assignment is to create a portrait that does not merely describe the appearance of the sitter. We are interested in providing the viewer with some clues as to who they are.

Ask a friend or family member to pose for you. Like Alice Neel, you will probably respond better to people you know and have feelings for. Do not necessarily imitate Neel's portrait style. Learn from her drawings and begin to develop your own interpretive approach to drawing the figure.

Any number of factors can be brought into play in order to express your own interests. The medium you use, the format you choose, and the environmental features you include in the drawing will all play important roles in this assignment. How you pose the subjects, or how they present themselves, will also greatly affect the outcome of your portrait. Think in terms of a series of drawings that explores various visual means and compositional approaches you have worked with. Review your past work and notice which drawing styles worked best for you. Incorporate these elements in this series.

CHUCK CLOSE

During the late 1960s Chuck Close (b. 1940) became known for his immense, photographically realistic portrait paintings of various friends and acquaintances. As an aid to making these paintings, Close photographed his subjects, drew an evenly spaced grid on the enlargement, and systematically referred to each square in the grid as he painted. The finished work was an enlarged, painted translation of the visual information contained in the photographic print. No gridwork was evident in these early paintings as Close smoothly joined each square into a seamless unity.

More recently, Close undertook a series of drawings based on the same systematic analysis of photographic information. In these drawings he works from a gridded photograph and translates the information square by square onto paper, using such media as graphite, ink, pastel, or watercolor. But instead of blending the squares together, Close preserves the identity of the grid and each mark is isolated and distinct. The result is drawings that appear partly to have been computer generated and partly to have been hand-drawn.

By controlling the size of the grid in his photographic source in relation to the dimensions and grid size of his drawing format, Close can create either coarse or fine drawing images. *Mark/Pastel* (Fig. **12.9**) is a drawing that measures 30 by 22 inches. Each square in the grid of this drawing interprets with a single pastel dot the appropriate color and tonal density of its corresponding square in the photographic image. By varying the density of the grid in the drawing, Close controls how fine or coarse the image becomes. The more units per square inch of the drawing, the finer the image.

Self-Portrait (Fig. **12.10**) is almost twice the size of *Mark/Pastel* and employs a finer grid. Its image appears sharper because the quantity of information it contains is greater. But the size of the mark is not the only factor which affects our perception. As we move toward or away from these gridded drawings, they become slightly out of focus. If we examine the relatively sharp self-portrait in Figure **12.10** from

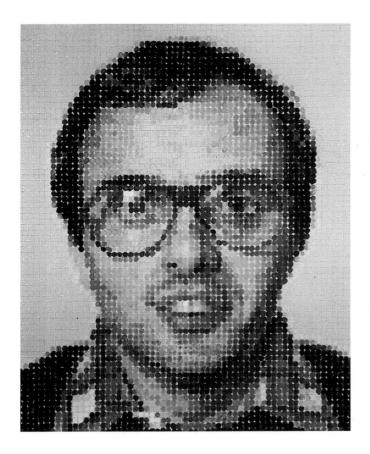

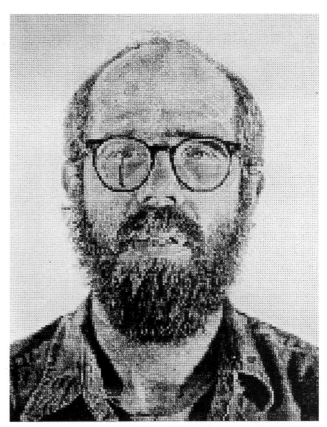

close up, it will appear less sharp and well defined. And to a certain extent the farther away we view the coarser portrait in Figure **12.9**, the "sharper" it appears.

Close's portrait drawings are created through an elaborate process of encoding and decoding visual information. Through this tightly organized system, however, Close enables us to experience a constantly changing and shifting world that assembles and disassembles itself as we perceive it at varying distances.

12.9 (left) Chuck Close, *Mark/Pastel*, 1977–8. Pastel and watercolor on paper, 30 × 22 in (76.2 × 55.9 cm). The Pace Gallery, New York.

12.10 (right) Chuck Close, *Self-Portrait*, 1977. Etching and aquatint, 54 × 41 in (137.2 × 104.2 cm). The Pace Gallery, New York.

PROJECT 67

Drawing with a Grid System

MATERIALS: Bond or rag paper with a smooth surface, tracing paper, charcoal or watercolor, a ruler.

Select a photo-image you would like to use as the basis for your grid drawing. It could be either an actual photograph or a printed image, but it should measure approximately 8 by 11 inches. Either on top of this photograph or using a transparent overlay of tracing paper to protect the print, draw an evenly spaced grid of lines with a sharp pencil. For your first drawing make a grid of moderate dimensions, as anything too large or too small will make this assignment unnecessarily complicated. A ¼ inch grid on a photo measuring 8 by 10 inches should be large enough. The dimensions of your drawing should be larger than your gridded photograph. If you have used a ¼ inch grid on the photograph, you should at least double the size of your drawn image by constructing a grid of ½ inch square dimensions. Experiment with different relationships between the grid of the photo and the grid on your drawing.

257

Place the prepared photo next to the gridded paper. Begin the drawing by analyzing the visual contents of the top left square on the photo, and translate that information into a solid tone or color that best approximates it. If the square in the photograph is not evenly toned, you will have to determine what value or color best represents it.

After you finish this drawing, you may wish to do another, perhaps one that uses a finer grid pattern, thereby achieving a sharper, more photo-realistic image.

RAYMOND PETTIBON

While the four artists profiled in this chapter so far produced paintings, prints, and sculpture as well as drawings, Raymond Pettibon (b. 1957) works almost exclusively in what might be considered a classic genre of drawing: he makes high contrast black-and-white ink drawings on paper. Since the 1980s he has created, by some critics' estimates, over seven thousand drawings that curiously juxtapose flat, iconic image with fragmented handwritten quotes taken from a variety of literary sources (all filtered through his quirky and ironic imagination). Based in Los Angeles, he is Postmodern Pop, as seen through a scathingly critical, Post-Hippie, irreverent viewfinder.

Although Pettibon is too young to have experienced the San Francisco "Summer of Love" scene in the late 1960s, he has immersed himself in a love-hate relationship with this free-wheeling period of American cultural history. Like a self-schooled

12.11 Raymond Pettibon, *No title (In which sun-baked)*, 1998. Colored ink on paper, 30 × 22¼ in (76.2 × 56.5 cm). Courtesy, Regen Projects, Los Angeles.

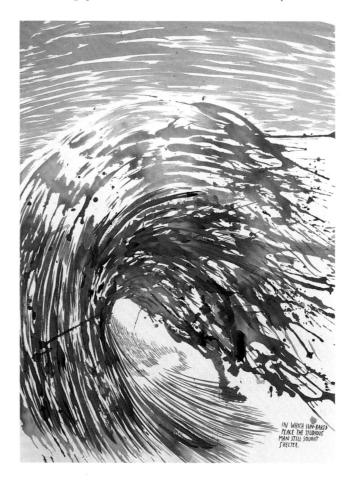

anthropologist, Pettibon has researched and collected every hippie era cliché and buzz word he could discover: some of that era's notions of "Peace," "Power to the People," acid trips, run-ins with the pigs, bellbottoms, and free-love communes found their way into his early drawings.

In the mid-1980s Pettibon branched out and began using nostalgic images rooted in a broader pop-culture psyche of America. He drew speeding steam locomotives, old sedans from the 1940s, occasionally incorporating texts characterized by innocence and idealism. For instance, one ink drawing from this period features a detailed, beautifully drawn image of a steam locomotive with the sentence: "When I see a train, I want to take it in my arms."

The sources for some of Pettibon's text-drawings are derived from violent B-movies, wise-cracking TV detective stories and lurid dime-store novels. His texts, which generally range from thirty to fifty words, take us on a helter-skelter ride of myriad feelings, concepts, and attitudes. Often there are several "voices" within one drawing. An untitled drawing made in 1991 presents a simple image of a target (Fig. **12.13**). The voice at the top states in an ambiguously romantic tone: "I can draw a line straighter than many (straight thru my heart)." Significantly, there are no straight lines in this drawing. The second voice shifts in tone to make a teasing reference to the Abstract Expressionism of the 1960s. Then, after an incongruous phrase about running a cross-country track event, the third voice inexplicably intones: "Most of all I can draw." Near the center of the target Pettibon writes in the persona of a rebellious teenager: "Kiss my ass." As the final statement the artist consciously resorts to platitudes: "Win, lose, or draw, I played the game. I gave it my all." How are we to interpret all of this disjunctive information? Pettibon gives no clues. Meanings are mutable and dependent on shifting contexts.

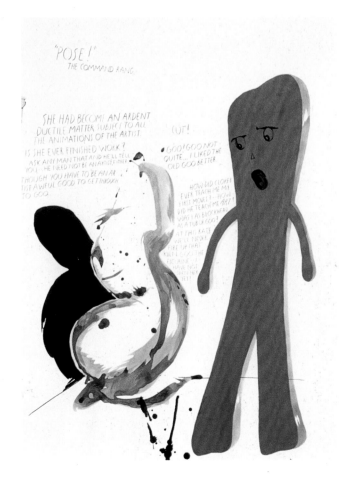

12.12 Raymond Pettibon, *No title ("Pose!" The Command)*, 1991. Colored inks on paper, 22 by 17 in (55.8 × 43.2 cm). Collection, Rudolf Zwirner, Berlin. Courtesy, Regen Projects, Los Angeles.

12.13 Raymond Pettibon, *No title*, 1991. Ink on paper, 30 × 27¼ in (76.2 × 56.5 cm). Courtesy, Regen Projects, Los Angeles

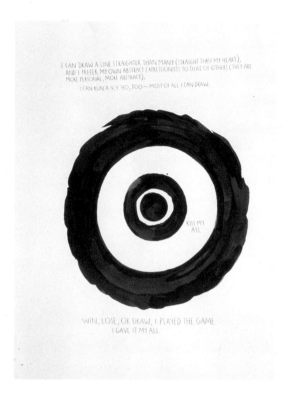

Although Pettibon's inventory of emblematic images seems inexhaustible (like his pop-culture sources), he has repeated several visual motifs; by using different texts, however, he in effect changes the images. Among his favorite images are silhouetted cityscapes (urban dreamscapes for his voices to interact in), atomic mushroom clouds, complex Gothic cathedrals, Joan Crawford's face, and huge crested waves (the kind dedicated surfers might ride to ecstatic oblivion). Figure **12.11** is one such drawing made with blue-green inks and executed in a semi-realistic, semi-abstract style. Again, Pettibon delights in ambiguity.

Pettibon belongs to a generation raised by television. During his childhood it was on from early morning until bedtime, functioning as babysitter, mentor, clown, and electronic drug. Not surprisingly, in the early 1990s he developed two alter-ego drawing characters based on popular television shows: the first, called Vavoom, is modeled after a bit-player on the series *Felix the Cat*, which appears in Pettibon's drawings as a wide-mouthed, cloaked creature that does only one thing – shout out its name in large-scale lettering. The other is based on Gumby, the green "claymation" figure of children's television whose elastic body could easily change shape or even be flattened to escape from places that might ensnare less mutable characters. One of Pettibon's particularly engaging drawings involves Gumby trying to fashion a mate, called "Goo," out of a lump of blue clay (Fig. **12.12**). The text includes the statement: "She had become an ardent ductile matter subject to all the animations of the artist." Although in the original Goo was predictably a Barbi Doll blond with a voluptuous figure, Pettibon allows *his* Gumby to fashion no more than an amoebae-shaped blob – "Is she ever finished work?" the text knowingly asks.

In a curious way Pettibon's drawings simultaneously look backward and forward in art history. They are camouflaged as antimodern statements in terms of the way they refer to illustration and popular graphic communications such as comic books. At the same time they are textbook examples of a new disjunctive sensibility that easily mixes elements of past with prognostications of the future. They are challenging drawings of high spiritual and intellectual worth – and, most importantly, they are very funny.

PROJECT 68

Popular Icons

MATERIALS: Rag or heavy-weight bond paper, appropriate drawing media of your choice.

No one can deny the pervasive influence of the popular media. Few people, whether more familiar with the stylized ears of Mickey Mouse or the amorphous form of Gumby, are immune to the seductive hold of cartoon characters. They are invented life forms that at times assume the credibility and psychological force of actual people in our lives. This assignment will enable you to examine who these cultural icons are and what they mean to you. The challenge is to use them in ways that were not intended by their makers. They need to be transformed in personal ways. Do not just make wholesale copies. Use visual elements of these characters, dissect them and reassemble them into new configurations. Mickey Mouse's distinctive ears, for example, have been used by contemporary artists such as Claes Oldenburg to comment on Walt Disney's cultural influence. Combine cartoon figures that do not normally appear together. Have fun: revisit your childhood with the insight of your adulthood. Develop a narrative for your characters to act in. The challenge is to use *them* and not have them use you.

SIDNEY GOODMAN

Sidney Goodman is among the rare individuals capable of breathing new life into a genre of drawing and painting that has been a mainstay of Western art for centuries: figurative and narrative realism. Goodman has been quietly and insistently developing a body of work that delves into new concepts of realism and allegory. His drawings and paintings, while remaining true to time-honored traditions of realism, also have an unsettling air of mystery about them. He is distrustful of mere appearances and uses his carefully observed images as departure points that lead us into illusionistic worlds that may not be what they first appear to be. Along with his

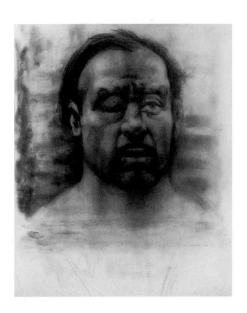

12.14 Sidney Goodman, *Battered Head*, 1995–7. Charcoal on paper, 29 × 23 in (73.6 × 58.4 cm). ACA Galleries, New York.

261

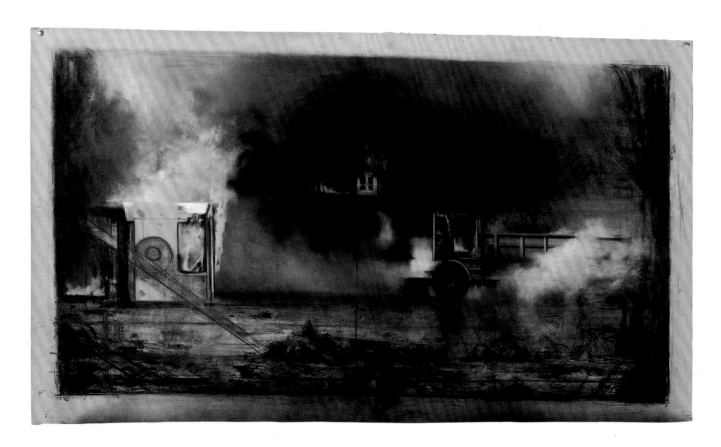

12.15 Sidney Goodman, *Burning Vehicles*, 1978–80. Charcoal and pastel on paper, 35 × 57 in (88.9 × 144.8 cm). Collection, Malcolm Holzman. Courtesy, ACA Galleries, New York.

finely honed eye, Goodman has a highly tuned intelligence that does not allow us to stop at surface appearances. He takes us through the skin of illusion and explores the psychological depths of his subjects for new meanings.

Goodman's many portraits exemplify his ability to be both realistic and transcendent of visual appearances. In 1968 he wrote: "I sometimes paint a realistic picture in order to justify logically something unreal." *Battered Head* (Fig. **12.14**) is a case in point. This charcoal drawing records with great detail the features of a prize fighter, cast in the role of a modern warrior. His pain is expressed by the physical distortion of his injuries. But the more we look at this drawing and think about who it might represent, the more unreal it becomes. Goodman achieves this quality through meticulous control of his visual forms; the image of the battered fighter is used as a jumping off point into the realm of our unconsciousness, where the image resonates in personally expressive ways.

Engaging equally with the worlds of fact and fiction, Goodman also likes to work with urban and suburban themes. One of the work tables in his studio is usually scattered with news photos from magazines and newspapers that Goodman collects for his compositions. *Burning Vehicles* (Fig. **12.15**) is a pastel and charcoal drawing of a truck on fire; the mysterious black field heightens the visual effects of the flames. On one level, the picture can be read as a commonplace urban accident – a collision and resulting fire at night. On another, it stands as a modern metaphor for the Nazi Holocaust of World War II. Haunted by the death-camp photographs published in *Life* magazine in 1945, Goodman has repeatedly used fire in his compositions to subliminally suggest death-camp incinerators working day and night. *Burning Vehicles* hints not only at the horrors of Nazi Germany but also the continuing atrocities in Africa, Asia, and the Middle East.

In both drawing and painting, Goodman enjoys working on a large scale. *Easter Sunday* (Fig. **12.16**) is drawn on a section of a 6 foot wide roll of heavy rag paper.

(Figure **12.17** shows the artist in his studio working on another charcoal and pastel drawing of similar size.) In this drawing a giant pink rabbit hovers near a small girl, who is squatting outside and playing with three doll-sized copies of the rabbit. Coloristically it is a *tour de force*: deep rich tones of charcoal are skillfully integrated with pastel passages of pink; hints of dark browns mingle with background passages and there is a wisp of blue pastel judiciously added to suggest the sky.

12.16 (left) Sidney Goodman, *Easter Sunday*, 1987–8. Charcoal and pastel on paper, 96 × 60 in (243.8 × 152.4 cm). Allentown Art Museum, Pennsylvania. Purchase, The Reverend and Mrs. Van S. Merle-Smith, Jr. Endowment Fund.

12.17 (right) Sidney Goodman in his studio. Courtesy, ACA Galleries, New York.

PROJECT 69

Transforming News Photographs

MATERIALS: Rag or heavy-weight bond paper, a collection of news photographs (black-and-white and color), and media of your choice.

Over a period of a week or so start a collection of newspaper and magazine photos that document current events. There are often interesting compositional elements to such images. Using one or a combination of several as visual notes, develop a series of drawings and build your own composition. The photos need to be transformed, not just copied. Collect the images that you find interesting and think about how you could interpret them. If you would like to work on a large scale, go to your local art supply store and ask about the availability of good paper on rolls. Perhaps you could share it with several other students.

ROMARE BEARDEN

Most of the mature work of Romare Bearden, considered to be the dean of black artists in America, drew its inspiration and meaning from recollections of the rural south. Symbolism plays a major role in his work; he referred to trains, for example, as "journeying things," a means of getting to a better place, both literally and metaphorically. Making art that related to his struggle and the struggle of his people had been Bearden's own "journeying thing" and the road he had traveled was long and difficult. After working professionally as an artist for decades, Bearden was finally able to make a living through his art only when he reached his fifties. Expressions of torment and sadness can be seen in many of his works; but joy and triumph reside there as well.

In his later years, Bearden was fond of wintering on the Caribbean island of St. Martin. The warmth helped the severe joint pain he was experiencing in New York City's cold climate. Bearden had set up a studio there but found he had difficulty doing the type of work he created in New York – Harlem street scenes and collages of southern memories. Those subjects seemed out of place on the island, whose customs and culture were slowly but surely exerting an influence on Bearden. He described how, one day, he watched a group of stonemasons on the island build a wall. Rather than use brute force to split the stones, they would tap lightly at the sides of the rocks and at certain place the rocks would split open. When Bearden asked how this was done, one of the workers explained that by tapping the rock, the men were "listening for its truth. When they discovered that vein of truth, only a few firm taps were needed."

12.18 (left) Romare Bearden, *Dream*, 1970. Newark Museum of Art, New Jersey.

12.19 (right) Romare Bearden, *Obeah's Choice*, 1984. Watercolor on paper, 30⅛ × 22⅜ in (76.5 × 56.89 cm). Maya Angelou Collection. Courtesy, Romare Bearden Foundation, New York.

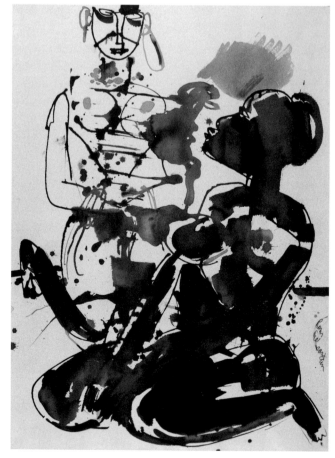

Bearden found inspiration for his art at Obeah rituals, part of a belief system of African origin whose practicing members are chiefly from the British West Indies, the Guianas, and the southern coastal states of America; the ceremonies are characterized by the use of sorcery and magic ritual. As a spectator Bearden attended all-night gatherings that were conducted by the sect's priests and priestesses, which inspired him to begin his series of watercolor drawings titled *Rituals of the Obeah*. This includes *Dream* (Fig. **12.18**) based on a woman's experience during a ritual. She told Bearden that she captured the moon "and held it as a locket on her breast and then threw a rooster out in the sky who spun himself in the rising sun." Bearden made the rooster a prominent feature at the bottom right.

The sharply contrasting treatment of the two figures in *Obeah's Choice* (Fig. **12.19**) communicates the metaphorical space that Obeah followers enter via their magic rituals. Bearden did not experience any state of trance himself, but found what he saw entirely outside the rational. Intrinsic to the belief system is a belief in the power of magic to control the world – to counter negative forces, to cure illness, and to tap into powers beyond understanding.

Bearden was able to listen to and see what was happening around him and to transform these experiences into visual interpretations. This watercolor series allows us to vicariously enter into the Obeah world and to compare it to our own modern world.

PROJECT 70

Transforming an Experience

MATERIALS: 140 lb. watercolor paper (approximately 12 by 30 inches), tubes of watercolor, large wash brushes.

This assignment requires you to think about and respond visually to a performing arts experience: a particularly good rock concert, dance performance, or a play that made an impression on you. You might want to take a sketchbook to make notes during the performance, but this is not mandatory. We are aiming for an impressionistic response to the experience rather than an accurate rendering of forms. You may wish to work with wet into wet watercolor techniques: wet the paper in select areas with clear water and go back into it with brushes loaded with pigment. This will give you soft passages and will allow different colors to smoothly blend into each other, as in Bearden's *Rituals of the Obeah* series. After doing some studies, work on a full sheet of watercolor paper and keep the details to a minimum.

PAT STEIR

In 1981 Pat Steir (b. 1940) embarked on a long-term series of paintings and drawings that explored the question of stylistic similarity and difference in the visual arts. "I feel there is really very little difference between stylistic modes of art history periods," she explained, "the 'alphabet' is the same but not the 'handwriting.' The difference is in the scale, in the use of space." She had been considering such a series for some time, visiting museums in Europe – she lives part of the year in Amsterdam – looking carefully at the works of such artists as Courbet, van Gogh, and Rembrandt, trying to find out what they had in common visually. But in order to begin her series, she needed a unifying theme and image to express her ideas. One day on the train home from a museum in Rotterdam she took a better look at a poster she had just bought of a floral painting by Jan Brueghel (1568–1625). While the train sped along she excitedly folded and cut the reproduction into sections to see if it would be suitable for her series. By the time the train arrived in Amsterdam Steir knew she had found her central motif.

For two years after the discovery of this image Steir steadily worked on what was to become *The Brueghel Series (A Vanitas of Style)* (Fig. **12.20**). To create this multi-paneled artwork Steir divided the image of the Brueghel painting into a grid of sixty-four rectangles. Each of these sections was then painted in the style of a well-known artist (the individual panels measured 28½ by 22½ inches and formed a finished work almost 20 feet high and 15 feet across). Steir paid homage to the widest cross-section of artists imaginable. Old Masters standing side by side with contemporary artists. The result is a macro-image formed out of these micro-examples of various visual styles and modes of expression.

Steir went on to extend her inquiry with a series of self-portraits that continue to explore art-historical issues such as graphic handwriting and appropriation (the use of historic images in contemporary art). Her studio in Amsterdam is directly across

12.20 (left) Pat Steir, *The Brueghel Series (A Vanitas of Style)*, 1982–4. Oil on canvas, 64 panels, each 28½ × 22½ in (72.3 × 57.1 cm). Courtesy, Robert Miller Gallery, New York.

12.21 (right) Pat Steir, *Self After Rembrandt #4*, 1985. Etching, 26¼ × 20 in (66.7 × 50.8 cm). Courtesy, Crown Point Press, New York.

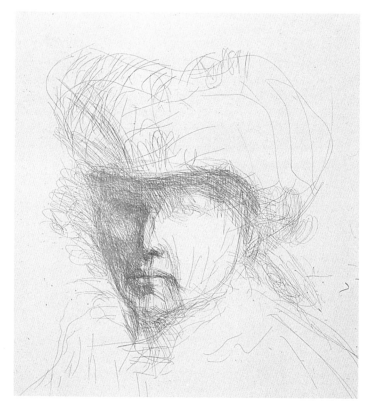

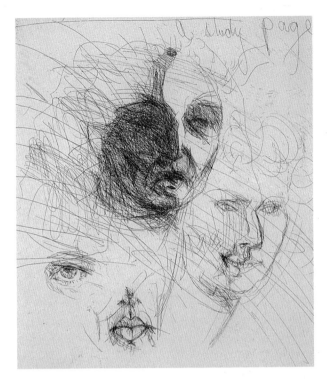

the canal from the house Rembrandt lived in, and for her etching *Self After Rembrandt #4* (Fig. **12.21**) she shows her absorption with that master by adopting one of his characteristic self-portrait poses and by manipulating tone with his concern for qualities of light and value. Another version of the same subject (Fig. **12.22**) imitates the kind of drawing studies that might be found in one of Rembrandt's notebooks. A finished sketch of Steir's head is ringed on the bottom of the page by detailed studies of her eye and mouth along with a less complete version of the drawing above.

Steir has also used a host of other artists as conceptual models for her self-portrait series, including Picasso, Courbet, and Cézanne. Her drawing titled *As Cézanne with a Dotted Line for Beard* (Fig. **12.23**) is distinctive in its use of such devices associated with Cézanne as leaving portions of the composition in an unfinished state and reducing elements of the face to simple geometric forms. What is striking about all these borrowings from the past is the way Steir manages to incorporate them into her own personal history. By holding a mirror up to the past Steir is able to see herself more clearly as an artist.

12.22 (left) Pat Steir, *Self After Rembrandt*, 1985. Hardground, 26 × 20 in (66 × 50.8 cm). Courtesy, Crown Point Press, New York.

12.23 (right) Pat Steir, *As Cézanne with a Dotted Line for Beard*, 1985. Monoprint, 24⅜ × 18 in (61.9 × 45.7 cm). Courtesy, Crown Point Press, New York.

PROJECT 71

Using Style as a Visual Element

MATERIALS: Rag or heavy-weight bond paper, drawing media of your choice.

The objective of this assignment is not to make a copy of a masterwork but to study and assimilate the stylistic methods of an artist whose work interests you. Remind yourself of what attracts you to the work of your favorite artists. What kind of lines did they use? What compositional devices recur? What kind of media are most frequently employed? Analyze and take note of spatial, thematic, and graphic techniques. Then do a series of drawings of any appropriate subject in the style of a particular artist, avoiding slavish imitation. Allow your own visual handwriting to merge with the assumed identity of your historic mentor. By examining the results of this assignment you should develop an increased awareness of stylistic content in drawing.

CHRISTO AND JEANNE-CLAUDE

Everyone has the ability to fantasize – without this form of imaginative dreaming we would not be entirely human. But while everyone engages in daydreams, few people manage to make their dreams a reality. The American artists Christo (b. 1935) and Jeanne-Claude (b. 1935) have built a long and successful career on the basis of realizing large-scale environmental art projects. Interestingly, the process of drawing plays a significant role in the materialization of these imaginative goals.

Christo and Jeanne-Claude are best known for such major projects as "wrapping" a large section of the Australian coast, stretching a huge curtain across a Colorado valley, and wrapping the Pont-Neuf, a bridge crossing the Seine in the heart of Paris. Drawings are an intrinsic part of every stage of the Herculean task of implementing these grand schemes. During the formative stage of a project, Christo may make sketches that enable him to fully visualize what he wants to accomplish. Later, more finished drawings are made to work out technical and aesthetic details. These drawings are vital to the project in that their sale to dealers, museums, and collectors raises the money to pay for expenses. Throughout the project, technical drawings are made (by engineers in the Christos' employ) to show the manufacturers how to build the various parts and to show construction workers where to place structural supports or how to assemble materials.

Packed Building (Fig. **12.24**) is a project drawing envisioning how the Allied Chemical Tower in New York's Times Square would looked wrapped with cloth and tied up like a package awaiting overseas postal delivery. This project was never realized, but the drawing allows us to visualize what Christo and Jeanne-Claude had in mind.

Running Fence (Fig. **12.25**) graphically illustrates the Christos' project for a cloth fence that would cross 24½ miles of rolling landscape in Northern California. Along with an accurate representation of how it would look, Christo and Jeanne-Claude used the drawing to note specific construction details.

For a proposed project in Spain, Christo and Jeanne-Claude made use of a variety of materials and processes to communicate their ideas. *Puerta de Alcala Wrapped* (Fig. **12.26**) uses fabric, twine, a photostat, a map, a photograph, and pastel, charcoal, and pencil markings. The drawing is done directly on the photostated image of the gateway to suggest how it would look wrapped. The collaged map and photograph on the bottom of the drawing serve to situate this project geographically and show its relationship to the city of Madrid.

12.24 Christo and Jeanne-Claude, *Packed Building, Project for Allied Chemical Tower, New York*, 1968. Pencil, charcoal, and color pencil, 96 × 36 in (244 × 91.4 cm). Private Collection, Paris. Courtesy, the artists.

PROJECT 72

Project Visualization

MATERIALS: Rag or bond paper, appropriate materials of your choice.

Conceive of an environmental or sculptural project that for reasons of scale, practicality, and economics would be difficult it not impossible for you to undertake. Make a drawing or series of drawings that clearly visualizes this fantasy project. You may incorporate collaged materials such as maps and photographs as aids, or you may rely entirely on drawn elements.

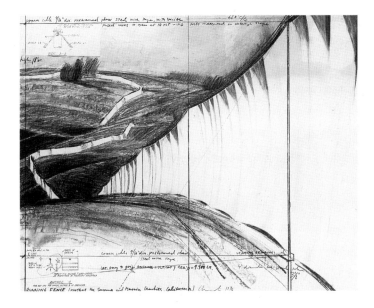

12.25 Christo and Jeanne-Claude, *Running Fence, Project for Sonoma and Marin Counties, California*, 1976. Pencil, fabric, charcoal, crayon, and engineering drawings, 22 × 28 in (56 × 71 cm). Courtesy, the artists.

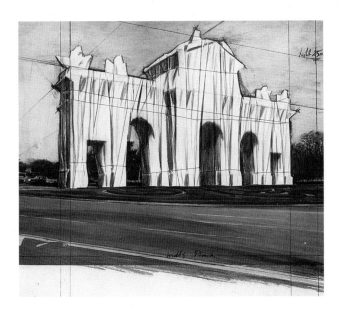

12.26 Christo and Jeanne-Claude, *Puerta de Alcala Wrapped, Project for Madrid*, 1980. Pencil, fabric, twine, photostat from a photograph by Wolfgang Volz, pastel, charcoal, photograph and map, 22 × 28 in (56 × 71 cm). Courtesy, the artists.

The artists discussed in this chapter have all chosen to explore and develop only a few concepts out of limitless possibilities. What is important for you to understand is not so much what these individuals do, but how they visually think and how they develop their ideas using the medium of drawing. I hope these examples will prove inspirational in encouraging you to continue your creative involvement with drawing.

13 DRAWING APPLICATIONS

This chapter will examine how drawings are put to use by a wide variety of visual arts professionals whose activities range from making us aware of the political situation to designing new buildings that challenge us both technically and aesthetically. Although a broad range of applications is covered, be aware that only a few that relate specifically to drawing are represented. Perhaps in the future your own use of the drawing medium will contribute to this growing list.

DRAWINGS FOR FILM

One of the most widely viewed and admired uses of drawing today is in animated films. Disney-style cartoons make use of tens of thousands of animation cels which race by at the rate of twenty-four per second. Although computer-aided functions today lessen some of the tedium involved in making all of these subtly changing sequential images, thousands upon thousands of individual drawings are created and photographed for each film.

By contrast the drawings used in the short films of William Kentridge, a white South African artist (b. 1955), number in the dozens rather than thousands. Kentridge has developed a process he calls "additive animation," a technique in which a large charcoal drawing (measuring about 2½ by 3½ feet) is filmed and then altered bit by bit through the addition of charcoal passages and through erasing sections of the drawing. Typically he uses about twenty-four individually altered drawings, sometimes changing each one as many as 500 times. The results yield short, animated films whose charcoal on paper images appear on the screen to be drawn, redrawn, and partially erased by the invisible hand of the artist. These rough-hewn, hesitant images are the antithesis of most commercial animation: whereas Disney's goal is the banishment of the artist's hand in favor of an anonymous corporate look, Kentridge celebrates the idiosyncrasies and imperfections of his hand-drawn vision.

The distinctive look of these films suits their author's political intentions. Kentridge, who was born in Johannesburg during the apartheid era, addresses South Africa's continuing social and political concerns, for example, the exploitation of miners (Fig. **13.2**). The backdrop for almost all his films is the social tension and personal fear that characterizes the aftermath of apartheid: despite the joyous

(opposite) Harold Cohen's "turtle" in action, San Francisco Museum of Modern Art, summer 1979. Courtesy, Harold Cohen.

13.1 William Kentridge, Drawing from *Felix in Exile*, 1994. Charcoal and pastel on paper, 47 × 59 in (120 × 150 cm). Courtesy, Marian Goodman Gallery, New York.

collapse of that regime, after decades of brutal repression, there are still daily killings and conflicts. The artist's films and drawings deal with psychological issues of estrangement, anxiety, and remorse that are generalized and metaphoric rather than specific propagandistic statements. Kentridge comments on this issue in a press release (San Diego Museum of Contemporary Art, 1998):

> I have never tried to make illustrations of apartheid, but the drawings and films are certainly spawned by and fed off the brutalized society left in its wake. I am interested in a political art, that is to say an art of ambiguity, contradiction, uncompleted gestures, and certain endings; an art (and a politics) in which optimism is kept in check and nihilism at bay.

Kentridge's films – and consequently his drawings – feature two men, alter-egos of each other. The films are not strictly narrative but bring together actions and events in a captivating series of images and vignettes. The first principal character is Soho Eckstein, a wealthy white industrialist who is rapacious capitalism personified; his identifying uniform is a banker's pin-stripe suit, worn even in bed. The other is Felix Teitlebaum, whose sensitive, artistic nature causes him to be perpetually concerned about his place in South African society; he is always shown naked, perhaps to represent his vulnerability to the brutality of apartheid. (The artist simply explained: "I couldn't think of an outfit for him.")

Felix in Exile was created between September 1993 and February 1994, a period coinciding with the first democratic General Elections in South Africa. This was a time of great uncertainty: nobody knew how people would live together in post-apartheid South Africa. Kentridge was inspired to create this film when a friend described seeing police photographs of murder victims at the station house. There is a poignant scene of Felix in his Paris hotel room – the wall is filled with images of South Africa's barren and exploited terrain – looking at drawings of corpses that an

13.2 William Kentridge, Drawing from *Mine*, 1991. Charcoal and pastel on paper, 29 × 47 in (75 × 120 cm). Courtesy, Marian Goodman Gallery, New York.

13.3 William Kentridge, Drawing from *Felix in Exile (Nandi Dreams of a Constellation)*, 1994. Charcoal and pastel on paper, 31½ × 47¼ in (80 × 120 cm). Courtesy, Marian Goodman Gallery, New York.

African woman he knows had sent to him (Fig. **13.1**). Her name is Nandi. She is a surveyor by profession and the optical measuring instrument she uses, a theodolite, employs a cross-hair sight much like the scope of an assassin's high-powered rifle.

Another lyrical drawing used in *Felix in Exile* features Nandi seated before her sheaf of corpse drawings. Above her in the night sky is a constellation of stars that assumes the configuration of a shrouded corpse (Fig. **13.3**). Behind her is a desolate and disturbed landscape that suggests both the environmental ruin brought on by large-scale mining operations and also, symbolically, the emotional devastation caused by apartheid. Although Kentridge's work is political, it avoids a heavy-handed, polemic approach. Instead he probes the multifaceted world of contemporary life in South Africa and offers us different points of view. While conjuring up all sorts of aspects of political and social actions, he offers no solutions to the problems. Perhaps viewing these drawings and the films that emerge from the act of drawing them will contribute to the process of healing and rebuilding in this once divided country.

POLITICAL COMMENTARY

On a much lighter political note, drawings have often been intended to poke fun at rulers and powerful elected officials. At certain places and times in history, an insolent caricature could get you hung. Irreverent humor is not only an American tradition, it is an inalienable right protected by nothing less than the Constitution. When *Rolling Stone Magazine* did an article on the Bill Clinton–Monica Lewinsky scandal they called on the underground cartoonist Robert Crumb (b. 1943), who produced a cartoon showing Monica boldly walking into the oval office with a pizza and a coke for the President (Fig. **13.4**). Much of the scathing humor of this drawing stems from its wealth of details. Crumb gets Monica's broadly smiling face right along with the surprised and flustered double take of Clinton as he interrupts his business call. The President's personal secretary, Betty Currie, stands hesitantly behind a half-open door with a disapproving expression on her face. Executed with bold cartoon colors and confident pen and ink hatch lines, Crumb sets the stage beautifully for the magazine's article about Monica and Bill.

13.4 Robert Crumb, *Monica Delivers the Pizza*. Pen and ink.

PROPOSAL DRAWINGS

Drawings can also work in a visionary way. Some artists have offered proposals that urban planners might think impossible to realize. In the late 1990s Madison Square Park in Manhattan was badly in need of renovation. This once glorious area of historic fountains and reflecting ponds was languishing in a sorry state with broken benches, dried out lawns, and cracked and empty pools. Its renovation began when Danny Meyer, who owned some restaurants across the street, got together with other businessmen in his building and raised some private money for the renewal project. The City Parks Foundation joined forces with Meyer and his friends and coordinated the replanting of shrubs and the renovation of the park's nineteenth-century fluted lampposts and wrought-iron fences. Target Art, a program sponsored by Target Discount stores, joined the consortium and solicited proposals for art projects from a variety of artists. Thai artist Navin Rawanchaikul submitted a proposal for taxi shelters in the park. This drawing (Fig. **13.5**) showcases its features: panorama paintings would be placed under the shelters; there would be a working taxi light on the cab's roof and a floodlight on one of the support columns to illuminate the painting under the cab at night. There is a youthful, upbeat spirit to this drawing and the structures it illustrates. Recently the taxi shelters were completed and they have already become a favorite gathering place in the park (Fig. **13.6**). Without Navin's free-wheeling proposal drawing to show the sponsoring committee what these shelters would look like, they might never have gotten past the planning stage.

13.5 (left) Navin Rawanchaikul, *I Love Taxi*, 2001. Mixed media. Shugoarts, Tokyo. Courtesy, the artist.

13.6 (right) *I Love Taxi*. Courtesy, *New York Times*, June 12, 2001. Photographer: Fred R. Conrad.

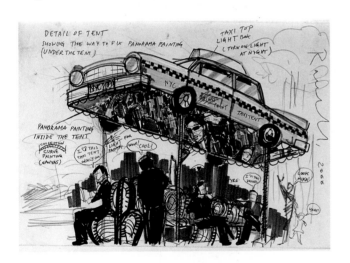

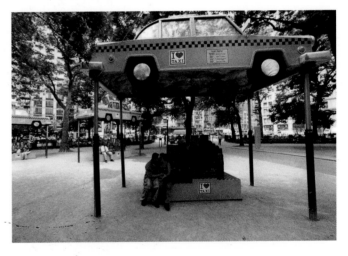

PUBLICATION ILLUSTRATION

Following the trend for visually appealing layouts, newspapers and magazines have become big consumers of images that spruce up the printed page and make columns of type seem less daunting. Working in tandem with the text, images created by artists make written concepts more accessible and can provide an emotional connection to the subject. When the *Miami New Times* ran an article concerning methadone treatment and addiction, it was accompanied by Tom Bennett's foreboding image of a woman with monkeys jumping on her back. Bennett conceptualized the slang expression for drug addiction – "monkey on my back" – as a visual interpretation of this saying.

275

13.7 Henrik Drescher, *Fish Man*, 1990. Pen and ink, 9⅜ × 16⅛ in (24 × 41 cm). Courtesy, *Boston Globe.*

13.8 Michael Caplanis, *Generals William Tecumseh Sherman and Jeb Stuart*, 1998. Cartoon, pen and ink and Dr. Martin's watercolors on illustration board, c. 16 × 20 in each (40.6 × 50.8 cm). From *Drawn to the Civil War*, John F. Blair, publisher. Courtesy, the artist.

In 1990 Henrik Drescher, a European-born illustrator working in America, was commissioned by the *Boston Globe* to produce a drawing to accompany an article expressing concern for the dwindling fishing resources along the New England coast. He was asked to do a black and white drawing, which printed well in a newspaper format, and he encapsulated the ecological problem by producing an image of a creature within a creature hooking itself (Fig. **13.7**). There is a whimsical and mysterious quality to this ink drawing which works in counterpoint to the serious nature of the article.

As an applied art, drawings continue to thrive as book illustrations. Whether diagrams elucidating scientific texts or enlivening cookbooks with drawings of vegetables, they are intended to enhance the publication's appearance and usefulness. Sometimes book illustrations play an essential role in the way a book functions, as is the case in *Drawn to the Civil War* by J. Stephen Lang and illustrator Michael Caplanis. The book's brief biographies of important Civil War figures are further brought to life by Caplanis's often hilarious pen and colored ink drawings (Fig. **13.8**). In an internet commentary about his drawings, responding to the question of what might be funny about the Civil War, Caplanis says: "The ancient photography from the period, which 'informs' my style. These poor old dudes had to sit motionless for as much as five minutes at a time while the lens was open. The result was usually pretty laughable and this stiff, 'deer in the headlights' appearance is what serves as my inspiration." Such caricatures are certainly humorous but they also function as catalysts to make us want to know more about historical figures and the various roles they played.

DRAWING IN THE DIGITAL AGE

Artists have, by necessity, always been inventors and adapters of new technologies that could advance the practice of their craft. Knowledge of metallurgy, optics, engineering, and chemistry were important tools of the trade for sculptors, painters, and architects. Even the common graphite pencil, now largely taken for granted was a new invention as recently as the late 1700s. It was invented by the Frenchman Nicolas-Jacques Conté in 1795, transforming the practice of drawing. Computers have made a major impact on the discipline of drawing, particularly in the fields of design, illustration, and architecture. In the last decade or so their use in the visual

13.9 Douglas P. King, San Marco Arcade, Venice, 2000. Autodesk Architectural Studio software. Courtesy, Douglas P. King, Principal, Perkins Eastman Architects.

professions has become commonplace. Inexpensive, fast, and powerful computers making use of ever more sophisticated and specialized software applications have dramatically changed the practice of graphic artists and architects. This section will focus on how digital drawing techniques are used for architectural illustration and advanced architectural design and development.

No student in any architectural program graduates today without an understanding and fluency in specialized computer languages. By learning to use a suite of specialized programs, architects can now work more quickly and accurately than before, designing buildings on the computer from concept stage, through working drawings and then on to project management as plans are transformed into brick, stone, and steel. The best programs combine a strong foundation of free-hand drawing skills with further experience on computer-aided programs and outputting devices. Computers can do many things, but they cannot yet initiate original concepts and establish working parameters. This is where human creativity and visual skills are put to the test. Ideally, of course, the solution is to learn both traditional drawing skills *and* how to apply these skills, cost effectively through digital technology.

According to some experienced architects, computer-aided drawing programs produce results that look as if they had been hand-created by a skilled draftsman. Ironically, this concept is driving the development of specialized software programs for architects. In 2000 Autodesk, Inc. announced its development of a product that gives architects working on computers the look and feel of hand-drawing. Figure **13.9** shows how the San Marco arcade in Venice can be drawn and reworked on screen. Just as the invention of the blueprint machine changed the practice of architecture, so the new digital technologies offer new opportunities for speed and accuracy in architectural design.

DIGITAL RENDERING

Computer inroads were first made in the architectural profession with the generation of contract and production drawings and have lately entered the design and schematic phases as well. But the two opposite ends of the architectural process – the initial sketch and the finished architectural rendering drawing – have remained almost immune to computer intervention. Many architects feel that computer-generated "final vision" drawings, the kind that offer clients a "virtual reality" of the end product, were too cold and precise, or had too much extraneous detail. The debate between "tech" (the inexpensive computer look) and "touch" (the more costly hand-drawn image) has generated much heat. But some professionals have advocated entering into an alliance rather than remaining in opposite camps. Architect Paul Stevenson Oles teamed up with the partners of Advanced Media Design, aiming to create a "graphically integrated approach to hybrid imaging of architecture." Oles and AMD used a sequential image-building process to create a rendering of the interior atrium view of the Bank of China, Beijing, a project of the Pei Partnership. The first stage is for the illustrators to select the best viewpoint from which to create the space wireframe (Fig. **13.10**). Oles then produces a preliminary value study by hand, using his considerable "touch" experience (Fig. **13.11**). Working back and forth in this way, Oles and AMD produce a digital "pre-rendering" image that gives them a good idea of how the finished product will look (Fig. **13.12**). Oles then fine-tunes the values and highlights, and adds details such as landscaping and people to give an impression of the final context. Machines have always been developed to help us with tasks, not control our lives. Such collaborations between human expertise and technical proficiency promise to have a positive impact on the field of architecture.

13.10 Paul Stevenson Oles/Advanced Media Design, Bank of China, Beijing, interior, 1995. Wireframe study. Courtesy, Advanced Media Design, Inc., Providence, Rhode Island.

13.11 Paul Stevenson Oles/Advanced Media Design, Bank of China, Beijing, interior, 1995. Preliminary value study. Courtesy, Advanced Media Design, Inc., Providence, Rhode Island.

279

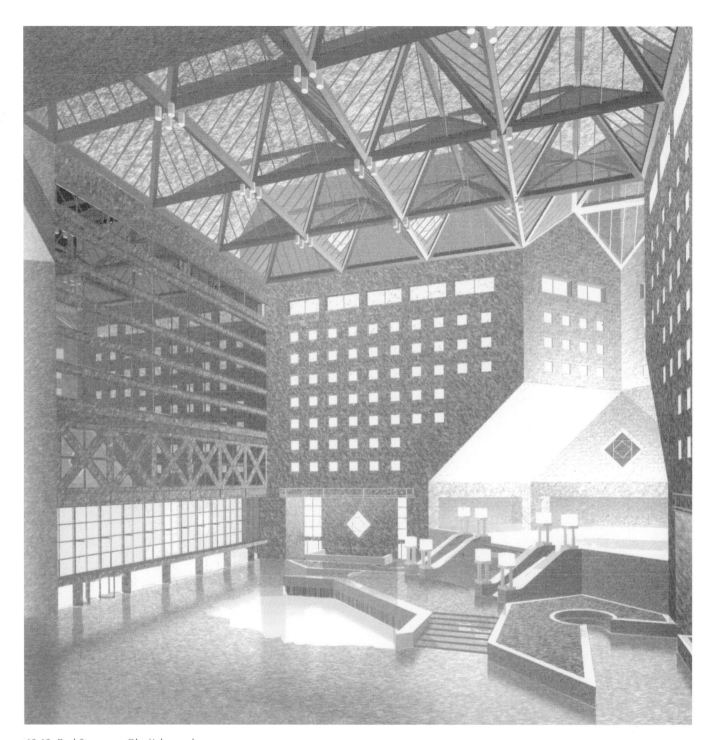

13.12 Paul Stevenson Oles/Advanced
Media Design, Bank of China, Beijing,
interior, 1995. Digital image. Courtesy,
Advanced Media Design, Inc.,
Providence, Rhode Island.

COMPUTER-AIDED VISIONS

Because of computer-aided drawing and design, architectural structure can now be built that would have been technically impossible or economically unviable a generation ago. The architect Frank Gehry (b. 1929), for example, used powerful computer-aided design and computer-aided manufacturing (CAD-CAM) technology to design the celebrated Guggenheim Museum in Bilbao, Spain, which opened to great acclaim in 1999.

Gehry was one of a select group of architects invited by officials of Bilbao, a center of the Basque provinces, to design a museum that would raise the status of this economically depressed industrial city to one of international renown. The architect was enthusiastic about the city but not the proposed site, a warehouse in the old section of town. Instead he proposed to build the museum on a bend of the Nervion River, where an existing bridge would cross over the building as an integral part of its design.

13.13 Frank Gehry, Sketch for Guggenheim Museum, Bilbao, 1995. Gehry Partners, LLP.

Gehry established the flowing energy and motion inherent in this entirely curvilinear building concept with continuous line drawings done by hand (Fig. **13.13**). In the initial stages of concept development, Gehry prefers to work with sketches and develop ideas in physical models of paper, clay, and wood. For the Bilbao Guggenheim, the model he submitted to the jury consisted of rolls of paper taped together by hand, the computer later transforming them into working drawings.

Since Gehry's buildings are anything but conventional, standard architectural drawing software was of limited use. As movement is one of his abiding interests, it made sense for him to turn to a computer program developed by the French aerospace industry in its design and manufacture of supersonic fighter jets. This program, called CATIA, is useful not only in three-dimensional imaging but also in the extremely complex process of engineering and fabrication. CATIA analyzes and "rationalizes" the complex curved surfaces of either planes or buildings, converting them into shapes that can be unfolded and manufactured out of flat sheets of high-tech metal such as titanium.

CATIA works from a scale model of the building. When an articulated arm with a probate attached to it touches a point on the model, it records its x, y, and z coordinate and generates a rough three-dimensional construct in the computer based on these series of spatial coordinates. The computer-generated model is then refined with the addition of shading and highlights (Fig. **13.14**, a, b, c). Once this digitized

281

13.14 a, b, c CATIA Sequence, 1995.
Gehry Partners, LLP.

13.15 Frank Gehry, Guggenheim Museum, Bilbao. © FMGB Guggenheim Bilbao Museum. Photo: Erika Barahona Ede.

information is in the computer, it is used to further develop all aspects of the building's development including the automated construction of precise three-dimensional models, simulation of load-bearing structures, and can even drive computer numeric machining tools to shape the constantly fluctuating titanium "skin" sections on the finished building (Fig. **13.15**).

Gehry commented that many artists in the past have thought about creating flowing, non-rectangular buildings but had been put off by the exorbitant costs. He observed that it is cheaper to make something with right angles in our culture. "But," he says, "if you figure out a way to make technology work for you, you can explore curved shapes and make them possible at competitive costs. You can do this because of the computer."

Gehry's work is an excellent example of how the computer can work in tandem with traditional drawing skills to produce visions of the world that push the limits of one's imagination. In a curious way, going forward into the Brave New World of cyberspace and technically sophisticated graphic systems brings us back to drawing's origins. Many visual products of computer processes are reminiscent of the magical, hallucinatory effects the earliest cave drawings were meant to have on our psyche. But all drawings are dreams of a sort and, if we think about it, they are tangible dreams that help shape our world and enrich our lives.

GUIDE 1:
CHOOSING SPECIAL PAPERS

It is important to match the paper to the drawing task. If you are sketching, warming up, or trying something for the first time, it would be wasteful to use a special paper. Most of the better papers are sold by the sheet and not in pads; since they are made of better materials and involve special manufacturing processes, they cost more than bond papers. However, if you are doing a sustained drawing, one you might work on for several hours, this might be the time to use some of the heavier, all-rag papers on the market. When you consider the time you put into a finished, successful drawing, a $2 piece of paper might not be viewed as an expenditure but an investment in your art.

The papers listed below are either 100 percent cotton rag or acid-free mixtures. Properly stored, they can last for centuries. There is nothing wrong with using inexpensive pulp papers, such as newsprint and bond papers, but they are far less durable than the fine papers mentioned in this guide.

Papers come in various weights, measured in pounds (lb.) in some cases and metric grams in others. They also vary in terms of surface texture: hot press is the smoothest; cold press is less smooth; and rough is the most highly textured. The absorbency of papers to liquid media is determined by sizing. Sizing is a dilute glue or gelatin mixed with the rag pulp during its manufacture. Sizing cuts down on the "bleeding" or spread of ink or watercolor on the paper. A paper with no sizing would be like blotting paper. Of course if you are using dry media, sizing may not make a difference.

Many fine papers have deckled edges: instead of being cut straight by a trimming blade, the edges of each sheet are irregularly and attractively feathered. In handmade and semi-handmade papers, deckled edges are the result of the forming process. Some also come with a torn rather than cut edge. Again, this produces an aesthetically pleasing and desirable effect.

Although separated into three categories below – pastel and charcoal papers, watercolor papers, and printmaking papers – be aware that these designations are guidelines and not strict limitations. You can draw with dry media and use watercolor and ink on any of them, provided they give you the results you desire. The list is selective, representing just some of the more readily available special papers. Go to a well-stocked art supply store and look at the papers first hand. Feel their thickness and note their textures. Buy a sheet or two to experiment with before you buy large quantities. Among the advantages of using good paper is that it is heavy enough to stand reworking. Working with fine papers is one of the most seductive and rewarding experiences of drawing.

PASTEL AND CHARCOAL PAPERS

Roma Pastel Paper: handmade in Italy, 100% chlorine-free cotton, neutral pH, laid surface, 4 deckle edges. Available in multiple colors and various sizes.

Canson Pastel Pad: acid-free, 160 grams; lightfast, rough texture, 12 sheets per pad. Available in assorted colors. Sizes: 9 by 12 inches and 12 by 18 inches.

Canson Ingres: colored laid drawing paper, made in France, gelatin sized, 100 grams. Available in assorted colors, 19 by 25 inches. Good for charcoal, pencil, pastel.

WATERCOLOR PAPERS

Saunders Waterford: white, moldmade in England, 100% cotton, gelatin sized, 2 natural deckle edges and 2 tear deckle edges.

- Waterford Watercolor paper: 22 by 30 inches, 90 lb., 140 lb., cold press.
- Waterford Watercolor paper: 26 by 40 inches, 260 lb., cold press.
- Waterford Watercolor paper: 30 by 42 inches, 575 lb., cold press.
- Waterford Watercolor paper: 60 inch by 10 yard roll, 140 lb., cold press.

Arches Watercolor: white, moldmade in France, 100% cotton, neutral pH, gelatin double sized, deckled edges.

- Arches Watercolor Blocks: moldmade, 12 by 16 inches, 18 by 24 inches, 100% cotton, acid-free, 140 lb., 20 sheets per block.
- Arches Single Sheets: white, moldmade, 22 by 30 inches. Available in various weights and surfaces.

PRINTMAKING PAPERS

Rives de Lin: white, moldmade in France, 85% cotton, 15% linen, neutral pH, rough surface, internally sized, deckle edges.

- Rives de Lin: 22 by 30 inch single sheets and 52 inch by 20 yard roll.

Stonehenge: machinemade in the U.S.A., 100% cotton, slightly textured, sized, deckled edges on 2 sides and 2 cut edges, various off-white tints. Available in various weights, tones and surfaces.

- Stonehenge: 22 by 30 inch single sheets.
- Stonehenge: 30 by 44 inch single sheets.
- Stonehenge: 50 inch by 10 yard roll, white only.

Rives BFK: moldmade in France, 100% cotton, neutral pH, vellum surface, sized, deckled edges, white and cream color.

- Rives BFK: 22 by 30 inches, white and cream.
- Rives BFK: 30 by 44 inches, white and cream.
- Rives BFK: 42 inch by 10 yard roll, white only.

GUIDE 2:
CONSERVING, MATTING, AND FRAMING DRAWINGS

Through this book we have aimed to learn drawing skills and make drawings that express our interests and passions. It would be a shame if your drawings were allowed to deteriorate and languish unseen. This guide will tell you how to safely store your drawings and professionally mat and frame them. At the very least, your finished drawings should be properly preserved and protected; the best of them should be matted and framed so they can be viewed and enjoyed every day.

The two greatest enemies of drawing are humidity and heat. When paper is subject to high humidity, it is at risk from mildew, fungus, and mold. Museums and large galleries use costly and sensitive instruments to determine the relative humidity of their environments. If you are unsure about the humidity in your storage area, inexpensive chemically treated cards are available that indicate the humidity in the air. Although too much humidity can be harmful, too little could cause excessive drying. Excessive heat is also bad for works or art on paper and hastens the aging process. Ideally drawings should be stored and exhibited in environments of 70 degrees Fahrenheit at humidity levels of between 30 and 50 percent. Mold spires thrive in warm, moist environments with limited air circulation. If mold is discovered on your drawings bring them into a drier, well-ventilated area to stabilize them. Exposure to direct sunlight for about an hour will impede mold growth. Separate any mold-infected artworks and keep them unwrapped until the mold growth is stopped. As usual a small amount of prevention is worth a lot of cure. In moist climates dehumidifiers and air conditioning will help to maintain the right level of moisture in your storage and work areas.

Light is also an enemy of drawings, watercolors, and paintings. This may seem paradoxical, considering the care we give to lighting our drawing subjects and our concern with the interplay of light on three-dimensional forms. But too much of the wrong kind of light will cause many drawing media to fade over time. Direct sunlight is the worst culprit because it contains large amounts of the ultraviolet spectrum – the segment that cause the most harm to works of art. Works of art should never be hung where they are exposed to direct sunlight. Incandescent and fluorescent light contains much less ultraviolet radiation and are relatively safer forms of illumination. If you are unable to change a drawing's location in your home, try and control sunlight with shades, drapes, or blinds. You want to continue to enjoy your drawings for many years to come, so be careful of placement.

HANDLING AND STORING YOUR DRAWINGS

Drawings on paper are relatively fragile and should be handled as little as possible. Fingerprint grime, oil, and sweat are destructive to paper. When leafing through a stack of drawings, move each drawing individually – there is less chance of damage in handling them this way. Wash your hands before you touch your drawings. Lift

each one by its two opposite corners, letting the paper curve downward, and gently move it to its new location. If you are doing a lot of reorganizing of your drawings, wear thin cotton gloves that are available from archival art supply dealers (see pp. below for addresses of mail-order and internet dealers).

Drawings should always be stored flat, with interleaving of acid-free tissue paper or glassine between each drawing. Flat plywood shelves can be built to accommodate large quantities of drawings. Storage units are intended to protect the drawings from dust, abrasion, and exposure to light. Inexpensive plywood shelves could provide flat, safe storage but they should be located away from heat sources, direct sunlight, sharp tools, solvents, and paints. Give the raw plywood several coats of polyurethane to isolate the acids in the wood from the paper. Metal flat files are efficient but expensive. Any materials that come in contact with the drawings should be pH neutral. Acidic materials such as cardboard, wood pulp matboard, and any unknown substances should not touch the paper. Eventually these acidic materials will "burn" the surface of the drawing and stain it yellow over time. Even short periods of contact are to be avoided. When buying storage materials the key word to look for is "archival." This means those products are pH neutral or acid-free. Good art supply dealers should stock archival, acid-free interleaving papers, adhesives, and storage containers (see pp. below). When you are storing matted works, the interleaving paper should go between the overmat (the "window") and the artwork. Loose drawings should be interleaved with archival tissue paper and should overlap the drawing by at least 2 inches all around. The layered drawings and tissue paper can then be stacked on open shelves or placed in flat files.

Thin, flat storage boxes (called solander boxes by museums) can be purchased and would be of use to further protect your drawings from dust and light. If you can't find acid-free boxes, line the top and bottom with medium-weight acid-free paper to create a barrier to residual acids.

There are various ways to organize your drawings: by size, media, chronology, themes. Think about what is important to you and what would serve your needs. Grouping works by size avoids the indentations in paper that might result when small and large drawings are placed on top of each other.

A good way to have access to your drawing images without excess handling of the originals is to have color slides or black-and-white photographs taken of your finished work (see "Photographing your Drawings" on page 292 below). There are now specialized computer programs that can organize and catalog hundreds, even thousands, of artworks with thumbnail images and details of originals' size, date, media, etc.

MATTING, HINGING, AND MOUNTING

Matting is the first step in preparing your work to be framed and publicly presented. A mat performs two important functions: it protects fragile work from damage and aesthetically enhances it by isolating it from distracting visual elements. This section will familiarize you with the sequential process of planning, measuring, cutting a mat, and safely mounting your drawing in it.

Professional quality matting can be done on a table of moderate size with relatively little equipment and at modest cost. It does take time, patience, and a little know-how to do it successfully, but – emphasized throughout this book – practice leads to increased efficiency. You must be committed to doing careful, methodical work to achieve good results. Read the procedure described below once or twice

and make sure you have all the necessary equipment and materials before you begin to mat.

Matting does not require a lot of expensive tools. You can make acceptable mats using only a sharp utility knife and a metal straight edge, but I recommend acquiring a simple mat-cutting device that holds the blade at a 45 degree angle for beveled cuts and at the right cutting depth. Beveled cuts are more aesthetically pleasing than a vertical cut and look more professional. If you plan to make more than one or two mats, the hand-held device is worth the investment. I find that the Logan series 4000 is the best and least expensive cutter on the market. Compare mat cutters at your art supply store and decide for yourself.

Here is a shopping list of equipment and materials you will need:

Equipment

- Mat knife and new blades
- Mat-cutting device (optional)
- 36 inch straight edge

Materials

- 4–8 ply museum board
- Japanese rice paper
- Archival starch paste
- Gummed linen tape, 1 inch wide
- Foam core as a cutting surface
- Inexpensive pulp board to cut on

Selecting Matboards

The only materials that should be used for matting and mounting drawings are acid-free matboards and archival tapes and pastes. These 100 percent cotton fiber boards are also called museum boards and they come in 2, 4, and 8 ply weights. The 4 and 8 ply boards are most commonly used – the 2 ply is too thin for most uses. Pulp-fiber matboards are cheaper but have residual acids that will eventually stain the paper and cause it to deteriorate. If a drawing is worth the cost of framing, it is worth the extra money it will take to use archival materials.

There are fewer decisions involved with using museum board. Colors and texture are limited. This is not a bad thing. Mats should not call attention to themselves; they exist to provide a neutral setting for the artwork. Museum boards come in white, natural, and an antique buff color. Cheaper pulp matboards come in a variety of decorator colors and stamped textures. Good drawings need only simple, eloquent presentation. Go to a museum or professional gallery and notice how drawings and watercolors are matted and framed. Contemporary works often have an off-white mat and a simple frame. Presentation is intended to focus the viewer's attention on the work of art, not the framing.

THE MATTING PROCESS

1. **Workspace.** Having a clean, organized workspace helps things go smoothly. A large work table to lay out your matboard and do the measuring and cutting on will promote success.
2. **Mat Dimensions.** Determine the size of the mat window first. This of course is based on the dimensions of your drawing. You will have to decide if the edge of

the mat window slightly overlaps the paper or if you will leave a small margin around it – this is called "floating" the work. If you decide to float the drawing, the window's height and width should each be ⅜ of an inch greater than the drawing's height and width. If you do not float the work, make the height and width of the window ¼ of an inch smaller so that the edges of the mat window slightly overlap the paper.

Now that the dimensions of the mat's window have been determined, we must work out the exterior size of the mat and backing. The standard margin for an average size work is about 3½ inches for the bottom and 3 inches for the sides and top. This is variable, however, and could be changed to accommodate smaller and larger work. Do not be too skimpy with the mat margin – 3 inches is about right, even for small drawings. If you are going to use standardized frame sections that are sold in 1 inch increments (more about this in the section on framing), you may wish to make sure the outer dimensions of the mat are in even inch measurements.

3. **Cutting the Mat.** When you have determined the outer dimensions of the mat window and backing, cut two identically sized pieces out of your museum board. Take one of these pieces and on the *opposite* side of what will be the front window, draw the dimensions of the opening. Have the four lines parallel to the edges overlap at the corners and be sure of their accuracy. Measure twice, because you can cut only once (on which topic, it would be a good idea to practice this process first on a small scale, using less expensive materials). In order to protect the surface of your work table, place an inexpensive sheet of paper board on the table and on top of this place a sheet of foam core. When the blade cuts through the matboard, it will pass easily through the top of the soft foam core and not mar the table top. By having the measuring lines cross by at least several inches, you will have a good idea where the corner intersection is. If you are using the Logan cutter or some other held-held device, follow the instructions that come with it. If you are using a mat knife to make a non-beveled straight cut, do not try and cut through in one stroke – multiple strokes are safer and more effective. Lightly score the first cut and gradually increase pressure. Exercise caution – these blades are sharp. After you cut through, rough edges can be smoothed carefully with some fine sandpaper or with a nail file. The beveled edge you get with a hand-held device is worth the modest cost and effort it takes to learn how to use it. After doing a few mats with the cutter, you will become proficient at using it.

Hinging the Drawing

The hinge for the drawing should be considered an extension of the drawing paper. *Do not* use masking tape or transparent office tape to attach your drawing onto the mat's backing. These materials will eventually discolor and stain the paper and perhaps tear it. Japanese tissue paper is the material of choice. And it should be used with archival starch paste (both of these materials are available from a good art supply store or they can be ordered on the internet). The hinges should measure about 1 inch by 1½ inches. Determine how many hinges you will need for the job and cut them out ahead of time (the number you need depends on whether you are floating the drawing or not).

Now that you have the hinges, carefully place the drawing face down on clean paper, and spread half of the hinge with a thin coating of paste. Do not use too much: the adhesive is strong and an excess amount could cause buckling. Carefully position the hinge so that half of it is glued onto the paper and the other half – like a

tab – extends freely beyond the drawing. Use a clean paper towel to blot excess moisture from the pasted hinge and allow them to completely dry for about half an hour.

Hinging the Matboards

Now it is time to attach the window mat to the backing board. For this job we will use linen tape (a special archival material) to keep the matboards aligned. Place the window opening mat on top of the backing board and then open the window piece as if you were opening a book. The two edges should now be tightly against each other. The longest side of the mat should be by the edge that is taped, regardless of the position of the drawing. Cut a piece of linen tape the exact length of the side, moisten its gummed surface with a sponge, and quickly tape the two sides together. Use a paper towel to wipe off excess moisture. Now close the window mat, making sure the edges are perfectly aligned, and gently smoothe the length of tape with a dry, clean paper towel. Allow the hinged mats to dry.

Positioning your Drawing

Center your drawing within the window opening. Once it is aligned carefully, put a small piece of paper on top of the drawing and place a weight on top of it to prevent the artwork from shifting. The window mat should open freely and return to its predetermined position.

Attaching the Drawing Hinge

Guide 1 "T" hinge.

Now that the drawing is positioned and held in pace by a weight (be careful not to absentmindedly or accidentally move it), it is time to hinge the work to the backing board. Open the window mat and make sure the glued hinging tabs extend freely onto the backing board. Cut some more pieces of Japanese paper, 2 by 1 inch strips will do; moisten one side of the strip and place it over the tab extending from the top of the drawing (Fig. **Guide 1**). This will make a "T" configuration and suspend the drawing from the backing. Make sure that this piece extends over and beyond the hinge that is glued to the drawing. If you are floating the drawing (that is exposing all four edges in the mat window), fold the hinge glued to the drawing paper in half, place a thin layer of paste on this hidden side, and press down firmly onto the backing board with a clean paper towel (Fig. **Guide 2**). In the floating mount all four corners of the drawing should be hinged. If the drawing is large, you may want to place hidden hinges halfway between the corners on all four sides of the drawing.

After your drawing is attached to the support board, the mat is complete. It can now be more safely stored, shown, and framed if you wish.

Guide 2 Hidden hinge.

Mounting a Drawing

If matting and framing drawings is too costly and complicated for you, mounting is a process that offers some of the protection of matting with less work and less money. To mount a drawing, cut a piece of 4 ply museum board at least 2 inches larger in each dimension than the drawing. You do not want to flush mount the drawing because this leaves the edges vulnerable to damage. Position you artwork on the board and use the concealed hinges you would use if you were floating a drawing in the mat. All four corners should be hinged with Japanese rice paper and archival paste. Then you would cover the entire mounted drawing with a thin film of acetate. This method, called *passe-partout*, makes use of pressure-sensitive tape to hold the acetate to the board. Make sure you use acid-free tape instead of masking tape. Tape each edge of the acetate-covered mount the entire length, lapping half of

the tape's width around the edge and then the back of the mounting board. Be aware that since the acetate touches the drawing surface, this method is unsuitable for powdery charcoal and pastel drawings. These works need the protective airspace that a 4 ply window mat can give them.

FRAMING

The frame works as an extension of the mat's functions which are to protect and aesthetically enhance the drawing. A frame can lock out dirt, grime, and some airborne pollutants to further safeguard the drawing. But, like the mat, it must be constructed properly to conserve the artwork and allow us to visually appreciate it. When framing drawings the glazing should never be placed directly against the paper. If temperature changes should cause moisture to condense on the glass – even slight amounts – it could be absorbed by the paper. The thickness of the 4 ply window matting prevents the glass from touching the artwork. Also there is a chance of acid migration from the glass to the paper.

Basically there are two choices for glazing in frames: glass or acrylic sheeting, often called by its trade name, Plexiglas. Glass is less expensive than acrylic sheeting and is easier to clean. But glass is also fragile, a concern if the framed drawing is to be shipped. Plexiglas is the preferred choice for glazing because it is better at protecting the work. This plastic sheeting is a poor conductor of heat, so there is less chance of condensation forming. Cleaning this plastic material is also tricky. Do not use commercial glass cleaners; their chemicals can affect the surface. Both glass and Plexiglas are quite reflective but do not be tempted to use nonglare materials. These must be placed directly on top of the artwork, which is bad from a conservation standpoint.

Choosing a Frame

There are thousands of different frames available on the market today. Your selection will essentially be dictated by two factors: aesthetics and cost. Custom framing gives you the most options but can be quite expensive. I would suggest using simple frames that are not only in keeping with contemporary styles, but fairly inexpensive. One viable alternative to custom framing is to check with your art supply store and see if they have standard-sized metal sectional frames. If your mat measured exactly 16 by 20 inches you would buy a pair of 16 inch frame sections and a pair of 20 inch sides. If you use sectional frames, you have to plan your mat so that it is cut on the even inch. Metal frames are available in several finishes – bronze, silver, gold, and black and white. They are usually quite elegant and inexpensive. Some of them might need a backing board for greater rigidity, so plan to use another piece of 4 ply museum board or see if foam core will fit. To prepare the mat for framing, place a cut sheet of glass or Plexiglas the exact dimensions of the mat over it and follow the instructions that come with the frames. If a custom framer constructs the frames, they will take care of all of these details for you. For the metal frames, attach braided picture wire to the back of the frame, hang it, and enjoy seeing a finished presentation of your work. Since you have worked with archival materials, your drawing should remain intact and look good for years to come.

GUIDE 3:
PHOTOGRAPHING YOUR DRAWINGS

Having professional quality slides or photographic prints of your drawings is a good way to organize and keep track of your work. Be selective. Photograph only your best work. Good slides can also help you when you apply for a job in a visual arts profession or go to graduate school. The art world relies on photographic images to keep track of and share images of artwork. Your slides and photographs are like calling cards – they say a lot about you. Poorly exposed, out of focus slides with distracting backgrounds tell the viewer that your work is not up to professional standards. The actual work may be skillfully done but few people will look beyond the poor quality of your slides.

There are two choices when it comes to obtaining effective slides or photographs. You can have a professional photographer make them or acquire some basic photographic equipment and know-how and learn to make them yourself. Paying a good photographer may prove a prudent investment. Alternatively, you may choose to learn how to take your own slides – in the long run this may be the most cost effective and efficient way to have what slides you need when you need them. Perhaps a friend is a photography major and would be willing to take slides for you. The following guidelines will help you to get professional-looking slides of your artwork. Placing your artwork outside in direct sunlight against a brick wall will leave you with slides that might be too yellow in color and have a distracting background. Doing it the right way takes some planning and special equipment but the results are worth the effort.

COPYING TECHNIQUES FOR COLOR SLIDES

- In order to get the correct color balance on your slides (no yellow or blue cast) you must use the right combination of film type and light source.
- You must obtain color slide film that is balanced for 3400 degrees Kelvin light (there are various brands) and you must use special quartz photo lights that produce 3400K color temperature light. This way the color rendition is true (if you need black-and-white prints, follow these guidelines substituting film emulsions).
- A Single Lens Reflex camera (SLR) is best because it allows you to precisely position and frame the image. Its lenses are usually capable of the resolution necessary to give you sharp slide images. Using a "point and shoot" camera will probably not give you acceptable results.
- Position the camera on a sturdy tripod. This will ensure proper positioning and minimize camera movement.
- Two photo quartz lights of the same wattage should be placed on both sides of the artwork at 45 degree angles to the wall. Light each side separately and overlap the fields of illumination. The goal is to create an even light over the

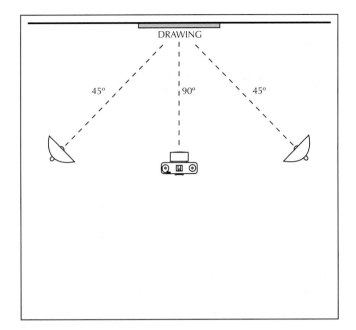

Guide 3 Lighting and camera placement.

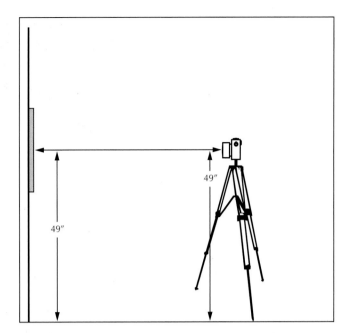

Guide 4 The position of a camera in relation to an artwork.

entire surface of the drawing. The camera must be directly in front of the drawing at 90 degrees to the wall (Fig. **Guide 3**).

- IMPORTANT! Do not mix light sources. Do this at night when no sunlight is streaming in and turn off other sources of light such as fluorescent bulbs. Your color balance will be off if you mix light sources.
- The drawing and the camera must be properly aligned to each other; if not, the image will be distorted. Mount the artwork onto a white studio wall and adjust the height of the camera so that the center of the lens is exactly at the same height as the center of the artwork (Fig. **Guide 4**).
- Determine the correct exposure. Using a Kodak gray card (available at good camera stores), take a meter reading through the SLR of the gray card and set the proper shutter speed aperture combination. In order to ensure that you get a correct exposure, you may wish to "bracket" your exposure: this means making an exposure at the setting indicated by the meter; then make two more exposures at a one ½ aperture stop more and the other at a ½ aperture stop less. If your meter is accurate one of these exposures should be just right.
- Keep records of distances from lights to artwork and the aperture shutter speed settings so you can duplicate successful results.
- Label the slides you wish to include in your slide portfolio (artist's name, title, size, media, the year the artwork was created) and insert them twenty at a time into vinyl slide holders.
- You may need multiple sets of images, so make up to five exposures of each drawing. You can also use your slide records to keep track of your stored drawings and thereby physically handle them less.

APPENDIX I

MUSEUMS AND GALLERIES

New York City

The Asia Society Galleries
725 Park Avenue
New York, NY 10021

The Frick Collection
1 East 70th Street
New York, NY 10021

The Metropolitan Museum of Art
5th Avenue at 82nd Street
New York, NY 10028

The Museum of Modern Art
11 West 53rd Street
New York, NY 10019

The Pierpont Morgan Library
29 East 36th Street
New York, NY 10016

North East Region

Boston Museum of Fine Arts
456 Huntington Avenue
Boston, MA 02115

Bowdoin College Museum of Art
Walker Art Building
Brunswick, ME 04011

Davison Art Center
Wesleyan University
301 High Street
Middletown, CT 06457

The Joan Whitney Payson Gallery of Art
Westbrook College
716 Stevens Avenue
Portland, ME 04103

Yale University Art Gallery
1111 Chapel Street
New Haven, CT 06103

East Coast Region

The Art Museum
Princeton University
Princeton, NJ 08544

The Carnegie Museum of Art
4400 Forbes Avenue
Pittsburgh, PA 25213

Fogg Museum of Art
Harvard University
Cambridge, MA 02138

The Institute of Contemporary Art
955 Boylston Street
Boston, MA 02115

Museum of Art
Rhode Island School of Design
224 Benefit Street
Providence, RI 02903

South East Region

The Ackland Art Museum
Columbia & Franklin Streets
University of North Carolina
Chapel Hill, NC 27599

The Baltimore Museum of Art
Art Museum Drive
Baltimore, MD 21218

The Corcoran Gallery of Art
17th Street & New York Avenue
NW Washington, DC 20006

High Museum of Art
1280 Peachtree Street
Atlanta, GA 30309

**John and Mable Ringling
Museum of Art**
5401 Bay Shore Road
Sarasota, FL 34243

National Gallery of Art
4th Street & Constitution Avenue
NW Washington, DC 20565

New Orleans Museum of Art
Lelong Avenue, City Park
New Orleans, LA 70124

Smithsonian Institution
1000 Jefferson Drive
SW Washington, DC 20560

Mid-West Region

The Art Institute of Chicago
Michigan Avenue & Adams Street
Chicago, IL 60603

The Cleveland Museum of Art
11150 East Boulevard
Cleveland, OH 44106

**Cranbrook Academy of Art
Museum**
500 Lone Pine Road, Box 801
Bloomfield Hills, MI 48303

Des Moines Art Center
4700 Grand Avenue
Des Moines, IA 50312

Detroit Institute of Art
5200 Woodward Avenue
Detroit, MI 48202

Fort Wayne Museum of Art
311 East Main Street
Fort Wayne, IN 46802

Indiana University Art Museum
Indiana University
Bloomington, IN 49405

Milwaukee Art Museum
750 North Lincoln Memorial Drive
Milwaukee, WI 53202

The Nelson Atkins Museum of Art
4525 Oak Street
Kansas City, MO 64111

University of Iowa Museum of Art
150 North Riverside Drive
Iowa City, IA 52242

University Museum
Southern Illinois University
Carbondale, IL 62901

Walker Art Center
Vineland Place
Minneapolis, MN 55403

South West Region

Archer M. Huntington Art Gallery
University of Texas at Austin
Art Building, 23rd & San Jacinto
Streets
Austin, TX 78712

Dallas Museum of Art
1717 North Harwood Street
Dallas, TX 77006

The Menil Collection
1515 Sul Ross
Houston, RX 77006

The Museum of Fine Arts
1001 Bissonnet
Houston, TX 77005

San Antonio Museum of Art
200 West Jones Avenue
San Antonio, TX 78215

University Art Museum
The University of New Mexico
Fine Arts Center
Albuquerque, NM 87131

West Coast Region

**Asian Art Museum of San
Francisco**
The Avery Brundage Collection
Golden Gate Park
San Francisco, CA 94118

The John Paul Getty Museum
17985 Pacific Coast Highway
Malibu, CA 90265

**Los Angeles County Museum of
Art**
5905 Wilshire Boulevard
Los Angeles, CA 90036

**Museum of Contemporary Art,
Los Angeles**
250 South Grand Avenue
California Plaza
Los Angeles, CA 90012

**San Francisco Museum of Modern
Art**
401 Van Ness Avenue
San Francisco, CA 94102

Seattle Art Museum
1st Avenue & University
Seattle, WA 98101

APPENDIX II
PUZZLE SOLUTION

GLOSSARY

AQUATINT An *etching* technique using acid on copper and producing an effect similar to *watercolor*. An unlimited range of tonal gradations from the palest grays to velvety blacks is possible with this medium.

BASSWOOD A lightweight yet hard wood often used in the manufacture of drawing boards.

BINDER The substance in paints, *pastels*, and *chalks* that holds the particles of *pigment* together in workable consistencies.

BISTER A brown *pigment* made from the soot of burnt beechwood. Before the advent of more permanent pigments, this colorant was used in paints for *watercolor* and *wash* drawings.

BOND PAPER Drawing paper that is heavier, whiter, and of a better quality than *newsprint*.

CHALK A drawing material in stick form made by binding powdered calcium carbonate with various gums (see also *pastel*).

CHAMOIS A soft pliant sheet of leather that is used to erase *charcoal* marks on paper.

CHARCOAL A drawing instrument made by charring tree and vine branches in a heated chamber.

CHIAROSCURO An Italian term ("chiaro" means "light" and "scuro" means "dark") that refers to the modelling of form by means of light and dark *values*.

CHROMATIC Relating to color, especially *hue*.

CHROMATIC INTEGRATION The organization of color in the *composition*.

COLLAGE An artform in which bits of paper, cloth, or other materials are glued onto a flat surface.

COLOR WHEEL The circular arrangement of *hues* based on a specific color theory.

COMPLEMENTARY COLORS *Hues* directly opposite each other on the *color wheel* and therefore as different from each other as possible. When complementary colors are placed next to each other in a work of art, they produce intense color effects.

COMPOSITION The arrangement of visual elements such as lines, spaces, tones, and colors in a work of art.

COMPRESSED CHARCOAL A drawing instrument made by mixing powdered *charcoal* with a binding agent and, under intense pressure, forming small cylinders or square-sided sticks.

CONTÉ CRAYON A French crayon with a waxy base, which helps it flow smoothly.

CONTOUR The perceived edges of any three-dimensional form.

CONTOUR LINE In drawing or painting, the line that follows and emphasizes the *contours* of three-dimensional forms.

CROSS-CONTOUR LINES *Contour lines* that intersect one another at oblique angles.

CROSS-HATCHING Closely spaced lines that intersect one another and create modulated tonal effects (the superimposing of *hatching* in opposite directions).

EASEL A free-standing frame designed to hold a canvas or drawing board in an upright position.

ELLIPSE A closed curve having the shape of an elongated circle – visible when true circles are seen from an oblique angle.

ENGRAVING A printmaking technique in which lines are incised on a metal plate with a cutting tool known as a "burin." The plate is inked and the surface wiped clean, leaving the ink in the recessed areas of the plate. Damp paper is placed on top of the plate, picking up the ink from the recessed lines when the plate is run through a press.

ETCHING A printmaking technique in which lines are produced by using acid to corrode selective areas of a metal plate. Ink is then transferred to paper using the same technique as for an *engraving*.

FIGURE 1. In two-dimensional works of art, the principal form or forms as distinguished from the background. 2. The human form.

FOOL-THE-EYE A form of realistic drawing or painting that creates believable illusions of three-dimensional forms on a two-dimensional surface. Also known by the French term "trompe l'oeil."

FOREGROUND In two-dimensional drawings or paintings, those forms or *figures* that appear nearest to the viewer.

FORMAT The shape and size of the drawing surface and its position in relation to the viewer.

FROTTAGE See *rubbing*.

FULL-SPECTRUM COLOR The use of a wide variety of *hues*, or colors, rather than variations of a single hue.

GESTURE DRAWING A drawing technique using rapidly drawn lines to describe and emphasize the essential visual characteristics of a form or forms.

GOUACHE A water-based paint that is more opaque than *watercolor*.

GRAPHITE A soft, black, carbon-based mineral that is mixed with varying amounts of clay and used in the manufacture of pencils and crayons.

GROUND 1. The surface on which a picture is drawn or painted. 2. In two-dimensional works of art, those areas that make up the background.

HARDGROUND An acid-resistant coating applied to the surface of an *etching* plate. The hardground is easily scratched off by an etching needle, leaving clear lines on the plate for the acid to corrode.

HATCHING A drawing technique in which parallel lines are placed close together to create tonal areas that model three-dimensional form.

HIGHLIGHTS In a drawing or painting, those areas that represent the lightest *values*.

HUE The color quality identified by the name of a specific color, such as blue, red, or yellow.

INDIA INK A permanent black liquid drawing medium consisting of lampblack *pigment* (made from carbon) in a natural resin *binder*.

INK A liquid drawing medium consisting of *pigments* or dyes suspended in a water- or resin-based solution.

INTENSITY In color, the fullest degree of brightness or *saturation*.

INTERMEDIATE COLOR See *tertiary color*.

KNEADED ERASER A soft, rubbery, pliable material used to erase *chalk* or *charcoal* lines. The eraser is kneaded to keep it clean.

LAYERING A drawing technique in which *pastel* or *chalk* lines are drawn over one another.

LITHOGRAPHIC CRAYON A fatty-based drawing crayon that contains high amounts of wax and tallow, thus giving it smooth-flowing characteristics.

LITHOGRAPHY A printmaking technique in which a greasy substance is used to make a drawing on a stone or metal plate. Only the drawing then retains the ink when the plate is inked for printing.

MASONITE A hard, synthetic board created by compressing wood fibers together under intense pressure.

MASSED GESTURE LINES A drawing technique using groups of lines which describe the subject's basic tonal characteristics.

MONOCHROMATIC Having a color scheme of tonal variations of one *hue*.

MYLAR A brand of strong, thin plastic film that can be drawn upon using special inks and drawing instruments.

NEWSPRINT An inexpensive, cream-colored, wood-pulp paper suitable for beginners.

OCHER A natural earth mineral that is processed into *pigments* of various yellow and red-brown colors.

OIL STICK A modern drawing medium made by mixing *pigments* with an oil *binder*. These soft and adhesive materials can be applied directly to a surface and can also be spread and blended with a brush soaked in turpentine.

PAPIER D'ARCHES (ROLL ARCHES PAPER) Paper made by Arches, the French paper manufacturing company.

PASTEL A colored *chalk* that consists of *pigment* mixed with a water-based gum *binder* and molded into small cylinders or sticks.

PATTERN A repetitive arrangement of certain forms or designs.

PERSPECTIVE A system of representing three-dimensional space on a two-dimensional surface. Forms of perspective include:

> *Atmospheric/Aerial Perspective* Forms in the *foreground* are made clear and sharp and those in the distance are represented by blurred and less distinct shapes.

> *Empirical Perspective* A form of perspective drawing that is guided by direct experience rather than theory or formula.

> *Linear Perspective* A system of representing items in space based on the fact that parallel lines receding into the distance converge at vanishing points on the horizon.

> *One-Point Perspective* Parallel lines converge at one point on the horizon.

> *Two-Point Perspective* Parallel lines converge at two points on the horizon.

> *Three-Point Perspective* Parallel lines converge at three points on the horizon.

PICTURE PLANE The flat surface area of the drawing.

PIGMENT Finely powdered coloring material used in the manufacture of artists' paints and drawing materials.

PRIMARY COLOR A *hue*, or color, that cannot be created by mixing together other colors. Varying combinations of the primary colors can be used to create all the other colors in the spectrum. In *pigments*, the primary colors are red, yellow, and blue.

RAG PAPER High-quality artists' paper made entirely from cotton fibers. This paper is characterized by its longevity and outstanding surface qualities.

RHOPLEX A trade name for a synthetic acrylic resin that is used as the *binder* in the manufacture of artists' acrylic paints. These paints are thinned with water but, upon drying, become durable and waterproof.

ROLL ARCHES PAPER See *papier d'Arches.*

RUBBING (FROTTAGE) A graphic impression of a *textured* surface made by laying paper over this surface and rubbing with *graphite, chalk,* etc., until an image appears.

SANGUINE A rusty-red *chalk* used for drawing.

SATURATION The relative purity or *intensity* of a color.

SCALE The relative size of an object compared to a "normal" or constant size. In architecture, for example, the scale of a building is illustrated by the size of a human figure.

SCREENPRINTING See *serigraphy.*

SECONDARY COLOR The *hue*, or color, that results when two primary colors are mixed together. In *pigments,* the secondary colors are orange, green, and purple.

SEPIA A dark brown, semi-transparent *pigment* used in *watercolor* and *inks.* Once made from the inky secretions of the cuttlefish, more permanent synthetic pigments are used today.

SERIGRAPHY (SCREENPRINTING) A printmaking technique in which thick inks are forced through a fine mesh screen. By selectively blocking and leaving open portions of the screen (stencilling) the image is transferred to the paper.

SIGHTING A means of determining *composition* through the use of a device that creates a rectangular "window."

SILVERPOINT A drawing technique in which a thin silver wire is used to make marks on the surface of a specially coated paper.

SOLVENT The liquid that is used to thin paints or clean brushes after use. Two of the most common solvents are water and turpentine.

SUGAR-LIFT ETCHING A method of drawing directly onto the *etching* plate using a mixture of sugar dissolved in *India ink.* The plate is then covered with an acid resistant varnish and, when this is dry, the plate is immersed in warm water. The sugar gradually dissolves, lifting the varnish with it and exposing the plate to the acid.

TEMPERA A paint made by binding *pigments* in a water-based emulsion that is traditionally made from egg yolk.

TERTIARY (INTERMEDIATE) COLOR Any *hue*, or color, produced by a mixture of *primary* and *secondary* colors.

TEXTURE In a work of art, the tactile qualities of a three-dimensional surface or the representation of such qualities.

TONE A term used in art to refer to the lightness or darkness of a color.

VALUE The relative darkness or lightness of a color or neutral tone, ranging from black to white.

VANISHING POINT In *linear perspective*, the point on the horizon at which parallel lines appear to converge.

VELLUM A heavy, high-grade paper often used in certificates and diplomas. Historically, vellum was made from skins of newborn calves but today this term refers to a number of smooth, quality papers.

VINE CHARCOAL A drawing tool made by charring twigs of wood, usually willow, or pieces of vine.

WASH A thin transparent film of *ink* or *watercolor* applied to the drawing surface.

WATERCOLOR A transparent water-soluble medium consisting of *pigments* bound with gum.

WOODCUT A printmaking technique in which areas are carved away from the flat surface of a wood plank. Only the uncarved portions of the wood accept the ink and register as dark marks on the print surface.

WORKABLE FIXATIVE A thin liquid containing dissolved resin that is sprayed over a *pastel* or *charcoal* drawing to protect it from smudging. Workable fixatives allow artists to redraw over the fixed surfaces.

FURTHER READING

General Reference

Atkins, Robert, *Artspeak: A Guide to Contemporary Ideas, Movements, and Buzzwords*. New York: Hacker Books, 1990.

Beier, Ulli, *Contemporary Art in Africa*. New York: Praeger, 1968.

Bertram, Anthony, *1,000 Years of Drawing*. London: Studio Vista, 1966.

Elderfield, John, *The Modern Drawing*. New York: The Museum of Modern Art, 1983.

Goldman, Paul, *Looking at Prints, Drawings, and Watercolors*. Santa Monica, CA: John Paul Getty Trust, 1989.

Klee, Paul, *Pedagogical Sketchbook*. London: Faber & Faber, 1968.

Leonardo da Vinci, *Leonardo da Vinci Drawings*. New York: Dover, 1983.

Lippard, Lucy, *Six Years: The Dematerialization of the Art Object from 1966 to 1972*. New York: Praeger.

Mendelowitz, Daniel M., *Drawing*. Palo Alto, CA: Stanford University Press, 1980.

Moskowitz, Ira, ed., *Great Drawings of All Time*, 4 vols. New York: Shorewood Publishers, 1962.

Rawson, Philip, *Drawing*, 2nd edn. Philadelphia, PA: University of Pennsylvania Press, 1987.

Selz, Peter, *Art in Our Times: A Pictorial History 1890–1980*. New York: Harcourt Brace Jovanovich, Inc., 1981.

Smagula, Howard, *Currents: Contemporary Directions in the Visual Arts*. Englewood Cliffs, NJ: Prentice Hall, 1983.

Varnedoe, Kirk, and Adam Gopnick, *High and Low: Modern Art and Popular Culture*. New York: Abrams, 1990.

The Elements of Drawing

Chaet, Bernard, *An Artist's Notebook: Techniques and Materials*. New York: Holt, Reinhart & Winston, 1979.

_____ , *Art of Drawing*, 3rd edn. New York: Holt, Reinhart & Winston, 1983.

D'Amelio, Joseph, *Perspective Drawing Handbook*. New York: Van Nostrand Reinhold, 1984.

Frank, Peter, *Line and Image: The Northern Sensibility in Recent European Drawing*. New York: Independent Curators Press, 1987.

Godfrey, Tony, *Drawing Today: Draughtsmen in the Eighties*. Oxford: Phaidon, 1990.

James, Jane H., *Perspective Drawing: A Directed Study*. Englewood Cliffs, NJ: Prentice Hall, 1981.

Medar, Joseph, *The Mastery of Drawing*, Vols I and II. Pleasantville, NY: Abaris Books, 1977.

Olszewski, Edward J., *The Draftsman's Eye: Late Italian Renaissance Schools and Styles*. Bloomington, IN: Indiana University Press, 1981.

Rose, Barbara, *Drawing Now*. New York: Museum of Modern Art, 1976.

Szabo, George, et al., *Landscape Drawings of Five Centuries, 1400–1900*. New York: Museum of Modern Art, 1976.

Walters, Nigel V., and John Broman, *Principles of Perspective*. New York: Watson-Guptill, 1974.

Warshaw, Howard, *Drawings on Drawing*. Santa Barbara, CA: Ross-Erikson, 1981.

Creative Expressions

Arbitrary Order: Paintings by Pat Steir. Houston: Contemporary Arts Museum, 1983.

Baur, Jack, text by Alice Neel, *Drawings and Watercolors*. New York: Robert Miller Gallery, 1986.

Castleman, Riva, *Jasper Johns: A Print Retrospective*. New York: Museum of Modern Art, 1986.

Chappeuis, Adrien, *The Drawings of Paul Cezanne*. Greenwich, CT: New York Graphic Society, 1973.

Clark, Kenneth, *Landscape into Art*. New York: Harper & Row, 1976.

Collischan van Wagner, Judy K., *Lines of Vision: Drawings by Contemporary Women*. New York: Hudson Hills, 1989.

Gardner, Howard, *Art, Mind, and Brain: A Cognative Approach to Creativity*. New York: Basic Books, 1984.

Giacometti, Alberto, *Giacometti, A Sketchbook of Interpretive Drawings*. New York: Abrams, 1967.

Goldstein, Nathan, *Figure Drawing*, 3rd edn. Englewood Cliffs, NJ: Prentice Hall, 1987.

Graze, Sue, and Kathy Halbreich, *Elizabeth Murry: Paintings and Drawings*. New York: Museum of Modern Art, 1987.

Guptile, A., *Color in Sketching and Rendering*, 2nd edn. New York: Van Nostrand Reinhold, 1989.

Henks, Robert, *New Visions in Drawing and Painting*. Independence, MO: International University Press, 1984.

Hinz, Renate, ed., *Kathe Kollwitz: Graphics, Posters, Drawings*. New York: Pantheon, 1987.

McClelland, Deke, *Drawing on the Macintosh*. Homewood, IL: Business I Irwin, 1990.

Miller, William C., *Creative Edge*. Redding, MA: Addison-Wesley, 1989.

Romare Bearden: The Prevalence of Ritual. New York: Museum of Modern Art, 1973.

Rose, Bernice, *New Work on Paper Three*. New York: Museum of Modern Art, 1985.

Schellman, Jorg, and Josephine Benecke, eds., *Christo Prints and Objects*. New York: Abbeville Press, 1987.

Smithson, Robert, *Drawings*. New York: The New York Cultural Center, 1974.

Spencer, Donald D., and Spencer, Susan L., *Drawing with a Microcomputer*. North Oaks, MN: Camelot Publishing, 1989.

INDEX

Numbers in *italics* refer to illustration captions.

NOTES

NOTES

NOTES

NOTES

NOTES

NOTES

NOTES

NOTES

NOTES